DIGITAL FILMMAKING
An Introduction

This book is dedicated to Victoria Mature and Steven Scheibner.

Victoria is my muse. Without her the creation of *As You Like It* and the writing of this book would not have been possible.

Steven co-created my first movie, an epic of dental hygiene called *Supercrest*. He taught me the vital importance of silliness.

I owe each of you more than I can ever repay.

CONTENTS

ILLUSTRATION CREDITS

Michael Rue
Figure 1.1

Andy Rogers
Figures 3.4, 3.12, 3.38, 3.40, 4.4, 4.37, 5.1, 5.17, 6.7, 6.14, 6.14, 6.15, 7.8,
 14.3, 14.5, 14.6, 15.2

Victoria Mature
Figures 3.31, 3.32, 3.33, 3.34, 3.35, 6.10

Gerald Everett Jones
Figures 3.36, 5.19, 7.1

Denecke Inc.
Figure 6.18

Sounddogs.com
Figure 9.5

Freeplaymusic.com
Figure 9.7

All other figures are courtesy of the author.

PREFACE

No Time Like Now

You've probably heard it. Everybody's saying it: There's never been a better, more exciting time to be an aspiring filmmaker. Why? Because never before have the tools for making movies been available to so many people.

Up until just a few years ago, if you wanted to make a movie, you had to use very sophisticated and highly specialized equipment only movie studios could afford. But today, you can get everything you need to make a movie at your local electronics superstore. All you need to begin is a camera, a computer, and some editing software—all of which are easily affordable.

Of course, digital technology has made all this possible. In the past, if you wanted to create a moving image, you needed a truck full of camera equipment, a highly trained crew, and the services of a photo lab and screening room before anyone could watch a single frame of footage. But today even the most basic camcorder gives you that same capability. And it doesn't stop there. The cameras and software keep getting more powerful. Every few months there's another breakthrough that brings even more Hollywood capability within reach of aspiring filmmakers.

What Makes Hollywood Different?

If everyone, however, has the same tools, why are the results so different? Why do most online videos look and sound so inferior when compared to

Hollywood movies? Sure, the cameras in Hollywood cost more, and big budget movies are full of well-known stars, but that's not what really makes the difference. What sets Hollywood movies apart aren't the tools they use, but how they use them. Regardless of the era in which they were created (or the technology available at the time), Hollywood movies have always had certain basic characteristics. Those characteristics include:

1. A carefully written, highly structured script

2. Shots characterized by strong graphic design and evocative lighting

3. A rich, deeply layered soundtrack

None of these elements has anything to do with cameras or stars. The basics of story structure have been studied as far back as ancient Greece. Renaissance painters often debated the use of light and shadow; and music composition has always depended on the layering and juxtaposition of sounds. Although you might not always see them, these basic fundamentals have more to do with what makes a movie than any specific technology. Once you let these fundamentals guide the use of your camera and software, that's when your videos start to look like movies.

The Digital Filmmaker Series

The *Digital Filmmaker Series* was designed to bridge the gap between the latest digital technology and the classic fundamentals of moviemaking. We've gathered a team of seasoned Hollywood professionals, in the fields of *introduction to filmmaking, screenwriting, storyboarding, editing, distribution,* and *studio methods.* Each of our authors will take you behind the curtain and show you how technology and theory intersect in their areas of filmmaking. In short, we'll teach you how to use the tools that technology has made affordable.

Through it all, our focus will be on using technology to tell effective stories with pictures and sound. Because once you know how to tell stories, it doesn't matter how the technology grows and changes. You'll be able to grow and adapt with that technology, because you'll know what the tools are for. You'll know how to make movies.

GETTING STARTED

OVERVIEW AND LEARNING OBJECTIVES

In this chapter, you will:

- Understand the basic definition of filmmaking
- Explore the many skills that go into making movies
- Understand how this course is organized (and why)
- Become familiar with the different types of digital video cameras best suited for this course
- Learn the features of the computer hardware and software you will need to edit digital video
- Start to think like a filmmaker

What is Filmmaking?

Think of a movie. Any movie. Now think about all the different skills that went into making that movie. There's the skill of the writer who wrote the script and the talents of the actors who brought the characters to life. There are the skills of the *cinematographer* who captured the images and the composer who created the soundtrack. Then there are those working behind the scenes: the planning and organizing of the producer and the supporting efforts of everyone on the crew. And coordinating it all is the vision of the director. All of them are filmmakers, and all of them make an indispensable contribution to the finished movie.

But filmmaking is more than writing. It's more than acting. It's even more than directing. It's the magic that happens when all these skills are brought together to do one simple thing: to tell a story with pictures and sound.

Telling stories

Many sociologists believe the need to tell stories is a defining aspect of being human—it's one way we make sense of the world around us. People have been telling stories since before there were languages. Early man told stories of hunting and survival in cave paintings. Myths and legends have been found in every language ever discovered, and people still perform the plays written by the ancient Greeks.

Stories take many forms: poems, plays, and even video games all tell stories. Filmmaking is just another form of storytelling. Poetry uses *metaphor*. Plays use actors and the spoken word, and filmmaking uses pictures and sound.

> **KEY TERM:**
>
> **METAPHOR Using one idea to explain another. An example would be to say your friend is a tiger as a way to explain his fierce competitive spirit.**

Although it seems simple enough, the relationship between the sounds and pictures in a film can be very complex. Consider the following ideas:

- The pictures can be of anything. They don't have to be people. They can be buildings or animals or abstract images.
- The sounds can be anything. They don't have to be words. They can be music or sound effects or just noise.

We'll talk more about stories in Chapter 2, but for now just recognize that filmmaking is a special form of storytelling, and it's one that relies on a collection of many different skills.

It Takes a Village

Many artists can create their works all by themselves. All a poet or novelist needs is a blank piece of paper (or a blinking cursor). A painter just needs his canvas. Filmmakers, on the other hand, need an entire community to make a movie, and each person in that community is an artist, each with their own talents and skills. For example:

- The writer's specialty is weaving together character and plot.
- The cinematographer should be a master of light and shadow and understand the elements of photography.
- The editor needs to understand pacing and juxtaposition.

The talents of all of these people affect the overall story, and it's the director who coordinates their efforts so they all come together in a single, unified story.

But you don't have a village of artists (or a movie studio)

You're just starting out. You've got a camera, a computer, and an idea. That's all. You don't have a cinematographer, or an editor, or a composer. So you've got to do it all yourself, with the help of a few friends. That's where this book comes in. It will teach you everything you need to know to tell a story with pictures and sound. It will teach you how to be a filmmaker, and more than that, it will teach you how to combine classic Hollywood techniques with new digital technology to create the most professional-looking projects possible (see Figure 1.1).

 All figures and shorts are included on the companion DVD with this book.

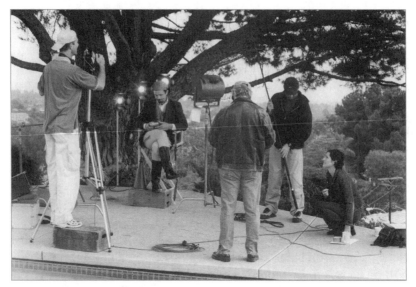

FIGURE 1.1 The cast and crew at work on the set of *Alan Smithee's Hollywood Tips*. This short was produced with a small group of friends using the techniques covered in this book.

What's Ahead

This book is written for someone who's never taken any course on filmmaking (or screenwriting, or cinematography, or editing). Maybe you've never even picked up a video camera. That's okay. We'll cover everything you need to know, including:

- Storytelling

- Using a digital video camera

- *Shot design* and theory

- Lighting

- Recording good sound on the set

- Directing

- Editing

- Building a soundtrack

- Adding finishing touches to picture and sound

- Getting your work seen

KEY TERM:

SHOT DESIGN The choice of what appears within the boundaries of the picture frame (or *shot*).

Each of these subjects is covered in a separate chapter, and there is also a series of chapters at the end of the book (Chapters 11 to 15) with descriptions of many different types of video projects from *narrative fiction* to interviews to live events.

KEY TERM:

NARRATIVE FICTION A story. Regardless of whether it's makebelieve or based on true events, it's still considered to be fiction. Most movies fall into this category. Sometimes the phrase is shortened to simply "a narrative."

By the time you finish this book, you should be able to tell an effective story with pictures and sound that you'd be proud to show your friends (or post online). But suppose you're already comfortable shooting video and doing basic editing? Unless you've taken film classes before, there's still probably material in this book that's new to you.

Choosing a Camera

If you've been to an electronics store lately, you've probably noticed the huge selection of video cameras out there. They range from simple cameras (like the one in your phone) to expensive professional-grade camcorders (see Figures 1.2 and 1.3).

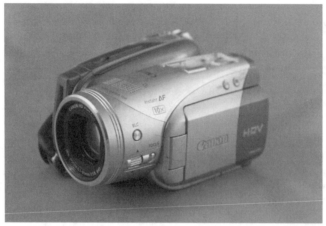

FIGURE 1.2 The Canon HV-20 is a tape-based, consumer-grade camcorder capable of recording both high-definition and standard-definition video. This camera was used to shoot the independent feature *As You Like It* featured in later chapters.

Figure 1.3 shows a *prosumer* camera.

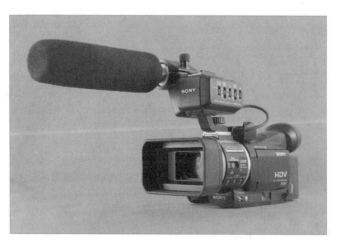

FIGURE 1.3 The Sony HVR-A1U is a prosumer camera, and it combines many features of both consumer-grade and professional-grade cameras. In addition to having a large set of manual controls, this camera can also use a professional external microphone.

There are many different options and price ranges to choose from. Fortunately, it's fairly easy to divide cameras into groups based on *format* and *recording media*.

Format

Format refers to the actual video signal produced by the camera. The most common video cameras today produce signals that are either Standard Definition (SD) or High Definition (HD). *Definition* refers to how much information is in the image, i.e., how sharp or crisp the image will be. Engineers measure definition by how many vertical lines of information are contained in the image. Standard definition has 480 vertical lines of information per image, while high definition can have either 720 lines or 1024 lines, depending on the camera.

You've all seen high-definition television, and you know how much better an HD picture looks than a regular (standard-definition) image. But just because HD looks better, doesn't automatically mean it's a better camera choice than a standard-definition camera (commonly referred to simply as *DV*; see the sidebar, "Digital Video and DV: They're Not the Same Thing"). There are two reasons for this:

- To fully appreciate HD, you need to have an HD television. Do you know for a fact that everyone you want to see your HD movie will have access to an HD disc player and TV? You may end up shooting in HD, but making standard-definition DVDs to show your movies.

- High-definition video contains much more information than regular DV. To record this much information, the video is highly *compressed* (see the sidebar, "Why is Digital Video Compressed?").

- Before your computer can edit HD, the images must first be decompressed. Normally, your editing software does this automatically, but doing this requires a more powerful computer and a larger hard drive than you would need to edit regular DV, and creating HD discs requires more computing power than making regular DVDs.

So when choosing between DV and HD, think about more than how detailed the image will be. Consider the power of your computer and how many HD televisions (and disc players) are in your target audience. Finally, think about cost. DV cameras produce excellent images and you can buy a new one for well under $300.

DIGITAL VIDEO AND DV: THEY'RE NOT THE SAME THING

Here's the deal. Any video that is recorded as computer data is technically digital video. These days, almost all video is recorded digitally—even HD. But when digital-video recording first entered the mainstream in 1995, the term *digital video* referred to a very specific format. That format was standard definition and it was only recorded on tape. This format came to be known as DV for short. These days, anytime you see the abbreviation DV, it refers to that original format (which is still very much in use).

And just to confuse matters a little more, when consumer cameras started using this format, they redesigned the tape and made it smaller. They called this new smaller tape a mini DV. But other than the size of the tape (and a few very technical differences), mini DV is the same as regular DV.

Figure 1.4 shows a mini DV tape.

FIGURE 1.4 The standard, consumer-grade mini DV tape records in standard definition, but the same tapes can also be used to record high definition in the HDV format.

Recording media

After choosing a format, the next decision you have to make is which recording media your camera should use. Recording media refers to how the video is stored within the camera, and both HD and DV cameras can sometimes use the same media. Currently, there are four different types of recording media:

- Tape

- DVD

- Hard drive

- Memory cards (also called *flash memory*)

SIDE NOTE

WHY IS DIGITAL VIDEO COMPRESSED?

All digital video is compressed. It's a fact of life. The reason it needs to be compressed is because a single frame of video contains far too much data to move and store easily, and that frame is just one single image in the constant stream of images needed to create the illusion of motion. When you consider that one second of video usually contains 30 separate images, the need for compression becomes even more evident.

So when engineers were figuring out how to record digital video, they invented software called a *codec*, which stands for compressor-decompressor. These codecs are busy compressing and decompressing video anytime you're recording video or editing it on your computer.

Codecs are good because they allow us to process video on a computer, but they also have some drawbacks. When an image is compressed, some of the data in that image is discarded. This can result in the image losing some of its sharpness or detail. If you've ever wondered why many of the videos you watch online look a little blocky, or choppy, it's because of how much they were compressed before being uploaded.

Understanding codecs is important when choosing a camera because the different formats and different recording media use different types of compression. A high-definition image is compressed more than a standard-definition image because HD has more data. When it comes to recording media, something recorded on tape usually has less compression than something recorded on a memory card because tape can handle more data.

What does all this mean? A tape-based camcorder recording standard-definition DV will use the least amount of compression and will require the least amount of computing power to process and edit. That means you'll need a less-expensive computer. On the other hand, HD video recorded to a memory card will need a newer, more powerful computer to turn your footage into a finished movie.

Tape Cameras

Tape is the oldest, and some would say most durable, recording media. Mini DV is the most common tape format, and it records standard-definition video. But tape can also be used to record high definition. This format is

called HDV, and it uses the same mini DV tapes used for DV, but it records a completely different signal. Some people think tape is old school and is on the way out, but there are others who insist on using nothing but tape. Here are some of the pros and cons of tape:

- Pros of Tape
 - You have a permanent, physical backup of everything you shoot.
 - Recordings made on tape use a less severe form of compression than any other media.
 - Tape is relatively inexpensive.

KEY TERM:

CAPTURING VIDEO The process of transferring footage from your camera to the hard drive of your computer so you can begin editing.

- Cons of Tape
 - Tape is sequential and moves at a constant speed. This means when you *capture* video, it happens in real-time. You cannot selectively capture shots and scenes out of sequence.
 - If the recorder malfunctions (while either recording or playing back) the tape could be damaged, resulting in the loss of your footage.
 - Tape can be subject to *dropouts*.

KEY TERM:

DROPOUT A momentary disruption of the data stream recorded on tape. This can be due to an imperfection in the tape or a bit of dirt on one of the recording heads. The result is a short break in the video signal with no picture or sound.

DVD Cameras

As the name implies, DVD cameras record the video on small DVDs inside the camera, and since all DVDs are standard definition, these cameras cannot currently record HD. Once recorded, you can watch the DVDs in any regular DVD player. Like tape, DVD cameras give you a physical backup of everything

you shoot, but the video it records is much more compressed. It is also much more difficult to capture and edit what you shoot. These cameras are primarily designed for ease of use and are not a good choice for video production.

Hard-Drive Cameras

Hard-drive cameras are a step up from DVD cameras, and they record the video on a small hard drive built into the camera. These cameras come in both high definition and standard definition and are often smaller than either tape or DVD cameras. Here are the pros and cons of using a hard-drive camera:

- Pros of a Hard-Drive Camera

 - Transferring your footage to the computer is fast and easy. All you're doing is moving files around. You don't have to watch the shots in real-time, and you can transfer individual shots in any order you like.

 - Once you buy the camera, you have no additional media costs. No blank tapes or discs are needed (unless you back up your footage—see the following).

- Cons of a Hard-Drive Camera

 - The footage is more highly compressed than with a tape camera.

 - There is no physical backup of your footage. After transferring the footage to your computer, you generally erase the camera's hard drive (to make room for more footage). If your computer's drive crashes, you could be sunk. That's why many people make backup tapes or DVDs of their footage after they capture it.

 - Regardless of its size, eventually the camera's hard drive gets full, and when it does, you've got to download (and erase) some footage before you can shoot more.

Some hard-drive cameras use the initials HD or HDD (for hard-disk drive) in their names. This can be confusing because HD also stands for high definition. Be careful when shopping or you could end up with a standard-definition hard-drive camera when you thought you were getting something to shoot high definition.

NOTE

Memory-Card Cameras

Unless you're using an older camera, more than likely your camera will be recording your video on memory cards, and in many ways memory cards are the most versatile media. These cameras can generally record both standard- and high-definition video, and they can use many different types

of compression, depending on how sophisticated the camera is, and that sophistication ranges all the way from cell phone cameras to professional cameras used on Hollywood movies.

Memory-card cameras have many similarities with hard-drive cameras, since they both use forms of computer memory to store their video. Their pros and cons are also similar, but there are a few significant differences. First, a memory-card camera has far fewer moving parts and is therefore more durable and shock resistant than any of the other cameras. Second, since memory cards are the smallest and lightest of the recording media, the cameras can also be smaller and lighter. Finally, unlike the hard-drive cameras, you can swap out memory cards when one gets full—but usually you'd only swap them out so you could download the video to your computer. Using a new memory card each time you filled one up would get very expensive!

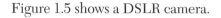

SIDE NOTE

VIDEO DSLRS: ONE MORE OPTION

Certain still cameras also have the ability to shoot video. Most often, these cameras are Digital Single Lens Reflex (DSLR) cameras, and they're designed primarily to shoot high-quality still photographs. But these cameras can also record standard and high-definition video on memory cards.

Using these cameras well requires some technical skill and a basic knowledge of photography, but the resulting video can look very cinematic.

Figure 1.5 shows a DSLR camera.

FIGURE 1.5 A DSLR camera like the Canon T1i can be an excellent choice for shooting high-quality video. But using a DSLR well requires more advanced production techniques than using a camera designed specifically for shooting video.

Manual controls you must have

So you've done some soul searching and figured out what format (DV or HD) and recording media would be best for your plans (and your budget). You're not quite done. As you've probably discovered, video cameras come with an almost infinite variety of options from infrared recording to built-in digital effects, and while we're not going to cover them all, we are going to discuss certain manual controls your camera must have to make movies.

> *A general rule of thumb regarding video cameras is the more control you have over the image, the more expensive the camera. A simple camera, like the one in your cell phone, generally has no manual controls. On the other hand, a professional Hollywood camera allows very sophisticated image manipulation.*

NOTE

Every video camera has an automatic point-and-shoot mode in which all you do is hit the record button and let the camera do the rest. It decides what should be in focus. It decides how bright or dark the image will be. It decides how loud or soft the audio is. While this is great for home videos, it can be a disaster when you're trying to make a movie. A big part of telling stories with film or video involves making specific choices about what each image should look like. To have that control, your camera has to have a few very important features (see Figure 1.6).

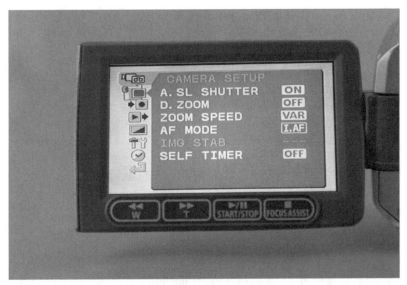

FIGURE 1.6 Most of the features on cameras like the Canon HV-20 are controlled by onscreen menus as shown here. Learning how to navigate these menus is crucial to getting the best possible results from the camera.

While you'll have many possible features to choose from, you need to select a camera with at least the following options:

- Manual Focus
- Control of Automatic Exposure
- White-balance control
- External microphone jack
- Headphone jack

We're not going to discuss how to use these features here (that's covered in Chapter 3), but we are going to briefly cover what you need to look for before deciding which camera to buy.

Manual focus

When a video camera is in point-and-shoot mode, it's deciding what should be in focus and what can be blurry. That's fine as long as it's making the right decision. But it can't read your mind (and it certainly hasn't read the script), and if it makes the wrong choice, or tries to change focus in the middle of a shot, it can ruin an otherwise perfect *take*.

KEY TERM:

TAKE A numbered attempt to get an acceptable shot from beginning to end. As an example, the director might say, "This is scene 37, take 2," before beginning the second attempt to film scene 37.

To maintain control over the focus of your shots, you need to have a camera that allows you to switch from Auto Focus to Manual Focus. This is usually in the form of a toggle switch or button somewhere near the lens that will stop the camera from trying to determine when objects are in focus (see Figure 1.7). In addition to a Manual Focus switch, these cameras will usually have a focus wheel or a focus ring around the lens. Using the focus wheel, you can set the focus to exactly where you want it to be.

Control of Automatic Exposure

Exposure is what determines how light or dark the image is. In a film camera, the film is literally *exposed* to a certain amount of light coming through the lens. This light reacts with a chemical coating on the film and creates an image.

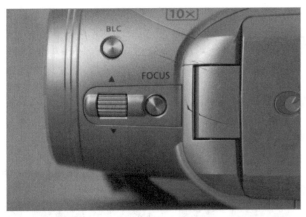

FIGURE 1.7 The focus button on the Canon HV-20 toggles between Auto Focus and Manual Focus. When the camera is in Manual Focus mode, the small dial next to the focus button is used to focus the lens.

In a video camera, a light-sensitive imaging chip replaces the film, but the concept is the same—an image is created when the chip is exposed to light.

When the camera is in automatic mode, it's measuring how much light is coming through the lens and deciding if the image is too light or too dark. Then the camera lets in more or less light based on what it thinks would make the best image. Of course, the camera isn't actually making these decisions—it's reacting to programming created by the engineers who built the camera.

As with Auto Focus, Automatic Exposure is not necessarily a bad idea. But the engineers who designed the camera were not thinking about creating artistic shots for your movie when they programmed the automatic exposure. Suppose you want a dark image to create a certain mood. If the camera is automatically adjusting your exposure, you would have difficulty creating a deliberately darkened image. And if the lighting changes during a shot, such as a character turning on a light when she enters a room, Automatic Exposure would instantly darken the image when the light came on.

To maintain control over your images, you need to be able to control Automatic Exposure. Different cameras offer different degrees of exposure control. Here are some of the most common options:

- **AE Shift**. This stands for *Automatic Exposure Shift*. It allows you to lighten or darken the image by readjusting what the camera considers normal. The camera still automatically adjusts exposure, but the resulting image is lighter or darker depending on how you set the controls. This does not give you as much control as Exposure Lock.

- **Exposure Lock**. This allows you to turn off automatic exposure, so the camera makes no changes to your image regardless of how the light in the environment changes. Some cameras combine this with *Manual Exposure Control*, which allows you to set the exposure anywhere you want with a wheel or dial. This is the best option for gaining complete control of your image (see Figures 1.8 and 1.9).

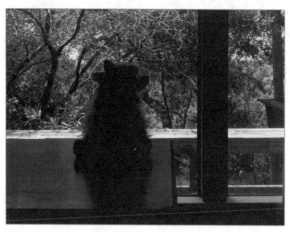

FIGURE 1.8 In this picture, the camera is using the light coming in through the window to set the exposure for the scene. As a result, you can see the trees very clearly, but the details of objects inside are totally obscured.

The following figure shows you the same picture with the exposure set manually.

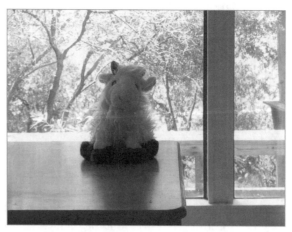

FIGURE 1.9 Here is the same scene as in Figure 1.8, but now the exposure has been set manually to compensate for the lower light level indoors. Being able to manually set the exposure on a camera allows you to choose which elements of an image should be properly exposed.

White-Balance Control

Before we define white balance, we need to talk briefly about white light. Without getting too technical, most light sources we consider to be white actually have a slight colored tint. A lightbulb, for example, puts out light that is slightly orange, and the light from the sun actually has a faint bluish tint. We don't usually see these colors because our brain automatically adjusts our color perception.

But cameras see these colors, and without some kind of adjustment to correct those orange or bluish tints, the colors produced by the camera will not look right to us. Controlling white balance is how we make that adjustment. White balance is the process of telling the camera that light from a certain source is truly white. Circuitry in the camera then adjusts all the other colors based on where the white balance has been set and makes the colors look true to our eyes (see Color Plate Figures 1 and 2.)

When Automatic White Balance is on, the camera is constantly evaluating the light sources in a shot and deciding which source should be represented as truly white. Normally, this doesn't cause any problems because you're either shooting indoors or outdoors. But if you're in a situation in which a manmade light source (such as a lightbulb) is mixed with sunlight—which could easily happen if you were in a room with a large window—automatic white balance could get you into trouble. The camera doesn't know whether the indoor lightbulbs or the sunlight streaming in through the window should be the predominant light source. In this situation, the white-balance circuitry would be constantly readjusting the white balance, which would cause the colors in the shot to be constantly changing.

The way to avoid having shots in which the color balance is constantly shifting is to have a camera with the ability to switch from Automatic White Balance to Manual White Balance. We'll cover the process of setting your own white balance in Chapter 3, but for now just be aware you need to select a camera that allows you to set your own white balance.

External Microphone Jack

Every video camera has a microphone built into it somewhere, and if you're just using the camera to shoot home movies, that built-in microphone is usually all you need. But no matter how expensive the camera, there's one major problem with every microphone ever put on a video camera—it's in the wrong place!

A microphone that's part of the camera will always be right where the camera is. But unless your actors are standing beside the camera, you'll never be able

to record their dialogue very clearly. If you've ever tried to videotape a play or any event in which the action was more than a few feet from the camera, you know how disappointing the audio from the built-in microphone can be.

On professional productions, they ensure they're getting the best quality sound by always using external microphones, and those mics are placed right where the action is, usually on or near the actors in a scene. But you can't use an external microphone unless your camera has an external microphone jack. So when you're shopping for a camera, be aware that it's common for less-expensive cameras not to have the capability to use an external microphone (see Figure 1.10).

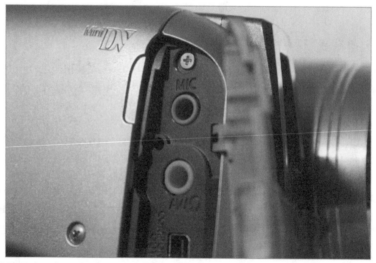

FIGURE 1.10 The microphone input on the Canon HV-20 allows you to use an external microphone to record sound. Using an external mic is the only way to record clean, crisp dialogue for a movie. This topic is discussed more fully in Chapter 6.

When you do find a camera that can use an external mic, it will either accept a 1/8-inch jack (3.5mm) or possibly even an XLR cable (see Figure 1.11). XLR inputs are usually found on more expensive cameras, and they allow you to use professional-grade microphones. For this course, either input will do, but if you're looking for a camera that can do more professional work, getting XLR inputs might be a good choice. We'll cover the many ways to use external microphones to get professional-quality sound in Chapter 6.

Headphone Jack

When you're recording sound with an external microphone, it's important to know if you've got the mic in the right place, and if the dialogue you're recording is *clean*.

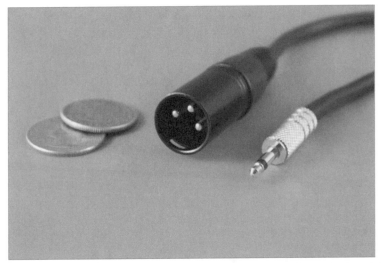

FIGURE 1.11 On the left is an XLR jack, widely used for professional-grade microphones. On the right is a standard 1/8-inch jack used on consumer-level mics and most lavalieres. Notice that the 1/8-inch jack has only a single black band on the plug. This identifies it as a plug used with a mono (single channel) microphone.

KEY TERM:

CLEAN DIALOGUE Dialogue is clean when there are no other sounds happening at the same time the words are being spoken. For example, if a car door slams while someone is talking, or if you can hear background noise like the hum of an air conditioner, the dialogue is not clean.

The only way to tell if you're getting good, clean sound during a take is to monitor the sound while you're recording, and to monitor the sound, you need to be wearing headphones plugged into the camera. Some of the simpler cameras on the market don't have a headphone jack, so make sure any camera you consider buying has a way for you to plug in a set of headphones (see Figure 1.12).

Other bells and whistles

As we mentioned earlier, the number of other options and features you can get on a video camera are almost endless, and these features can certainly create some very cool effects and images. But from a moviemaking and storytelling point of view, you can do without most of the digital bells and whistles. Here are the most important things you need to know about some of the most common video-camera options.

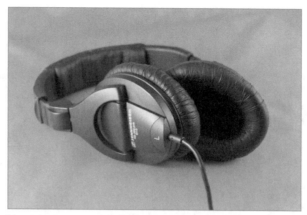

FIGURE 1.12 A set of headphones used to monitor sound on a film set should have earcups that are closed-backed and large enough to cover the ear completely. It's not possible to accurately evaluate the sound of recorded dialogue using earbuds.

Zoom Lenses

Zoom lenses are a good thing. They allow you to bring your subject visually closer to the viewer without having to move the camera. The important thing to know about zoom lenses is they can be either *optical* or *digital*. Optical zooms are the best, and they can range anywhere from 10X to over 70X magnification. Digital zooms can go to ridiculously high numbers (over 1000X), but they do so at the expense of image quality. The higher the magnification on a digital zoom, the worse the image. Most cameras have a mix of optical- and digital-zoom magnification. That's okay, but know you'll rarely (if ever) want to use the digital part of the zoom. Avoid cameras that have only a digital zoom. They will have the worst picture quality.

Image Stabilization

Image stabilization is also a good thing. You need to have it, especially if you want to try a handheld shot with the camera zoomed all the way in. Just like zoom lenses, image stabilization can also be either optical or digital. The optical version is often called OIS (for Optical Image Stabilization). This is the best type of stabilization because it keeps your image steady without degrading the image. It is also more expensive than digital stabilization (which is called Electronic Image Stabilization, or EIS). Using EIS will degrade your image very slightly, but most people don't notice any difference.

Digital Effects

There are a wide range of digital special effects available on most cameras. They include options such as black and white, sepia, and old movie among others. Generally, these effects change the appearance of the image as it's being recorded. But what many people don't realize is you can recreate most

of these effects using the editing software on your computer, and even if you're certain you want to use a specific effect in your movie, it's best not to record your footage using it.

Suppose you shoot a particular scene in black and white, and while you're editing your project, you decide it would be better if the scene were in color. If the camera recorded your footage in black and white, you can't go back later and put color in the shots. But if you shoot something in color, you can always remove the color using your editing software, and that's true about most digital effects. Your editing software can duplicate almost any effect built into the camera.

24P

24P refers to the capability of the camera to record video at 24 frames per second. This means that 24 individual images are recorded every second to create the illusion of motion. Video is normally recorded at 30 frames per second, but each of those images is further broken up into two *fields*, effectively creating 60 separate images per second.

> **KEY TERM:**
>
> **FIELD** A field is one half of a video frame containing information from every other horizontal line of the image. A standard-definition video image contains 480 lines of horizontal information. This means the first field contains all the odd lines in the image (1, 3, 5, etc.), and the second field contains all the even lines. When the image is viewed on your television, the two images are interwoven (a process called *interlacing*) to create a single image.

Figure 1.13 illustrates the process of interlacing.

The fact that each second of video contains 60 separate fields of information is one of the characteristics that give video its distinct look of crisp reality. Motion-picture cameras, on the other hand, only shoot 24 frames each second. This difference in *frame rate* is one of the main reasons film and video look so different.

> **KEY TERM:**
>
> **FRAME RATE** The number of frames per second captured by the recording medium. Film is usually shot at 24 frames per second (or fps), while video captures 60 fps (fields per second).

60 Interlaced fields per second

First field, Time = 0s

Second field, Time = 1/60s

Even lines

Odd lines

Both fields shown together to make a frame

FIGURE 1.13 Interlaced video takes two fields to create a single frame. Each field lasts 1/60th of a second, which means that the resulting frame (composed of two fields) lasts 1/30th of a second.

But by shooting video at the same frame rate as film, you can start to make video look more like film. Using a camera with the ability to shoot 24P will enable you to create some very filmic images.

So which camera do I choose?

Ultimately, the camera you choose will be influenced by two factors: your budget and your future plans. A tape-based DV camera would probably be the least-expensive choice and could be a perfect camera to start out with, especially if your primary goal is to make videos for posting on the Web. But if you want a camera you can use for a few years that also has the potential to do more professional projects, you might select a memory-card HD camera.

Keep in mind that camera technology changes as fast as computer technology, and today's top-of-the-line model will be much less expensive in six months to a year. Also remember that choosing a camera determines how powerful a computer you need. You might get a great deal on an HDV camcorder, but then realize you need a new computer and software to edit the footage.

Choosing a Computer

At this point, let's assume you've found a camera and shot some footage. Now you'll need a computer for *postproduction*.

> **KEY TERM:**
>
> **POSTPRODUCTION** All the work you do to turn the raw footage shot during production into a finished movie. Typical steps in postproduction include editing your footage, adding special effects, and creating the final soundtrack. The entire process is often abbreviated to the single word *post*.

The good news is almost every computer out there has enough power and speed to edit basic DV (standard-definition digital video). Here's a list of the other basic features any computer needs to process digital video:

- An open Firewire or USB port
- A large hard drive with at least 20GB of free space
- Some basic editing software

Firewire and USB ports

Firewire is the data cable used to transfer video data from your camera to the computer (see Figure 1.14). It can also be called iLink or IEEE 1394

FIGURE 1.14 The standard Firewire (iLink) cable is used to transfer tape-based video (both SD and HDV) from the camera to the computer. The smaller plug on the right plugs into the camera and the other end plugs into your computer.

depending on who makes it. This data format is used most often with tape-based camcorders (DV and HDV). Cameras using other recording media (memory cards, DVDs, and hard-drive recorders) often use USB cables for transferring video (see Figure 1.15). Neither is better than the other, you just need to make sure your computer has an available port for whichever format your camera uses.

The following figure shows a USB cable.

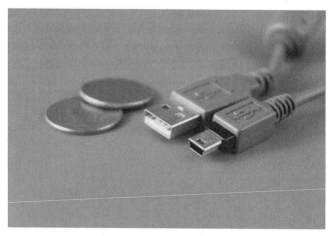

FIGURE 1.15 A standard USB cable is used to transfer video files from any camera that records to media other than tape (memory cards, DVDs, and hard-drive recorders). For cameras that record to memory cards, card readers can also be used to transfer video files.

A large hard drive

Video files are large. A one-hour DV tape takes up 13GB of space when it's transferred to a hard drive, and while an hour sounds like a lot when you're just starting out, it doesn't take long to collect several hours of footage and eat up well over 100GB of hard-drive space.

If you have a computer with only one hard drive (such as a laptop), it's possible to store video files on the same drive with your programs and system files, but it's not the best idea. As your hard drive fills up, you may find your editing software begins to slow down, especially if you're working on a large or complex project.

The best plan is to keep all your video data on a separate, portable hard drive (see Figure 1.16). This is especially important if you're working with memory cards or hard-drive recorders in which you don't have a physical backup for the video you shoot. The portable hard drive then becomes your

FIGURE 1.16 A portable, external hard drive is a good way to keep all the video files of a project organized. Using an external drive also saves hard-drive space on your editing computer.

backup (sometimes people even make backups of their backups, depending on the importance of their footage). The added bonus of using portable hard drives is the ability to switch to another drive if the one you're using fills up.

Basic editing software

All editing software has certain basic features. In this book, you'll learn to use those features and become comfortable with moving clips around and creating multi-layered soundtracks. Apple computers come bundled with a free program called iMovie, and Windows computers have a similar free program called Movie Maker. Either of these programs is a good place to start (see Figures 1.17 and 1.18).

But just like cameras, there are many different editing programs on the market with many different capabilities, and some of the more advanced techniques covered in this book (as well as the material covered in the follow-on editing book in this series) will require a more powerful program such as Final Cut Express for Apple computers or Adobe Premiere Elements for Windows.

Movie Maker is shown in Figure 1.18.

Final Thoughts About Equipment

Having the right computer and software can be just as important as having the right camera, and the camera you choose will definitely affect the computer you need. Almost any computer can edit the footage shot by

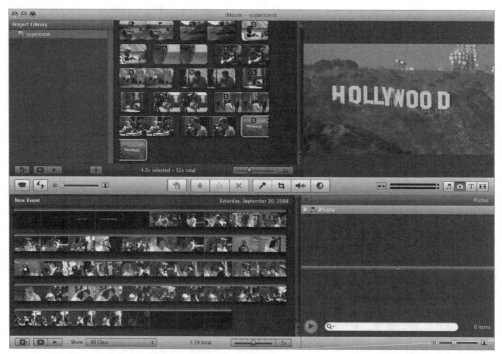

FIGURE 1.17 iMovie is the free video-editing program that comes bundled with all Apple computers. We'll cover the basic elements shared by all editing software in Chapter 8.

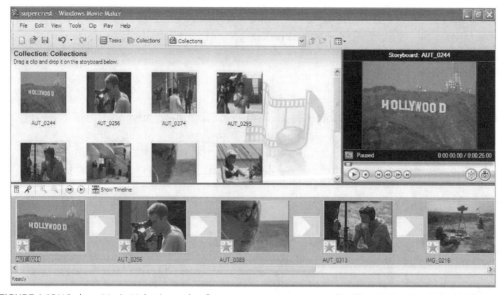

FIGURE 1.18 Windows Movie Maker is another free program you can use to edit video. Notice the similarities between the Movie Maker interface and the iMovie interface.

a basic DV camcorder, but you'll need a more powerful computer and more sophisticated software to work with HD footage.

As you consider which camera or computer you want, don't restrict yourself to just looking in one particular price range or at one particular technology. Remember: The reason for using this equipment is to tell stories, and stories can be told in all formats with any level of equipment.

If you're starting from scratch, be sure to consider all your options. Many industry professionals swear by Apple computers and consider them to be easier to use and more reliable, although they can be more expensive. Don't rule out the possibility of finding good, second-hand equipment.

With the technology that's readily available today, anyone can make projects ranging from short Internet videos to professional, Hollywood movies. The skills you learn in this book will apply to projects at all levels. The rest depends on your goals and your budget.

SUMMARY

The overall purpose of this chapter was to get you ready for the course that lies ahead. Everything we covered was designed to do one of two things:

- Introduce you to filmmaking and the skills involved in making movies.

- Give you enough technical information to choose the cameras and computers you'll use to tell your stories.

At this point, you should have a general idea of the subjects we'll be studying and the equipment we'll be using in this course. If you're feeling a little overwhelmed, that's okay., It's a little like trying to take a sip of water from a firehose—there's lots of information coming at you.

You might also be wondering about all the subjects we didn't cover in this first chapter. For example, we talked about selecting cameras, but what about choosing microphones and tripods and lights? And how do you use all those camera features we talked about? Don't panic. All of that will be covered in the chapters ahead.

REVIEW QUESTIONS: CHAPTER 1

1. List all the skills that go into making movies. Include any you can think of that weren't specifically mentioned in the text.

2. What five features need to be on any video camera you select for this course?

3. What do you think is the biggest disadvantage of using memory cards as recording media? How could you overcome that disadvantage?

4. What is 24P, and why would you want to use it?

5. List three things you need to consider when selecting a computer.

DISCUSSION / ESSAY QUESTIONS

1. Define filmmaking in your own words.

2. Which particular area of filmmaking interests you the most, and why?

3. Which recording format would work best for you?

4. Tell us about the camera you'll be using for this course. What are its strengths and weaknesses?

5. Tell us about the computer and software you'll be using for this course. What are their strengths and weaknesses?

Research/Lab/Fieldwork Projects

1. Pick three video recorders currently on the market and discuss the pros and cons of each one.

2. Watch the video short *Alan Smithee's Hollywood Tips* included on the companion DVD with this book. This short will give you a basic introduction to using your camcorder like a professional.

ON DVD

3. Shoot a "talking head" introduction of yourself as described in the following section.

Talking-Head Exercise

Shoot a short video introduction of yourself. It should be no more three minutes long, and it should be a single, continuous shot.

Do not use a webcam for this assignment. Use the camcorder you plan to use for this course. For now, use the camera in point-and-shoot (fully automatic) mode, and if possible, use a tripod. If you don't have a tripod, set the camera on a stable surface, or have a friend help you shoot it. This will be the only time in the course when you will appear on camera in your own project. After all, this is a book on filmmaking, not acting.

Here are some possible things to talk about in your intro. These are only suggestions. Feel free to talk about anything else you think is interesting or important.

- Tell us who you are and why you're interested in filmmaking.

- Tell us about any courses you've taken, or any directing or video-making experience you have.

- Tell us what you hope to learn.

- Tell us what you think your strengths or weaknesses might be as a director.

- Tell us what your favorite movie is, and why.

- Tell us who your favorite director is, and why.

- Tell us what type of camera/computer/software you'll be using for the course.

Use an external microphone if you have one. If you don't, make sure you are close enough to the camera so that the built-in microphone gets good, clean sound.

WHAT'S YOUR STORY?

OVERVIEW AND LEARNING OBJECTIVES

In this chapter, you will:

- Understand the importance of story
- Learn basic story structure
- Explore different story formats
- Start telling visual stories
- Become familiar with movie script format
- Write your first movie scripts

Story is Everything!

There is only one inescapable truth in filmmaking—one reality that no amount of money or technological wizardry or star power can change. It's very basic, and although everybody knows it, too often this simple truth gets lost. Are you ready? Here it is:

Story is all that matters.

That's it. Period. Nothing is more important than having a good story.

"But wait," you might be thinking, "What about having great special effects? What about casting a big name star? What about having a cool, pop-culture sensibility?" All of those elements can help a movie, and Hollywood spends a great deal of time and money trying to find just the right formula to attract a big audience, but none of those elements means anything unless they're being used to tell a good story.

NOTE *Of course, being "good" and being a financial success are often two separate things. Everyone knows rotten movies that made lots of money and great movies that never made a dime. Making movies that make a profit is sometimes very different from making good movies. But that's a subject for a whole different book.*

What makes a story good?

There are many factors that go into making a good story. Does it have interesting characters? Do those characters behave in believable ways? Does the subject engage your curiosity? Is it original? The list goes on and on. Countless books have been written about screenwriting and storytelling and each of those books are full of lists describing what makes a story good.

But the real truth of what makes a story good is not found in a list or a set of rules. Because for every rule you can name, you can also name a really good movie or story that broke that rule. The real measure of a good story is not what it looks like or how it's made. The real measure of a story is the effect it has. Think about it. Why do you tell a story? You tell a story to affect an audience. Good stories affect an audience and bad stories do not. It's that simple.

What's Your Point?
You tell a story because you want a certain reaction from the audience. If your story is a comedy, you want the audience to laugh. If your story is an

action-adventure, you want to thrill them, and if you're telling a horror story you hope to scare your viewers. As a storyteller, you should always be aware of the effect you want each moment in your story to evoke, and you should also be aware of the overall effect you want the whole story to achieve.

After the audience has finished laughing or crying at the action on the screen and left the theater, what do you want them to do or feel? Do you want them to see certain aspects of their life in a new way? Do you want them to reach out to loved ones or maybe rally to change a social injustice? Or do you want to take them to a marvelous new world and make them forget the routine of their daily lives for a couple of hours? Whatever your goal, your first responsibility as a filmmaker is to know why you're telling your story. That single decision affects every other choice you make.

It's harder than it looks

Understanding what makes a good story is easy, writing one is not. Writing a good story is hard. It's the hardest part of filmmaking—harder than cinematography, harder than editing, even harder than directing. And the sad truth is, most people don't spend near enough time and energy getting their story just right.

Why? One main reason is because there's a misconception about filmmaking that creative magic happens on the set and in postproduction that can fill in gaps in your narrative and greatly improve your story. And while it's true that improvisation on set and the right music and effects in post can significantly enhance a cinematic moment, they can't repair basic story flaws. You have to get the story right before you start, and before that can happen, you need to understand basic story structure.

What Makes a Story?

All stories share one basic characteristic: structure. It doesn't matter if we're talking about a poem, a joke, or a movie; there's a structure shared by every story ever told, and that structure isn't a rule so much as a definition of what it means to be a story. Without this fundamental shape, you might be recounting an event or describing something you've seen, but you're not telling a story.

Like all basic definitions, story structure is simple. So simple it seems obvious. Here's the key to story structure:

Every story has three parts: a beginning, a middle, and an end.

Doesn't seem like much of a definition, does it? Knowing the definition is the easy part—the hard part is understanding it and applying it.

 All figures and shorts are included on the companion DVD with this book.

Parts of the whole

Beginning, middle, end. In different types of stories, these three parts have different names. In a movie script, each part is an *act*. Act I is the beginning, Act II is the middle, and Act III is the end. In a joke, the beginning is the *setup*, the middle is the *build*, and the end is the *punchline* or *payoff*. And in advertising, the beginning is called the *hook*, the middle is called the *pitch*, and the end is called the *close* (see Figure 2.1).

Even a commercial has a beginning, middle, and end as discussed in the following sidebar.

Story forms

	Movie	Joke	Commercial
Beginning	Act I	Set up	Hook
Middle	Act II	Build	Pitch
End	Act III	Punchline	Close

FIGURE 2.1 Every story has a beginning, middle, and end. Different types of stories have different names for these three basic components.

Each part of the story exists for a very specific purpose:

- The beginning: Introduces your characters and presents a problem or conflict.

- The middle: Wrestles with the problem and tries different solutions.

- The end: Solves the problem and resolves the conflict.

In many ways, the overall effectiveness of a story is determined by how well each section accomplishes its goal. Let's look at each part in greater detail.

Act I – The Beginning

In Act I, the audience is a clean slate. They don't know anything about your characters or the world they live in. It's up to you as the storyteller to introduce your characters in a way that makes the audience want to know more. It may sound easy, but here are some of the things that can go wrong:

- ***The characters are boring or uninteresting***. Unless there's something unique about the characters, the audience won't care about what happens to them.

- ***The characters are too familiar***. How many times can you tell a story about a high-school bully or a snobby cheerleader? If you're going to use familiar characters, there must be something new or different about them (such as a high-school bully who volunteers at a homeless shelter on the other side of town).

- ***The characters aren't likeable***. If your characters are cruel or apathetic, an audience will have trouble connecting with them. This doesn't mean your characters can't have flaws, but you don't want the audience to hate them.

This obviously doesn't apply to villains. Villains should be bad. But keep in mind, the audience's relationship with villains is different. They're waiting to see how the villain will be caught, or what his punishment will be.

NOTE

After you introduce your characters, the next thing you have to do is give them a problem or a challenge, and just like your characters, the problem you present should be new or unique. If the challenge is a football game for your quarterback, there needs to be something that makes this game different than the rest. Or if you're telling a romantic comedy, what's keeping the boy and girl from ending up together?

Regardless of the challenge you finally select and how you present it, there is one task you must accomplish before the end of Act I:

You must engage the curiosity of your viewers.

No matter what the obstacle is, the audience has to wonder how it's all going to turn out. If the outcome is too obvious, or if the audience doesn't care, then Act I hasn't accomplished its purpose and the story will fail.

NOTE *Many of the filmmaking examples used in this text come from an independent feature adaptation of Shakespeare's As You Like It. For more information about this production, see the sidebar "As You Like It: An Independent Case Study" in Chapter 15.*

Figure 2.2 shows the scene that set the story of *As You Like It* in motion.

FIGURE 2.2 At the end of Act I in *As You Like It,* Rosalind is banished to the island of Arden by her uncle. Her banishment is the obstacle that sets the story in motion.

The following sidebar discusses how to gauge the length of Act I.

SIDE NOTE

HOW LONG SHOULD ACT I TAKE?

You've got an awful lot to do in Act I. You have to introduce sympathetic, unique characters and give them a challenge that engages the audience's curiosity, and you need to do it quickly before your viewers lose interest. How long will it take to do all that?

In feature films, Act I is usually between 20 and 30 minutes long. If the movie you're watching goes past 30 minutes and you still don't know what the main obstacle is, you're going to start feeling antsy and a little annoyed.

But the beginning of a story doesn't have to take that long. In a very short film, it's possible for the beginning to be a single shot. Consider the following image: A small boy holding a basketball stands in the driveway looking up at a basketball hoop. Depending on how it's shot, that could be all you need—a sympathetic character and an obstacle.

How does he make the shot? Does he get a ladder? Does his brother, or father, or best friend help him? Does he give up? Depending on the point of your story, there are an infinite number of ways to resolve the problem. How many can you think of?

Act II – The Middle

The middle of your story is where most of the action happens. It's also the longest part of the story. In a typical 120-minute movie, Act II can be over an hour long. This is where your characters try to solve their problem in a variety of ways, and whatever they try, usually the first thing doesn't work (if it did, the story would be pretty short).

After their first attempt (and failure), the problem usually gets more difficult. Someone they thought they could count on lets them down, or something they thought would be easy turns out to be very difficult. The result is that solving the problem now requires your characters to change something about themselves or see the world in a different way (see Figure 2.3).

FIGURE 2.3 Orlando arrives in Arden with his friend Old Adam. Orlando's arrival on the island (and the relationship that will soon develop between Orlando and Rosalind) takes Act II into new territory.

Many people consider the middle of the story the hardest part to write. That's because there are so many options. Pretty much anything can happen in Act II as long as it makes sense and it's consistent with the personality of your characters. Having so many choices can make it hard to decide what should happen next. Here are some tips for getting through Act II:

- Life should always get harder for your characters, not easier. They shouldn't have any lucky breaks (unless that luck is bad luck).

- If they do have small successes, they should be followed by even greater failures or setbacks.

- Everything your characters try should be logical and seem intelligent from their point of view. The audience may know your characters are making a bad choice, but your characters should think they're being smart.

- Usually at the end of Act II, it seems like your characters have been completely defeated, and there is no possible way they will solve their problem.

- Finally, you need to keep finding ways to surprise your audience. Nothing that happens in the story should be predictable. If the audience can consistently guess what will happen next, they're going to get bored and lose interest.

Keep in mind, these tips are just guidelines. They aren't rules. There have been many successful movies that ignored every one of these suggestions. But they can be helpful if you get stuck, or things don't seem to be working.

The bottom line is this: Regardless of how long or short your movie is, by the end of Act II, the audience must feel as if your characters have tried everything they could to solve their problem. If the audience can think of something the characters haven't tried, or if your characters don't seem to be trying their hardest, the audience will lose respect for your characters and the story will fail (see Figure 2.4).

Act III – The End

Here's the good news: For many writers, Act III is the easiest to write. The reason is fairly obvious—most people know how they want the story to end before they begin. Sometimes you even know the ending before you've figured out the beginning. This makes sense if you consider that you're telling the story to make a point. You should know the point before you start, and that point (together with the effect you want to have on the audience) will help

FIGURE 2.4 By the end of Act II, the odds are stacked against Orlando and Rosalind. It seems there is no possible way for them to be together.

determine the ending you choose. But just because it's easier doesn't mean you don't have to work at it. Just like the beginning and the middle, certain things need to happen for an ending to be satisfying.

First and foremost, the ending has to bring resolution to your characters and their problem. Whatever conflict or challenge they faced at the end of Act I needs to be solved. But that doesn't mean the solution they discover is the solution they hoped for. In the best stories, the characters learn something about themselves on the journey and solve their problem in a way that would not have been possible at the beginning of the story.

The second most important thing about the ending is that it can't be predictable. How many times have you seen a film in which you figured out the ending after watching only the first few minutes? It probably wasn't a very good film, and you probably didn't enjoy it very much. Now think of a movie in which you thought you knew the ending, but at the last minute something unexpected happened. Odds are, you enjoyed that movie more and recommended it to your friends. The more you can surprise the audience while still being true to the nature of your characters, the more satisfying the ending will be.

> *The truth is, we know how most movies are going to end from the beginning. The home team will win the big game and the boy almost always gets the girl. But don't confuse the end result of a story with how that result is achieved. It's how the game is won that makes a sports film good or bad, and it's how the boy wins the girl that makes a romantic comedy work.*

NOTE

There's one more tricky thing about endings: The way an audience feels about the ending is often the way they'll feel about the entire story. It's a sad truth that many good films are ruined by a bad ending, and sometimes (though not very often), an excellent ending can make an average film seem better than it is. So just like the beginning and the middle, if an ending is not executed well, the entire story will fail (see Figure 2.5).

FIGURE 2.5 By the end of *As You Like It,* Rosalind and Orlando have beaten the odds and found each other. Even though this ending seems predictable, Shakespeare's storytelling makes their reunion both surprising and satisfying.

The following sidebar discusses how to make your story both unpredictable *and* inevitable.

UNPREDICTABLE AND INEVITABLE: FINDING THE RIGHT BALANCE

You've probably noticed a trend in stories by now. The story can't be predictable or it will most likely be boring and unsatisfying. Think about this:

Everything that happens in a story should be both completely inevitable and totally unpredictable at the same time.

At first this sounds like a contradiction. How can something be both unpredictable and inevitable? But the more you think about it, the more it makes sense. If something is unpredictable, that means nobody saw it coming (neither your audience nor your characters), and if something is inevitable, that means it had to happen, nothing else could have happened instead.

So what you're looking for is a story in which everything that happens makes total sense when you look back at it, but that you couldn't foresee as you were going through it. That's a pretty tall order (and one that very few movies actually achieve), but it gives you something to shoot for.

Don't worry if the whole *unpredictable and inevitable* thing is making your head hurt. It takes a while to sink in.

Not All Stories Should be Movies

We know all good stories share certain characteristics. They have a well-defined structure. They capture the attention of an audience. They're unpredictable. And if properly told, they have an effect on those who see or hear them, and achieving that effect is the main reason for telling your story in the first place. That means every choice you make as a storyteller should be aimed at one thing: *maximizing the impact of your story.*

Before you start writing, your first choice will be which format to use. Stories come in all shapes and sizes, from feature films to operas to epic poems. Each form has certain strengths and weaknesses, and each form is best suited to tell certain kinds of stories. If your goal is to make a good movie, you greatly improve your chances by beginning with the right story. Let's take a brief look at what stories are best suited for the most common formats.

Choosing the right format

Suppose for a moment you have a story inside that's burning to come out. Also suppose you don't care what form the story takes. It could be a novel, it could be a play, it could be a movie. You don't care. You just know you have to tell the story, and you want it to be as good as possible. Each of the formats we mentioned (novels, plays, and movies) has specific characteristics and limitations. Knowing those characteristics will help you find the best format for your story.

The Novel Approach
The novel is a fictional story in book form. It relies on the written word, and written stories have been around as long as people could read and write.

There are several characteristics unique to novels, but the following are the most important to a storyteller:

- Novels consist of words on paper and are experienced in the imagination of the reader. This gives them enormous flexibility. You can set a novel anywhere in time and space, and even create whole new worlds (all without spending a penny on special effects).

- Novels can let you know exactly what a character is thinking or feeling. An author can describe the internal dialogue of any character at any time.

- Novels are experienced one person at a time. Each reader creates the story in their own imagination as they read (or listen to the book on CD).

The fact that novels take place in the imagination is both a strength and a weakness. You can go anywhere and do anything inside a novel, but you're limited to things that can be described. There is no way to accurately and faithfully depict a sweeping scenic vista or the beauty of a human face in words alone. And regardless of how skilled or artistic you are as an author, each reader will experience the story in their own unique and personal way. This is neither good nor bad; it's just a fact. But that's why whenever a novel is made into a movie, many people will say, "That's not how I imagined it."

The real strength of a novel lies in the fact it can get inside the heads of its characters. No other story format does this as well, and this makes the novel a perfect match for stories that rely on a character's thoughts and perceptions. It's the ideal way to tell an internal story.

The Play's the Thing

Some of the earliest known plays date back to the ancient Greeks, and there have been live performances as long as people have been able to talk or dance around a campfire. Because a play is an event, it's very different from a novel. Let's look at some of the key features of a play:

- It's a live performance. It only exists for the time the actors are performing. And although you can read a written script, you don't truly experience a play unless you see it on stage.

- It consists mostly of people talking to each other. Even though many plays have music, dance, and other visual elements, dialogue remains a defining feature of the format.

- Unlike the novel (that takes place in your imagination), you experience a play by seeing and hearing physical events in real time.

In a play, you tell the story with live performers on a stage. That means you must create a physical, visual representation for every part of your story, and there are certain things you simply can't do on a stage. You can't realistically depict a battle with thousands of soldiers. You can have someone describe a battle that they've seen, or that is occurring just offstage, but you can't show the actual battle. You also can't experience the internal thoughts or feelings of the characters like you can in a novel. You can have the characters talk about their thoughts, but that's very different from feeling like you're inside their head.

What makes a play unique is the fact the performers are creating the story right in front of you. Regardless of the fact they're following a script, those are real people up on the stage, and that gives plays a physical, tangible reality novels and movies can't match. And because plays rely on dialogue, that makes them an excellent form for depicting the struggles (and joys) of interpersonal relationships (see Figure 2.6).

FIGURE 2.6 At a play, the relationship between the audience and the performers gives the experience true emotional depth. This emotional connection is one reason plays are still popular despite the competition from movies and television.

The Motion Picture Show

Movies are one of the newest storytelling formats and have only been around for a little over a century. They share certain characteristics with plays, but there are several important differences:

- The very first movies were silent and could not use dialogue to tell the story. This limited early filmmakers to stories that could be told through physical action. This preference for telling action-oriented stories remains a part of filmmaking today.

- Movies don't have the same physical restrictions as plays and can allow the viewer to see and experience anything the filmmaker can imagine (and special effects can create).

- Film is a visual medium that tells stories through moving pictures (and carefully chosen sounds). Much of a movie's impact comes from the inspiring beauty or stark reality of the images the filmmaker captures.

NOTE

The strengths and weaknesses given for each format are not hard and fast rules. Many excellent movies have been made that consist of little more than people talking, but these films don't rely on the strengths of moving imagery. They get their power from exceptional dialogue and performances.

In the same way that plays are limited to events they can depict on a stage, movies are limited to the images and sounds they can present to an audience, and those images are most effective if they are constantly moving and changing. The close-up images of two people engaged in a lengthy conversation becomes visually boring very quickly.

The real power of film (and video) comes from its ability to transport viewers to different worlds—anything from gritty urban cityscapes to worlds that exist only in the imagination. Films thrive on movement and striking images, which makes them a great choice for telling action stories in exotic locations, but a poor choice for exploring the inner torment of a character struggling with their own thoughts and feelings (see Figure 2.7).

FIGURE 2.7 In this shot from the action short *Neo's Ring*, Tracy has been transported to the ruins of an ancient Mayan city. Like the ring Tracy wears, movies have the ability to transport the viewer anywhere in the known (or unknown) universe.

How Can I Make My Story Visual?

So you've got a story in mind. It's got a beginning, middle, and a killer ending. You've also thought about story formats and decided to make a movie. That means the story should be visual. You should use images and action to move the story forward (instead of relying on dialogue). The following sections discuss a few visual storytelling strategies.

Show me, don't tell me

Movies excel at showing events to an audience. So whenever possible, show an event or action instead of describing it. Suppose your story relies on your main character having a lousy day at work. You could have her come through the front door and announce to her boyfriend, "I just had the worst day," and then describe all the things that went wrong.

But regardless of how compelling the dialogue or performance, this is not a visual choice. Don't have someone tell us about an event. Show us the event. Let us see her day going badly. Let us see her spill coffee on her suit. Let us see her drop her cell phone down the stairwell. If we see the stress in her day, when she gets home all she has to do is sigh and we know how she feels (see Figure 2.8).

FIGURE 2.8 In this scene from *As You Like It*, Orlando battles with a lion (remember, this is a comedy). In the stageplay, this battle was described, but not seen. But since movies rely on showing rather than telling, the scene was rewritten to show the fight onscreen.

Find a physical action to represent a thought

Movies are external, not internal. We're always outside our characters looking in. So we never really know their thoughts. Sure, we could have a dialogue scene in which they discuss their feelings, but then we're *telling* the audience instead of *showing* them. We want to *show* our character's thoughts, and the easiest way to do this is find an action that reflects what the character is thinking or feeling.

An example might be a scene in which your character is a former athlete who misses his glory days. You could show him getting his old medals and trophies out of the closet and dusting them off. Or maybe he goes for a walk by a high school and stops to watch the track team. Or he could be on a basketball court trying to make a lay-up shot and feeling his age. The possibilities are endless, but usually, the more specific and unique you can make the actions, the more the audience will learn about your character.

KEY TERM:

CLICHÉ Any technique or story convention that is overused, sometimes to the point of being laughable. The idea that villains always wear black is a cliché. Clichés are often described as *trite*, which is another way of saying stale and unoriginal. The tricky thing about clichés is at one time they were ideas so fresh and effective that everyone used them (and they ended up being overused).

Figure 2.9 shows a scene from *As You Like It* where key information is revealed about the relationship between Rosalind and Orlando.

Keep dialogue to a minimum

A movie is not a play or a soap opera. Both plays and soap operas rely on dialogue to tell their story. If you closed your eyes while watching either one, you would still be able to follow what was happening. But what would

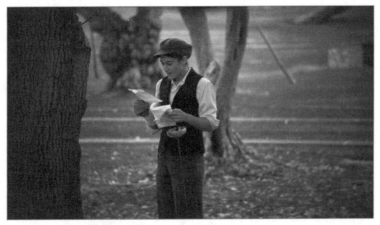

FIGURE 2.9 As Rosalind wanders through Arden, she finds poems left by Orlando. These poems are physical representations of the unrealistic feelings Orlando has for her.

happen if you muted the sound while watching a soap? Odds are, you would quickly lose track of where the story was going.

With a movie, just the opposite should be true. You should be able to watch a movie without the sound and still understand the story. But try listening to a movie sometime without looking at the screen. You might be surprised to discover they don't actually talk very much about what's happening. Consider the following dialogue between two characters:

> **FIRST PERSON:** What do you think?
>
> **SECOND PERSON:** It's unexpected.
>
> **FIRST PERSON:** Is that a yes?
>
> **SECOND PERSON:** It's not anything.
>
> **FIRST PERSON:** Right.
>
> **SECOND PERSON:** Now what?
>
> **FIRST PERSON:** Nothing.
>
> **SECOND PERSON:** I'm sorry.
>
> **FIRST PERSON:** Just stay focused.
>
> **SECOND PERSON:** Do you really want to do this?
>
> **FIRST PERSON:** Let's go.

What's happening in this scene? You can't tell just from just the dialogue alone. The characters are obviously involved in some activity, but you'd have to see what they were doing to understand the scene. This demonstrates a key point about dialogue in a movie script:

The dialogue does not contain the story, the story contains the dialogue.

If we were listening to a story on the radio, it would be different—the dialogue would contain all the information of the story. But a movie is visual. We watch the characters engage in a series of activities to resolve a dilemma. We should see what they're doing and understand the story without needing to be told. That means that anything the characters say should arise from the situation and the distinct personalities of those characters. This is the way things happen in life and it's the way they should happen in your movie.

What Should My Script Look Like?

Movie scripts have a very specific format. This format evolved during the days of the studio system in Hollywood when the studios churned out movies with factory-like precision. These were the days before computers and copiers, even before electric typewriters, when every script was typed on a manual typewriter by a slump-shouldered, chain-smoking screenwriter.

NOTE
Even though scripts today are written with word-processing software, they always use the Courier font—that makes it look like each page was written on an old, manual typewriter.

The reason this specific format evolved has to do with *preproduction*, which is all the planning and budgeting that must take place before shooting begins. The movie script format makes it easy to identify when and where a scene must be shot, what props are required, and which actors will appear in the scene. The format also makes it easy for actors to study their lines by making them stand out on the page.

There's one other added bonus to the format: If written properly, each page of a script will average out to about a minute of screen time in the finished movie. This means it's easy to estimate the running time of the film just by looking at how many pages are in the script (see Figure 2.10).

Fortunately, you don't usually have to worry about the exact margins for an action block or your character's dialogue when you're writing. There are

```
                                                          FADE IN:

       EXT. MINNEAPOLIS STREET -- DAY

       PJ CLARK is finishing a stand-up

                          PJ
                     ...and don't forget to join Dave
                     and I tonight at seven for our live
                     coverage of the Governor's Spring
                     Fling.

                          DIRECTOR
                     And we're clear.

                          PJ
                     Was that okay...?

                          DIRECTOR
                     It was great.  Are you okay on
                     time?  You need a ride?

                          PJ
                     Are you kidding....?

       PJ grabs her bag and DASHES down the street.

                                                          CUT TO:

       EXT. VARIOUS MINNEAPOLIS LOCATIONS -- DAY

       PJ RUNS through the SKYWAY doing various last minute
       errands.

                                                          CUT TO:

       INT. LIVING ROOM -- EVENING

       PJ CLARK bursts inside.  She caries five hangers of dry
       cleaning, a bag of groceries, a voluminous purse, a
       newspaper.

       She plunks the grocery bag on the floor with the mail.
       The bottom of the bag bursts, sending oranges SKITTERING
       across the floor.
                          PJ
                     Great....
```

FIGURE 2.10 This is the first page from the comedy short *Minneapolis*.

several screenwriting programs on the market that keep track of where you are in the story and make sure your script is perfectly formatted.

> *This description only scratches the surface of script formats and how a professional script should look. You can find much more specific information in the many screenwriting books available including Developing & Writing the Screen Story in this digital filmmaking series.*

NOTE

How Do I Know If It's Any Good?

By now, you know what it takes to write a good movie script:

- You start with a reason for telling your story. You've got a definite desired effect in mind.

- You structure your story so it has a strong beginning, middle, and end.

- Your characters are unique and likeable.

- They're confronted with a dilemma the audience wants to see resolved.

- The characters struggle with their challenges in dynamic, visual ways and eventually find a satisfying solution.

Now let's assume you've taken on the challenge. You've spent a few sleepless nights wrestling with your inner demons and finally tamed the blinking cursor. You have a script you're sure is perfect. How do you know if it's any good?

Get a second opinion

The best way to know if your script is ready is to get feedback. Show the story to friends, teachers, and fellow students. Then sit back and listen to what they say. Don't respond at first. Just nod and occasionally say, "Hmmm…go on…."

This will probably be exceedingly difficult because if they say anything negative about the script, you won't want to agree with them. Quite often, you'll be sure they're dead wrong, and then you'll have to make one of the hardest decisions a filmmaker ever faces: You'll have to decide if their comments are valid.

Here's a little guidance. If you find yourself thinking any of the following thoughts, you're probably in trouble:

- "I can make it work."

- "I'll fix it in post."

- "They just don't get it."

These thoughts are the siren songs of self-delusion. They'll keep you from hearing anything valuable in the comments of people who've read your script. If any of these thoughts worm their way into your consciousness, it's almost a sure sign your script needs more work.

Finally, if you're telling a story about an event that actually happened to you or a friend, sticking strictly with the facts as they occurred may not be the right choice. If your story drags, or doesn't hold the audience's interest, you've made some wrong choices. Telling someone "but that's the way it really happened!" will never excuse a story that isn't working.

SUMMARY

The purpose of this chapter was to get you ready to write your own scripts. To do that, we covered the following topics:

- The importance of having a strong story

- The elements that make a story good, including structure

- Different story formats and their strengths and weaknesses

- How to make your story visual

- What a movie script should look like

- Why you need feedback

That's a lot of material. The good news is you now know everything you need to get started. But before you sit down to write, there are a couple of things you need to keep in mind:

One: Writing a good script is hard. You're going to get frustrated. It's part of the process. If you're not feeling a little lost, then you aren't venturing into new territory, and that's where all the good stories are.

Two: Don't rush through the writing process because you're in a hurry to start shooting. There's an old saying that originally comes from the theater, but it's equally true for movies. It captures the undeniable importance of a good script:

"If it ain't on the page, it ain't on the stage."

Making movies (even short ones) takes an incredible amount of time and energy, and a beginning filmmaker is often relying on the goodwill of friends and fellow students. Don't waste their time trying to shoot a weak script. Get the story right *before* you shoot and edit it.

1. What's the real measure of whether a story is good?

2. What are the three parts of a story? What must each part accomplish?

3. What does "inevitable and unpredictable" mean?

4. If a properly-formatted movie script is 94 pages long, what's a good estimate of the running time of the finished film?

5. What three thoughts indicate your script might be in trouble?

DISCUSSION / ESSAY QUESTIONS

1. What story elements do you look for in a good movie? *Note: there are many possible answers to this question.*

2. Name a movie you like that breaks all the "rules" discussed in this chapter. What makes it work?

3. Think of a novel that got turned into a movie. Was it good or bad? Why?

4. *The dialogue does not contain the story, the story contains the dialogue.* What does this mean?

5. Why is feedback on your script important?

Research/Lab/Fieldwork Projects

1. Write a short, non-dialogue visual story. This will be the script for a project you will shoot in a later chapter. Here are the requirements for the exercise:

- The running time of the story should be no longer than five minutes. Shorter is better. Three minutes would be ideal.

- You must tell a complete story with a beginning, middle, and end. Get our attention, engage us in a dilemma, then resolve the conflict.

- You must plan the story so that everything can occur in a single shot. When you shoot this in a few weeks, you may not have any cuts, dissolves, or editing in the finished project. You'll be able to move the camera if desired, but the entire story must unfold in one shot. Watch the short, *Sweet Reward*, included on the companion DVD, for one example of how this can work.

 ON DVD

- You may not have any dialogue in the finished project. Your characters cannot speak to each other. Film is a visual medium. Tell the story with action and pictures. The primary goal for this exercise is to start thinking about how to tell a story visually.

2. Watch the shorts *Neo's Ring* and *Minneapolis* included on the companion DVD. Compare the finished shorts with the original scripts (found in the resources folder on the DVD).

3. Write a story that contains the dialogue provided below (you may remember this dialogue from the reading).

FADE IN:

INT/EXT: AN INDETERMINATE LOCATION -
DAY OR NIGHT

A number of characters (at least two)
are involved in activity yet to be
determined....

> CHARACTER ONE
> What do you think?

> CHARACTER TWO
> It's unexpected.

> CHARACTER ONE
> Is that a yes?

> CHARACTER TWO
> It's not anything.

> CHARACTER ONE
> Right.

> CHARACTER TWO
> Now what?

```
        CHARACTER ONE
Nothing.

        CHARACTER TWO
I'm sorry.

        CHARACTER ONE
Just stay focused.

        CHARACTER TWO
Do you really want to
do this?

        CHARACTER ONE
Let's go.

FADE OUT:
```

Here are the requirements for the exercise:

- You must use every line of dialogue as written. You cannot add to, change, or delete any of the dialogue, and the lines must be spoken in the order written.

- The dialogue as it appears on the page is intentionally non-specific. Yet within the context of your story, it must refer to very specific actions and feelings. It's your job to create a complete story in which this dialogue occurs.

- The story can take place in any time and place, and the two characters can be any age, race, or gender.

- The story must be visual. It's not just two characters sitting at a table talking. Your characters must be engaged in some sort of activity, and the dialogue grows out of the activity. But the dialogue is not the story—the story is what's happening between the lines.

- Remember that the essence of drama is conflict. This doesn't mean your characters are necessarily arguing. It just means that they want different things—they are each pursuing a different objective.

The goal for this exercise is to use dialogue, but to look at it in a different way. Remember: The dialogue does not contain the story, the story contains the dialogue. There can (and should) be sections of your story in which the characters aren't talking, but are actively engaged in the activity of the scene. Think of this project as a non-dialogue scene except that the characters get to say a few words as the story plays out.

STOP OR I'LL SHOOT!

OVERVIEW AND LEARNING OBJECTIVES

In this chapter, you will:

- Appreciate the importance of manual camera controls
- Learn to operate the three most important camera controls: Focus, Exposure, and White Balance
- Explore different techniques for getting professional-looking shots
- Practice your skills as an operator

I Want More Control

In Chapter 1, we talked about the manual options you should have on any video camera used for telling visual stories. We covered the following controls and discussed what makes them important:

- Manual Focus
- Control of Automatic Exposure
- White-Balance Control

We also introduced the fully automatic *point-and-shoot* mode all cameras possess. In automatic mode, microchips in the camera are making all the decisions about how the image should look. These decisions were programmed into the chip by video engineers trying to maximize the technical perfection of the video signal at all times. This is not necessarily a bad thing. Automatic mode generally creates pictures that are very pleasing. But from a creative storytelling point of view, there are two things wrong with this approach:

- Technical perfection is not always the right artistic choice. If you want an image that's tinted green, or that's unnaturally bright, you'll never be able to get it in automatic mode, since those images would not be technically correct.

- The camera's processor is continually analyzing and adjusting the image. This means if an element within your shot changes while the camera is recording (such as type or intensity of light), the camera will automatically adjust the image to compensate for the change. These corrections will be noticed by the audience and will make your production seem less professional.

Why do you need to know these technical details about your camera? In the same way you need to carefully sculpt the elements of your script to maximize the power of your story, you need to keep tight control over your images to generate maximum visual impact. You already know which manual controls your camera should have. Now we're going to learn how to use them.

 All figures and shorts are included on the companion DVD with this book.

I Can See Clearly Now

The concept of focus is simple. An image that is in focus is clear, crisp, and easy to see. An image that is out of focus is blurry, foggy, and indistinct. As a general rule, you want your images to be in focus. But there will be times when an out of focus shot would be appropriate—such as when you're trying to show the point of view (POV) of someone who might be drugged or groggy. There will also be images in which you want just one object to be in focus while everything else is blurry. This is called *selective focus*, and it's a way of showing the audience where to look (see Figures 3.1 and 3.2). But before you can use focus creatively, you have to know how to control it.

The next figure shows an image with *shallow* or *selective focus*. Notice the difference in focus between the images shown in Figures 3.1 and 3.2.

FIGURE 3.1 Both the fire truck and the goat are in focus in this image. This is an example of a shot with *deep focus,* which means that objects both close to and far away from the camera are in focus at the same time. See how your attention is split between the two objects?

On professional movie sets, they still adjust the focus manually, and it's the job of the *first camera assistant* to ensure each shot is always in focus. This job is called *pulling focus,* and on complicated shots in which the camera and the actors are both moving, it can be very demanding.

TECHIE'S TIP

FIGURE 3.2 Only the fire truck is in focus here, and the goat is unidentifiable. This is an example of *shallow* or *selective* focus. In this shot, only the fire truck holds your attention.

Let's stay focused

One of the key factors that determines whether an object is in focus is the distance between the subject and the lens. If an object is in focus, and the distance between that object and the lens changes, you'll have to refocus. Before the days of Auto Focus, the only way to do this was to use the Manual Focus ring on the lens itself (see Figures 3.3 and 3.4).

FIGURE 3.3 This is a professional 35mm lens. The numerical markings on the left side of the barrel represent distances for focusing (the gray numbers are feet and the white numbers are meters). This lens is focused properly for a subject slightly less than eight feet from the lens.

The following figure shows the follow focus used on film and video cameras.

FIGURE 3.4 The circular dial with the white rim is called a *follow focus*, and it's used on film and video cameras to change the focus setting whenever the subject or camera moves during a shot.

But can you imagine someone shooting vacation footage with her camcorder and trying to pull focus on every shot? Not very practical, and that's what Auto Focus is for—it pulls focus for you. It's constantly evaluating the image and adjusting the lens to keep things in focus. But a problem occurs when you're shooting two or more objects that are each at different distances from the lens. The camera has to choose which object will be in focus. Most cameras do this by having one or more *focus zones*.

KEY TERM:

FOCUS ZONE(S) A box (or series of boxes) within the camera's field of view that determines what will be in focus. The lens will automatically focus on an object inside the boundaries of the zone and ignore objects outside the box. If a camera has more than one zone, you can choose which zone has priority. As a general rule, the more sophisticated the camera, the more focus zones it will have. Most consumer camcorders have only one zone, and it's right in the center of the lens.

Although focus zones can be a good idea, they can cause you problems if:

- You want to focus on something outside the zone (possibly something near the edge of the frame).

- You want to change the focus during a shot without moving the camera.

- Something (or someone) passes through the shot in front of the object you want to remain in focus. If this happens, the camera will refocus on the moving object as soon as it crosses into the focus zone. The camera will then refocus again after the moving object has left the shot.

NOTE

When Auto Focus is on, sometimes you'll notice the image blurring in and out of focus when the shot changes suddenly (such a when someone crosses through frame or when you zoom in quickly). This is called **hunting***, and it happens when the camera can't decide what should be in focus. One of the main reasons for using manual focus while shooting is to keep the camera from hunting in the middle of your shots.*

Trying to work with these restrictions could severely limit your options as a filmmaker. The only way to have complete freedom when designing shots (and still be sure the focus will remain where you want it) is to learn how to use the Manual Focus on your camera.

How to focus manually

The good news is it's pretty easy to control the focus on most cameras. There's usually a toggle switch or button that allows you to switch from Auto Focus (AF) to Manual Focus (MF) (see Figure 3.5). When you do, the focus stays where it was set the moment you switched to manual focus. So if the camera

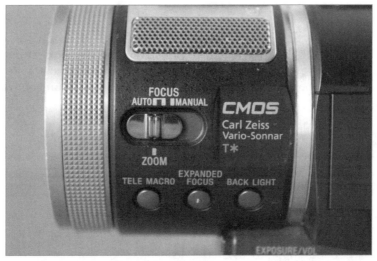

FIGURE 3.5 On the Sony HVR-A1U, the switch to toggle between Auto and Manual Focus is near the front of the lens. When the camera is in manual mode, the focus is adjusted by turning the silver ring around the lens. Notice there are no distance markers on the focus ring (we'll discuss why shortly).

was focused on something close to the lens, that object will still be in focus when the AF is switched off. You can use this feature to set your focus before each shot. Here are the steps:

1. With AF on, zoom in to the person or object that should be in focus.

2. Give AF a moment to bring the subject into sharp focus.

3. Switch from AF to MF while you're still zoomed in.

4. Zoom back out and *frame the shot*.

5. As long as the distance between the subject and the lens doesn't change, the subject will remain in focus.

The following terms relate to the boundaries of an image captured by a camera and how to decide what to include within the boundaries of that image.

KEY TERM:

FRAME The top, bottom, left, and right sides of an image captured by a camera—the visual boundaries imposed by the act of taking a picture.

FRAME A SHOT To make a conscious, artistic decision about what appears within the boundaries of the frame. When you frame a shot, you set the exact zoom distance and select the exact composition you want for the image.

Many cameras have a feature that enables you to momentarily engage the Auto Focus while the camera remains in manual mode. This feature is usually called *Push AF*, and it's a way of quickly checking or adjusting your focus.

TECHIE'S TIP

You can sometimes use Push AF to create a *rack focus*. To do this, set your initial focus on the first object you want to emphasize. Make sure you're using Manual Focus, and begin recording. As the shot progresses, reframe the shot so the second object enters the camera's focus zone. As you finish reframing, hit the **Push AF** button. The focus should shift to your second subject, completing the rack. It takes a little practice to get good at this technique, but it can create some very cool shots.

The following term, rack focus, describes a shot where the focus changes noticeably from one object to another, a technique often used to indicate a revelation or an epiphany of some sort.

KEY TERM:

RACK FOCUS A shot in which the focus changes noticeably from one object to another, usually between an object close to the camera and one further away. One use of this technique is to draw attention to something that wasn't previously noticed in the shot. This could be used to indicate a character having a sudden revelation.

Figure 3.6 shows another example of selective focus where the most important element in the image is in focus and everything else is blurred.

FIGURE 3.6 This shot is similar to Figure 3.2. The fire truck is in focus while the goat is blurred. As before, the fire truck is the most important visual element in this image.

Figures 3.6 and 3.7 illustrate a rack focus.

FIGURE 3.7 After a *rack focus*, the goat is seen clearly, while the fire truck is blurred. Using a rack focus will redirect your viewers' attention from one subject to another.

But using Auto Focus and Push AF aren't the only ways to control the focus of your shots. Most cameras also have a focus ring around the lens or a focus wheel that you can use to manually set or change focus. Unfortunately, with many camcorders this is not as easy as it sounds.

Using the Focus Ring

On professional lenses, there are markings on the focus ring that correspond to the distance between the camera and the subject (refer back to Figure 3.3). That means if you know the distance between your subject and the lens, you can accurately set the focus. So every time you set the focus at 10 feet, something 10 feet from the lens will be in crisp, clear focus. These lenses are called *repeatable* because you can find the exact same focus every time.

The bad news is that the Manual Focus rings and wheels on most camcorders are not repeatable. There are no markings on the lens (or wheel), and there is no way to know for sure exactly where the focus is set (see Figure 3.8). To make matters worse, some focus controls are *velocity sensitive,* which means the same number of turns of the ring or wheel could result in different amounts of focus change depending on how fast you turn the ring. This makes it almost impossible to accurately and consistently pull focus by hand.

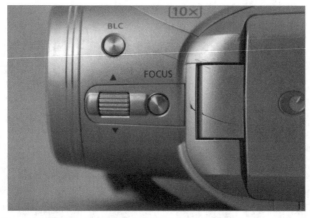

FIGURE 3.8 On the Canon HV-20, Manual Focus is set by the small wheel next to the focus button. There are no markings on this wheel, and the only way to tell if your shot is in focus is to look at the viewfinder (or LCD screen).

TECHIE'S TIP Some camcorders do have repeatable lenses, and other camcorders have a digital readout in the viewfinder that tells you where the focus is set (see Figure 3.9). But camcorders with these features are usually much more expensive.

With this type of controller it's still possible to manually change focus during a shot, but you'll have to rely on the viewfinder and practice each shot many times before you get a take you like.

Figure 3.9 shows the numerical readout on the Sony HVR-A1U that tells you where the focus is set.

FIGURE 3.9 On the Sony HVR-A1U, a numerical readout on the screen tells you where the focus is set. In this instance, the camera is focused on a point 0.3 meters from the lens.

Generally, you'll find using the Push AF feature to be an easier way to change focus, but it limits you to focusing on objects inside the camera's focus zone. It's a sad truth that most camcorders are not designed to allow you to easily pull focus, and this is a limitation you'll have to consider when designing your shots.

Many factors contribute to depth of field, and every shot you design will have its own unique DOF depending on exposure, lighting, zoom setting, and the size of the imaging chip in your camera. Out of all these factors, the easiest one to control is your zoom setting.

A shot that's zoomed all the way out is called a *wide-angle shot*, and it will have the widest apparent depth of field in which everything will be in focus. A shot that's zoomed all the way in is called a *telephoto shot* (or sometimes a *long lens shot*), and it will have the narrowest (or most shallow) DOF.

So if you want a shot with selective focus and a shallow DOF, move the camera back from your subject and zoom in. But keep in mind that if your subject moves during the shot, they could easily go out of focus (which would require you to pull focus), and if you're designing a shot with a lot of movement and you don't want to worry about focus, zoom out and move the camera closer to get a wide DOF.

But to get a truly filmic depth of field with a typical camcorder, you need to use a 35mm adaptor, which effectively changes the image size of your camera and allows you to use external 35mm lenses (see Figure 3.12). The independent feature *As You Like It* was shot using the Redrock Micro 35mm adaptor.

The following figure illustrates an image with a narrow depth of field.

FIGURE 3.10 This shot has a narrow depth of field. Notice how objects both in front of and behind the subject are out of focus.

Figure 3.11 shows the same shot shown in Figure 3.10, but with a greater depth of field.

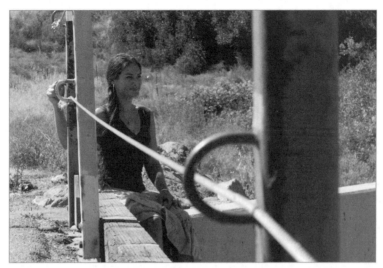

FIGURE 3.11 This shot is from the same perspective as Figure 3.10 and has a much greater depth of field. The post close to the camera is still slightly out of focus, but everything else is in crisp focus.

The following figure shows a 35mm lens adapter being used with a Canon camcorder.

FIGURE 3.12 The Redrock Micro 35mm adaptor allows you to use 35mm lenses with any camcorder. In the picture above, the Redrock adaptor is shown with the Canon HV-20 on the set of *As You Like It*.

Feeling Exposed

The second manual control we're going to tackle is exposure. Basically, exposure control determines how light or dark your image is. It does this in one of three ways:

- Physically controlling the amount of light hitting the imaging chip through the use of a mechanical *aperture* (see Figures 3.13 and 3.14).

KEY TERM:

APERTURE A mechanical device between the lens and the imaging chip with a circular opening that can be made larger or smaller to regulate the amount of light hitting the chip. The aperture works just like the iris in the human eye. When the aperture is *wide open*, it lets in the most light. When you make the opening in the aperture smaller (which is called *stopping down*), you let in less light.

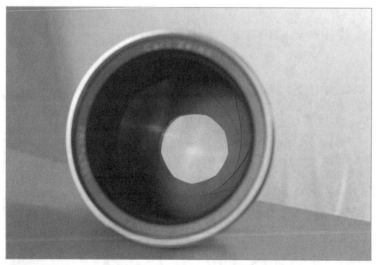

FIGURE 3.13 In this shot, you can see the mechanical aperture of the lens. The opening is relatively large, which means that more light will be allowed into the camera for a greater exposure.

- Changing the *shutter speed* of the camera. Shutter speed controls the amount of time light is allowed to hit the imaging chip. A slower shutter speed means the chip is exposed to light for a longer amount of time, which makes the image brighter (see Figure 3.15).

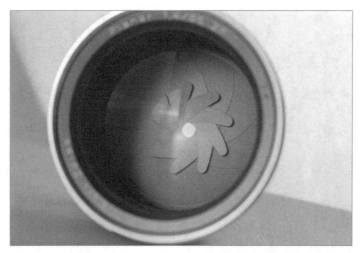

FIGURE 3.14 Here is the same lens seen in Figure 3.13. The mechanical aperture has been *closed down* to allow less light into the camera.

The following figure shows how to manually control the shutter speed on a Sony HVR-1AU.

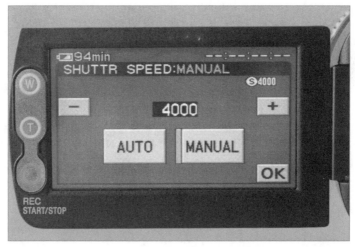

FIGURE 3.15 On the Sony HVR-1AU, you can manually control the shutter speed. In the example shown here, a shutter speed of 1/4000th of a second has been selected.

- Electronically boosting (or amplifying) the strength of the image created by the imaging chip using *gain circuitry*. You can think of this as turning up the volume of the image as if you were adjusting audio (see Figure 3.16).

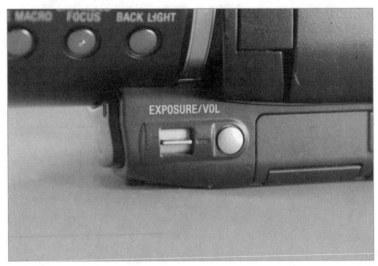

FIGURE 3.16 On many cameras, the exposure adjustment not only controls the aperture of the camera, it also controls how much *gain* is applied to the image.

When your camera is using automatic exposure, it's constantly evaluating the brightness of the surroundings and adjusting the aperture, gain, and shutter to create a well-exposed image. Like all automatic controls, this is only bad when it does something you don't want. There are two primary ways automatic exposure negatively affects the images you create:

- The exposure changes while the camera is recording. For example, if a bright light passes through frame during a shot, the camera automatically stops down and then opens up again as the light goes by. This results in the overall image getting darker and then brighter as the camera compensates for the intensity of the passing light.

- If the camera continuously optimizes image exposure, you won't be able to create an image that's deliberately bright (*overexposed*) or dark (*underexposed*).

Keep in mind that the whole goal of controlling the exposure is to create an image that is exactly as bright (or dark) as you want it to be. It doesn't matter if the camera is using the aperture, gain, or shutter speed to affect exposure, and it also doesn't matter if the image is brighter or darker than ideal as long as you get the look you want. But to make the camera do what you want, you need to know what controls are available.

The many, many types of exposure control

Unlike focus control (i.e., on or off, manual or automatic), most cameras offer many different degrees of exposure control. The best type of control is fully manual, where you can set the brightness of the image, which doesn't change unless you intentionally readjust the exposure. As described in Chapter 1, this control is usually called *exposure lock*, and it freezes the exposure and lets you brighten or darken the image with a dial or toggle (refer back to Figure 3.13).

Although this is the most useful type of exposure control, it isn't very common unless you're dealing with professional-grade cameras. The most common exposure options don't give you this level of complete control. Instead, they allow you to alter what the camera considers normal, but the exposure circuitry still adjusts the image automatically.

Here are three of the most common exposure control options:

- **AE Shift (Automatic Exposure Shift).** The most basic control. It makes the overall image brighter or darker by shifting what the camera considers normal. But it's important to remember the camera still automatically adjusts the image if the lighting changes (it strives to achieve the new definition of normal set by AE Shift) (see Figure 3.17).

Most cameras have many more options and controls than discussed here (and the options vary from camera to camera). Read the manual to see what your camera can do, then go out and experiment with each setting to learn how it affects your images.

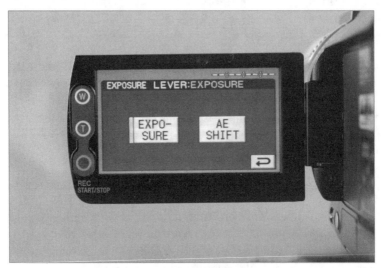

FIGURE 3.17 This menu on the Sony HVR-1AU allows you to select either full control of exposure (left) or *AE Shift* (right) to redefine what light level the camera considers *normal*.

- **Back Light.** Use this control if you have a strong light source behind your primary subject such as the sun or a large window (refer back to Figure 1.8 for an example of a subject photographed with a strong back light). Normally, the camera would set exposure based on the overall brightness of the image. This would result in your primary subject seeming dark. *Back Light Compensation* boosts the overall exposure of the image, making your primary subject brighter (see Figure 3.18).

- **Spot Light.** This control is designed for shots in which your primary subject is being hit by a strong light source. In these situations, the rest of the surroundings are usually very dark. If the camera sets the exposure based on this low average illumination, your subject will appear too bright or *blown out*. Spot light reduces the overall exposure, allowing the central, brightly-lit subject to be properly photographed (see Figure 3.19).

FIGURE 3.18 The *Back Light Compensation* button is usually located near the Manual Focus control, as it is here on the Canon HV-20. Refer back to Figure 1.9 to see the effect Back Light Compensation would have on a subject with strong back lighting.

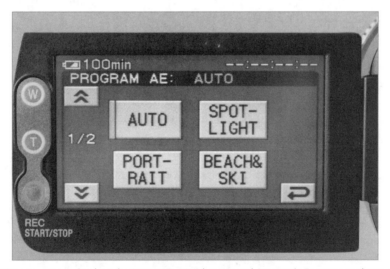

FIGURE 3.19 Some cameras (such as the Sony HVR-A1U) have several Automatic Exposure modes to compensate for extreme lighting conditions. *Spotlight* and *Beach & Ski* modes are designed to correct for situations brighter than normal. Refer to your camera's manual (and experiment) to learn how specific controls on your camera affect the image.

The following term describes an image that is severely overexposed.

BLOWN OUT The description of any portion of a video image that is severely overexposed. You will not be able to see any detail in an area that is blown out. Normally, this is considered bad. You wouldn't want your leading lady's face to be blown out, but sometimes you can intentionally blow out part of an image to hide something you don't want the viewer to see. Windows are commonly photographed so they blow out to keep the audience from being distracted by objects or activities outside the window.

Using shutter control

As we discussed earlier, the shutter also controls exposure by regulating the amount of time the imaging chip is exposed to light. Shutter speeds are usually expressed in fractions of a second; $1/100^{th}$ or $1/250^{th}$ of a second are common shutter speeds. But if you're outdoors on a bright day, a shutter speed of 1/4000 might be needed to keep the image from blowing out, and indoors, in very low light, using a shutter speed of 1/60 or 1/30 might be necessary to get sufficient exposure.

Normally, the camera controls shutter speed automatically as it attempts to maintain an ideal exposure, but some cameras will let you set the shutter speed yourself (usually through a menu setting). Very fast and very slow shutter speeds each have distinctive looks and are often used to create specific moods as discussed in the following sidebar.

ALTERED STATES: USING SHUTTER SPEED TO MIRROR THE MIND

Besides affecting how much light each image receives, the shutter also controls how motion is captured by the camera. You can slice motion into tiny slivers or smear it into a groggy blur by choosing different shutter speeds.

A very fast shutter speed freezes motion in crisp, discrete images with little or no blurring. This effect makes motion look choppy and is often used in action sequences to depict a heightened sense of reality. When you watch a scene shot with a fast shutter, you can almost feel the adrenaline coursing through your veins as time both speeds up and slows down simultaneously. You would usually use a shutter speed of 1/4000 or 1/8000 to achieve this effect. On some camcorders, this setting is referred

to as the *sports setting*, since you could use the crisp, imagery to study quick motion like a golf swing.

At the other end of the spectrum, some cameras let you select a shutter speed of 1/15th or even 1/8th of a second. The key feature here is that the shutter speed is less than the frame rate (which is usually 24 or 30 frames per second). With this combination, the images of several frames are allowed to blur together in a soupy smear. This gives any movement a surreal, liquid quality while objects that aren't moving look completely normal. This effect can be used to create the illusion of someone moving through the frame at superhuman speed (as demonstrated during the fight sequence in *Neo's Ring*, which can be found on the companion DVD). Or you can make the audience **ON DVD** feel they're unable to properly perceive the world around them, depending on how you use the shot in your story. Even if your shutter won't go any lower than 1/30 or 1/60, these settings will still provide subtle blurring to movement in the frame, which can make your images look more film-like.

Working with gain control

The last way your camera can brighten a shot is by increasing the gain, which is a measure of how much the exposure circuitry is amplifying an image. Gain is normally set at zero and increased in positive amounts, which means gain is designed to make an image brighter. You wouldn't use gain to reduce the brightness of a shot.

Professional cameras measure gain in *decibels* (abbreviated as dB), and allow you to increase the gain in specific set amounts. But most consumer cameras also let you increase the gain using settings that are usually called *Low Light* or *Nighttime*. These settings are designed to allow you to capture an image even in very dark environments.

But gain comes with a price, and that price is image quality. The more gain you use, the more *noise* is created in the image. Noise usually shows up as a kind of white static, which is why it's sometimes called *snow* (see Figure 3.20).

Most filmmakers avoid using gain if they can, or they use it in very small amounts. It's usually better to add some light to the scene if you can (as will be discussed in Chapter 5). But if you can't get the shot without adding some gain (or using a *Low Light* setting), and if the noise isn't too severe (or if you like the way it looks), then switch on the gain and keep shooting. It's another tool you can use to control the look of your shots.

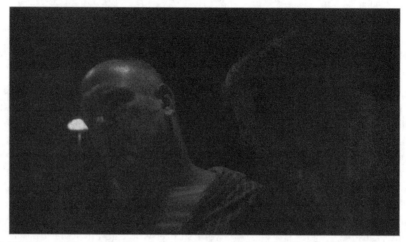

FIGURE 3.20 In this scene from *As You Like It*, the Duke interrogates Orlando's brother on the whereabouts of Orlando. Notice how the noise introduced by too much gain reduces the detail in the image and makes it look grainy.

Staying Balanced

The last camera control we're going to explore is white balance. As we discussed in Chapter 1, white balance is how the camera figures out what is truly white based on the main light source hitting your subject.

Each different source of light has a different tint or *color cast*, and these colors are arranged on a scale from orange to blue. Orange is at the low end of the scale and is described as a *warm* light source. Blue is at the high end of the scale and is considered a *cool* light source.

> **TECHIE'S TIP**
>
> *Color temperature* is the term used to describe the tint in light, and it's measured in *degrees Kelvin*. A warm light source (like a lightbulb) has a color temperature of about 3200 degrees Kelvin, while a cool light source (like the sun) has a color temperature of around 5600 degrees Kelvin.

Light sources and their colors

It's important to know the primary color casts of standard light sources because you never want to mix lights with different color casts. An example

of mixed light sources would be someone sitting by a sunlit window in a room illuminated by regular lightbulbs. In this case, part of their faces would either look blue or orange depending on how the white balance was set (see Color Plate figures 3 and 4).

Here are the most common light sources you're likely to encounter, arranged from warmest (most orange) to coolest (most blue):

- Candlelight or firelight
- Standard lightbulbs
- Sunlight at sunrise or sunset (referred to as the *golden hour* because of the golden/orange cast of the light)
- Fluorescent lightbulbs (these often have a greenish tint)
- Sunlight on a cloudless day
- Sunlight on a cloudy day

Once you know the color properties of these light sources (and that you should never mix them), the next step is knowing how to set the white balance of your camera.

Setting your white balance

Most cameras have three different ways you can control white balance:

- Fully automatic
- Standard presets
- Custom settings

We discussed automatic white balance in Chapter 1. Although the circuitry in the camera generally does a good job of keeping the colors balanced, using the automatic mode is risky in narrative filmmaking because the white balance could change in the middle of a shot.

To ensure the white balance stays constant during your shots, it's a better to use presets that lock the white balance at a certain setting and keep it from changing. These presets can either be standard (built into the camera) or custom (set by you and stored in the camera's memory).

Besides keeping the white balance from changing during a shot, using a preset also keeps the white balance constant from shot to shot. When shooting narrative fiction, several separate shots are edited together to create the illusion of an event happening in real time. These shots are sometimes filmed over the span of several days. Keeping the white balance constant helps ensure the shots will cut together seamlessly.

Standard Presets

Almost all cameras have at least two built-in presets: One for indoors and one for outdoors. The indoor preset symbol is a lightbulb and the outdoor preset symbol is the sun (see Figure 3.21). Simply select the symbol that corresponds to your primary light source (manmade lighting or sunlight) and your white balance will be locked in.

The only problem with using standard presets is that they correct for an idealized, average light source. Unfortunately, the color temperature of the sun changes throughout the day and different lightbulbs can have slightly different color casts depending on how they were made. Standard presets are a good approximation, but they're not 100% accurate.

FIGURE 3.21 On the Canon HV-20, there are six preset white balances to choose from, each with a slightly different color cast. From left to right on the menu above, the white balance presets are *daylight, shade, cloudy, indoors,* and two separate settings for *fluorescent lighting.* Each preset has its own distinct icon.

Custom Settings

The only way to have complete control over white balance is to set it yourself. Fortunately, this is fairly simple. Here are the steps (check the manual to see where the specific buttons are for your camera):

- Set up the shot completely. Know the area your actors will be moving through and place any additional lights you may be using.

- Take a piece of white paper and hold it in place so it's being hit by the same light sources that will be hitting your actors. It's important that the paper be clean and white without any writing or markings on it.

- Zoom in with your camera so the white paper completely fills the frame.

- Hit the *set white balance* button. The white balance symbol will flash for a few seconds in the display (see Figure 3.22).

- When the symbol stops flashing, the white balance is set.

FIGURE 3.22 The symbol for setting your own custom white balance is a square floating above two triangles. This feature allows you to accurately set the white balance in any unique lighting environment.

The advantage to using this technique is that it assures the white balance is as accurate as possible for your particular lighting setup. On professional sets, the white balance is often reset every time there is a change in lighting.

The following sidebar discusses how to trick your camera's white balance to create unnatural colors for cool special effects.

TRICKING YOUR CAMERA'S WHITE BALANCE AS A SPECIAL EFFECT

The purpose of white balance is to keep all the colors in your images looking natural and life-like. But suppose you don't want your colors to look normal. Maybe in the universe of your story, everything has a sickly greenish hue. Or maybe your world has a warm, golden feeling instead. You can easily create these worlds by tricking your camera's white balance.

When you balance the camera using a clean, white sheet of paper, you're telling the camera, "This is white. Use it as a reference to set all your other colors." But what happens if you lie to the camera? Suppose you point the camera at a red sheet of paper and say, "This is white." The camera shifts its definition of the other colors based on the assumption that red is the new white. In this case, all the colors in your video would end up with that sickly green hue. If you used a bluish piece of paper for your white balance, all your colors would end up with a golden sheen (see Color Plate figures 5 and 6).

The best way to know how different white balances will affect your camera is to experiment. Use different colors and see what happens. One tip: Using pastel shades when setting the white balance generally gives better results than using rich, vibrant colors.

One other note: It's also possible to change your white balance later using editing software. This is a more cautious approach. If you shoot all your footage with natural colors, you will have more flexibility if you decide to change the colors while editing.

 ## Operating Like a Professional

In the world of professional moviemaking, the person who actually controls the camera is called the *camera operator* (which makes *operating* the process of controlling the camera), and if the concept of *operating* makes you think of a surgeon, you're on the right track. Properly controlling a camera demands an almost surgical skill and precision.

The first part of an operator's skill is knowing his or her instrument—understanding all the camera's controls and being able to use them to achieve specific effects. That's what we've been concentrating on so far.

The second part of operating involves physically manipulating the camera to achieve the shots required by the story. This can be anything from handholding the camera to mounting it on a *dolly* for smooth moving-camera shots.

KEY TERM:

DOLLY A wheeled platform used to create smooth camera movements. At its simplest, it can be a skateboard, wheelchair, or even a shopping cart. At its most complicated, it's a heavy mechanized cart that rides on a specially-made track.

But let's start at the beginning. The first and most basic tool every camera operator must know how to use is a tripod.

First things first: Put that camera on a tripod!

The reason for using a tripod is simple: It provides a level platform for the camera and lets you make stable, professional-looking shots. Using a tripod should be your first choice for shooting a typical narrative story. It allows the camera to observe the action from a neutral, non-intrusive perspective. Handheld shots (because of their motion and energy) call attention to the fact someone is holding the camera. There are times when this is the right creative choice, but going handheld should be a conscious decision you make because it's right for the story, not because it's more convenient.

FIGURE 3.23 Panning is horizontal movement, either from left to right or right to left from a fixed position to follow a moving object or capture a panoramic view. The smoothest pans are achieved using a tripod, but you can also pan while handholding the camera.

The two principal moves you can make with a tripod are the *pan* and the *tilt*. Panning involves moving the camera on the horizontal plane, either from left to right or right to left (see Figure 3.23).

Tilting involves moving the camera along the vertical plane, either up or down (see Figure 3.24). When making these moves, you want them to be as smooth as possible, and the only way to do that is by using the right tripod.

Choosing the Right Tripod

To begin with, pick a tripod that's big enough. Tripods come in all configurations, from travel-size tripods that can fit in a backpack to heavy-duty models capable of holding a studio camera (see Figure 3.25). You want one that can easily hold the weight of your camera. The smaller tripods may be easier to take on vacation, but you want a tripod that won't wobble even when the legs are fully extended.

Next, make sure you get a tripod with a *video head*. The head is the top platform of the tripod to which the camera attaches, and some heads are made for still cameras, while others are designed for use with video cameras (see Figures 3.26 and 3.27). The most expensive video heads are filled with fluid, but there are others that use special friction-reducing bearings. Regardless of how they're built, the key point is to ensure you can smoothly and easily tilt and pan the video head without the camera jerking.

FIGURE 3.24 Tilting involves moving the camera up or down from a fixed position. Just like a pan, a tilt is normally done from a tripod.

Figure 3.27 shows the head on a smaller tripod.

Finally, make sure you get a tripod with a level built into it. When you're outdoors on uneven terrain, you'll have to extend the camera legs to different lengths to set up the tripod. Having a level for reference will help ensure your shots are always properly aligned (see Figure 3.28).

But you're not always going to use a tripod. There are times when taking the camera into your hands is the right choice.

FIGURE 3.25 Here are three common tripod sizes. Notice that as the tripods get larger, the tripod heads become sturdier and more robust. On more expensive tripods, you can select and use a variety of different tripod heads with the same tripod.

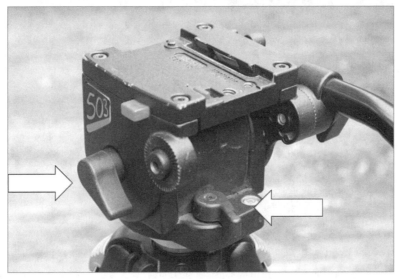

FIGURE 3.26 The video heads on more sophisticated tripods are capable of very smooth tilts and pans. The arrows point to the tilt and pan locks, which allow you to lock the camera in a specific position and keep it from moving. But be careful not to overuse the tripod locks (see the sidebar, "Using a Tripod Like a Pro").

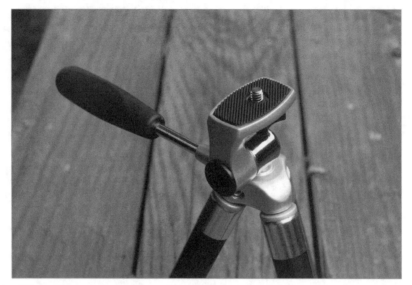

FIGURE 3.27 The heads on smaller tripods are designed primarily for still cameras. It's difficult to execute smooth tilts and pans with these tripods, although with practice you can often get acceptable results.

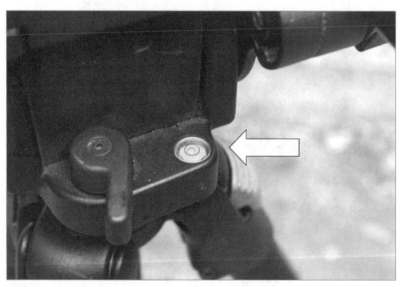

FIGURE 3.28 Having a level makes it easy to be sure your shots are always aligned with the horizon, regardless of where you set up your camera.

USING A TRIPOD LIKE A PRO

There are certain shots where even the slightest amount of wobble or camera movement could ruin a take. All tripod heads have *locks* that keep the camera from tilting or panning when they're engaged. You use these locks anytime you absolutely don't want the camera to move. When both the pan and tilt locks are engaged, the camera is said to be *locked off*.

But a mistake made by many beginning filmmakers is to lock off the camera when they shouldn't. Here's an example. Suppose you're shooting a closeup of a girl reading a book in the library. She's just going to sit there. She doesn't get up and no one else enters the shot. You might be tempted to frame the composition you want and then lock off the camera. If she absolutely, positively wasn't going to move her head or pause for a moment to think, locking off the camera might be okay. But odds are, something will happen during the scene that will slightly change your initial composition. Maybe she tilts her head to one side as she turns the page. Or maybe she pauses for a moment to stare off into space in thought. Depending on how close the closeup is, any small movement could ruin the dynamics of the shot.

Ideally, you would keep your hands on the tripod handle and make continuous small adjustments to compensate for any movement of your actor. This is how you keep the shot *alive*—by *floating* with any changes and constantly readjusting. It's almost never a good idea to lock off the camera when shooting closeups.

Going handheld

Shooting with a handheld camera has many potential effects on the viewer. First of all, the slightly unstable motion of the image instantly makes the audience aware of the camera. There's an unconscious feeling that someone is in the room with your characters. This can be very effective if you're shooting a thriller and you want the audience to know the characters are being observed by someone about to attack. In this case, the shot is called a *Point of View* (or POV) since the camera represents the viewpoint of an unseen character that's actually in the story.

But if you're not specifically creating a POV shot, then the handheld perspective can sometimes make the viewers feel as if they're the ones in the room with your characters. They can feel as if they're eavesdropping or spying on the scene, and this can create some interesting tension, especially if the scene is about a very private or sensitive issue.

Another reason to shoot handheld is for an action scene, or a scene with a lot of movement. The look of a handheld camera can add a dynamic energy you can't get any other way.

But there are dangers to using too much handheld. If the camera moves too much or the image has too much motion, it can make the action hard to follow. Watching the scene can be tiring, and some people actually feel seasick when watching handheld camera work. The final danger with using too much handheld is it can make your work look amateurish. Most home movies and Internet videos are shot handheld. If your work visually resembles these amateur efforts, the viewer unconsciously puts it in the same category. The only way to avoid being lumped in with these less than professional projects is to use your handheld camera properly.

How to shoot handheld like a pro

The key to shooting good handheld shots is to make sure the camera doesn't jiggle or wobble too much. You want to be as stable a platform as possible. Being too stable will not rob the shot of its handheld energy because the mere act of holding the camera in your hands imparts a human energy and motion to the shot.

TECHIE'S TIP

To get the smoothest handheld shots possible, use a *wide-angle adaptor* (see Figure 3.30). A wide-angle adaptor increases your camera's FOV, the amount of your surroundings the camera can actually see. This can be especially useful if you're shooting indoors in a small space because it will allow you to see more of the room, and a side benefit of having a wider angle is that your shots become far more stable.

Grips and Body Positions

There are many ways to hold the camera, depending on the nature of the shot and whether you're going to be moving or standing still. We're going to look at some specific shot types, but before we do, there are a few pointers that apply to all handheld shots:

- Use both hands. Holding the camera in two hands gives you more control over the shot and keeps the camera more stable. It also allows you to shoot longer without your arms getting tired (see Figure 3.29).

- Use the flip-out view screen instead of the viewfinder. This enables you to keep an overall awareness of where you are in relation to your actors, which is especially important in shots where you are moving

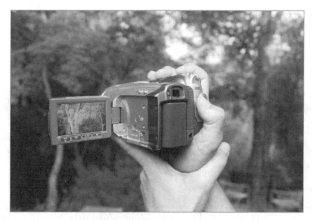

FIGURE 3.29 Using two hands on the camera will give you smoother handheld shots. Notice how the left hand provides support to both the camera and the wrist of the right hand.

with the camera. Keeping your eye off the viewfinder also keeps any motion of your head from being transferred to the camera.

- Shoot with a wide-angle lens. When you are zoomed all the way out, small bumps and jiggles are far less noticeable. The more you zoom in, the less stable the shot will become.

Figure 3.30 shows a wide-angle adaptor attached to a camcorder's lens.

Beyond these basics, there are specific techniques you can use for static and moving handheld shots. If you're doing a static shot, you want your body to be as stable as possible. The goal is to think of your body as a tripod. Plant

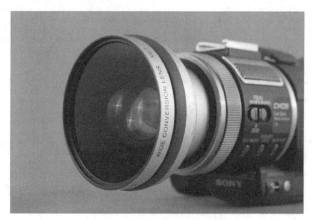

FIGURE 3.30 Wide-angle adaptors screw on to threads just inside the camcorder's lens. You'll often see adaptors like these on cameras used to shoot dynamic, rapidly-moving sports like skateboarding or mountain biking. These adaptors make your handheld shots very stable, but the tradeoff is you must be very close to the action to get a good shot.

your feet slightly wider than shoulder width, and tuck your elbows into your sides to give stability to your forearms. If you need to pan, try to pivot from the waist without moving your feet (see Figure 3.31).

FIGURE 3.31 The trick to stable handheld shots is to think of your body as a tripod. Your legs are the tripod legs, and your entire torso is the tripod head. Pan by pivoting from the waist, and tilt by using your wrists and forearms.

If possible, try to find something to lean against. Outdoors, you can use a tree or a building; indoors, you can use a wall or a doorway. In some locations, it might be possible to use a table or a countertop to prop your elbows on (see Figures 3.32 and 3.33).

FIGURE 3.32 Whenever possible, find a wall or doorway to lean against. Not only will this give your shots more stability, it will allow you to shoot longer takes without getting tired.

FIGURE 3.33 Very stable handheld shots are possible when you can provide support to both elbows. In this position, it's possible to shoot medium telephoto shots without introducing too much camera shake.

The goal is to make yourself as stable as possible while maintaining the ability to follow the action.

The goal in a moving shot is the same, although the techniques are a little different. To begin with, you want to hold the camera slightly away from your body to isolate the camera as much as possible from the movement of your body (just be careful not to hold the camera out so far that your arms get tired) (see Figure 3.34). Next, you'll need to change the way you walk. Normally, the human body tends to bob up and down slightly when walking.

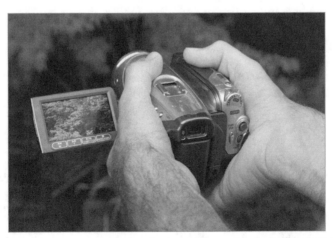

FIGURE 3.34 Cradling the camera in both hands will help create smoother-moving handheld shots. Also be sure the camera is zoomed out as wide as possible; otherwise, the shots will be too shaky.

You want to eliminate this bobbing as much as possible and move forward with a smooth, gliding motion (see Figure 3.35). The easiest way to do this is to keep your knees slightly bent when you walk. We do this naturally when we're carrying a full cup of coffee or something else we don't want to spill. Think of the camera as a cup of coffee or a full bowl of soup, and your shots will be much steadier.

FIGURE 3.35 By walking with your knees slightly bent and using deliberate heel and toe steps, you can keep the camera from bobbing up and down as you follow the action.

Using these techniques will seem awkward at first, but with a little practice they'll make a huge difference in the quality of your handheld shots.

TECHIE'S TIP	The technique of walking with your knees slightly bent is called the *Groucho Walk*. It's named after the comedian Groucho Marx who had a very distinctive comedic manner of walking.

Hello dolly

Moving camera shots are a key element of filmmaking. By moving the camera through the environment of the story, you're giving the viewer important information about the physical world in which the characters live. It's also a way of immersing the audience in that world and making them feel more connected to your characters. Handheld-camera techniques are one way of moving the camera. But if you want to move a camera further,

faster, or steadier than you can easily do by hand, you're going to need a dolly (see Figure 3.36).

FIGURE 3.36 The *doorway dolly* shown here is commonly used on student films and low-budget productions. It rides on a metal track and is pushed by a crewmember called the *dolly grip*.

Dollies come in all shapes and sizes, but their function is the same: to smoothly and fluidly move the camera from one point to another during a shot. In the old days, dollies had to support a heavy motion-picture camera with two operators and could easily be as large as a small car. Camcorders are considerably easier to carry, and there are several dolly rigs you can buy designed especially for digital video cameras. But it's also possible to get the same shots without spending a dime by using some common wheeled platforms. Remember, the audience never knows or cares what equipment was used to get a shot; the only thing they see is the end result.

Three of the most cost-effective dollies a cost-conscious filmmaker can use are a skateboard, a wheelchair, and a shopping cart:

- **Skateboard.** The operator sits crosslegged on a standard skateboard and cradles the camera in his lap with both hands. An assistant called, the dolly grip, pushes the skateboard at the proper speed and in the right direction to follow the action (see Figure 3.37).

- **Wheelchair.** Used the same way as the skateboard with the operator sitting in the chair. Hold the camera with both hands and use your

FIGURE 3.37 A skateboard dolly was used to film much of the chase sequence for *Neo's Ring*. For this shot, the dolly grip pulled the camera operator backwards while the actor ran towards the camera.

best handheld techniques. The wheelchair allows you to get the camera higher off the ground than the skateboard.

- **Shopping cart.** Like the other methods, except the operator sits in the shopping cart.

It's also possible to build your own custom-made dollies using skateboard wheels and PVC pipe for track. There are numerous design plans for Do-it-Yourself (DIY) dollies available online. With a little ingenuity, you can find many ways to create very effective dolly shots (see Figure 3.38).

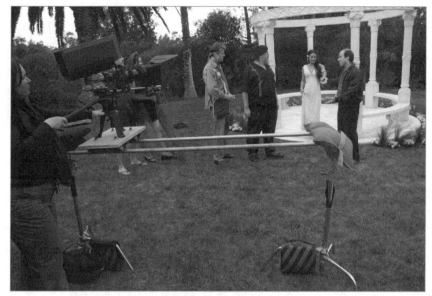

FIGURE 3.38 The DIY dolly shown here was built from scratch for the production of *As You Like It*. The camera rode on a piece of plywood attached to skateboard wheels. The track was built from steel pipe and supported between two *C-stands* (see Chapter 5 for more information about C-stands).

Other Operator Options

So far, we've concentrated on equipment and skills available to just about anyone: tripods, skateboards, and handheld techniques. We haven't discussed any of the equipment and tools that can be used to get even more complex and stable shots. This equipment can range all the way from simple *monopods* and *shouldermounts* to complex *Steadicam rigs* and *cranes*.

> **KEY TERM:**
>
> **MONOPOD** A tripod with one leg. These are easy to carry and are the middle point between using a tripod and going handheld. They can add another measure of stability to handheld shots.

We're not going to discuss the use of these systems here since they're beyond the means of most beginning filmmakers, but be aware there are many ways to support and move cameras (and we've only mentioned a few of the standards). If you can imagine a shot, someone's probably designed a way to get it.

Figure 3.39 shows a Merlin Steadicam example.

FIGURE 3.39 The Merlin Steadicam is a gimbal-balanced platform designed specifically for use with lightweight camcorders. When properly used, it will keep the camera stable regardless of any body movement of the operator.

The following term discusses another option for carrying your camera and keeping it steady.

Figure 3.40 shows a crane in action.

FIGURE 3.40 There are many tripod-mounted cranes built specifically for use with small, lightweight camcorders. These cranes give you a great deal of flexibility when designing moving camera shots.

KEY TERM:

CRANE A piece of equipment that can move the camera from ground level to several feet in the air. Cranes range from small portable systems that can be used with a tripod and a camcorder to large industrial rigs that can lift a motion-picture camera and two operators.

The purpose of this chapter was simple: to give you the knowledge of the skills you'll need to be a camera operator. In doing so, we covered the following topics:

- Controlling focus, exposure, and white balance
- Techniques for moving and supporting your camera like a pro

Of course, we've only scratched the surface. Depending on your particular camera, you may have many more features and controls than we've covered here. The different ways of operating a camera to get specific shots and effects are limited only by your imagination, and the key to learning what your camera will do is experimentation. Try different settings and combinations of the controls and see what happens. The only way to become a good operator is to practice. Every time you use the camera, you'll get better. Just keep at it.

Remember: There is no bad or wrong setting on the camera. Every setting and every movement creates an effect. The only wrong thing you can do is not get the image you want. If you like how the image looks, then you're using the right controls and the right techniques, no matter what they are.

REVIEW QUESTIONS: CHAPTER 3

1. How can you use AF to set your focus before a shot?
2. What three methods does your camera use to control exposure?
3. Describe the procedure for setting your own white balance.
4. What is a POV shot?
5. Explain the difference between dollying and trucking.

1. How can you use focus as a creative element in a story?

2. Suppose you have a camera that won't let you lock the exposure. What techniques can you use to ensure the automatic-exposure feature won't ruin your shots?

3. What would be the disadvantages of tricking your camera's white balance to obtain a unique color cast for your movie?

4. Think of a movie that used extensive handheld camera operating. How did it make you feel? Was it effective?

5. We mentioned skateboards, wheelchairs, and shopping carts as possible dollys. How many other techniques can you think of to create a moving camera shot? What would make these techniques visually unique?

APPLYING WHAT YOU HAVE LEARNED

Research/Lab/Fieldwork Projects

1. Grab your camera and head outdoors with two friends. The following series of shots will give you an opportunity to experiment with the manual controls on your camcorder. Be sure to use a tripod. Tape a few seconds of each shot:

 • Set up a shot with a shallow depth of field that will enable you to practice pulling focus. Have one friend stand close to the camera and the other stand far away. Keep both in the frame at the same time, but make sure only one at a time can be in focus (you'll probably have to use full telephoto on the zoom). Rack focus from close to far and far to close. Try both the Push AF method and the focus wheel.

- Set up a shot in which the sun is behind your actors. Your goal is to design a situation in which you will be able to choose between properly exposing either your actors or the background (if the sun isn't shining, you can create the same situation indoors by standing your actors in front of a large window). Using the controls on your camera, set the exposure so you can see their faces clearly. Now change the exposure so your actors are as dark as possible given the limits of your particular camera. Ideally, you should be able to stop down enough so your actors appear as silhouettes.

- Pick a location either indoors or outdoors in which your actors can sit and have a conversation. Tape a few seconds with auto white balance turned on. Switch the white-balance control to the preset for your situation (indoors or outdoors) and tape a few more seconds. Now switch the white balance to the wrong preset (i.e., indoors if you're outdoors). Shoot a little more. Then, using a white sheet of paper, set a custom white balance for your location and tape more of the conversation. Finally, set a custom white balance using a reference that is NOT white and record that as well. You should be able to see clear differences in how the colors are captured.

2. Remember the nonspecific dialogue scene from the last chapter? We're going to use it again, but this time just as dialogue. The goal is to set up a scene in which the two characters are exchanging the dialogue as they're walking. Rehearse it a few times so they get comfortable with the scene. Don't worry about the acting; your main concern is that they can do the scene more than once and that their performances look the same each time.

Now you're going to shoot the scene three times:

- Once with the camera on a tripod
- Once using handheld techniques
- Once using some form of dolly (use the ones suggested in the text or be creative)

The following guidelines apply:

- Each time you shoot the scene, you must shoot it from beginning to end in a single take.
- Don't worry about whether you can record the dialogue clearly (when the camera's on a tripod and the actors are far away, you won't be able to record clean dialogue). The purpose of this exercise is to use different operating techniques and to visualize the scene in different ways. You're not trying to produce a finished scene.
- If you get inspired and want to shoot the scene more than three ways, go right ahead!

THE LANGUAGE OF THE SHOT

OVERVIEW AND LEARNING OBJECTIVES

In this chapter, you will:

- Understand the visual characteristics of lenses
- Learn basic shot vocabulary
- Explore graphic shot design
- Become familiar with stageline and screen direction
- Start to think of story elements as specific shot types

What'd He Just Say?

"Give me a clean single on a long lens. Tight, but not a Warner's. Be sure to keep the eyeline camera right."

When most people think of language, they think of words. Words in French, words in Spanish, words in English. But language is any form of communication. Music is a language. Mathematics is a language. The visual imagery in pictures and movies is a language. You speak that language with a camera and you hear it with your eyes. That's what this chapter is about: The language of the shot.

But don't worry. This isn't a foreign language. You've been surrounded by it ever since you watched your first moving images, and you already understand it. You may not know how to describe in words what each shot does yet, but you already know what different types of shots look like and how they make you feel. Now it's time to learn how to speak that language with the images your camera captures.

Lenses: The Director's Quill

If images are the director's language, then lenses are the quills. They write the images the camera sees. But lenses do more than capture the world before them. They translate it. A lens takes the physical three-dimensional world and converts it to a two-dimensional representation of that reality, and different lenses see the world in different ways.

 All figures and shorts are included on the companion DVD with this book.

"Wait a minute," you may be thinking, "my camera's only got one lens, and it pretty much sees whatever I point it at." Actually, if you've got a zoom lens, that isn't true. A zoom lens can see the world in an infinite number of ways, depending on where you set the zoom control. But let's keep it simple. To begin, we'll concentrate on the two ends of the zoom-lens range: *wide* and *telephoto*.

WHY IS A WIDE-ANGLE LENS CALLED A WIDE-ANGLE LENS?

The angle referred to as *wide angle* is what's called the *field of view* (or, if you remember from the last chapter, FOV), which refers to the amount of your surroundings a lens can see. With a wide-angle lens, the angle inside the FOV is large (or wide), i.e., the lens can see a great deal of its surroundings.

A telephoto lens, on the other hand, has a narrow (or small) FOV. It can only see a small part of its surroundings. Sometimes the view through a telephoto lens is described as "looking through a soda straw" because you see so little of the total picture.

Where is the dividing line between wide and telephoto lenses? Oddly enough, it's the human eye. The average human eye has an FOV of about 46 degrees in the sharpest, center part of your vision (you can actually see more using your peripheral vision, but you don't have full resolution at wider angles). So if a lens can see more than your eye sees, it's called a *wide-angle* lens. Conversely, a lens that sees less of its surroundings than your eye is considered *telephoto*. If a lens sees the world with the same FOV as your eye (about 46 degrees), it's called a *normal* lens.

Figure 4.1 illustrates FOV, the amount of surroundings a lens can see.

Figure 4.2 illustrates a wide-angle FOV.

Figure 4.3 illustrates a telephoto FOV.

Characteristics of wide-angle lenses

By definition, a wide-angle lens has an FOV wider than the human eye. So if you look at a picture of a landscape captured with a wide-angle lens, it will show more of the scenery and surroundings than you could see with your eye if you stood in the same spot as the camera (and you didn't move your head or look side to side).

To capture and show more than a normal observer would see, a wide-angle lens distorts the *spatial relationships* between the objects in the image. This type of distortion is most apparent in images taken with an extreme wide-angle lens, also known as a *fisheye* lens (see Figures 4.4 and 4.5).

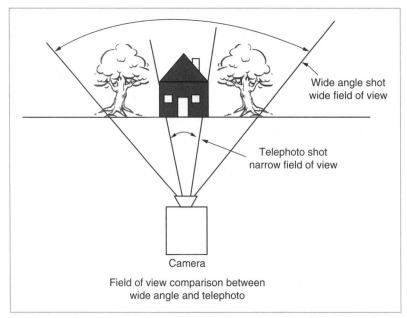

FIGURE 4.1 This drawing illustrates how a wide-angle lens has a wider FOV and can see more of its surroundings than a telephoto lens, which has a narrow FOV.

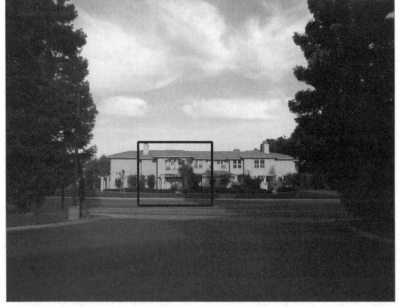

FIGURE 4.2 In this wide-angle view, you can see the house along with the trees and streets around it. The boxed area represents the telephoto view seen in Figure 4.3.

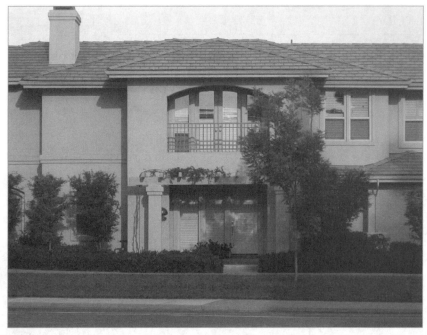

FIGURE 4.3 This telephoto shot has a much narrower FOV than the shot in Figure 4.2. You can only see a portion of the house, and you have no visual information about the neighborhood or the rest of the house.

FIGURE 4.4 A fisheye lens has an extremely wide FOV and sees far more of its surroundings than your eye would see if standing beside the camera. Notice the distortion of the objects near the edges of the image.

SPATIAL RELATIONSHIP The physical orientation between objects in a given location. An example would be how close two people are standing together, or the distance between someone's eyes in a closeup.

Figure 4.5 shows the normal perspective of Figure 4.4.

FIGURE 4.5 This is what the scene in Figure 4.4 looks like through a normal lens. Notice how the band takes up most of the frame as opposed to the view of the band through the *fisheye* lens.

This distortion of the physical world has several visual characteristics that give wide-angle lenses their unique look:

- Objects appear farther apart than they really are, and distances are exaggerated. This can have a comic effect when used for a closeup (see Figures 4.6 and 4.7).

- Because distances are exaggerated, people and objects often seem to be moving faster than they really are (they're covering apparently larger distances in a given amount of time).

FIGURE 4.6 This *closeup* was shot with a wide-angle lens. Notice how it slightly distorts the features of the face. The nose, forehead, and chin appear larger, and the ears appear farther back on the head. This effect is used in certain types of comedies.

Figure 4.7 shows a closeup shot with a telephoto lens.

FIGURE 4.7 In contrast, shooting a closeup with a telephoto lens is very flattering and is often used to make a leading lady appear even more beautiful.

- Parallel lines (such as the sides of a building) will appear to converge. This type of distortion is known as *keystoning* (see Figure 4.8).

- Wide-angle lenses have a greater depth of field, i.e., more of the image is in focus.

- Wide-angle lenses minimize the effect of camera shake or instability in a handheld shot.

To reach the wide-angle setting on a zoom lens, you *zoom out*, and as discussed in Chapter 3, if you put a wide-angle adaptor on your camera, you can create an even wider angle and increase your FOV.

FIGURE 4.8 The *keystoning* caused by a wide-angle lens makes this building look almost like a pyramid. Notice the extreme distortion of the trees in the upper right-hand corner of the image. Those trees are actually parallel to the sides of the building.

Characteristics of telephoto lenses

We know that a telephoto lens has a narrower FOV than the human eye and sees less of its surroundings. To reach the telephoto setting on a zoom lens, you *zoom in*, and this creates the same effect as looking at an object through a telescope—a portion of your subject is magnified. In the same way

FIGURE 4.9 With a *normal lens* (neither wide-angle or telephoto), the distance between objects appears natural. Notice the actual distance between the two subjects in this figure and then compare that distance with Figure 4.10.

that wide-angle lenses give your subject very specific visual characteristics, telephoto lenses also have unique characteristics:

- A telephoto lens tends to compress the distance between objects along the *z axis*. This has the effect of flattening an image and making things appear closer together than they really are. This flattening characteristic is sometimes called *stacking*, since it often appears that objects in the image are stacked on top of each other (see Figures 4.9 and 4.10).

KEY TERM:

THE Z AXIS This is a concept borrowed from geometry. The *x* axis goes left and right, the *y* axis goes up and down, and the *z* axis is the dimension of depth that extends outward from the camera to infinity. This axis of depth is compressed with a telephoto lens, which is what flattens the image.

FIGURE 4.10 The *stacking* caused by the telephoto lens makes it seem as if the two subjects from the previous figure are now very close together, but the actual distance between them hasn't changed. Also notice how Vanessa (standing in the back) is slightly out of focus. This is the result of the shallower *depth of field* created by the telephoto lens.

- Because the z axis is compressed, the velocity of objects moving towards or away from the camera appears to be slower than it actually is (since it looks like it's taking them longer to cover an apparently shorter distance).

- Closeups of the human face shot with a telephoto lens are generally more flattering than closeups shot with a normal or wide-angle lens (refer back to Figures 4.5 and 4.6).

- Telephoto lenses have a shallower apparent depth of field than wide-angle lenses. This characteristic is most often used to create shots with selective focus (see Figures 4.12 and 4.13).

- A telephoto shot amplifies any camera shake or instability, which means it's very difficult to shoot handheld when the camera is zoomed in. You will almost always need a tripod to keep your shots steady when using a telephoto lens.

Shooting with a telephoto lens is sometimes called *being on a long lens*, since telephoto lenses are usually physically longer than wide-angle lenses.

Figure 4.11 illustrates concept axis of depth.

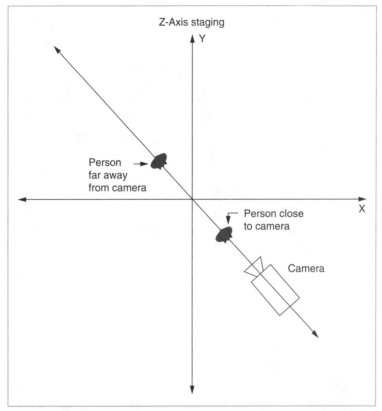

FIGURE 4.11 In this drawing, the *x* and *y axes* represent the two-dimensional plane of this page. The *z axis* extends out from the page towards and away from you. Imagine holding the camera in front of you and looking down along the *z axis*. Figures 4.9 and 4.10 show what objects look like stacked along the *z axis*.

Characteristics of normal lenses

A normal lens sees the world the way your eyes see it—that's why it's called normal. In theory, there's only one exact place along the zoom range that's considered normal: the setting where the FOV is 46 degrees. This exact setting will vary from camera to camera, depending on the optical characteristics designed into each lens, but in general, the normal setting will be closer to the wide end of the lens than the telephoto end. In practice, it doesn't matter exactly where the setting is. If the image looks normal to you, then you've found the normal setting.

The most remarkable thing about a normal lens is there's nothing remarkable about it. It isn't wide, and it isn't telephoto. When you use a wide or

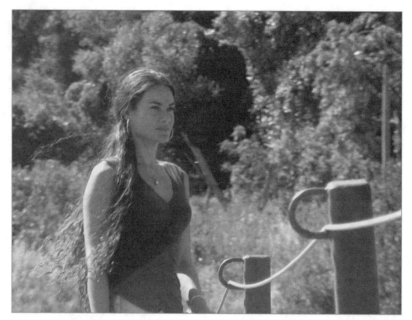

FIGURE 4.12 In this telephoto image, notice how objects in front of and behind the subject are slightly *soft* (out of focus). Also notice how *flat* the image appears as a result of *stacking*. The railing and the trees don't seem very far from the subject.

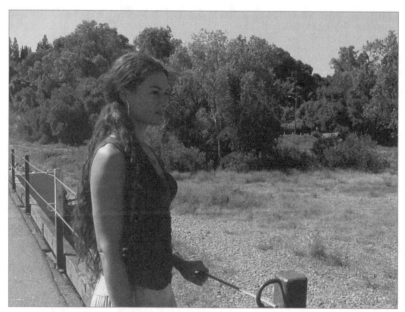

FIGURE 4.13 This image has the same composition as Figure 4.12, but was shot with a wide-angle lens. Notice how everything in the image is in focus. Also notice how far away the trees appear from where the subject is standing. This is another example of how wide-angle lenses exaggerate distance and telephoto lenses compress distance.

telephoto lens, you do so because you want your shot to have a specific visual characteristic. You're using the lens to make a point. But what if you don't want the lens to make a point? What if you don't want to call attention to the fact that the action is being captured with a camera with a specific point of view? That's when you use a normal lens. Anytime you want the audience to forget they're watching a movie and feel like they're seeing an event unfold naturally before them, you should be using a normal lens.

Your Visual Vocabulary

If the lens is a quill, then shots are the words the director writes with that quill. To be an effective writer, you need to have a good vocabulary. That's what we're going to cover next: the shots used in visual storytelling. But before we look at specific shot types, you need to understand how those shots are used. You need to understand the concept of *coverage*.

What the heck is coverage?

When a director analyzes a scene, he thinks about what he wants it to look like onscreen. He thinks about which moments should be closeups, and which moments should be seen from across the room. He thinks about when the camera should be moving and when it should be stationary. He thinks about which lenses he wants to use. Throughout this process, the director is translating the script from words on a page to the shots he will capture with his camera.

> *Coverage can be simple or complex. You can cover an entire scene with a single shot, or you can have an extensive list of shots that could take several days to shoot. It all depends on how you think the final scene should look.*

NOTE

Eventually, the director creates a *shot plan* (see Figure 4.14), which is a list of all the different shots needed to complete a scene. In movie lingo, this collection of shots is referred to as *coverage*, and the process of getting those shots is called *covering the scene*. How a scene should be covered is ultimately determined by the way those shots are pieced together in the editing room during postproduction.

We're going to explore editing in Chapter 8, but for now it's important to know that the process of designing coverage requires a thorough knowledge of how those shots are used in the editing room. You can think of it like this: In the visual language of filmmaking, shots are the words written by the

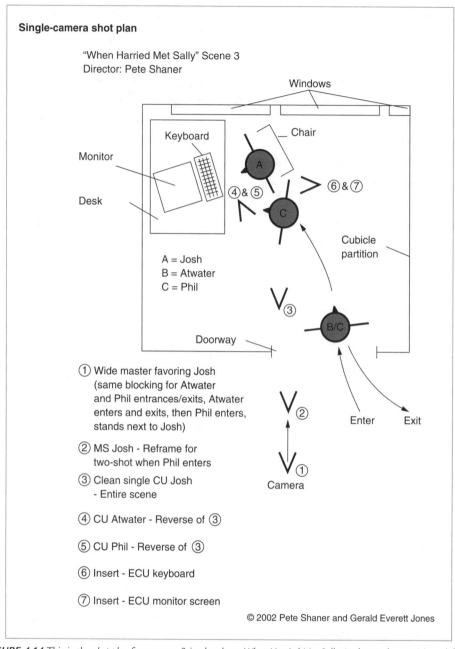

Single-camera shot plan

"When Harried Met Sally" Scene 3
Director: Pete Shaner

Windows

Keyboard

Chair

Monitor

A

Desk

4 & 5

6 & 7

C

Cubicle
partition

A = Josh
B = Atwater
C = Phil

3

B/C

Doorway

Enter Exit

1 Wide master favoring Josh
(same blocking for Atwater
and Phil entrances/exits, Atwater
enters and exits, then Phil enters,
stands next to Josh)

2

2 MS Josh - Reframe for
two-shot when Phil enters

3 Clean single CU Josh
- Entire scene

1

Camera

4 CU Atwater - Reverse of 3

5 CU Phil - Reverse of 3

6 Insert - ECU keyboard

7 Insert - ECU monitor screen

© 2002 Pete Shaner and Gerald Everett Jones

FIGURE 4.14 This is the *shot plan* from scene 3 in the short *When Harried Met Sally*. It shows the set (viewed from above), the location of the actors as they move through the scene, and the placement of the camera for each shot of coverage. Compare this diagram with the completed scene in the film.

director with the lens. In the editing room, you string those words together to write the sentences that tell your story.

But before you can start writing sentences, you need the right vocabulary. The following shots form the basic vocabulary of anyone who uses a camera to communicate:

- Establishing Shot
- Master Shot
- Long Shot
- Medium Shot
- Closeup (CU)
- Extreme Closeup (ECU)

Next, we're going to describe the basic characteristics of each shot type, and then we'll take a look at different uses and variations of those shots.

Often, the main action of a scene is shot at a different time than the establishing shots. This is because the actual location where you film a scene may be on a set, possibly nowhere near the location used for the establishing shot.

NOTE

The establishing shot

The *establishing shot* is usually the first shot in a scene or *sequence*. It establishes the location where the following scene will take place. It's usually a fairly wide-angle shot of a city, a specific building, or a recognizable landscape (see Figure 4.15).

> **KEY TERM:**
>
> **SEQUENCE** A series of moments or events in a movie that don't stand alone, but (when taken together) move the story to a specific point. An example might be the collection of shots and short conversations that show a boxer training for a fight. A sequence is different from a *scene*, which usually takes place in a single location and has its own beginning, middle, and end (although sometimes a sequence can be composed of several short scenes).

Establishing shots help define the world in which your story takes place.

FIGURE 4.15 Notice how much information is revealed in this establishing shot from a scene in *As You Like It*. The palm tree and the sand dunes tell you you're at the beach. The clouds and the lack of people tell you it's probably during the chilly off-season, and the RV gives you some insight about the people we're about to meet.

The master shot

The master shot is used when you are filming a complete scene from beginning to end. It's designed to capture all the action in a single take. In its simplest form, a master is a *static* wide-angle shot showing the entire room in which the scene is occurring (see Figure 4.16). At its most complicated, it's a dynamic moving shot in which the camera is in constant motion as it follows the actors through the scene.

The master shot is often thought of as insurance. As long as you've got a good master, you know the scene is covered. An editor can always use portions of the master as a backup (or second choice) for any of the other coverage (or shots) the director got.

KEY TERM:

STATIC SHOT A shot that doesn't move in any way. It doesn't pan, tilt, dolly, or truck (as described in Chapter 3). It's usually shot from a tripod that's been locked off.

FIGURE 4.16 In this scene, we meet *Sylvius* and the object of his affection, *Phoebe*. This *master shot* is wide enough to contain all the action in the scene, but still close enough to allow you to see the expressions and attitudes of the characters onscreen.

The long shot

As the name implies, the long shot is usually taken from far away. Think of the image of a lone cowboy high on a ridgeline against the evening sky and you get the idea (although if the figure is very small, the shot could also be called a *very long shot*).

> *As you've probably figured out, some shots can fit into more than one category. An establishing shot can be a long shot (or a very long shot), and depending on how a master is framed, a master could also be a long shot.*

NOTE

Technically, to qualify as a long shot, there should be a person in the frame, and you should be able to see that person from head to toe (see Figure 4.17). Generally, a long shot is used to show your characters in relation to their surroundings.

The medium shot

The medium shot is an in-between shot. It brings the audience in closer than a long shot, but doesn't have the intimacy of a closeup. Like the long shot, it's defined by the people in the frame. In a medium shot, you'll generally see your subject from the waist up.

FIGURE 4.17 This *long shot* lets you see the characters and their surroundings. Since you could conceivably watch the whole scene from this shot, this could technically be considered a master shot as well. But this would be a poor choice for a master, since the characters are too far away for the viewers to connect emotionally with the action on the screen.

TECHIE'S TIP

A special type of medium shot is called the *cowboy*. These shots were developed when westerns were popular and the director wanted a shot in which you could also see the gun and holster the actors were wearing, especially if they were going to be involved in a shootout. Consequently, a cowboy cuts your subject off just above the knees (see Figure 4.19).

You'll use a medium shot if you need to see the action your character is performing, but their thoughts or feelings at the moment aren't critical.

Sometimes, if you're shooting in a small room, even with the camera zoomed all the way out, a medium shot is as wide as you can get (see Figure 4.18).

The closeup

A closeup is defined as a shot that shows only the head and shoulders of your subject. Closeups imply a certain intimacy, since you'd usually only get that close to someone if you knew them well.

FIGURE 4.18 This is a classic *medium shot*, since it allows us to see the characters from the waist up. Like the master shot, the medium shot also allows us to see the actions and attitudes of the characters onscreen.

FIGURE 4.19 Here is the same moment shown in Figure 4.18 reframed as a *cowboy* shot. Notice how this shot gives you more information than the classic medium shot. You can see Phoebe is actually wearing a mini-skirt, and Sylvius is carrying even more bags than we saw before.

Before television, when all movies were seen in theaters with 40-foot screens, closeups were fairly rare. Most of a scene would play out in long or medium shots, and the director would only use closeups when a significant emotional moment was taking place. Since the audiences in those days were used to watching wider shots, when a closeup did flash across the screen, it had tremendous impact.

NOTE

Because they concentrate on the face, you use closeups when you need to see what a character is thinking or feeling (see Figure 4.20).

FIGURE 4.20 This *closeup* of Sylvius gives us even more insight into his feelings for Phoebe. Closeups are typically used during emotional moments in a scene to allow the viewer to connect with the thoughts and feelings of a character.

The extreme closeup

By definition, an *extreme closeup* is extreme. It's any shot that shows only a portion of the face, such as the eyes or the mouth.

TECHIE'S TIP

A variation of the extreme closeup is called the *Warner's*. It's a closeup that shows an actor's face from just above the eyebrows to just below the bottom lip. The name comes from Warner Brothers Studios, which used this shot extensively in the 1940s and 1950s.

Because extreme closeup shots get closer than is socially acceptable, they can represent an invasion of privacy of the person being photographed and are sometimes used to make an audience feel uncomfortable (see Figure 4.21).

FIGURE 4.21 In this *extreme closeup*, we get a clear look at the joy Sylvius feels when he's with Phoebe. Seeing this devotion is a little unsettling for the audience because they know Phoebe does not have the same feelings for him.

Expanding Your Vocabulary

So far, the shots we've described are all concerned with one thing—the distance between the viewer and the subject. This is a handy way to organize shots, but it's not the only way. Shots are also described by how the characters in them are photographed. The next few shots we'll examine describe what's in the frame instead of where the frame is located.

The two-shot

One of the most common shots in filmmaking is the *two-shot*. It's also one of the easiest to describe. It's a shot with two people in it. That's it. Anytime you have two people having a conversation, you're going to have a two-shot (see Figure 4.22).

A two-shot can be long, medium, or a closeup. As long as two people are the primary focus of attention, it's a two-shot. But there is one condition: Both people must be of equal importance visually. If one person dominates the frame, it's not really a two-shot. It's probably a variation of the *single* instead.

> *Technically, you can have more than two people in a two-shot— such as a shot where your two lead actors are sitting at a table in a crowed restaurant. In this case, even though other people are in the frame, the focus of attention is on your two leads. That's what makes it a two-shot.*

NOTE

FIGURE 4.22 This *two-shot* is also known as a classic *50/50*. In a 50/50, the two actors face each other in equal profiles. This shot also qualifies as a *cowboy*, which is appropriate for this scene where Orlando and Rosalind are engaged in a verbal duel.

The single

A single is a shot that focuses your attention on only one person. That doesn't mean only one person is in the frame, just that only one person is prominently featured. So if you've got a shot that looks over the shoulder of the person who's listening and concentrates on the person who's speaking, it's not a two-shot even though two people appear in the frame. And not only is it a single, it's a special category of single called an *over-the-shoulder* (see Figure 4.23).

The Dirty Single

In an over-the-shoulder shot, the face of one character shares the frame with the shoulder (and back of the head) of another character. This is a great shot if both people are standing or sitting. But suppose the person talking is sitting and the person listening is standing? (see Figure 4.24).

In that case, the face of the person talking shares the frame with the lower back and arm of the person listening. It's still a single because only one person is featured, but it's not really an over-the-shoulder. The proper name for it is a *dirty single*. Anytime the face of a person shares the frame with any part of another person, the frame is considered dirty (which means an over-the-shoulder is just a specialized dirty single).

The Clean Single

So what do you call it if two people are talking, but you don't see any part of the person who's listening? It's called a *clean single* (see Figure 4.25).

FIGURE 4.23 In an *over-the-shoulder* shot, both characters appear in the frame, although only one character is clearly featured. Having both characters appear in the frame at the same time visually links them and implies a relationship between them, as is the case between Orlando and Rosalind.

FIGURE 4.24 In this *dirty single* from *As You Like It*, the Duke has called Rosalind into his office to banish her to Arden. He remains seated through most of the scene, which makes the dirty single an ideal shot to convey the distain he feels for her character.

FIGURE 4.25 In a *clean single*, no part of the other person present in the scene is visible. Clean singles are often used in scenes where characters are fighting or somehow feel estranged from each other.

The most important thing to remember about a clean single is that you've got to keep it clean. For example, if the head of the person who's listening pops in and out of the frame as they nod their head, the shot isn't really a clean single.

The insert

There's one other shot that should be mentioned, even though it's not related to either the two-shot or the single. As a matter of fact, this shot usually isn't related to the people who are talking. Instead, it's an image of something else in the scene the director wants to call attention to. This shot is called an *insert* because you're inserting a new piece of information into the scene.

*So far, we've said the single focuses on the person who's talking, but it doesn't have to. A single can also concentrate on the person who's listening. It's still considered a single, but it's also called a **reaction shot**, since you're concentrating on how the character is reacting.*

NOTE

A classic example of an insert is a closeup of the clock hanging on the wall. This lets the viewer know that time is important, and may even remind the audience of something that's about to happen.

Sometimes this type of shot is called a *cutaway* because you have to cut away from the main action of the scene to show the image. But no matter what you call it, it does the same thing: It gives the viewer new information while the scene continues to play out.

Variations on Theme

At this point, you've got a good basic vocabulary of shots. You could easily shoot an entire feature-length film using only the shots we've covered. It's even possible to argue that these are all a director needs and that anything else is a variation or combination of the shots we've already covered.

We've seen how those shots can be combined. A master shot can be a medium shot that could also be a two-shot if the scene only has two characters. Another way to expand your shot vocabulary is to make small changes or variations to any of the basic shots. We're going to look at two of the most common changes you can make:

- Changing the angle (high or low)
- Changing the size (tightening or loosening)

What's your angle?

The *angle* of a shot refers to whether the camera is above or below the subject. If the camera is above the subject looking down, it's considered a *high-angle shot*. If the camera is below your subject looking up, it's called a *low-angle shot*. The dividing line between a high angle and a low angle is the eye level of your subject. If the camera is the same height as their eyes, the shot is considered *neutral* as far as angle is concerned.

High Angle

A high-angle shot looks down on your subject from above (see Figure 4.26). Depending on how high the camera is and how small your subject appears in the frame, this can have the effect of making your subject seem weak and powerless. It's as if the viewer is towering over the person in the frame.

FIGURE 4.26 In this scene, Sylvius sits on the ground while Phoebe lounges in a beach chair. This arrangement allows for a *high-angle shot* of Sylvius, giving the viewer a visual clue to the one-sided nature of their relationship.

Low Angle

The low-angle shot looks up at your subject from below the eyeline (see Figure 4.27). This makes the viewer feel like they're beneath the subject and makes the subject appear larger. As a result, a low angle can often make your subject seem more powerful or domineering.

Keep in mind that any of the shots we've covered can be turned into a high or low angle simply by raising or lowering the camera. So if you raise the camera in an over-the-shoulder, the person who's back is to the camera is perceived as more powerful than the person facing camera.

Size matters

One of the defining features of a shot is how large the subject appears in frame. In a medium shot, for example, the subject is smaller in frame than in a closeup. One of the ways to change the impact of a basic shot is to make the subject slightly larger or smaller. In general, the larger in frame something

FIGURE 4.27 This *low-angle shot* from *As You Like It* introduces the character of Charles the Wrestler. Charles is a powerful force who will soon challenge Orlando in the ring, and this low angle emphasizes his threatening nature.

is, the more important it is. So if you want to make something seem more significant, make it slightly larger in the frame.

Making the subject of a shot larger is referred to as *tightening*, whereas making the subject smaller is generally called *loosening*. So if you've got two people sitting at a table, and you want to make sure they fill the frame completely, you'd ask for a *tight two-shot*. But if you then decided you want to see more of the restaurant, you might move the camera back and *loosen the shot* (see Figures 4.28 and 4.29).

> *It doesn't matter how you change the size of the subject in the frame. You can use a zoom lens or physically move the camera closer or farther away. The end result in terms of image size is all that matters.*

NOTE

Let's Get Graphic

By now, you know how to classify a shot based on who's in the frame and how big or small her image is, which is a very practical way of analyzing shots because it makes it easy to design effective coverage. But there's another way to break down the images in a movie, a more artistic way....

Each second of video is composed of 30 still images, and each one of those images is composed of *graphic elements* like lines, shapes, and colors. The

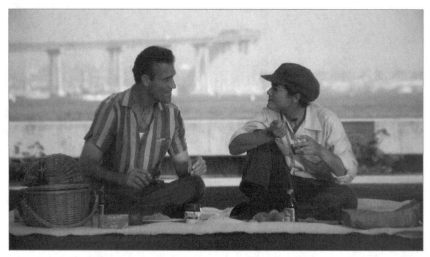

FIGURE 4.28 This is a *loose two-shot*. It gives you a great deal of visual information. In addition to Rosalind and Orlando, you can clearly see the picnic before them and the bridge in the background. The environment and the characters are of equal importance.

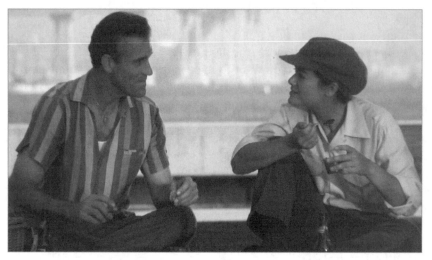

FIGURE 4.29 This is the same image shown in Figure 4.28, reframed as a *tight two-shot*. The characters are much larger in this shot, and their surroundings are far less important. Very little of the picnic can be seen and the bridge is unidentifiable. In this shot, only Rosalind and Orlando are important.

same principles that make a painting such as the Mona Lisa great apply to every single frame of a motion picture. Think of a movie that not only had a great story but also had stunning visuals. Odds are, the director and cinematographer were paying careful attention to the *graphic design* of their shots.

The study of graphic design is an artistic discipline all its own, and you could spend years trying to master it. While we're not going to turn you into graphic artists in the next few pages, we are going to introduce a few of the key concepts you should think about every time you frame a shot.

The rule of thirds

One of the most basic concepts in composition is called *the rule of thirds*. Simply stated, if you've got a rectangular image (such as a movie frame), the human eye is naturally drawn to objects that fall on either the horizontal or vertical *third lines*.

Figure 4.30 illustrates the rule of thirds.

Figure 4.31 creates a greater sense of vastness than Figure 4.32 because the frame is divided differently.

What does this mean to you as a filmmaker? If you want to draw attention to something, frame your shot so that a third line falls on the object you want to emphasize. A perfect example of this is an *exterior shot* in which you can see the horizon. In a classically-framed exterior, the horizon will fall on one of the two horizontal third lines (see Figures 4.31 and 4.32).

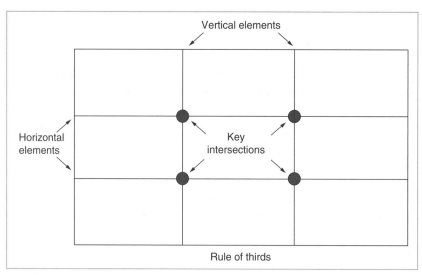

FIGURE 4.30 Any rectangle (such as a movie frame) can be divided into thirds, both vertically and horizontally. These *third lines* and their intersections are important for composing your shots. Some cameras will even display an overlay of third lines on the LCD while recording (see Figure 4.37).

FIGURE 4.31 The horizon in this landscape is aligned with the lower horizontal *third line*. This framing places an emphasis on the sky and conveys a greater feeling of vastness than the shot shown in Figure 4.32.

FIGURE 4.32 This is the same scene as shown Figure 4.31, reframed with the horizon on the upper horizontal third line. With this framing, the river becomes the main subject of the shot.

> **KEY TERM:**
>
> **EXTERIOR SHOT** Any shot that takes place outdoors is called an *exterior*. Conversely, any shot occurring indoors is an *interior*.

The horizontal and vertical third lines in a frame intersect at four places (refer back to Figure 4.30). These intersections are significant because they sit on two different third lines at the same time, which makes them very strong from a graphic perspective. Placing one of these points over an object in the frame is one way to draw attention to that object.

Put a frame on it

The rule of thirds is an example of using graphic-design concepts to influence how you frame a shot. Other graphic-design concepts related to framing are *positive space, negative space,* and *headroom.*

FIGURE 4.33 This is a classically-composed shot. The subject is aligned along the left vertical *third line*, and her eyes are at the intersection of the upper horizontal and left vertical third lines. The character's attention is directed toward the *positive space* to the right, and that space dominates the frame. Any expected action in this frame would occur in front of the character. Compare this framing with Figures 4.34 and 4.35.

Positive space in a shot is the area your character is looking towards. In the closeup example in Figure 4.33, the area between the subject's eyes and the right side of the frame is considered positive space.

Headroom is the area between the top of a character's head and the top of the frame (see Figure 4.35). The relationship between positive space, negative space, and headroom often determines how visually pleasing or how potentially unsettling a shot can be. If a shot feels a little off, analyze the balance between these elements in relation to the third lines. You can often make a significant difference in the impact of a shot by reframing slightly and changing how these graphic elements are balanced.

Negative space is the area behind your character—in this case, the space between the back of the subject's head and the left side of the frame. Generally, in a balanced shot you should have more positive space than negative space (see Figure 4.34).

FIGURE 4.34 With this framing, the character is still on a third line, and her eyes are still at an intersection of third lines, but the *negative space* behind her dominates the frame. This shot creates the expectation that someone (or something) will approach the character from behind, taking her by surprise.

FIGURE 4.35 In this shot, the positive and negative space are properly balanced, but there is too much headroom above the subject. In addition, the character's eyes are no longer on a third line, which throws this shot out of balance. How does this composition make you feel?

The following sidebar discusses how you can create powerful closeups by using the rule of thirds.

SIDE NOTE

THE RULE OF THIRDS AND THE HUMAN FACE

The rule of thirds is often used when composing closeups of the human face. For example, if your subject is looking to the right side of the frame (also called *camera right*), then you would generally align their face with the left vertical third line. The reason for using the left third line instead of the right third line is to properly balance the positive and negative space in the shot.

Using this technique, you can create a particularly powerful closeup by placing your subject's eyes on the intersection with the top horizontal third and their mouth on the intersection with the bottom horizontal third as shown in Figure 4.36. For an alternate (but equally effective) use of the rule of thirds for a closeup, see Figure 4.37.

Figure 4.36 shows a properly-aligned closeup.

FIGURE 4.36 In this closeup, the eyes are on the upper horizontal third, the mouth is on the lower horizontal third, and the subject is framed along the left vertical third. In addition, headroom, positive, and negative space are all properly balanced.

Some cameras allow you to display third lines on the LCD, as shown in the following figure.

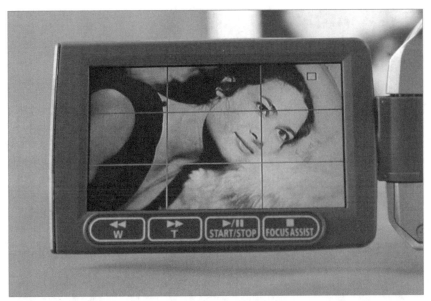

FIGURE 4.37 Some cameras like the Canon HV-20 allow you to display third lines on the LCD. Notice how third lines are used to frame the subject in a unique pose in this image.

It's all in the lines

From the perspective of graphic design, all images can be broken down into certain basic elements. It doesn't matter whether you're looking at a building, a landscape, or a human face, every image is composed of lines and curves. Lines are further broken down into *verticals*, *horizontals*, or *diagonals*, and each type of line can be used to communicate a different feeling or impression.

Verticals

Vertical lines are often used to represent strength or growth. Think of objects with strong vertical lines. Tall buildings and trees come to mind. An upright human figure could also be a vertical line. If you compose an image so the vertical features of an object or subject are emphasized (and aligned with the vertical thirds), the image will convey a certain power (see Figure 4.38).

Horizontals

A horizontal line can be used to convey stability or relaxation. Common horizontal lines are the surface of the ocean, the top of a table, or a reclining human figure. By choosing to emphasize horizontal elements in your image, you can generate a feeling of calm strength or possibly stagnation (see Figure 4.39).

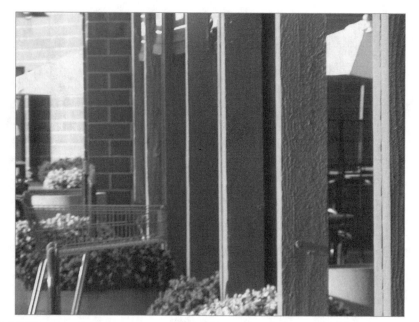

FIGURE 4.38 This image is dominated by strong vertical elements. The uprights in the walkway almost seem to form a solid wall. The shopping cart on the left doesn't stand much chance of making it much farther.

FIGURE 4.39 The horizontal lines of the bench and along the brick wall in the back have an almost soothing effect. This image invites you to sit down and relax.

Diagonals

An image composed of diagonal lines often brings to mind conflict or motion. Think of closeups of clanging swords or the forward dash of a charging soldier. Diagonals are often created by an object rushing through the frame or by shooting subjects so the lines composing them are crossed in opposition (see Figure 4.40).

FIGURE 4.40 Trees are often photographed in a way that makes them seem calm and serene. By contrast, this shot of branches is composed of chaotic, opposing diagonal lines. Can you imagine a character having to battle his way through this forest?

Curves

A curved line can represent many things, but some of the most common are grace, nature, and even sensuality. Curves are more complicated than the direct simplicity of a straight line, and the meaning of curved elements in a shot will depend on context and the composition of the shot as a whole (see Figure 4.41).

It's good to be different

The last graphic-design concept we're going to consider is the concept of being different. When we look at an image, our eyes are naturally drawn to elements that are different from those things around them. The difference

FIGURE 4.41 This image contains several graceful curves interwoven to create a tapestry of glass and steel. But it also contains some opposing diagonals. Does this image evoke any particular feeling? What if you saw a character navigating through these curves to reach a particular car?

can be anything: color, size, shape, even direction of movement. If something is different, we're going to look at it (see Figure 4.42). Picture a single red daffodil blooming in a sea of green, or a small toddler wandering through a mall crowded with adults. You get the idea. This is also the principle behind selective focus—if only one object in the frame is in focus, that's what we're going to look at.

The bottom line with graphic design is to consider each shot as a work of art. Pay attention to the lines and shapes and colors that make up your images. Be aware of how objects move through your shots. Take control of your framing, and use the rule of thirds and the concept of difference to create shots that tell your stories with unique, compelling visuals.

Don't Cross the Line

When shooting coverage of people engaged in a conversation, it's very important not to violate a convention known as the *stageline*.

FIGURE 4.42 There are many different graphic elements in this shot—verticals, horizontals, diagonals, and curves. Is your eye drawn to any particular part of the image? Why? How could you use this image in a story?

KEY TERM:

STAGELINE An imaginary line drawn between two characters facing each other. By drawing the line, one person will end up on the left side of the conversation and the other will be on the right side of the conversation (see Figure 4.43).

When you shoot the master shot of two people in a conversation, the person on the left will be facing the right side of the frame (called *camera right*), and the person on the right will be facing the left side of the frame (or *camera left*). Then when you shoot coverage of this scene (usually in the form of *matching singles*), as long as the camera remains on the same side of the stageline from which you shot the master, person A will always be looking camera right and person B will always be looking camera left (see Figures 4.44 and 4.45). This is the way audiences are used to seeing a conversation onscreen.

You get into trouble if you move the camera to the other side of the stageline to shoot coverage anytime after establishing who is facing left and

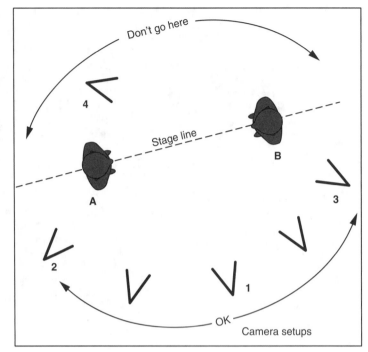

FIGURE 4.43 This illustration shows the *stageline* between two people and the different possible camera positions for shooting *acceptable coverage*. Acceptable coverage is defined as coverage that doesn't *cross the stageline*. These concepts are illustrated in Figures 4.44, 4.45, and 4.46.

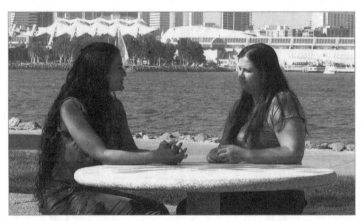

FIGURE 4.44 This is the master shot of a conversation between Character A (on the left) and Character B (on the right). This shot was taken from *camera position 1* as shown in Figure 4.43. Notice that Character A is facing the right side of the frame, and Character B is facing the left side of the frame.

FIGURE 4.45 These are the *matching singles* for the master shot in Figure 4.44. On the left is the shot of Character A from *camera position 3*. On the right is the shot of Character B from *camera position 2*. Notice A is still facing the right side of the frame and B is still facing the left side of the frame. Also notice how the characters seem to be looking at each other, even though they're in separate shots. The stageline has been properly observed.

who is facing right in the master. Moving the camera across the stageline is called *crossing the line*, and it will result in your characters seeming to switch places. All of a sudden, the character that was facing left will now be facing right, and the character that was looking right will end up looking left (see Figure 4.46). This has the potential of disorienting your audience and causing them to momentarily disengage from the story.

FIGURE 4.46 In these two singles, Character A (on the left) was still photographed from *camera position 3*, but Character B was photographed from *camera position 4*, across the stageline. Notice how both characters are now facing the right side of the frame and no longer seem to be looking at each other, even though they are. This is a result of crossing the line.

You get into trouble if you move the camera to the other side of the stageline to shoot coverage anytime after establishing who is facing left and who is facing right in the master. Moving the camera across the stageline is called *crossing the line*, and it will result in your characters seeming to switch places. All of a sudden, the character that was facing left will now be facing right, and the character that was looking right will end up looking left (see Figure 4.46).

This has the potential of disorienting your audience and causing them to momentarily disengage from the story.

A stageline is created anytime two characters interact with each other, so if you've got a group of friends sitting around a poker table, there will be multiple stagelines, depending on how the conversation unfolds. Keeping track of each stageline and where the camera should be placed to keep each character looking in the proper direction can be a daunting task.

KEY TERM:

MATCHING SINGLES The master shot of a conversation usually shows both people in the frame at the same time. Then when you shoot coverage, it almost always includes individual single shots of each character. These single shots are generally similar in framing and image size and are called *matching singles* (refer back to Figure 4.45). *Mismatching singles* are singles in which the characters are different sizes (see Figure 4.47).

FIGURE 4.47 These are two coverage shots from the scene in Figure 4.44. On the left is an *over-the-shoulder*, and on the right is a *clean single*. Although the stageline has been respected in these shots, repeated cuts back and forth between these *mismatching singles* would be jarring for an audience.

But regardless of the number of people in the scene, the important thing to remember is this: Whenever people are talking to each other, if you compare the singles that will be intercut with the master, the characters should appear to be looking at each other (or at least acknowledging where the other character is sitting). That means one character should be looking camera left and the other character should be looking camera right. As you're shooting singles of a conversation, if you ever end up with two characters that should be facing each other looking towards the same side of frame,

you've crossed the line. To keep this from happening, always shoot coverage from the same side of the stageline where you shot the master.

The direction in which a character is looking is also called his eyeline. So if a character is facing the right side of the frame, you would describe this by saying his eyeline is camera right.

NOTE

Preserving Screen Direction

Screen direction refers to how moving objects are shown on the screen. They can be moving left to right, right to left, top to bottom, bottom to top, or towards or away from the camera. Preserving screen direction is a concept very similar to stageline because it involves setting up an expectation in your viewers and then being careful not to violate that expectation. This means if you're showing a character or object moving from one location to another in a series of shots, they should always appear to be moving in the same direction. If you don't, you risk confusing and disorienting your audience.

For example, if a character sets out on his bike to go to the gym, and in the first shot you show him traveling from left to right, then each subsequent shot should also show him moving left to right until he arrives at his destination. Even if you cut away from him to show something happening at another location, when you cut back to him, he should still be moving left to right.

An ideal way to change direction would be to have the character ride straight towards the camera to an intersection and then have him turn left. Keep in mind that from that point on you should only show him moving right to left.

TECHIE'S TIP

The only way to change the screen direction of your character without making it look like he's doubling back is to intercut a *neutral shot*—a shot in which the character is moving directly towards or away from the camera. After showing the character in a neutral shot, you can then reestablish his movement in any direction you desire (see Figure 4.48).

FIGURE 4.48 Even though the chase scene in *Neo's Ring* is highly stylized, we still had to respect the convention of screen direction. In the first two shots as Traci is chased by the Agent, the movement is from *camera left* to *camera right*. We then used a *neutral shot* of Traci running directly towards the camera (but to mix things up, we placed the camera on its side). After the *neutral shot*, we changed screen direction from *camera right* to *camera left*.

The following sidebar discusses screen direction and expectation.

SCREEN DIRECTION AND EXPECTATION

In English and other western languages, we read from left to right. That means we expect things to begin on the left and move towards the right. We apply this same expectation unconsciously to images we see onscreen. If something is moving from left to right, we think of it as moving forward. It's the direction of progress—it's the direction things should be moving. This also means things moving from right to left are going in the wrong direction—they're headed backwards.

Filmmakers use this cultural programming to build expectations in the audience. A character that's made a bad choice and is heading into danger is often seen moving from right to left. Someone on the rise who is destined for success will be seen moving from left to right. In the simplest terms, heroes move from left to right and villains move from right to left.

Look for it the next time you see a car chase or a western showdown. You'll discover the good guys are usually going in the right direction (see Figure 4.49).

FIGURE 4.49 In this shot from the climactic showdown of the film *Supercrest*, our hero Supercrest (the good guy) faces off against the Evil Toothbrush (the bad guy). Supercrest always faces camera right and always moves left to right (as do all heros). The Evil Toothbrush faces camera left and moves right to left. Naturally, Supercrest wins.

SUMMARY

This chapter had two basic goals. The first goal was to teach you the language of the shot. At this point, you should be able to accurately describe in film terms just about any shot you've ever seen onscreen. This skill is especially important when you're on the set creating your own shots. The ability to clearly communicate the images you see in your mind to other members of the cast and crew is a crucial skill for any director.

The second goal of this chapter was even more important—to start thinking of shots as the building blocks for telling visual stories. When you understand how lenses and framing and graphics can be used to emphasize specific story elements, then you're looking at the world through the eyes of a director.

Remember: Your goal is to tell an effective story with pictures (and sound). The more control you have over the images in your story, the more effective you'll be. Shot design is more than deciding how many shots you need to cover a scene; it's also carefully designing what appears in those shots.

1. Remember the line that started this chapter? *"Give me a clean single on a long lens. Tight, but not a Warner's. Be sure to keep the eyeline camera right."* What would that shot look like?

2. If you wanted to make your leading lady look more beautiful, would you use a wide-angle or a telephoto lens? Why?

3. What's the difference between a clean single and a dirty single?

4. How do you use the rule of thirds when you're framing a shot?

5. Why is it important to preserve screen direction?

DISCUSSION / ESSAY QUESTIONS

1. The classic movie *Citizen Kane* was shot almost entirely with wide-angle lenses. What effect does this have on the visuals in the film?

2. Suppose you wanted to shoot an entire scene with just a moving master shot and no other coverage. What would be the pros and cons of this approach?

3. You've just been given a scene to direct in which two people end their romantic relationship. What are some different shots you could use to illustrate the isolation they feel?

4. Pick a scene from a recent movie that has artistic or stunning visuals. How did they use graphics in their shot design? Was it effective?

5. Briefly explain the concept of stageline in your own words. Why is it important not to *cross the line*?

Research/Lab/Fieldwork Projects

1. In Chapter 2, you had to write a story that contained the non-specific dialogue we provided. One of the requirements for that story was that it be visual. Now you'll get to design the coverage you would use to shoot that story.

- Break the script down into shots. Be sure to use establishing shots, a master shot, two-shots, singles, and inserts as needed.

- Once you've created a shot list, grab a digital still camera and a few friends. Shoot one still photo for each shot on your shot list. You don't have to worry about costumes, props, or specific locations. The pictures you're shooting are a rough draft of the movie you will make later. The goal is to concentrate on image size and framing.

- Once you've finished the pictures, either print them out or put them in a slideshow. By looking at the pictures in order, you should get a good idea of what the finished movie would look like.

2. In Chapter 2, you also had to write a script for a short, non-dialogue visual story you could shoot in a single shot. Now you get to shoot that script. This is an exercise in designing and shooting a single, moving master.

ON DVD

By restricting yourself to a single shot, you have to think your story all the way through and have it completely planned and rehearsed before you even roll the camera. But just because the camera keeps rolling doesn't mean you can't use many different types of shots. Look at the example short, *Sweet Reward,* included on the companion DVD. It's all one shot, but it starts in a closeup, moves into a long shot and has several medium shots as the story progresses. It also starts out as an exterior shot and ends up as an interior. With some planning, you can include many different types of shots in your story, and you should, because it will keep the movie visually interesting for your audience.

Think of all the different ways you might move the camera. You could use a makeshift dolly, or you could go handheld. Or you could put the camera on a tripod and move the actors to achieve different shot sizes. Try to use elements of graphic design as well. Be bold, and have fun. You might be surprised at what you come up with.

LIGHTING MADE EASY

OVERVIEW AND LEARNING OBJECTIVES

In this chapter, you will:

- Understand the purpose of lighting
- Learn basic lighting concepts
- Explore the characteristics of hard vs. soft light
- Become familiar with standard three-point lighting
- Examine practical lighting considerations
- Discover different types of lights and how to light on a budget
- Learn how to light outdoors

Why Do I Have to Light My Scene?

In the early days of filmmaking, the reason for using lights was simple: They HAD to use lights to get an image. Film was not very sensitive and unless they used lots of light, nothing would show up on the negative.

Some of the very first sound stages were built without a roof so filmmakers could use the sun to light their sets. Some stages were even built on giant revolving turntables, so they could rotate the set to match the sun's movement across the sky.

These days, film and video cameras are extremely sensitive to light. It's even possible to shoot scenes in almost total darkness. So why do filmmakers go to all the trouble of lighting their sets? The answer is very simple. They do it because they're not just capturing images; they're creating pictures to tell a story, and those pictures will tell the story more effectively if they're carefully lit and composed. There's another reason, too. A scene that is lit will almost always look better than a scene shot in *natural light*.

KEY TERM:

NATURAL LIGHT The light that naturally exists in a given environment. If you're outdoors, this will generally be the sun. If you're indoors, natural light could come from lamps, fireplaces, windows, or any other light source. Natural light is sometimes called *ambient light*.

Light can also be used to direct a viewer's attention much the same way attention is directed by selective focus. Just like we tend to notice objects in the frame that are different, our eyes are naturally drawn to whatever is brightest in an image.

Finally, light and shadow are graphic elements just like lines and shapes. Through the artistic use of lighting, you can create emotions and expectations in the audience and highlight specific story points. As a matter of fact, cinematographers often consider the work they do to be "painting with light."

But I'm not a cinematographer

The prospect of lighting a scene scares a lot of people. That's understandable. If you've never worked with lights before, the idea of having to

light every shot can seem pretty intimidating. Here are some of the most common fears:

- It's too technical. I don't know which lights to use, or where to put them.

- It takes too much time. I can shoot much faster if I don't have to worry about setting up lights.

- I'll need to find more people to help set up and move the lights.

- Lights are expensive. I can't afford all that extra equipment.

There's truth in some of these concerns. Lighting does take time, and you probably will want to have a couple of extra people on the crew to help. But the concepts behind lighting are actually very simple, and once you understand them it's easy to figure out where the lights should go. And although professional movie equipment can indeed be expensive, it's possible to get the same results using hardware and lights available at any large home-improvement store.

All figures and shorts are included on the companion DVD with this book. ON DVD

There's never been a better time to learn about and practice the art of lighting. In the old days, when the only way to make movies was shooting film, learning how to light was nerve-wracking. Buying and processing film was very expensive, and you didn't get to see the results of your lighting until after the film had been developed. This made mistakes costly, and it was difficult for beginning cinematographers to get enough practice and experience.

> **KEY TERM:**
>
> **MONITOR An LCD display or television used to watch (or monitor) the footage as you shoot (see Figure 5.1). The flip-out LCD screen on your camera is a type of monitor, but usually it's too small for anyone to see except the person using the camera.**

But with video, you get instant feedback and can see right away if you're making the right choices. All you have to do is watch the *monitor*. Once you know what to look for, lighting is easy. That's what this chapter is about—learning what to look for. If you like what you see when you look at your images, you're doing it right.

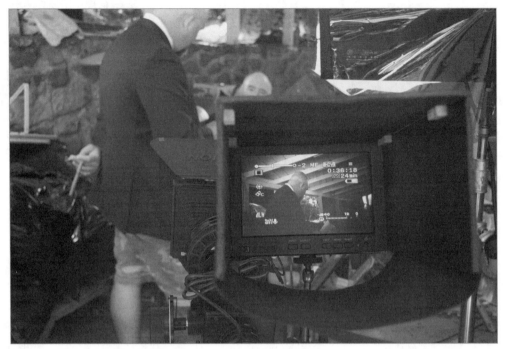

FIGURE 5.1 An external 8-inch LCD monitor was used on the set of *As You Like It*. Having a large, bright monitor to refer to makes it easy to see exactly how your lighting is affecting the image.

 ## Basic Lighting Concepts

Before we talk about specific lighting techniques and types of equipment, we will discuss some basic lighting concepts. These concepts apply to any image, whether that image is drawn, painted, or photographed. Everything you do with lights as a filmmaker is in response to one of these principles, and if you keep them in mind, lighting becomes far less mysterious. These concepts include:

- Controlling the placement of light and shadows
- Controlling the relative brightness of people and objects
- Using light to guide the eye

Light and shadows define form

Any painting or photograph is a two-dimensional representation of a three-dimensional reality. What does that mean? We live in a three-dimensional

world and have 3D eyesight. It's easy for us to tell the size and shape of different objects as we move through a particular room or landscape. But a picture of that room or landscape is flat. We observe it from outside and don't have the ability to get inside the image to see what's in front of or behind the objects we see. Depending on where you place the camera when you photograph a scene, it can be difficult to tell the relative size of objects, or what their actual shape is. This is the principle behind many photographic illusions (see Figure 5.2).

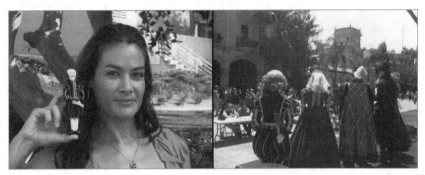

FIGURE 5.2 Because photographic images reduce the world to two dimensions, it's possible to create illusions like the one above. The small figure of Shakespeare seen on the left appears full-sized on the right and seems to be joining the other characters onstage. In reality, the Shakespeare figure is much closer to the lens, making it appear larger.

It's possible to light a scene so that there are virtually no shadows in the image. Without shadows, there are fewer indicators of depth or shape and everything in the picture tends to look flat. For that reason, this type of lighting is called *flat lighting* (see Figure 5.3).

TECHIE'S TIP

One of the visual cues we use to make sense of images is shadow. Shadows help us figure out the shape of objects by giving them a more three-dimensional appearance.

You will often hear crewmembers talking about shadows as a bad thing. What they're talking about are unwanted *shadows. A common example would be the shadow of an overhead boom microphone falling across the face of your lead actor. This is a bad shadow, and cinematographers work hard to eliminate such shadows.*

NOTE

FIGURE 5.3 The lighting in this image is *flat*. There are almost no shadows on the face, and consequently the cheekbones have no definition, and it's hard to determine the shape of the nose.

As a cinematographer, you will often place a light to either create or eliminate specific shadows. The use of light and shadow to emphasize shape is called *modeling*, and it's a key concept in lighting.

What's brightest object?

We've already said the human eye is naturally drawn to the brightest object in an image. This doesn't mean an audience will stare incessantly at a bright spot in the corner of the screen and not see anything else, but it does mean a bright object will be one of the first things they notice.

NOTE

Hollywood has always been aware that the brightest objects in frame are the most visually important. If you look at the closeups or medium shots of almost any leading lady in a classic movie, you'll see that her face is the brightest part of the image. Often this doesn't make sense based on the setting of the shot (i.e., the scene may be outdoors against the bright sky, or in a dark, shadowy nightclub), yet her face is still the brightest spot in the frame. Even though it's not logical, we accept the image as natural.

For this reason, you need to know where the bright objects are in each of your shots. If the bright objects are small highlights or reflections, that's generally acceptable, but if the brightest object is an unimportant person,

or a billboard in the background, then you need to think about relighting or reframing.

Look over there!

Since we know our viewers are going to pay attention to the brightest objects in frame, we need to control what's bright and what isn't. By controlling where the bright spots are, we control what the audience looks at. We show them what's important and make sure they notice our subject by *highlighting* it.

> *The concept of* highlighting *relates directly to the use of light. If you highlight something, you make it stand out, and you make it stand out by using a higher intensity of light.*

NOTE

In a sense, we're *separating* a specific person or object from the rest of the shot and making sure that person or object stands out. The concept of separation is very important in cinematography, and there are many ways to achieve it. You can separate (or isolate) a subject using selective focus. You can separate a subject by making it a different color or shape, and you can separate an object using light.

Hard or Soft: Two Types of Light

There's one more concept you need to understand before we start setting up lights, and that's the difference between *hard light* and *soft light*. Contrary to what you might think, hardness and softness have nothing to do with how bright a light is, but have everything to do with the kind of shadows a light creates.

Hard light is any light that comes from a single point. The best examples of hard light are the sun on a cloudless day or a bare, unfrosted lightbulb. A hard light source will create dark shadows with clear, well-defined edges (see Figure 5.4).

Soft light is any light coming from a large surface area. The best examples of soft light are the sky on an overcast day or a lamp with a large circular lampshade (see Figure 5.5). Soft light will cast a weak, diffuse shadow with indistinct edges. The softer the light, the less distinct the shadow.

An ideal soft light (like an overcast sky) would cast almost no shadow at all (see Figure 5.6).

FIGURE 5.4 This shot was taken outdoors in direct sunlight. Notice the harsh shadows on the face. The chin casts a dark shadow down the neck, and the shadow from the nose obscures part of the mouth.

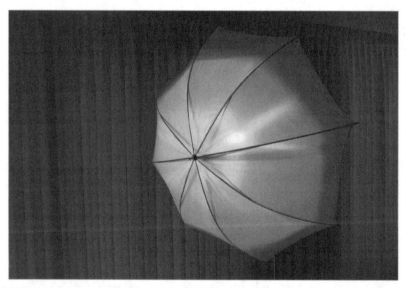

FIGURE 5.5 This translucent umbrella is one type of *soft light box*. The hard light shining into the umbrella from the rear is diffused to create a large, soft light source. This light was used to provide the lighting for many of the examples in this book.

FIGURE 5.6 Compare this image, taken in the shade, with Figures 5.4 and 5.3. The subject is being illuminated by light bouncing off a building to the right. There are just enough soft shadows to provide a rounded, dimensional image without creating dark lines on the face or neck.

Hardness and softness are at opposite ends of the same spectrum. The hardest light casts the crispest, darkest shadows, and the softest light casts almost invisible shadows. The surface area of the light-emitting object determines how soft a light source is—the larger the surface area, the softer the light (and the less distinct the shadow).

You can use hard light to create a soft light source. To do this, you diffuse the hard light by shining it through a translucent material (refer back to Figure 5.5). This material is commonly called *diffusion*, and it's often made of a white, semi-transparent cloth (called a *silk*, regardless of the actual material you use). The larger the silk, the softer the resulting light source (see Figure 5.7).

TECHIE'S TIP

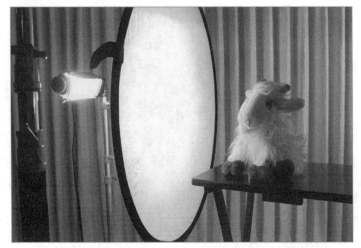

FIGURE 5.7 This translucent disc is another form of diffusion like the umbrella in Figure 5.5. The hard light on the left is diffused by the disc, which provides a large soft light source for the subject on the right.

It All Starts With Three-Point Lighting

Alright. It's time to start lighting. The most basic *lighting setup* is *three-point lighting*. It's called three-point lighting because three lights are used, each placed at a specific point with a specific purpose.

> **KEY TERM:**
>
> **LIGHTING SETUP** The collection of lights and associated equipment (stands, electrical cables, and other lighting gear) used to illuminate a specific shot. On most sets, the cinematographer will change the lighting setup (i.e., the position of individual lights) every time the camera changes position.

We will introduce those three lights in a minute, but before we do, let's summarize the *purpose of lighting* as defined by the basic concepts we've just covered.

The purpose of lighting is to:

- Illuminate your subject in a way consistent with the type of story you're telling (i.e., dark and shadowy for a horror film, bright and cheery for a comedy). Generally, you want your subject to have a well-rounded, three-dimensional appearance.

- Highlight those parts of the frame that are important. Often, a person is the most important element in the frame, and you want to make sure they're clearly separated from the background.

So we're trying to create a three-dimensional image with a central subject separated from the background. Three-point lighting does this by positioning three lights around your subject. The specific lights are called:

- The *key light*
- The *fill light*
- The *back light*

Figure 5.8 shows you how these lights are arranged in theory, Figure 5.9 shows you an actual three-point lighting setup, and Figure 5.10 shows you the image created by the lighting setup of Figure 5.9.

The following figure shows the effects of a three-point lighting setup.

Key light

The key light is considered the principal, or main light, in a lighting setup. It's usually the most powerful light and it provides most of the illumination of your subject. In a standard setup, it's placed in front of your subject about 45 degrees off center (refer back to Figure 5.8).

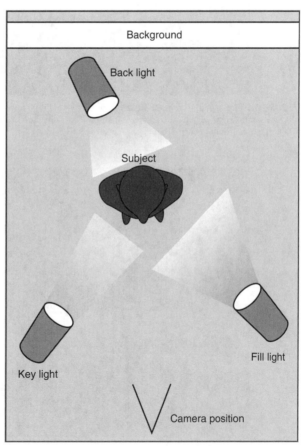

FIGURE 5.8 This lighting setup (shown from above) shows the relative positions of the lights in classic three-point lighting. Notice how the *key* and *fill* lights are each placed about 45 degrees off the axis of the camera. This configuration allows you to create subtle shadows to define the features of the face.

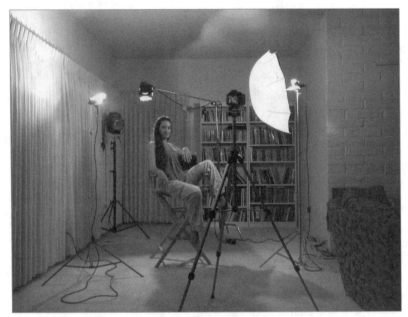

FIGURE 5.9 In this actual three-point setup, the *key light* is the large soft source on the right. The *fill* is provided by the light on the right, which is bouncing light off the curtains, and the *back light* is positioned over the subject's head. The large movie light in the corner is just for show.

FIGURE 5.10 This is the image produced by the lighting in Figure 5.9. Notice how the right side of the face is slightly brighter than the left side. Also notice the rim of light along the top of the head and the highlight along the subject's left arm caused by the back light.

The key light is the first light you place when you begin lighting. By moving the key light left or right and changing its height you can control where the shadows fall on the dark side of the face (see Figures 5.11 and 5.12).

FIGURE 5.11 In each of these figures, the soft key light has been replaced by a hard key light. In the left image, notice the placement of the shadow under the chin and the shadow cast by the nose. In the image on the right, the key light has been lowered and repositioned closer to the camera. Notice how this affects the shadows of the nose and chin.

The next figure shows the effects of key light placed below the camera.

On a brightly-lit set, the intensity of the key light will be high. This type of lighting is called high key, and it's appropriate for cheerful scenes. On a dark, shadowy set, the key light will be of low intensity. This is called low-key lighting, and it can be used to create a mysterious atmosphere.

NOTE

Fill light

To create modeling, you need some shadows on the dark side of the face. But you don't usually want those shadows to be too harsh, so you have to control how dark they are. That's what the fill light is for. It provides light to fill in the shadows created by the key light.

FIGURE 5.12 In classic Hollywood horror movies, the monster was often lit by a key light placed below the camera. This caused shadows to be cast upward, which distorted the features of the face in an unnatural (and often disturbing) way.

You place the fill light to illuminate the shadow side of the face, usually about 45 degrees off center opposite the key light (refer back to Figure 5.8). The fill light will be less intense than the key light, and by varying its brightness, you control how dark the shadows are (see Figure 5.13).

NOTE

If the fill light is just as bright as the key light, you'll have no shadows (which means you have flat lighting), and if the fill were brighter than the key, it wouldn't be a fill light anymore. It would be the new key.

FIGURE 5.13 The image on the left has the same lighting as Figure 5.10. On the right, we've reduced the level of the fill light, making the shadow side of the face darker.

Back light

With the key and fill in place, we've illuminated our subject and provided three-dimensional modeling. The only thing left is to ensure our subject is separated from the background. It's the back light that provides this separation (see Figure 5.14).

FIGURE 5.14 Once again, the image on the left is a repeat of Figure 5.10. On the right, we've turned off the back light. Notice how the image on the right seems flatter? Even though the subject's dark hair is clearly separated from the light background, without back light, the image doesn't seem to *pop*.

The intensity of the fill light should be determined by the effect you're trying to create. If you're lighting the villain of your movie, dark shadows might be appropriate, so you'd use little or no fill. If you're lighting the female lead of a romantic comedy, you'd add fill until there was just enough shadow to flatter the contours of her face.

TECHIE'S TIP

As the name implies, the back light is placed above and behind your subject and aimed at the back of her head and shoulders (refer back to Figure 5.8). Ideally, the back light should be bright enough to highlight the outline of your subject. This outline or rim of brightness is what separates your subject from the background. In extreme instances, it can almost look as if your subject is glowing (see Figure 5.15).

Figures 5.15, 5.16 and 5.17 illustrate the effects of back lights placed in different locations.

FIGURE 5.15 In this image, the back light has been moved directly behind the subject's head. This type of lighting is often used to create the impression of someone spiritual or other-worldly.

FIGURE 5.16 For this image, the back light has been moved to the left and aimed at the subject's hair. Notice how the light accentuates the texture of the hair and makes it shine. This type of lighting is often used in commercials for hair products.

Practical Lighting Considerations

Now that you know the basic premise behind three-point lighting, it's time to look at how it's actually applied. Here are some of the questions we'll explore:

FIGURE 5.17 In this image from the set of *As You Like It*, the back light has been moved directly over the subject. In this configuration, the back light is often called a *top light*. This type of lighting is highly stylized and very dramatic.

- Should I use hard lights or soft lights?

- I've got my subject lit, but what about the rest of the set?

- Can I do three-point lighting with less than three lights?

- I've only got one light. What do I do?

By slightly changing the position of the back light, you can call attention to different aspects of your subject. For example, placing the light higher and aiming it at your subject's hair will create beautiful highlights that emphasize the hair's color and style. By moving the light slightly to one side and aiming it at the cheek, you create a splash of light that can emphasize the strength of a hero's jaw. When used in this way, the back light is often called a kicker.

TECHIE'S TIP

Hard or soft?

In our discussion of hard and soft lights, we said that hard lights cast hard shadows and soft lights cast soft shadows. You can use this fact to create shadows that are appropriate for a particular scene or a particular character.

For example, men usually have more rugged, angular faces than women (at least in the movies). Using hard light on men will often accentuate the angles in their faces and can make them look more masculine. But hard light can also accentuate lines and wrinkles in someone's face. While this might be desirable in a weather-beaten hero, you generally don't want to see lines in the face of your leading lady.

For this reason, soft light might be a better choice for the women in your movie. Soft light tends to fill in and minimize slight irregularities like lines or wrinkles, whereas hard light draws attention to any imperfections by casting shadows that make them stand out. Many people consider soft light to be glamour lighting because it's very flattering to the human face.

It's also perfectly acceptable to mix hard and soft lighting in the same setup. For instance, you might choose a hard key light to create a well-defined shadow, but decide on soft fill light to avoid casting an unwanted shadow on the background. Some cinematographers prefer to always use hard light for their back light regardless of what they use for key and fill lights.

SIDE NOTE

SOFT LIGHT, VIDEO, AND LATITUDE

Because soft light is created by a large surface area, it's more even and diffused than hard light. The illumination coming from a soft light source has a tendency to evenly "wrap around" its subject. This is one reason the shadows it creates are lighter and less defined. And because the shadows are lighter and the overall illumination is more even, soft light is perfectly suited for video. The reason for this has to do with something called *latitude*, which is a measure of the total range of illumination an imaging medium can capture.

Video has less latitude than either film or the human eye, which means the range of brightness that can be accurately represented (from the darkest part of the image to the brightest part of the image) is relatively narrow. This narrow latitude requires a cinematographer to light video with more care to ensure the shadows aren't too muddy and the bright spots don't *blow out* (turn into white blobs with no detail).

On a subject lit with soft light, the shadows are less dark, and the bright spots are less bright, which makes this form of illumination a great match for the capabilities of video. All of which is a long explanation for a simple truth: *Video likes soft light.* This doesn't mean you can't use hard light with video, only that you should carefully monitor your image when doing so.

What about the set?

You've probably noticed that three-point lighting concentrates on illuminating a central subject (usually one or more of your actors). But your actors are on a set (or more likely in the room of an actual location). If all you did was provide three-point lighting for your actors, the rest of the set could seem pretty dark. So depending on your location (and the demands of your script), you're probably going to have to spend some time lighting your set.

KEY TERM:

PRACTICAL The Hollywood name for any type of lamp, lantern, wall sconce, or other light fixture that's an actual part of the room you're shooting in.

But don't worry. Lighting the set can be as simple as turning on some *practicals* or the room's overhead light.

Another easy way to light your set is by *bouncing* light off the ceiling or a wall that isn't in the shot.

SIDE NOTE

BOUNCED LIGHTING: THE QUICK AND EASY SOFT LIGHT SOURCE

Bouncing light refers to the practice of pointing a light at a large white object. This large object is usually the ceiling, or a wall, or even a white piece of cardboard. The light reflects (or bounces) off the surface of this object, essentially turning the entire object into a soft light source.

By bouncing light off the ceiling, you can illuminate an entire room, and by bouncing light off a piece of white cardboard mounted on a stand, you can create a moveable soft light source to use as either key or fill (see Figures 5.18 and 5.19).

Bouncing light is an incredible technique for the filmmaker on a strict budget (or no budget at all). The different ways you can bounce light are limited only by your location and your imagination.

FIGURE 5.18 Here's an easy, low-budget way to create a soft light source. Bounce a hard light off a large piece of white cardboard. By changing the position of the cardboard and light in relation to your subject, you can precisely control the intensity of the illumination.

Of course, sometimes lighting the set can be more complicated. If you're trying to create a moody or mysterious look with murky shadows and slashes of light, it could take many lights and much more time to get the look you want. But regardless of how many lights are in your setup, remember this: Illumination from the lights you use for the background can sometimes spill over onto your actors and change the look of your three-point lighting. So anytime you turn on additional lights, recheck the lighting on your actors.

Do I really need three lights?

Here's a cool concept: You don't always need three lights to create the look of three-point lighting. Keep in mind the purpose of lighting we discussed earlier: You're trying to create an image with good modeling (which means one side of the face is a little brighter than the other, but the shadows are not distracting). You also want to provide separation from the background. That's the look three-point lighting creates.

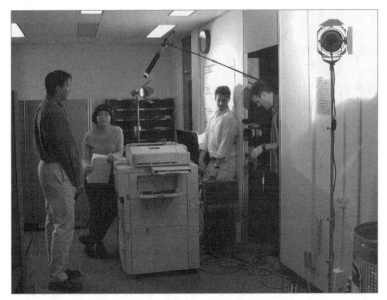

FIGURE 5.19 *When Harried Met Sally* was shot in an office with white walls. By bouncing our lights off the walls, we were able to provide soft, even illumination.

Now suppose you're shooting a student in a light-blue shirt standing in front of a dark blackboard. Generally, the overhead lighting in a classroom provides a nice even level of soft light illumination. This existing lighting could act as your fill and the lighting for the background at the same time. If you used a soft light for the key, then you'd get modeling with soft shadows and you wouldn't need a separate fill light.

Remember that separation doesn't have to be created by light. You can also use color to create separation. The contrast between the blackboard and the light-blue color of the shirt could easily provide nice clean separation. But keep in mind, you could still use back light as a kicker to emphasize his hair or jaw line if that was the look you wanted.

Help! I've only got one light!

We just looked at a situation in which you could create the look of three-point lighting with a single light. To do this, you've got to rely on the ambient light at your location and your knowledge of the purpose of lighting, which are the keys to all lighting situations. Here's the procedure you should follow regardless of how many lights you have on set:

1. Analyze the available light where you plan to shoot.

2. Compare the look of the available light with the ideal look three-point lighting would provide.

3. Augment the available light with just enough additional light to create a balanced, modeled, and cleanly separated image.

If you follow these steps, you'll find there are some instances in which you don't need to add any light at all (of course, there will be other situations in which you might need an entire truck full of lights to get the look you want).

TECHIE'S TIP

Sometimes you can use bounced lighting to create two light sources from a single lighting fixture. The trick is to place your light so it hits both your actor and a bounce board at the same time. Using this technique, a single light can be both key and fill simultaneously. You could also create a setup in which one fixture can be used as a back light and then bounced back to provide either key or fill illumination at the same time (see Figure 5.20). With careful positioning of a single light and bounce board, you can get some very professional results.

No, really, I only have one light!

Okay. You really do have only one light. Here are some techniques you can use to get the best possible image (as always, begin by analyzing the ambient light in your environment):

- If you're shooting a wide shot, your first priority is to get a properly-exposed image. In this case you'd want to use your single lighting fixture to add more light to the set. The easiest way to do this without creating unwanted shadows is to bounce the light off the ceiling (or a wall that isn't in the shot). Try moving the light around and aiming it at different spots on the ceiling until you get the effect you want.

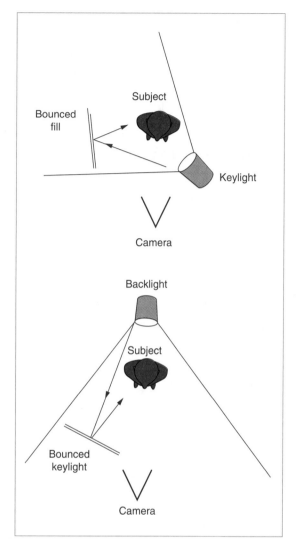

FIGURE 5.20 Here are two ways to use bounced lighting to create multiple light sources. In the upper example, bounced light is used to provide fill for your subject. In the lower example, the back light is bounced back towards your subject to act as either key or fill, depending on your setup.

Sometimes the room is too big, or your light isn't quite strong enough for this technique to work. Another option is to tighten up your shot so you see less of the room and aim your light directly at the actors. In this situation, you're using your light more as a key than as a source of general illumination.

NOTE

- If you're shooting a closeup, the most important thing is to create a well-modeled, separated image. First, analyze the ambient light hitting your actor. If you need more modeling, you should use your single light for a key light as described in the previous section. If the modeling is okay but you need more separation, you might want to use the light as a back light or kicker instead.

Lights, the Cinematographer's Paintbrush

At this point, you know enough to light your sets like a Hollywood pro. Now it's time to learn about the tools of the *DP*'s trade. It's time to take a brief look at lights.

> **KEY TERM:**
>
> **DP Cinematographers are also known as Directors of Photography, or DPs (except in Great Britain, where they use the abbreviation DoP instead).**

The basics

Regardless of whether you're using professional movie lights or shop lights purchased at a home-improvement store, a lighting fixture must have four basic parts to be useful on a set (see Figure 5.21):

- The *light head*—where the bulb is housed
- The *stand*—holds and positions the head
- The *cord*—gets power to the light
- The *power switch*—turns the light on and off

In addition to these basics, a professional light kit will also have *barn doors* to shape and direct the light and *wire scrims* to control its intensity (see Figures 5.22 and 5.23).

The brightness of a light is measured by its *wattage* (how many watts it uses). On Hollywood sets you'll find lights ranging from a low of 100 watts all the way up to 10,000 watts. In independent filmmaking (and on student films), the most commonly used wattages are between 250 and 1000 watts.

FIGURE 5.21 This is a small professional light from a company called Mole-Richardson. It's called a *Teenie-Weenie*, and it can take bulbs (called *globes*) ranging from 250 watts to 650 watts.

FIGURE 5.22 A *scrim* is a circular wire screen placed in front of a light to lessen its intensity. Scrims come in different densities and are often used two and three at a time. You can also lessen the intensity of a light by moving it farther away from your subject. Dimmers usually aren't used on movie lights because they affect the color temperature of the light.

FIGURE 5.23 *Barn doors* are used to shape and direct the light. They help ensure light only goes where you want it to.

Grip equipment

On a movie set, everything used to light the set (except the actual light heads themselves) is called *grip equipment*, and the people who move and set up that equipment are called *grips*. So even though the light head is mounted on a stand, the stand isn't considered part of the light. It's considered grip equipment. Here's a short list of some of the most commonly used grip equipment:

- **Stands**. There are two basic types of stands—light stands and stands used for holding other grip equipment. The most common type of stand for holding grip equipment is called a *C-stand* (see Figure 5.24).

- **Sandbags**. These weighted bags are used to keep light stands, C-stands, and other grip equipment from tipping over. They typically range in weight from 5 to 25 pounds and can also be filled with lead shot instead of sand. The use of sandbags is crucial for safety on a set (see Figure 5.25).

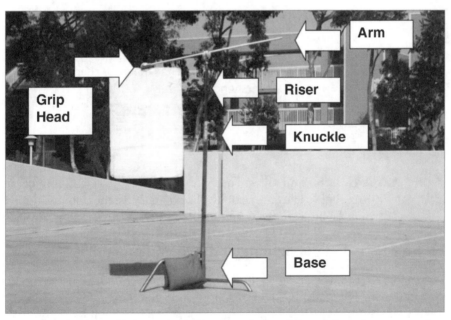

FIGURE 5.24 Here is a C-stand being used to hold a piece of white cardboard. C-stands are commonly used to place and hold flags, silks, nets, and reflectors in a lighting setup, but they're incredibly versatile and their uses are only limited by your imagination.

FIGURE 5.25 Here's a sandbag being used to stabilize the base of a C-stand. Always use sandbags (or some kind of additional weight) to stabilize your lighting setups. If you're using homemade equipment, there are many kinds of DIY sandbags and weights you can make. A quick Web search will show you how.

TECHIE'S TIP

It's an unwritten rule of physics that if you don't have a sandbag on a lightstand (or C-stand) that stand will fall over at some point, and it will always manage to fall so that it causes the most possible damage. That means if there's an actor anywhere near the light, it will fall and hit the actor on the head. It always happens. So protect your actors and use sandbags.

- **Flags, nets, and silks**. These items are used to shape, reduce, or diffuse light. They are usually placed on a C-stand and positioned in front of a light source to modify its characteristics (see Figure 5.26).

So where do I get lighting and grip equipment?

Lights are often available in light kits that have 2 to 4 lights per kit along with all the cords, stands, barn doors, and scrims you'd need for those lights (see Figure 5.27). Most medium to large cities have companies where you can rent those light kits and associated grip equipment.

You may not have the money to rent lights and C-stands. If you're lucky, you can borrow lights from a local school or other community institution.

FIGURE 5.26 *Flags*, like the one shown here, are commonly used to create shadows or keep light from hitting certain parts of the set. Flags are also called *cutters* and come in many sizes from small *fingers* and *dots* to large *frames* several feet on a side.

FIGURE 5.27 This light kit contains three light heads, stands, scrims, barn doors, and power cords. When cleverly used with a few C-stands and other grip equipment, you could light the interior scenes of an entire short film with a kit this size.

Some people prefer to buy their own lights and equipment. While new movie equipment is generally expensive, it's very possible to find used equipment by doing a little online searching and bidding. Professional movie lights are very rugged and can easily last a lifetime, but many of them require specialized (and expensive) lightbulbs (commonly called *globes*). So before you buy a

fixture sight unseen, make sure it's still possible to get the proper globes for the light you're considering

Making your own equipment

There's also another alternative, which for most people is the most cost effective. You can make your own equipment. Every large home-improvement warehouse sells halogen shop lights, sometimes for as little as $20 (see Figure 5.28). They come in many intensities and sizes, ranging from 250 watts up to 1000 watts. This can be a very affordable way of lighting just about any set.

It's also possible to create your own C-stands, flags, and silks using PVC pipe, plumbing connectors, and cloth from any fabric store. A quick Internet search for a DIY C-stand, flags, or silks will pull up numerous detailed tutorials with step-by-step instructions for building your own gear.

Once you get started, don't stop with stands and flags. The Internet has a treasure trove of information for no-budget filmmakers. With a little Web surfing, you can find instructions for DIY dollies, cranes, stabilizers, and much more. With ingenuity and some inexpensive supplies, you can find a way to create almost any piece of movie-making equipment you need.

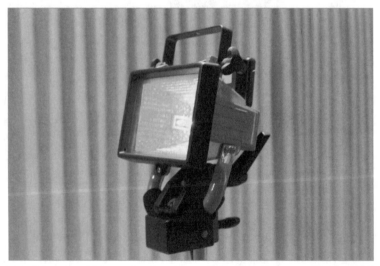

FIGURE 5.28 This 250 watt *work light* cost less than $20 at a home-improvement store. These lights are ideal for bouncing light off a wall or piece of white cardboard to create a soft light source.

Shooting Outdoors

We've covered everything you need to know to rig lights and shoot a set or practical location indoors, and for most people, that's the scariest part of cinematography. Learning exactly which lights to use, where to put them, and how to control them seems like a huge task. By comparison, shooting outdoors should be relatively easy. After all, the sun's out there. How hard can it be?

As it turns out, getting good-looking shots outdoors isn't as easy as you might think. Using the sun as a light source presents it own unique challenges. In this section, we'll look at the following common outdoor scenarios:

- Bright sunny days
- Cloudy days
- Outdoors at night
- Day for night
- Magic hour

But the good news is this: Once you understand the issues associated with shooting outdoors, you'll be able to capture some stunning imagery.

It's a bright, bright, sunshiny day

It's a beautiful summer day outside. Everything seems to sparkle, and there's not a cloud in the sky. The sheer beauty of the location takes your breath away. That means it's the perfect day to shoot, right? Not necessarily….

The key thing to remember is that your video camera sees things differently than the human eye. The full beauty your eyes see will be difficult for your camera to capture because video has less *latitude*. (Remember from our discussion of soft light that latitude measures the total range of illumination an imaging medium can capture.)

In lighting terms, the sun is a very bright source that puts out very hard light. It casts dark, harsh shadows and creates situations with a great deal of *contrast* between sunlight and shade.

CONTRAST In photographic terms, contrast is the difference in brightness between the light and dark parts of an image.

In a sunlit environment, the contrast between bright and dark often exceeds the latitude of a video camera, and if the contrast of a scene is greater than your camera can capture, the image will suffer. Either the bright areas in frame will *blow out* (turn into white blobs with no definition or detail), or the darker parts will be so dark you can't see any details (see Figure 5.29).

The solution to this dilemma is relatively simple. You have to reduce the contrast in the environment so your camera can capture both the bright and dark areas of the scene. There are three primary ways to do this:

- Diffuse the sunlight
- Add light to the scene
- Subtract light from the scene

DIFFUSION FRAME A rigid frame that supports the diffusion material. Typically, diffusion frames are square and are referred to by their size. A 4' x 4' frame is common for closeups and is easily held by one or two C-stands. For budget-conscious filmmakers, it's very easy to make diffusion frames out of PVC piping.

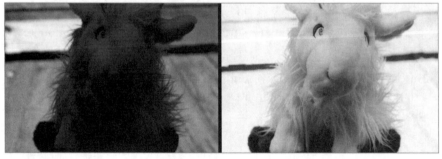

FIGURE 5.29 In the image on the left, the background is properly exposed, but the goat is too dark. In the image on the right, the goat is properly exposed, but the background is *blown out*. The biggest challenge when shooting outdoors is creating the proper balance between the darker and brighter parts of each shot.

Diffuse the Sun

You diffuse the sun the same way you diffuse any hard light source: by putting a semi-transparent material between the sun and your subject. The denser the material, the softer the light source.

If the material is so dense it blocks all the sunlight, then you've created shade instead of a soft light source. But as we'll see when we discuss the procedure of subtracting light, sometimes creating shade is the right solution.

NOTE

Diffusing the sun solves two problems at the same time. It both reduces the sun's intensity and softens its shadows. On big Hollywood movies, they use silks that are 20 feet square and suspend them over their actors using cranes. But this approach isn't practical on lower budget projects. A more economical solution is to only use silks for closeups. In this instance, you shoot the master in full sunlight and then suspend a smaller *diffusion frame* over your actors when you shoot their closeups (see Figure 5.30).

Add Light to the Scene

If you can't diffuse the sun, another solution to reduce the contrast of your scene is to add fill light to the shadows. There are two ways to do this: Using lights and using *reflectors*.

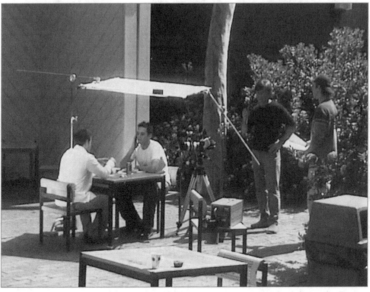

FIGURE 5.30 On this student film set, a *4 by 4* (4 feet by 4 feet) *diffusion frame* is suspended over the actors using C-stands to keep them from being hit by direct sunlight.

REFLECTOR A shiny surface used to bounce (or reflect) sunlight toward your scene. Reflectors come in many forms—from rigid, mirrored frames to collapsible light discs to white pieces of cardboard (see Figures 5.31 to 5.33). The more mirror-like the surface, the harder the reflected light will be. Keep in mind that it's also possible to diffuse reflected light with a silk to create a softer fill light. You can easily build your own reflectors using rigid cardboard and aluminum foil.

FIGURE 5.31 This is an example of a solid metal reflector. Rigid reflectors like this are ideal because they can be locked in position and won't be affected by wind or breezes. But keep in mind that all reflectors have to be constantly re-aimed as the sun moves across the sky.

FIGURE 5.32 Collapsible *light discs* like the one shown here are lightweight and inexpensive. But if there's more than a gentle breeze, it's difficult to keep them aimed on your subject. One common solution is to have a crewmember handhold the disc to keep it in place.

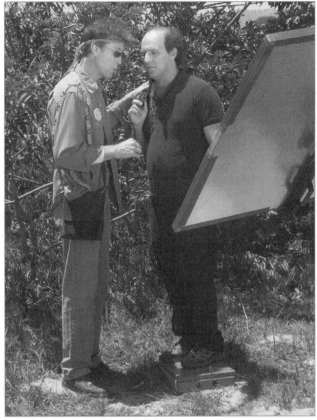

FIGURE 5.33 This reflector on the set of *As You Like It* was used to keep dark shadows off the faces of actors standing in direct sunlight. When shooting closeups, it's sometimes necessary to position lighting equipment (or silks or flags) close to the actors to ensure a properly-lit image.

A limitation when using movie lights outdoors is the brightness of the lights available. Professional lights designed for outdoor use are heavy, expensive, and require a great deal of power. But you can use smaller lights to provide fill for closeups if you place them close to your actors.

Subtract Light from the Scene

The easiest way to avoid problems of contrast when shooting outdoors is to keep the sun from hitting your subjects. You can do this by setting your scene in a shady location. If you're in a park, move your actors under the shade of some trees, or if you're in an urban setting, shoot in the shadow of a building or on the shady side of the street.

When using lights outdoors, pay attention to the color temperature of the light (covered in Chapter 2). Unless the lights were specifically made to be used outdoors, they will have a color temperature around 3200 and will appear orange when seen in outdoor daylight. These lights can be corrected for use outdoors by placing a blue gel called CTB (for Color Temperature Blue) in front of the light (see the *Secrets of Hollywood Lighting* video included on the companion DVD).

You can also subtract light from a scene by creating your own shade. Putting dark cloth on a diffusion frame creates a *flag*, and it can be used to keep sunlight from hitting your actors (refer back to Figure 5.26). As with silks and smaller lights, creating your own shade will be easier and more effective when you're shooting closeups.

SIDE NOTE

A QUICK SUMMARY OF SHOOTING IN SUNLIGHT

So far, we've looked at several different ways of dealing with sunlight. Here's a quick summary:

1. You can shoot in direct sunlight without making any changes. This will usually lead to harsh shadows (see Figure 5.34).

2. You can add light using either reflectors or high-powered lights. This is a good choice if you have access to the equipment needed.

3. You can diffuse the sunlight hitting you actors using some type of diffusion frame or material. This is a low-cost way of softening shadows while still retaining the look of sunlight (see Figure 5.35).

4. You can create shade for your actors with flags. This is a low-cost solution when shooting closeups or medium shots. But you need to be careful that your backgrounds don't blow out (see Figure 5.36).

Anytime you shoot in the shade, it's often a good idea to use reflectors placed outside the shaded area to bounce additional light on to your subjects. With proper use of shade and reflectors, it's possible to create a perfect three-point lighting setup using nothing but the sun (watch the example demonstration in the video *Secrets of Hollywood Lighting* included on the companion DVD).

FIGURE 5.34 Our friendly goat is seen above in direct sunlight. Notice how the side of his face is almost blown out. Also notice the shadow area under his chin and between his front legs.

FIGURE 5.35 Here, the sunlight is being diffused by a translucent light disc (the same disc used to create soft light in the indoor setup of Figure 5.7). Notice the overall level of illumination is more even. The bright spots are not as bright, and the shadows are not as dark.

FIGURE 5.36 In this image, a *solid flag* (also a collapsible disc) is being used to completely shade the goat. This creates a very flat light. Compare this image with Figure 5.35. Notice how the lack of shadows on the goat's face and fur makes it more difficult to see details in the image.

Cloudy days

Believe it or not, clouds can be a DP's best friend. On a cloudy day, the entire sky becomes a soft light source, and everything is bathed in an almost shadow-less light that looks great on video.

SIDE NOTE

TODAY'S FORECAST: PARTLY CLOUDY

While cloudy days are great for shooting video, days that are only partly cloudy can be exceedingly frustrating. When clouds are rolling across the sky, you'll have alternating periods of bright, contrasty sunshine, and smooth shadow-less soft light.

On these days, you have to make a decision before you begin to shoot. Do you want your finished scene to appear as though it takes place on a sunny day or a cloudy day? In some instances, the script may dictate whether or not the sun must be shining, but often the choice is up to you. Here are some things to consider as you make your decision:

- If you choose to shoot in the sun, you'll be managing contrast. This is always difficult, and it's harder when the sun keeps going in and out of the clouds. Just as you get your reflectors set, the sun could slip behind a cloud and bring everything to a screeching halt.

- If you choose to shoot in the shade, pay attention to the size of the cloud covering the sun. If the cloud is small, sometimes your actors are shaded while the building down the street is still being hit with direct sunlight. This can wreak havoc with your contrast and make the background blow out.

Just be aware that regardless of whether you choose sunlight or shade, there's going to be a portion of the day when you're not able to shoot because the clouds are not cooperating. When you're "waiting on the sun," sometimes the best course of action is to just sit back and relax (see Figure 5.37).

The one danger on a cloudy day is that you won't have enough separation between your subjects and the background. You won't be able to use reflectors, but it's still possible to use lights for a little extra modeling or back light in your closeups. If you don't add any light at all, it's still possible to provide separation by dressing your actors in colors that stand out from the background, or by using selective focus.

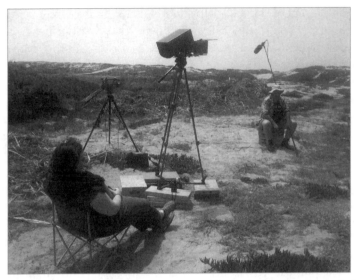

FIGURE 5.37 When shooting *As You Like It*, we spent many partly-cloudy days shooting at the beach. Unfortunately, that meant we also spent a great deal of time waiting for the clouds to be just right.

Nighttime

The nice thing about shooting outdoors at night is you don't have to worry about the sun. It's up to you to provide the light. This makes nighttime shooting very similar to shooting indoors. You use a combination of hard and soft light sources to create modeled subjects with separation from the background.

But shooting at night is far from easy because you have to light everything in the scene. The basic rule of thumb at night is if you don't point a light at it, you're not going to see it. So unless you're shooting in an urban environment with streetlights and shop signs, you're going to need extra lights to light the background (if you don't, your scene will appear to take place in a black, featureless void).

KEY TERM:

PROCESS SHOT In older Hollywood movies, everything was shot on a soundstage, and they would use different special effects to make the characters seem to be in different locations and situations. These effects included rear-screen projection and optical process shots such as animation and matte paintings. These days, the same results are achieved using green screen shots and Computer Generated Imagery (CGI).

One of the biggest obstacles to shooting at night is getting enough power for your lights. If you're shooting in a neighborhood or business district, you can pull power from a nearby building or house (assuming you've made prior arrangements with the owners). Just make sure you have plenty of *stingers* (the movie term for extension cords).

One of the advantages to shooting at night is you can use darkness to hide parts of the environment or create illusions not possible during the day. For example, with careful lighting you can make it seem like actors sitting in a parked car are driving through the night. This technique is often referred to as the poor man's process because it cheaply duplicates the results of an old time Hollywood special effect called a process shot.

But if you're not near any buildings, you'll have to provide your own power with a generator. Generators come in all sizes from small units designed for camping to large rigs capable of lighting entire sets. Most Hollywood generators are specially constructed to run silently, but these are beyond the means of most beginning filmmakers. Instead, you'll probably use a generator designed for camping or emergency use. These generators are often quite noisy and can easily ruin any recorded dialogue if they're too close to the set, so be sure to bring a few hundred feet of extension cords so you can position the generator far enough away to mute its sound. Be sure to check the output of any generator you plan to use, and make sure it has enough wattage to power the lights you'll be using.

One final note about shooting at night: Everything you do will take roughly twice as long as during the day. For some reason, when the sun goes down, people work slower. It doesn't have anything to do with being tired or wishing they were somewhere else, it's just a fact of human nature. So whenever you plan to shoot at night, be sure to give yourself plenty of time.

Day for night

Because shooting outdoors at night requires many lights, uses a great deal of power, and takes a long time, many producers and directors choose to shoot *day for night*.

The key to successfully shooting day for night is to carefully control your exposure. You need to intentionally underexpose the scene so the brightest areas of each shot don't seem bright, but just appear to be normally exposed (see Color Plate Figures 7 and 8). Those bright areas will typically be either areas of the sky or spots where direct sunlight is hitting something in the frame. Ideally, you don't want direct sunlight hitting your actors. When the scene is properly exposed, the principal subjects of the shot will be dark, but you should still be able to see detail in their faces.

It's important to note that in order for this effect to look realistic, there should be highlights and small areas of the frame that are brighter than the faces of your actors. If the frame is universally dark, it looks less believable as a night-time image. One other tip: If you add a very slight blue tint to the image with your editing software, it will also help *sell the effect*.

Magic hour

The last outdoor topic we're going to cover is *magic hour*. This magical time of day (also known as *golden hour*) is the first hour after sunrise and the last hour before sunset. During this hour, sunlight is less direct and the shadows are less harsh because the sun is angling through a thicker slice of the earth's atmosphere. The sky takes on a golden hue (hence, golden hour), and the sun acts as a back light or kicker for the entire horizon. During this brief hour, moments of indescribable beauty occur naturally, and all you have to do is be there with a camera to capture them. You have to work fast because

the light is constantly changing, but if you choose the right location, you can shoot without lights and still get amazing results.

TECHIE'S TIP

A common practice is to shoot the master and establishing shots during the magic hour and then shoot the closeups and coverage during a different part of the day (or on another day). This technique works because it's much easier to control the lighting in a closeup, since you're seeing a much smaller area.

This same trick is sometimes used for outdoor scenes that take place at night. The master is shot during twilight while the sky is a dark shade of royal blue (but not yet completely black), and you can still see detail along the horizon. Then when you shoot the closeups, you have far less area to light.

SUMMARY

Lighting is an art form. Professional cinematographers are masters of light and shadow and literally "paint with light." Teaching you how to wield their paintbrushes and create your own images has been the focus of this chapter. We've covered a lot of theory and techniques in the hopes of making lighting seem a little less scary, but the only way to truly understand how to light something is to just do it. Grab some lights or reflectors and start creating images of your own.

You may not remember why video likes soft light, and three-point lighting might make your head hurt, but if you remember that the purpose of lighting is to created well-modeled shots with good separation, you'll never go wrong. It doesn't matter how you do that. You might have a truck full of lights, or you might only have a single reflector. Experiment with all the tools and techniques you can find. When you succeed in creating images you're pleased with, you're on the right track.

Don't worry about trying to make art. Your primary goal should always be to create images that match the needs of your story. They can be beautiful images or scary images, gritty or glamorous. As long as they match the script and create the right mood for the story, you're doing your job.

REVIEW QUESTIONS: CHAPTER 5

1. What is the basic difference between hard and soft light?

2. What are the three lights in a three-point lighting setup?

3. You've got a light kit with 3 x 500 watt lights. Approximately how many amps would you need to power them all?

4. How can you create soft light outdoors?

5. What are the three primary ways to reduce contrast outdoors?

DISCUSSION / ESSAY QUESTIONS

1. With video cameras, it's possible to get an image in almost any environment. Since that's true, why do we bother to light anything?

2. Briefly summarize the goal of three-point lighting.

3. When are shadows a good thing? When are they a bad thing?

4. Why does video like soft light?

5. How are contrast and latitude related?

APPLYING WHAT YOU HAVE LEARNED

Research/Lab/Fieldwork Projects

1. Watch the instructional video *Secrets of Hollywood Lighting* included on the companion DVD.

ON DVD

2. A basic indoor lighting kit might consist of the following:

- 3 x 500 watt lights (with stands and extension cords)
- 2 pieces of white cardboard (or foamcore) for creating soft, bounced light
- Some type of stands for holding the cardboard or foamcore
- Work gloves (for handling hot lights)
- Duct tape (a universal tool on any set)

Visit a local home-improvement store and find all the items listed above (as well as anything else you think would be useful in your lighting kit). How much would it cost to assemble a basic lighting package?

3. Obtain a basic three-light package (either by borrowing, renting, or purchasing lights of your own). Set up an interior scene with two people seated at a table having a conversation. You're going to shoot two different scenes on the same set.

- **Scene One:** Two people are discussing their upcoming summer vacation plans. They are both happy and upbeat. Use high key lighting. The mood should be bright and cheery.

- **Scene Two:** Two people are discussing their upcoming summer vacation plans. Neither of them is looking forward to their trip. Use low-key lighting. The mood should be dark and ominous.

For each scene, shoot a master and then one single of each actor. The singles can be clean or dirty, your choice. Don't change your actors or their wardrobe. Your goal is to create two completely different moods and feelings on the same set using lighting and camera angles. Be creative, push the limits, and have fun!

NOW HEAR THIS

OVERVIEW AND LEARNING OBJECTIVES

In this chapter, you will:

- Understand the importance of sound
- Learn the basic characteristics of well-recorded dialogue
- Appreciate the importance of putting the microphone in the right place
- Become familiar with different types of microphones
- Learn recording techniques that guarantee easier postproduction
- Understand why you need to record more than just dialogue
- Explore techniques and equipment used by industry professionals

Telling Stories with Pictures AND Sound

Up until now, we've concentrated on the visual side of movies. After all, everyone says movies are a visual art form, right? Well, yes…and no. It's a commonly accepted fact in Hollywood that sound is *more* than 50% of your experience in a movie. If you don't believe that, try this simple experiment. Put on a DVD and watch it with the sound turned completely down. Regardless of how stunning the visuals are or how cool the special effects look, unless you can hear the soundtrack, you'll find that your mind starts to wander. Without a rousing score, well-crafted sound effects, and crisp, clear dialogue, a movie is nothing more than lights flashing in the darkness.

NOTE

People often refer to movies made before the invention of synchronized sound as silent movies. Nothing could be farther from the truth. Although early movies did not have recorded soundtracks, they were almost always presented with a live musical accompaniment either in the form of a piano or an organ. Some of the larger movie halls had special instruments that allowed the pianist to create live sound effects to match the action on the screen.

As you learned in the last chapter, cinematographers work very hard to control light and shadow in their images. Their goal is to use light, composition, and movement to create imagery that captures your attention and moves the story forward. The goal of those who create movie soundtracks is the same. They strive to create a unique, audio universe that serves the story and captivates your emotions and imagination.

NOTE

There's a single person on a film crew responsible for most of the visual look of a movie. That person is the cinematographer, and not only does he capture the shots, he's also involved in manipulation of the images in postproduction. There is no similar single person responsible for the sound of a movie. Separate teams of specialists are responsible for on-set recording and every aspect of post.

The finished soundtrack of a Hollywood film is a complex and nuanced work of art containing many elements created by many separate artists. Traditionally, those elements are broken down into three major categories: *Dialogue*, *Music*, and *Effects* (commonly abbreviated as *D*, *M*, and *E* by sound professionals).

Music and many types of sound effects are created during postproduction, and we'll discuss those parts of the soundtrack when we cover audio post in Chapter 9. In this chapter, we're going to concentrate on the theory and techniques for getting good *production sound*.

> **KEY TERM:**
>
> **PRODUCTION SOUND** All sound that's actually recorded during the shooting of a movie. This consists primarily of dialogue (referred to as *production dialogue*). But there are also many other specialized sound elements you can collect during production, which will make audio post much easier (and result in a far more professional-sounding movie).

When Dialogue is King

Everyone knows well-shot movies have a certain look. It isn't likely you'd mistake footage from a finished film with someone's vacation video footage. The same is true of movie dialogue. It has a certain sound, and no matter where the characters are, you can easily hear what they're saying (unless the director purposely garbles or obstructs their voices for plot purposes). Even if they're in a gale force wind, or standing on the sidewalk of a busy intersection, you can hear their dialogue loud and clear.

But have you ever tried to listen to a conversation recorded in a noisy environment with a point-and-shoot video camera? It's not the same, is it?

Beyond being able to understand every word, movie dialogue has some very specific qualities. These qualities add a rich fullness to the voice, something sound pros call *presence*.

> **KEY TERM:**
>
> **PRESENCE** Many technical factors such as frequency and intensity contribute to presence, but the result is a sound that feels close, as if it's happening right in front of you. *Vocal presence* describes how easily the voice cuts through the noise surrounding it. While some aspects of presence are created in post, the most important attributes of presence have to do with how the sound is recorded.

Audiences expect this full, rich sound in the voices of movie characters, and when they don't hear it, it's harder for them to connect to the action onscreen.

Poorly-recorded sound also has certain characteristics, and you hear those characteristics in most home videos. The camera's on-board microphone often makes voices sound hollow and distant. The sound is *thin*, or *tinny*, and the vocals in home videos compete with other sounds in the environment (and they generally lose the competition).

So what makes home-video dialogue and movie dialogue sound so different? Two primary factors are responsible:

- Microphone location (or placement)
- Microphone type

In simple terms, this boils down to the equipment you're using (*microphone type*) and how you're using it (*placement*). In the next sections, we'll explore each of these areas.

Microphone Placement

If the most important thing in lighting is where you put the light, the most important thing in sound is where you put the mic. It's that simple. The reason most camcorder sound is so bad has nothing to do with the quality of the microphone.

NOTE

As a matter of fact, the mics on most video cameras are very well engineered, and anytime you're shooting an event in which human speech isn't a major part of the action, the sound can be excellent. But the minute you point the camera at someone who's talking, you're going to be disappointed. Why? Because the microphone's in the wrong place. It's on the camera instead of next to the person who's talking.

Usually, when you're shooting a conversation, you're not standing right in front of your actors with the camera. More likely, you're standing back a few feet and you've got the lens zoomed in a little. While this is great for getting a beautiful, well-framed image, it's the worst thing you could do if you're relying on the on-board microphone to record sound. You're several feet away from the person who's talking, and that's too far away to get dialogue with any presence.

The key to recording good, clean dialogue is to get the microphone as close as possible to the person who's talking.

> While you might be able to position the camera right next to the actor who's talking in an attempt to record clean sound with the on-board mic, this is not a practical solution. For starters, to get close enough for good sound and still get a useable image, you'd have to be zoomed all the way out, which restricts you to using wide angles. Additionally, on-board microphones are likely to pick up camera handling and operating noise, which can make the dialogue unusable.
>
> **TECHIE'S TIP**

The only way to consistently get the microphone next to your actors (regardless of where the camera is placed) is to use an external microphone. There are several different microphones available, and the one you use is often determined by your budget. But before you can make an informed decision, you've got to know what's out there.

The Different Types of Microphones

We've already discussed the camera's on-board microphone and the reasons you may not want to use it. In the world of professional sound recording, there are many different types of microphones. Each is used for a specific purpose and each has certain strengths and weaknesses. A detailed discussion of microphone characteristics is more than you need at this point, but before we talk about external mics, you need to know certain microphone basics.

All figures and shorts are included on the companion DVD with this book.

A quick microphone primer

Most microphones fit into one of two groups: those that require power and those that don't. The ones that don't need power are called *dynamic* microphones, and the most common powered mics are called *condenser* microphones (or sometimes *electret condenser* microphones). The power for condenser mics can be supplied by an internal battery, or by an external power source (usually the recorder or mixer into which the mic is plugged).

Externally-supplied power for condenser microphones is called phantom power.

The power in a condenser microphone is used for an *internal pre-amplifier*, which means that condenser mics are more sensitive (and can record sound from quieter sources) than dynamic microphones. The on-board mics on most video cameras are condenser mics, and most likely, you will use a condenser for your external microphone.

Microphone pick-up patterns

Every microphone has a *pick-up pattern* (or *polar pattern*) that describes how sensitive the microphone is to sound arriving from different directions.

In technical terms, the pick-up pattern describes the directionality *of the microphone.*

If a microphone is equally sensitive to sound arriving from all directions, it's called an *omnidirectional* mic (or *omni* for short). Most *lavaliere microphones* are omnidirectional.

> **KEY TERM:**
>
> **LAVALIERE MICROPHONE** A small condenser microphone designed to be worn on clothing. They're usually clipped to a tie or lapel, or hidden in a costume. Sometimes they're called *lavs* or *lapel mics* (see Figure 6.1).

If a microphone is more sensitive to sound coming from one direction than another, it has a *cardiod* or *hypercardiod* pattern (see Figure 6.2). Hypercardiods have the most directionality. *Shotgun microphones* are a common type of hypercardiod condenser microphone used in film and television (see Figure 6.3).

Shotguns and lavalieres are the microphones you're most likely to use on student or independent film sets. In the next section, we'll examine them in more detail.

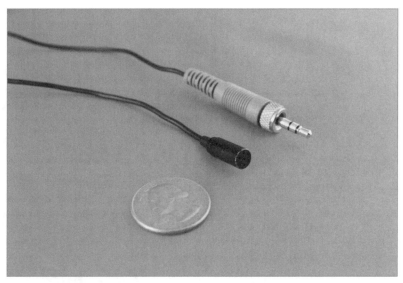

FIGURE 6.1 Although they're small, lavaliere microphones are capable of recording excellent sound. This particular lav is designed to be used with the wireless transmitter seen in Figure 6.5.

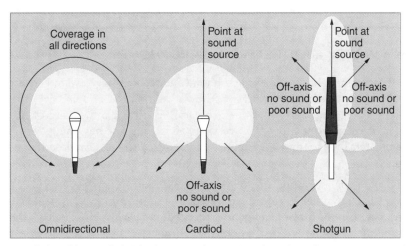

FIGURE 6.2 *Cardiods* and *hypercardiods* (also known as *shotgun* microphones) are the most common mics on film sets. These mics reject sound coming from the sides or the rear. Lavalieres, on the other hand, usually have an *omnidirectional* pick-up pattern.

Wired lavaliere microphones

Now that we know a little about microphones, it's time to talk about how they're used to record movie dialogue.

FIGURE 6.3 Shotgun microphones are most sensitive to sound directly in front of the mic. Such sound is said to be *on-axis*. For a demonstration of the difference between *on-axis* and *off-axis* sound, watch (and listen to) the *Microphone Demonstration Video* included on the companion DVD.

DON'T WORRY ABOUT STEREO MICROPHONES

SIDE NOTE

Every video camera has a stereo microphone and records stereo sound. This makes sense. These cameras capture footage of the world around us, and since we experience the world in stereo (courtesy of our two ears), we expect cameras to capture our world in stereo. For most people, two channels are just the beginning. Movies and home theaters have many more channels, all designed to create an immersive sound experience.

But the multi-channel sound environments of television and movies are not captured that way. Each channel is created separately, one sound effect at a time. This is true of dialogue as well. Movie dialogue is recorded *monaurally* (i.e., single channel, or *mono* for short). Although professional stereo microphones exist, they're typically used to record performances of live music. They aren't used on movie sets.

But just because you aren't recording stereo doesn't mean you aren't using both the channels on your camcorder. As we'll discuss later, it's often a good idea to connect a separate microphone to each channel. This gives you two separate sources to choose from when you begin editing your project.

So even though your camera records stereo, and even though there are stereo microphones out there, don't use them when making your movie. You'll be creating the layered, multi-channel sound of your movie in postproduction.

The first microphone we'll examine is the wired lavaliere mic. As the name implies, this is a lavaliere condenser microphone you connect directly to the camera by means of a long wire (see Figure 6.4).

The good thing about wired lavs is they're relatively inexpensive (usually less than $50) and they have excellent sound quality. The bad thing about wired lavs is your actors are tethered to the camera by the microphone cable.

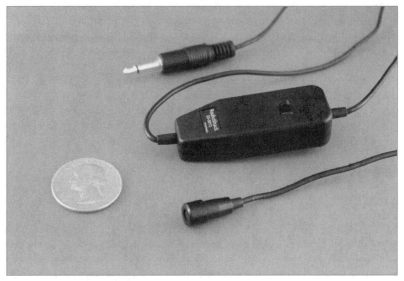

FIGURE 6.4 This is an affordable wired condenser lavaliere mic from Radio Shack. The module just above the microphone has an on/off switch and contains a small watch battery used to power the condenser mic.

When an actor is wearing a lavaliere, you say they're *body mic'd*. The trick to body mic'ing an actor is to make sure the wire is hidden. This can be easy if you're shooting a closeup, since the microphone may be out of the shot. But if you're wider than a closeup, you'll have to hide the wiring under your actor's clothes, and in the case of a long shot, you'll probably have to run the wire down the pant leg of your actor to keep it from being seen.

TECHIE'S TIP

Wireless lavaliere microphones

The next step up from wired lavs are the wireless lavaliere microphones. These consist of the microphone, a transmitter, and a receiver (see Figure 6.5). The microphone connects to a transmitter that must be hidden somewhere in the costume of your actor. The receiver is then plugged into the camera.

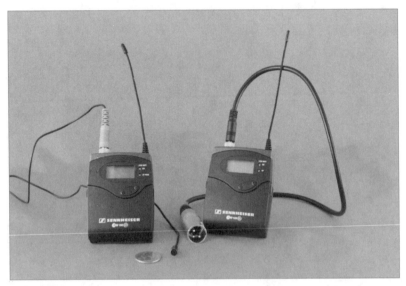

FIGURE 6.5 In the wireless microphone system shown here, the mic is plugged into the *transmitter* on the left, which is worn by the actor. The output from the *receiver* (on the right) is then plugged into the external mic jack on the camera or into a separate recorder.

Wireless lavs are significantly more expensive than wired lavalieres and can cost from a few hundred to a few thousand dollars. The thing that determines the cost of a wireless setup is the sophistication of the transmitter/receiver pair. Wireless lavs operate by transmitting sound over radio frequencies. Less-expensive transmitters can have more problems with interference and have less range than more sophisticated (and expensive) equipment.

Lavaliere dos and don'ts

Lavalieres are capable of recording professional-caliber sound. Most talking-head commentators on television (as well as the majority of reality TV shows) use lavaliere mics. But getting great sound isn't guaranteed. There are a few dangers that come with using lavs, regardless of whether you're using wired or wireless mics. The first of these dangers is *clothing rustle*.

Clothing Rustle

Clothing rustle occurs when your actor's costume rubs up against the microphone. This isn't a problem on TV news shows, since newscasters wear their mics out in the open. But when you're shooting a movie, you generally hide the microphone behind a layer of clothing (see Figure 6.6). This creates the danger of clothing rustle.

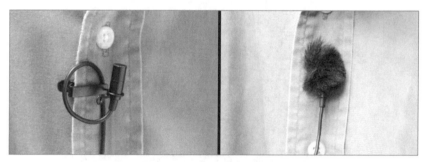

FIGURE 6.6 When a lavaliere is worn outside the clothing, the cord is usually looped as shown to prevent any tugging on the cord from affecting the mic. When a lav is hidden under clothing, it's usually wrapped in cloth (or fake fur as shown) to keep clothing rustle and wind noise from affecting the recording.

You can minimize the risk of clothing rustle through careful placement of the microphone, but you can never completely eliminate it. Your only safeguard is to constantly monitor the dialogue through headphones while you're shooting.

Anytime you're recording dialogue, someone should always be listening to the sound through headphones connected to the camera or recorder. That way, you're instantly aware if there's a problem with the sound. On projects with a small crew, the person monitoring the sound is often the director who can then make an instant decision on whether to shoot another take (see Figure 6.7).

TECHIE'S TIP

But clothing rustle isn't the only thing you have to listen for. Anytime an actor is body mic'd, there's the chance they will accidentally bump or hit the microphone. This can happen when they're gesturing, putting on a jacket, or adjusting their costume, and it happens every time body mic'd actors hug each other. As with clothing rustle, the only way to know this has happened is to constantly monitor your recordings. Then you can work with your actors to change the *blocking* so they don't hit their mics.

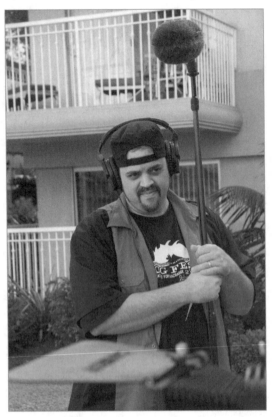

FIGURE 6.7 It's common practice for the boom operator to use headphones to ensure the desired sound is always on-axis and the dialogue is clean. If he detects any sound flaws during a take, he should let the director know as soon as the take is over.

> **KEY TERM:**
>
> **BLOCKING** The preplanned (and repeatable) movements an actor makes as they perform a scene. It's everything from large movements (like crossing through a room) to small gestures (like picking up a glass). Usually, blocking is determined during rehearsal by collaboration between the actors and director. Key factors in developing blocking are the needs of the scene and the composition of specific shots desired by the director. Like any creative collaboration, blocking can be changed at any time to make the scene better or solve a technical problem.

Sound Quality and Head Position

Another danger with lavaliere microphones is related to mic placement. Let's say you've attached the lav underneath a t-shirt in the center of your actor's chest. Now suppose at a certain point in your scene the actor turns his head and says a line over his shoulder. Depending on where your actor's head is when he speaks, this line may not be clearly recorded.

A similar situation can occur if you've hidden the lav on one particular side of the body (e.g., under the left collar). In this instance, dialogue will sound different depending on whether your actor is looking to the left or to the right. Once again, the remedy is to monitor your recordings and change the blocking if needed (and possibly change where you've hidden the microphone).

Lavaliere Recording Tips

If you've only got two actors in a scene, it's possible to use two lavs and record each actor's dialogue on a separate channel. To do this, you need a *mono-to-stereo adaptor* that you can find at any electronic hobby shop (see Figure 6.8). Plug one mic into the left channel and the other mic into the right and you'll get a clear, mono recording of each actor's dialogue.

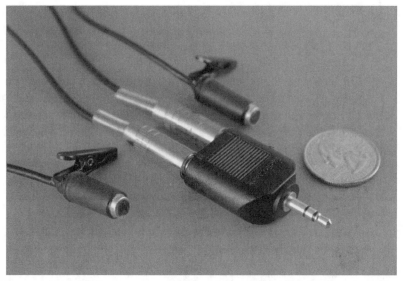

FIGURE 6.8 It's possible to record two separate channels using two separate microphones on the single stereo track of your camcorder. Using a *mono-to-stereo adaptor* and two wired lavalieres, you can easily mic and record two actors at the same time (provided they're not too far apart, or you have really long wires).

Who says lavalieres have to be worn? The lav's small size makes it an ideal *plant mic*.

Using plant mics is a good solution when you've got more than two actors in a scene. The key is to get the mics as close as possible to the actors who are speaking, and the possible locations for hiding a lav are endless. Here's a short list to get you thinking:

- On the dashboard (or sunshade) of a car
- In the floral centerpiece of a dining table (making it a real *plant* mic)
- On a bookcase (or any tall piece of furniture) for actors who are standing
- Hanging from the ceiling over your actors (just be sure to keep it out of the shot)

If all you have are lavalieres, a good technique for multi-actor scenes is to use plant mics when shooting the master, then switch to body mic'ing when you're doing coverage. Keep in mind that you only have to mic the actor who's facing the camera. As long as you shoot a single of each actor, you'll get some takes with good dialogue for each actor in the scene.

TECHIE'S TIP

The general rule regarding the use of mics for coverage is this: If you can see an actor's lips moving, they should be wearing a mic. If you can't see their lips, you can steal their dialogue from another shot (we'll cover this technique in the chapters on postproduction).

Lavalieres are a good solution for many production sound challenges (and if you're using wired lavs, they can be very affordable), but they're not always the best solution. In many instances, shotgun mics are a better choice.

Shotgun microphones

Shotgun mics are highly-directional condenser microphones used on almost every movie set (see Figure 6.9). Like lavalieres, they can be expensive, ranging from a few hundred to over a thousand dollars. The good news is many film schools with their own equipment have shotgun mics you may be able to use.

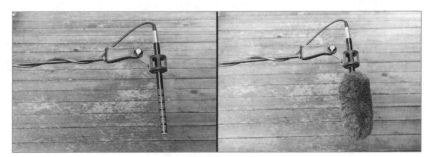

FIGURE 6.9 On the left is a shotgun mic in a *shock mount* on the end of a boom. The shock mount isolates the microphone from any handling noise created by the boom operator. On the right is the same mic with a *windscreen* in place. A windscreen is almost always necessary when shooting outdoors, since even the slight breeze can ruin a recording with a deep bass rumble.

Characteristics of Shotgun Mics

Because shotgun mics are very directional, sound sources in front of the microphone are recorded clear and crisp, while anything that occurs to the sides and rear of the microphone sounds muffled and dull. Sounds to the front are said to be *on-axis*, while sounds to the side and rear are *off-axis*. For a demonstration of the difference between on-axis and off-axis sound, watch the *Microphone Demonstration Video* on the DVD included with this book.

In technical terms, the microphone accepts *sounds coming from the front and* rejects *sounds from the sides and rear.*

NOTE

Using a Shotgun

Traditionally, shotgun microphones are suspended in a *shock mount* on the end of a *boom* or *fishpole*. The boom is controlled by a *boom operator* who typically holds the boom overhead with both hands and positions the shotgun so that it's pointing at whoever is speaking (see Figure 6.10).

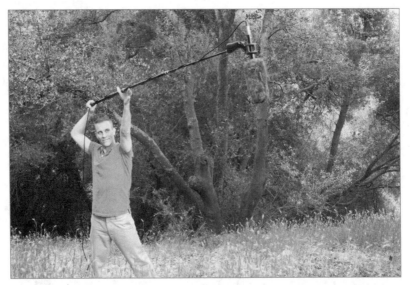

FIGURE 6.10 It's common practice to hold the boom overhead with two hands as shown. Using this position, it's possible to aim the mic directly at the actors, while still keeping the boom out of the shot (above the frameline). Boom poles and mics are generally very lightweight, but even so, it takes a little practice to be able to boom this way for an entire scene.

TECHIE'S TIP

The best boom operators know the script as well as the actors and can anticipate when each actor will be speaking. This is important because of the directionality of shotgun microphones. Unless the mic is pointed squarely at the actor who's talking, the recording will be off-axis and won't have the full, rich presence of on-axis dialogue.

Shotgun mics are very sensitive on-axis and don't have to be as close as other microphones to record good presence (as long as they remain on-axis). For this reason, boom operators will usually wear headphones to ensure their recordings remain in the on-axis *sweet spot* (as well as to monitor the dialogue for any other problems).

SIDE NOTE

THE PROBLEM OF PERSPECTIVE

Everyone understands the concept of perspective when you're talking about visuals. The camera is either close to the subject or far away. You might be looking at the subject from a high angle or a low angle. Perspective is determined by where the

camera is in relation to the subject, and just looking at the resulting shot tells you exactly what the perspective is.

Sound professionals know that audio also has perspective, and just like visual perspective, audio perspective is determined by where the microphone is in relation to the audio source. For instance, if someone is holding the microphone right up against their lips, the sound will be *close-mic'd*. Vocals recorded this way have a very intimate quality, as if you're right beside whoever's talking (or maybe even inside their head listening to their thoughts). As the microphone moves further away, vocal presence decreases and the recording is described as having more *air* in the sound.

The concept of audio perspective is important because you usually want the visual perspective of a shot to match the audio perspective. This means a closeup will have a more close-mic'd sound than a long shot. Normally, this problem takes care of itself. In a closeup, you can get the microphone closer to your actor without seeing the mic in the shot. In a long shot, obviously the microphone would have to be further away.

But it's possible to get in trouble with perspective when you're using lavs. Because body mics are worn by the actors, the resulting sound is always close-mic'd, regardless of where you put the camera. So you could end up with a long shot that has an intimate, close-mic'd perspective.

The way to fix this problem is to record the sound both with a body mic and with a microphone positioned much further away. This gives you two different perspectives that you can mix together in post, and depending on how the tracks are mixed, you can vary the audio perspective and seemingly move your audience closer to or further from your actors.

Recording with Postproduction in Mind

Let's review. At this point, you know quite a bit about how to get professional-sounding movie dialogue. You know about the different possible microphones, and you know the pros and cons of each. You know about the importance of presence and how to ensure you get rich, full dialogue. You also know how vital it is to monitor your sound while it's being recorded. Paying attention to these factors alone will result in better sound than the vast majority of beginner films.

But your soundtrack will be even better if you think ahead to the process of audio post while you're shooting. In the same way coverage is determined by how the movie will be edited, proper onset recording anticipates how the sound will be used in the *final mix*.

We're going to cover audio postproduction in Chapter 9, so you don't need to know all the details just yet. To get the best possible production dialogue, you just need to understand one concept: *separation*.

Separation: The audio holy grail

Sound mixers (the people who perform the final mix) like control. Lots of control. And in the audio-mixing universe, complete control can be defined as complete separation. Here's what that means to a mixer (and this example applies even if you're doing your own final mix with basic editing software):

Let's say you're mixing a scene shot at the beach. You've got the roar of the surf, the squawking of seagulls overhead, the sounds of children playing (and maybe dogs barking if it's a dog-friendly beach), and the dialogue of your two principal actors. In the final mix, it will sound as if all these elements are happening naturally and simultaneously in the world of your story. But that's not the way you should record them.

In a perfect mix, each of these individual sound elements would exist cleanly recorded and separate from the other sounds. Then the mixer would be able to individually adjust the volume of any one element without affecting the other elements. Suppose the surf were just a touch too loud. The mixer could bring down the volume of the ocean without affecting the plaintive cries of your seagulls. And if the dog barking sounded a little too distant, you could bump its level up a notch to bring it closer.

You can only achieve this level of control with separation. If the seagulls and the children and the surf and the dog were all recorded in a single audio take, you couldn't adjust their levels relative to each other. You could only make them all louder or softer together.

Keep that dialogue clean!

We defined clean dialogue in Chapter 1, but here's a reminder: Dialogue is clean when there are no other sounds happening at the same time the words are being spoken. You can now see how this relates to having separation for the final mix. In general, there are two dangers to look out for:

- Shooting in a noisy location

- Sounds that occur related to physical activity in the scene

Being able to get clean production dialogue in these situations will greatly increase the professional caliber of your final mix.

Shooting in Noisy Locations

Shooting in a noisy location should be avoided for obvious reasons. If you can barely hear the dialogue because your actors are standing on a busy street corner with traffic whizzing by, you've got a problem. Since the traffic occurs on the same recording as your dialogue, you can't raise the level of one without raising the level of the other.

> *Because you can see the actual traffic in the shot, the audience expects to hear some traffic on the soundtrack, but the traffic shouldn't overpower the dialogue.*

NOTE

On bigger-budget features, the producer and director would most likely solve this problem by replacing the production dialogue with *ADR*, but this isn't a practical solution on a low- (or no-) budget project.

KEY TERM:

ADR (Automated Dialogue Replacement) This is the technique of re-recording lip-synced lines of dialogue after the fact in a sound studio.

If you absolutely have to shoot on a busy street corner because the script demands it (i.e., your lead character is a traffic cop), you want to ensure the dialogue is as loud as possible relative to the background noise. The best way to do this is by close-mic'ing your actors. You can do this either by using lavalieres, or by framing your shots so you can get a shotgun mic close to your actors without being seen.

The next best way to get good sound is to shoot the master in the location required by the script, then *cheat* the closeups and shoot them in a quieter location so you have clean dialogue for your coverage (see the sidebar, "The Magic of Cheating"). Using a combination of close mic'ing and cheating, you should be able to get good production dialogue regardless of your location.

THE MAGIC OF CHEATING

In movie-making lingo, *cheating* refers to changing the framing or location of a closeup (or any piece of coverage) in such a way that it still appears to match the master shot. The purpose behind cheating is to solve either a visual or audio problem in a way the audience won't notice.

In our example of the busy traffic location, when you shoot the closeups, you could move the actors to a quieter location to get better sound (possibly by moving back from the intersection or to a nearby side street). The idea is to shoot somewhere with less traffic so the sound will be clean. If you frame the shot properly (and throw the background out of focus by using a long lens), the resulting shot will appear to take place at the same location as the master and will cut seamlessly into the final scene.

But cheating is used for far more than solving sound problems. Anything in a shot can be cheated to tweak the resulting image. You can cheat props or furniture (it's very common to hear someone say, "Cheat the table to the left," or "Cheat the lamp to the right," when they're framing a shot). You can cheat actors ("Cheat two steps to the right please, Brad"), and you can cheat entire shots ("Let's cheat this whole thing 30 degrees to the right").

There's no limit to the number of ways you can cheat a shot to solve composition or sound problems, and as long as the audience doesn't notice the cheat, you've done it right.

Avoiding the Noise of Movement

Actors are notorious for making noise when they move or handle props. Think of a woman in high heels walking across a hardwood floor, or of an office worker stirring sugar into a cup of coffee while he's talking. Production dialogue in each of these situations could have potential problems. The clacking of the woman's heels could easily obscure dialogue, as could the clinking of the spoon in the worker's coffee cup.

These situations may not seem like problems because we've seen these scenes in countless movies and we could always hear both the dialogue and the footsteps (or the silverware), but keep in mind that you've only heard the

final soundtrack, and most likely, the footsteps and silverware were recorded separately and mixed appropriately. The first time you actually record someone with hard heels walking on a hard floor while they're talking, you'll be surprised at how loud the footsteps really are, and because the footsteps are clacking during the dialogue, you can't control their volume separately.

The way to avoid these potential mix problems is to ensure nothing the actors do while they're talking makes noise (or makes minimal noise). The rule of thumb when shooting is this: If you can't actually see something happening onscreen, you shouldn't be able to hear it (at least not on the production dialogue track). So unless you're shooting a long shot and can actually see the high heels your actress is wearing (and actually see them hitting the floor), then have her take off her high heels and wear sneakers (or give her a strip of carpet to walk on so she makes no noise).

And for your actor with the coffee cup, either have him pantomime the action (if the cup isn't in the shot), or make sure he stirs very carefully and doesn't clink the cup with his spoon (although you'll probably add separately recorded sounds of clinking and stirring in the final mix).

KEY TERM:

MOLESKIN A soft felt material with an adhesive backing. It's commonly used in movies to keep items from clanking while dialogue is being recorded. Common uses are on the bottom of shoes and underneath plates and glasses that might clink against a table (see Figure 6.11).

But what if you want to see your actress in a long shot, with her high heels hitting the hardwood floor while she's having a conversation? Then you should put *moleskin* on the bottoms of her shoes to muffle the sound her heels make (and you would record clacking heels separately to mix into the final soundtrack).

The more you record production dialogue, the more sensitive you'll become to noise occurring while your actors are talking. You'll also become increasingly skilled at finding ways to minimize or eliminate that noise, and while it may initially seem like paying attention to this level of detail is a lot of trouble, you'll be glad you did when you get to the final mix.

FIGURE 6.11 *Moleskin* placed on the heel of a shoe will keep it from making noise on a hardwood floor. Moleskin can also be placed on the bottom of plates and glasses if they're being used on a hard surface like the counter of a diner or a wooden table.

NOTE
Keep in mind that footsteps are only a problem if your actors are walking while they're talking. So if your actress is crossing through a room in silence, you don't have to worry about deadening the sound of her heels. Let her clack away.

Refrigerators, air conditioners, and planes

By now, you know how vitally important it is to record clean production dialogue. A key element to getting great sound is ensuring your location is as quiet as possible before you start shooting. Sometimes this means going through the location and turning off or unplugging anything that makes unwanted noise. Here are some of the most common offenders:

- **Refrigerators.** It's best to unplug your fridge to keep it from humming in the middle of a scene. Just don't forget to plug it back in when you're done.

TECHIE'S TIP
There's a common trick used by soundmen to remind themselves to plug in the refrigerator before leaving the set. Put your car keys in the freezer. That way, you'll have to go back to the refrigerator before you can leave, and you'll remember to plug it back in.

- **Air conditioners.** Like refrigerators, central air or heating systems have a nasty habit of turning on in the middle of a take. Turn them off.

- **Computers.** Most computers have a cooling fan that whirrs with a low hum. We're so used to hearing this sound, we often don't notice it, but the mic will pick it up, so shut down any nearby computers.

- **Buzzing lights.** Sometimes overhead fluorescent lights emit a buzzing noise, and fluorescents aren't the only lights that buzz. Any light connected to a dimmer will usually buzz as well.

- **Open windows.** Close any open windows before you start shooting. But if it's summer and the air conditioning is off and you've got movie lights blazing, be sure to open the windows after the shot or your crew will get very uncomfortable.

In addition to the noises we've already discussed, there's one special category of unwanted sound that's especially frustrating. That sound is the noise of aircraft, particularly small private planes. You may not think there are many small airports near your home, but the minute you start shooting outdoors, you'll discover how popular flying really is.

The sound of airplane engines is particularly troublesome because it can be heard a long distance away and no form of digital processing can cleanly remove it from your soundtrack. Unfortunately, the only way to deal with airplanes is to wait for them to pass by. It's low tech, and feels like a great waste of time, but it's the only way to get production dialogue free from the annoying whine of single engine planes.

NOTE

Usually a boom operator (wearing headphones and listening to his shotgun mic) will hear approaching planes first. If you're in the middle of a take, the director will decide whether to cut or continue shooting. But if the scene hasn't started, the boom operator will usually shout "incoming" to let the director know planes are on the way.

Sound Recording Levels

There's still one area of recording onset dialogue we need to discuss, and that's how to set proper *recording levels*.

RECORDING LEVEL A measure of the signal strength of the audio being recorded. The higher the recording level, the louder the playback volume will be.

Like the video gain used for making an image brighter, audio-recording levels are measured in decibels (dB). The loudest possible signal you can record will have a level of zero (0) dB. Levels less than this maximum are shown as negative decibels (see Figure 6.12). When you're setting levels, you want to ensure you have a good strong signal, but you also want to ensure you never go above zero dB. Keeping your audio levels between –12dB and –6dB is considered ideal for digital video.

FIGURE 6.12 This is the sound meter display on the Canon HV-20. It has a range from 0 to –40dB. Notice that *–12dB* is clearly marked, since it represents an ideal level for recorded sound. The sound level shown in the image here is sufficient to be heard, but still less than –12dB.

Automatic gain control

Just like using the automatic-exposure and focus controls of your camera, you can also let your camcorder automatically control your audio-recording levels. This feature is frequently called *AGC (Automatic Gain Control)*, and unlike your camera's other automatic features, this is one you should actually consider using.

If you have good mic placement (i.e., the microphone is very near your actors), and the scene does not have an extreme *dynamic range* (i.e., your actors go from whispering to screaming in the same scene), then the AGC will usually give you very good results. But if your mic is in the wrong place, or if there are extreme changes in the loudness of the dialogue, you should consider setting your levels manually.

Setting manual audio levels

Many mid-level and higher video cameras allow you to manually set the recording level for each channel of your stereo audio signal. The audio-level controls are usually buried deep in the on-screen menu system of your camera, which makes riding your audio levels during a shot impractical (see Figure 6.13).

FIGURE 6.13 On the Canon HV-20, *the manual sound level* is controlled by a small joystick on the back of the camera. Given the size of the display and the size and location of the joystick, you can see why attempting to reset your audio levels in the middle of a shot would not be very practical.

Since you can't really change levels to match the audio dynamics of the scene (unless you're using a separate recorder), the best you can do is use the fact that your stereo audio track has two separate channels. If you've got two lavalieres (one plugged into each channel), set a different level for each

channel based on the relative loudness or softness of each actor, and remember that you never want the signal to go above 0db at its loudest.

But what if you're using a single shotgun mic, and you've got both whispering and shouting in the same scene? In that case, record the signal from the shotgun on both channels, but adjust one channel so it gets a strong signal during the quiet parts of the scene, and adjust the other channel so that the loudest shouting does not go above 0db. Then during audio postproduction, you'll be able to use different portions of each channel to construct a dialogue track with good levels during each part of the scene.

Movie Sound is More than Dialogue

Up to this point, we've been concentrating on dialogue. That makes sense because dialogue is the one aspect of sound you absolutely must get right during production. If you don't get clean production dialogue, you will have a very difficult time during postproduction. But there's a lot more to a finished soundtrack than dialogue, and before you can complete your mix, you'll have to gather a whole collection of sounds. Many of these sounds can be found in sound-effect libraries, but nothing is more authentic than custom sound effects captured on location while you're shooting.

Shooting sound

In the last section, we talked about a scene with a coffee-drinking office worker. If you recorded production sound properly, you got a nice clean dialogue track without the sound of coffee being stirred. But you're going to need that sound for the mix, so why not take a minute to record your actor adding sugar to his coffee and stirring. Just get the sound of the coffee being stirred, not the dialogue (see Figure 6.14).

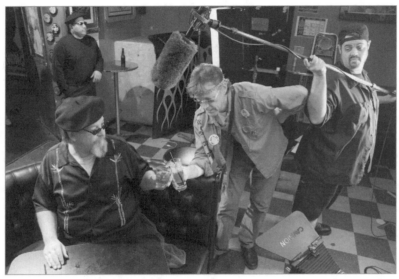

FIGURE 6.14 We spent time recording *wild sound* (also called *shooting sound*) on the nightclub set of *As You Like It*. Here, the boom operator records the sound of two glasses *clinking* for a toast.

You'll be able to add this effect to the final mix, and it will sound completely natural. The more of these specific sounds you can collect during production, the easier and more authentic your soundtrack will be.

> The process of collecting sound effects during production is often referred to as *shooting sound*. The actual sounds themselves are called *hard effects* or *production effects*.
>
> **TECHIE'S TIP**

Wild lines

Suppose you've got a scene in which an actor slams a door while delivering a line. You need to see the door slam and the actor saying the line in the same shot. Yet, every time you shoot it, the sound of the door slamming is so loud it obscures the line. There are many ways to solve this particular problem, but one way could be through the use of *wild lines*.

You create wild lines by recording dialogue from a scene without actually shooting the scene. In this case, you'd record the audio of your actor performing the scene, but without slamming the door. Then you'd also record the sound of the door slamming separately.

In postproduction, you'd use production dialogue right up until the moment before the door slammed shut. You would then replace the real door slam and the obscured line with the wild line and the separately recorded door. With proper mixing (which we'll discuss in Chapter 9), you'd be able to create a soundtrack in which you could hear both the line and door slam perfectly.

TECHIE'S TIP

The key to getting usable wild lines is to record them right after the last take of a scene. At this point, the actors are still in character, and their adrenaline is still pumping. The wild lines you get will be an almost exact match to the performance you just taped. These lines will mix seamlessly with your production dialogue (and will be far less time-consuming and expensive than attempting to use ADR to fix dialogue problems).

Ambience and room tone

In addition to hard effects and wild lines, there's one other type of sound you'll generally collect on location, and these sounds are referred to as *ambience*. Ambience is the unique collection of sounds that exist at any given location.

KEY TERM:

SEPARATE SOUND The process of recording sound separately from the picture. When shooting a movie on film (which doesn't have the ability to record sound on the same media that captures the image), all sound is separate sound. Using a separate recorder to capture sound is sometimes called *dual system sound*.

Remember the scene you were trying to shoot next to the busy intersection? Many elements would make up the ambience at that location, from engines idling, to brakes squealing, to distant sirens, to vague snippets of passing conversations. Before leaving that location, you'd want to record at least 60 seconds of ambience to use during audio post (see Figure 6.15). We'll cover the specific uses of ambience in Chapter 9.

There's one specific type of ambience that's unique to sets and interior locations. That ambience is called *room tone*, and it's a critical element of audio postproduction. Although you may not be able to tell by listening, every

FIGURE 6.15 Taking time to record the ambience of your location will make sound postproduction much easier. In the image shown here, the boom operator records the sound of the beach for a scene in *As You Like It*.

different set or room has a very specific sound to it. That sound is a collection of all the tiny noises made by things in the environment and how those noises reflect and bounce off the objects in the room. One of the lights on the set may have an almost imperceptible buzz. The muffled sound of the refrigerator in the apartment next door is there, too. All of these sounds make up room tone, and you should get 60 seconds of room tone at every location to use in post.

> The best way to get room tone is right after the last take of a given scene. Ideally, all the lights you used should stay on, and everyone who was on the set when you shot the scene should stay in place (but be very quiet). Sometimes it's hard to convince the actors and crew to stand still for 60 seconds after you've shot a scene, but it's the only way to get accurate room tone.
>
> **TECHIE'S TIP**

Going to the Next Level

For most of your projects, you're probably going to record audio by plugging one or two microphones into your video camera. Mostly, you'll use the AGC to control your levels (but you can always go manual if the situation requires). If you follow the techniques discussed in this chapter, you'll be able to get excellent production dialogue and create very professional finished soundtracks.

But there will be times when having mic cables connected to your camera is impractical. Or times when you need more responsive control over your levels. Or times when you need more than two channels. In situations like these, the solution is to use an external recorder and record *separate sound* (see Figures 6.16 and 6.17).

FIGURE 6.16 The memory-card recorder shown here can record sound using its own built-in microphones, or it can accept external XLR inputs. This makes it possible to record high-quality sound without needing to connect microphones directly to the camera.

When you shoot separate sound, you need to have a way to synchronize the picture with the sound. Since the earliest talkies, movie crews have used *slates* or *clapboards* to create a visual and audio *sync point* to align the sound and the image (see Figure 6.18). The visual image of the clapper hitting the slate corresponds with the audible "clack" on the soundtrack and makes synchronization easy.

FIGURE 6.17 Some small, lightweight *MP3 players* also have the ability to record sound using an external microphone. The mic is worn by an actor, and the MP3 player/recorder is slipped into a pocket of his costume. This setup gives you the freedom of using wireless microphones at a fraction of the cost. The only drawback is the inability to monitor the sound as it's being recorded.

FIGURE 6.18 The clapper across the top of the slate is used to generate a visual and aural sync point for aligning the picture with the soundtrack. The numbers on this particular slate display *timecode*, an index used by professional video editors to precisely track individual frames. (Photo courtesy of Denecke, Inc.)

Using a separate recorder is only the tip of the iceberg. An onset mixing console along with wireless headphones for the boom operator and director are standard on most movie sets.

TECHIE'S TIP

Suppose you need (or want) to record separate sound, but you can't afford a dedicated sound recorder. It's possible to use a second camera as a sound recorder. Simply plug your external mic into the second recorder, set your sound levels (or rely on the AGC), and roll the "sound camcorder" every time you shoot a scene. Then when you edit, you will use only the audio track from your sound camera (separating audio and video tracks will be discussed in Chapter 8). When using this technique, be sure to use a slate (or clap your hands) before every take, so you can sync your sound.

This chapter introduced you to the art and science of recording clean dialogue and sound effects onset. This may have been the first time you've seen how much work goes into creating and capturing good sound. Everyone understands the importance of artistic lighting and composition because the results of good cinematography are visible the instant an image flashes across the screen. But good sound work is invisible. It works on an unconscious level and pulls you deeper into a movie than any image can. Poor sound will do just the opposite—it will act as a barrier and keep the audience from being drawn in.

Your movie needs an engaging, affecting soundtrack to succeed, and the first step to creating that soundtrack is to record dialogue with full, rich presence from the beginning. Get a good external microphone or two and use them carefully. Monitor the sound as you record it, and don't stop shooting until your sound is as good as your imagery. Use all the tips and techniques we've discussed. Record wild lines when necessary, and don't forget to collect hard effects and ambience. These things are just as important as the visuals in your story.

It won't be easy. There will be times when you'll be tempted to settle for less than perfect sound. The sun may be setting and you still have five more shots and every plane in the country seems to be doing circles over your location, and someone will come up and say, "Just get the shot! You can fix the sound in post!" But the person urging you to shoot won't be sitting beside you in the editing room when you realize not a single word of your dialogue is useable. So stick to your guns. Get the sound you need. You'll be glad you did.

REVIEW QUESTIONS: CHAPTER 6

1. What does *D, M, E* mean when you're talking about movie sound?

2. What is *vocal presence*?

3. If your dialogue is not clean, what challenges will you face in postproduction?

4. When is the best time to record wild lines? Why?

5. What is *room tone*?

DISCUSSION / ESSAY QUESTIONS

1. Why is using the on-board microphone on your camera to record dialogue a bad choice?

2. What are the strengths and weaknesses of a lavaliere microphone? How about a shotgun mic?

3. In this chapter, we talked about one possible solution to the dilemma of a line being delivered just as a door is slammed. What are some other ways to solve this problem?

4. Why is audio perspective important? How do you control it?

5. Why is separation important for a final mix?

Research/Lab/Fieldwork Projects

1. Watch the *Microphone Demonstration Video* included on the companion DVD.

 `ON DVD`

 - Get your camcorder, an external microphone, and an actor (the quality of the acting isn't important in this exercise). It doesn't matter if your microphone is a shotgun or lavaliere. If you have access to both types of microphones, consider doing this exercise twice (once with each microphone).

 - Connect the microphone to the camera. Set up the camera so the same mono signal is being recorded on both channels (you may need to consult the camera's manual for instructions on this procedure).

 - Ensure that AGC is on.

 - Using good techniques, record the dialogue that follows, with the actor giving a very subdued performance (at a low volume). Close-mic the actor. (Don't worry about lighting the scene or careful framing. For this exercise, the camera is primarily an audio recorder.)

 - Record the scene again, with the actor using full voice. Have the actor shout a few of the lines. Use a good mic'ing technique.

 - Switch the AGC off, and repeat the exercise (one quiet scene and one loud scene). You will have to set different manual levels for the quiet and loud scenes.

 - Listen to the audio of each take. Pay particular attention to the quality of the voice. Did you get good, clean dialogue? Did the voice have good presence?

Dialogue for Exercise 1:

 RYAN

We came to you for help. You were
the expert who was supposed to fix
everything. So we did exactly what
you said and what happened? Bobby got
killed. And it's all my fault. It's
my fault because I listened to you.
Because I thought you knew something.
Well I was wrong. You don't know
anything!

2. For this exercise, you need a basic lighting kit, your camera
 with an external microphone, and two actors.

 - Create an interior lighting setup for two people sitting at
 a table (or you could try an exterior lighting setup for two
 people sitting on a park bench if you prefer).

 - Using the two-person dialogue scene from Chapter 2,
 create a scenario with contained action (i.e., nobody gets
 up or moves from their seated position) in which two actors
 will use the dialogue in the scene (you could substitute a
 short scene you've written yourself, but it's important that
 both people stay seated and that the script be written out so
 the dialogue is repeatable).

 - Shoot the scene with a master and two singles. Pay
 particular attention to getting high-quality dialogue with
 presence.

QUIET ON THE SET!

OVERVIEW AND LEARNING OBJECTIVES

In this chapter, you will:

- Learn the basic responsibilities of the director
- Prepare for going into production
- Learn basic on set procedures and considerations
- Explore techniques for working with actors
- Understand the need to stay organized
- Gain confidence in running a set

But What I Really Want to do is Direct

Okay. We're almost there. We've spent a lot of time the past few chapters learning about story, cameras, shots, lighting, and sound. These are all things you need to know to be a director. But knowing these things doesn't make you a director. It might make you a screenwriter or a cinematographer or a sound recordist, but not a director. As a matter of fact, we haven't spent any time talking about the director's job.

 All figures and shorts are included on the companion DVD with this book.

While some of you may want to work as a camera operator or an editor, it's likely that many of you hope to step on set as a director. This chapter's for you. We're finally going to look at how all the skills we've been studying come together during production, and we'll start with the most basic question of all: *What does a director really do?* (see Figure 7.1).

The director as storyteller

Remember our description of filmmaking? We're telling stories with pictures and sound. That means, first and foremost, the director is a storyteller. As a director, you have to be able to tell a story that captures the interest of an audience, keeps them engaged, and has an impact when it's over. That doesn't mean you have to actually write the script (although many directors are screenwriters as well), but you do have to know how to use all the tools and techniques of filmmaking to bring the story to life.

FIGURE 7.1 You'll spend a lot of time looking through the camera (or at the monitor) as a director. But framing shots (or approving the framing of your camera operator) is only a small part of being a director. Your primary responsibility is to orchestrate the skills of the many different artists on the set to tell the best story possible.

It's important to realize the story and the script are not the same thing. The script is a blueprint. It's a rough sketch of the movie that helps organize a

production. But it's not a finished product. It's up to the director to find the story embedded in the script and use the resources of the cast and crew to turn that story into pictures and sound.

So your first task is to understand the story. What does it look like? How does it sound? How will an audience feel while they're watching it and after it's over? To be a director, you have to know what the story is and how you're going to tell it.

It's often said that the director is the only person on set that's seen the movie before production even begins. Maybe you've seen it in your sleep. Or in your daydreams. Maybe you know what's in each frame. Or maybe the images are vague, but you know how the movie feels. It doesn't matter how your muse reveals the story to you, but you need to be clear about what the story means, and you need to have a reason for telling it.

TECHIE'S TIP

Knowing how to tell a story is crucial. Without that ability, nothing else matters. But it's not the only skill important to a director.

The director as leader

Filmmaking is a collaborative art form. It takes a team of artists with very specific skills to create a finished film, and it's up to the director to provide guidance to that team. Without guidance, the collective efforts of the cast and crew could work in opposition instead of reinforcing each other, and the last thing you want is everyone heading off in their own separate directions.

To keep that from happening, you have to ensure everyone's creative efforts are in sync. You have to provide a sense of direction for the project. In other words, you have to be a leader. But what exactly does it mean to lead a film crew? (see Figure 7.2).

The Director as Communicator

You've seen the movie in your head. You know what each shot looks like and how each moment should feel. But the cast and crew aren't in your head. They haven't seen the movie you've been obsessing over since you wrote (or discovered) the script. So you'll have to communicate what you want. Each person on the crew will want different information. The DP will want to know about imagery and lighting. The actors will want feedback on their performances. And everyone will want to know how many more shots before lunch.

FIGURE 7.2 To be a leader, you have to make decisions. Then you have to communicate those decisions so people know what you want. There will be moments when you're not sure and moments when you know exactly what to do. But even when it seems there's no good choice, you still have to make a decision. That's your job.

TECHIE'S TIP

Keep in mind that communication takes many forms. Less is often more. If you can show your DP a painting or a photograph, that single image might be more effective than a lengthy description of the images swimming in your head. Sometimes a simple word of encouragement to an actor is better than trying to explain the psychological roadmap of a scene.

The crew is there for you. They want to make the best movie possible. But they can't read your mind, and unless you tell them what you want, they'll just be guessing.

NOTE

Most inexperienced directors make one of two mistakes. They either talk too much or not enough. Besides taking up valuable time on set, explaining too much can confuse and overwhelm actors or crewmembers. But saying nothing can be equally frustrating and leave your crew in the dark. Unfortunately, there's no magic formula for knowing just how much to say, but if you're not getting the results you want, you've got to say something.

The Director as Cheerleader

Did someone mention lunch? That brings to mind another important leadership function. You have to motivate and inspire your cast and crew (and good food is surprisingly effective as a motivator). We'll talk about feeding the crew later in this chapter, but just know it's important to provide food and snacks (especially if you're not paying anyone).

But beyond taking care of their stomachs, you need to give your crew a reason to get up before dawn and spend their entire weekend helping you chase your dream. One of the best ways to motivate people is with your own passion. Enthusiasm is contagious. If you're truly excited about your project and people sense you're giving it everything you've got, they'll be more likely to give you their best efforts.

Another way to motivate people is to recognize their work. If you like a particular lighting setup or moment of performance, or if someone goes out of their way to get a great shot, tell them how well they did. Never forget you wouldn't be able to make your movie without the help of everyone on the cast and crew. Thank them for their time and effort at every possible opportunity.

> There's an old military saying about leadership: *Praise in public, correct in private*. This is especially true on a movie set. If someone does something good, point it out. Praise their work, and the more people who hear you, the better. But if someone makes a mistake or disappoints you, don't say anything in front of others. Take them aside and talk to them privately. Nothing is more demoralizing (or embarrassing) than having a mistake pointed out in public.
>
> **TECHIE'S TIP**

The Director as Peacekeeper

The people who make movies are artists. They're passionate, talented, and a little crazy (why else would anyone give up all their free time to play make-believe with a camera?). Their passion and talent (and slight insanity) are vital. No movie ever gets made without them.

But every artist has his or her own muse, and the artists working on your movie will have ideas and inspirations they're passionate about. Unfortunately, sometimes those ideas are going to clash. Tempers could flare as passion is redirected to support a misplaced conviction. In these instances, it'll be up to you as the leader to restore peace and calm.

Remember, when it comes to artistic interpretation, there are no absolute rights and wrongs. There are only opinions. Even though you'll probably be partial to your own point of view, sometimes peace on the set is more important than deciding which idea is best. You don't have to win every argument. As a matter of fact, sometimes losing the little arguments will help you win the big ones. And don't forget that time you spend arguing is time you're not shooting.

> **TECHIE'S TIP**
>
> You probably won't agree with 95% of the creative suggestions your cast and crew make. But you should listen to every idea they have because the other 5% will be pure gold, and regardless of whether you use their ideas or not, thank them for their suggestions. They're only trying to make the movie better.

So what does it really mean to be the storyteller and leader on set? It means when you show up you have to *know what you want*, and with the help of the cast and crew, you've got to get it.

Being Prepared: The Importance of Preproduction

Knowing what you want comes from an understanding of your story and how you want to tell it. This is usually a gut feeling based on the impact you'd like your movie to have. Sometimes you'll know exactly what you want right from the start, and other times you'll constantly change and modify your ideas. But regardless of your creative process, deciding what you want is your first (and most important) responsibility as a director.

Once you know what you want, you've got to figure out how to get it. This is the purpose of *preproduction*. Preproduction is a planning phase. It's everything you do to be ready when the camera starts rolling, and the degree of success you have on set is always related to how much planning and organizing you do.

The length and complexity of preproduction is determined by your script. But regardless of whether you're shooting an epic blockbuster or a five-minute short, there are certain preparations you must make, which include:

- Breaking down the script

- Casting

- Selecting locations

- Creating shot plans and/or storyboards
- Finding the right equipment
- Conducting read-throughs and rehearsals
- Preparing to feed the cast and crew

You don't have to do these in any particular order (and often, you'll be doing many of them at once). You'll send messages and tweets, make phone calls and have meetings, and the more people you have helping, the better. You'll feel overwhelmed at times, but the more work you do now, the more fun you'll have when the shooting starts.

Breaking it down

One of the first things you'll do in preproduction is a *script breakdown*. When you break down a script, you go through it line by line and make note of everything you'll need to shoot the project. All the locations, cast members, props, costumes, and special effects you'll need are identified (see Figure 7.3).

The breakdown form (along with several other preproduction and production forms) is included in the "Forms" folder on the companion DVD.

NOTE

If you're doing a short film set in present day, the script breakdown can be as simple as a list of locations and props. But if you're shooting a feature set in World War II, the list of costumes, cars, unique locations, and special effects for battle sequences could be quite extensive.

Regardless of how simple or complex your project is you should do a breakdown. You'll use it to figure out how many days it'll take to finish the project and how long you'll need to stay at each location, and it will help ensure you have all the props, costumes, and special equipment you'll need for each scene. There's nothing worse than showing up at a location you can only use for a couple of hours and realizing you've forgotten to bring an important prop or crucial costume.

> Although it may be possible to shoot a two-day short without doing a breakdown, you'll never be able to create a detailed budget or accurate shooting schedule for a larger project without having a thorough breakdown.
>
> **TECHIE'S TIP**

Scene #: 3	Breakdown Sheet	Sheet #: 1
		Int/Ext: INT
Script Page: 2		Day/Night: Day
Page Count: 2 3/8		

Scene Description: Josh's computer freezes
Settings: Josh's Cube
Location: UNEX Cube
Sequence: 1 Script Day: 1

Cast Members	Background Actors	Probs
Atwater		Computer
Josh		Computer monitor
Phil		Computer mouse
		Headset for Josh
		Keyboard
		Phone
	Stunts	**Vehicles**
Special Effects	**Wardrobe**	**Makeup/Hair**
Red X for computer screen		
Computer crash screen		
Reboot screen		
Set Dressing	**Greenery**	**Special Equipment**
Notes	**Music**	**Sound**
Record help desk V.O. in post		wild sound keyboard FX

FIGURE 7.3 The breakdown sheet for scene 3 of *When Harried Met Sally* gives you all the information you need to shoot the scene. You know the location, you know which actors are in the scene, you know how long the scene is, and you know which props you need. This level of preparation keeps you from being surprised on the set.

Casting

One of the primary tasks of preproduction is casting your film. In your initial projects, you might use friends or family members in your movies, but that won't always be the case. Knowing how to hold an audition and what to look for in an actor is a skill every director must learn.

There are two principal things you're looking for when you audition an actor. The first is their gut instinct, which is how they approach your scripted character without any input other than the script.

The second thing you need to know is how *directable* they are. Can they take suggestions or adjustments from you and make significant changes to the way they interpret the character? You want to measure these skills during the audition.

The sidebar, "How to Hold an Audition," gives you some surefire casting techniques, and even if you're using friends and relatives, having an audition and using some of these techniques might be a good idea. It will let you know what level of performance to expect.

SIDE NOTE

HOW TO HOLD AN AUDITION

At some point in your career as a director, you're going to have to hold an audition, and the sooner you learn this valuable skill, the better. Here are a few tips to get you started:

- Pick a scene that's no more than two pages long for the audition. This is more than enough to give you an idea of an actor's ability. And don't pick the most difficult scene. It's usually not a good idea to ask an actor to cry or get really angry during a first audition.

- Select a classroom or other neutral place to hold the audition. Avoid having the audition at your home, dorm room, or apartment if possible.

- Set aside a specific time to hold the auditions. Publicize them using school papers, bulletin boards, word of mouth, and any other way you can think of. The more people who respond, the more choices you'll have.

- Provide copies of the scene (or scenes) to the actors before the audition. If the actors have a little time to prepare, you'll get much better results.

- Set up a video camera in the audition room. Ideally, you would have at least two other people helping you: one to run the camera and one to read the scene with your actors.

- Bring the actors in one at a time. Take a few moments to talk with them and get to know them. Avoid answering any questions about what you're looking for. They may ask, "What can you tell me about this character?" Tell them you'd like to see what their initial gut instinct is without receiving any input

from you. Also reassure them that they'll have more than one chance to perform the scene.

- Have them read the scene with one of your friends, while another crewmember videotapes the scene. Don't give them any direction. You want to see how they interpret the character. (Note: It's also possible to have them read the scene with another actor.) A key point to remember is that as the director, you shouldn't be the person reading lines opposite the actor. Doing so will make it difficult to observe their performance objectively.

- After their first attempt, ask them to do the scene again, but give them some direction this time. Try to get a performance that reflects how you think the scene should be played.

- Finally, ask them to perform the scene once more. This time, ask them to make a major change that has nothing to do with how the scene will eventually appear in the finished film. For example, if your movie is a comedy, ask them to be deadly serious. Or if it's a dramatic scene, ask them to be silly. The whole idea is to see if they can break away from their own preconceptions and be playful with script. Very few actors will be able to do this really successfully (and if they can, you should seriously consider casting them; they will be creative and very directable).

- After the third reading, thank them for their time and tell them you'll let them know your decision after you've seen everyone and given it some thought.

- Go back and watch the audition tape the next day. Compare what you see on tape with your memory of their performance. If you've asked for different variations during the audition, you should have a good idea of their ability and how they might fit in your movie.

- Finally, after you've decided whom you want to cast, call everyone who auditioned and thank them for their time. Keep in mind, even though you may not cast a specific actor this time, they may be perfect for a project you'll do in the future.

Location, location, location

You'll also have to find the actual locations in which you'll shoot your project. Again, for some of you, this will be a place you know, possibly where you live or work. But if you're *scouting a location* you're not familiar with, here are some things to consider: How noisy is the location? Close your eyes and listen for a few minutes. What do you hear? Traffic, airplanes, air conditioners, running water. All these things can create challenges when you're trying to record clean dialogue.

> **KEY TERM:**
>
> **LOCATION SCOUTING** The process of visiting different potential locations as you try to find the perfect setting to shoot your movie.

What's the light like? If you're shooting outdoors, or somewhere with large windows, be sure to visit the location at the same time of day you plan to shoot. Lighting will change throughout the day, and you don't want to be surprised. If you're bringing your own lights, are there enough electrical outlets? Where are they? How many extension cords will you need?

Are bathrooms available and is there a place for your cast to change? How about parking for the cast and crew? If you're planning to shoot outdoors, what will you do if it rains? These are all factors to consider when you're choosing a location. Anything you don't plan for will go wrong at the worst possible moment.

Shot plans and storyboards

Once you start shooting, you'll discover a truth every director knows. *You never have enough time*. It doesn't matter if you've got millions of dollars and months to shoot, you still never have enough time. You've got to make every minute count, and one of the best ways to be efficient on set is to know exactly which shots you're going to need. That's the purpose of a *shot plan*.

In its simplest form, a shot plan is a list of all the shots you need to tell your story (see Figure 7.4).

In some cases, an itemized shot list might be enough, but you can also create *shot diagrams* (refer back to Figure 4.14) and *storyboards* (see Figure 7.5) during preproduction.

| | | | Production Co.: | When Harried Met Sally | Date: | 08/01/XX |
| Production Title: | | Director: | Pete Shaner |

| Scene #: 3 | Scene Name: 3 | |
| Int./Ext.: Int | Day or Night: Day | Page Count: 2 3/8 |

Shot No.	Type:	Description:
1	Wide Master favoring Josh	Josh talks to Atwater, types, makes phone call, talks tp Phil, Phil enters cube.
2	Medium Josh	Same as Shot 1. When Phil enters, reframe for two shot.
3	CU Josh	Clean single on Josh for entire scene.
4	Med Atwater (reverse of 2)	Atwater appears at cubicle entrance. Let him enter and exit the shot.
5	Med Phil (reverse of 2)	Same as shot 4 except for Phil.
6	Insert of keyboard	CU of keyboard as Josh types.
7	Insert of monitor	CU of monitor as error message, reboot, and crash occurs.

FIGURE 7.4 Having a thorough shot plan will help you get all the coverage you need. A shot plan is often accompanied by a shot diagram. The shot diagram for this scene was given in Chapter 4 as Figure 4.14.

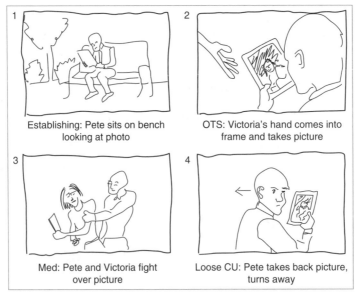

FIGURE 7.5 The easiest way to communicate your vision of a scene is to have a series of storyboards. If you don't have the artistic ability to draw a storyboard, you can also visit the locations during preproduction, with your actors and a digital camera, and shoot a series of still photos that illustrate the coverage you're planning.

Shot plans and storyboards serve two main purposes. First and foremost, they help you organize your thoughts as you figure out which images would tell your story. Secondly, they help you communicate your visual ideas to the cast and crew. Being able to show your crew pictures of the coverage you want to shoot will save a great deal of time on the set, and the more time you can save, the better.

Getting the right equipment

The breakdown and your shot plan will help you figure out what equipment you'll need. For example, if you're shooting outdoors, you'll probably need reflectors, and if you've designed a kinetic chase scene you might want a skateboard or wheelchair to use as a dolly (see Figure 7.6).

FIGURE 7.6 After you've identified the equipment you need, you'll have to figure out how to transport that equipment to the set. All of the equipment shown here will fit into this small car. Never underestimate your resources.

Just like getting the right props and costumes, the key to identifying the equipment you'll need is doing a thorough analysis of the script. Remember: You're always trying to conserve time and energy. Don't bring more equipment than you'll need (although it's always a good idea to have a few spare lights, stands, and sandbags).

Rehearsing

But besides having actors, locations, shot plans, and equipment, there's another type of preparation that can increase your efficiency on set: rehearsal. If your scene has complicated visuals or demands your actors to hit specific emotional notes, then you'll want to set aside some time to rehearse before you shoot.

Rehearsals have many benefits. If you're working with actors you don't know, or who don't know each other, rehearsals allow everyone to become comfortable with each other. Rehearsals also help ensure everyone shares a common understanding of the script.

If possible, you should get together before production, and ideally, rehearse in the actual location you'll be shooting in and have any necessary props available. This allows everyone to get familiar with the physical environment and the movement needed in the scene.

The first part of any rehearsal is the *read-through*. This is where everyone sits around a table and reads the script aloud to get comfortable with the dialogue and the rhythms of the scene. This is when you discuss any unique visuals and answer any questions your actors may have about their characters.

TECHIE'S TIP

There's a key point to consider regarding the intensity and number of rehearsals. Film is a very different medium than theater. In theater, a performance has to be recreated over and over, night after night, and consequently rehearsals can be long and intense. In film, a performance only has to be right once (or at most, a small number of times as you shoot your coverage). You want the performance to feel fresh and undiscovered each time, so be careful not to over-rehearse your scene. That way, your actors have new things to discover while the cameras are actually rolling.

After the read-through, you *block* the scene, in which you coordinate any physical movement and discover natural motivations for your characters to move from one place to another. Keep in mind that if you have specific shots in mind that require the characters to be in a specific position or location, it's important to give the actors logical or emotional reasons for the characters to be where you need them.

If rehearsing on the set isn't possible or practical, be aware you'll need to allow a little extra time during production to smooth out the blocking (refer back to Chapter 6 for the definition of blocking, if needed).

Feeding the cast and crew

One of the most important things to plan for is how you're going to feed those working on your project. It may not seem entirely logical, but often, the dedication of your cast and crew is directly related to the quality of food you provide. You shouldn't shoot for more than six hours without stopping for a meal (and that meal is usually called *lunch* if it occurs halfway through your shooting day, regardless of the actual time you eat).

The food can be anything from burgers to subs to pizzas to homecooked meals. But it's important for the food to be warm, if at all possible. So figure out where the food is coming from and how you're going to get it to the set without interrupting your shoot. After the food has arrived (and you've finished the last shot before your break), it's tradition to announce the meal by saying, "That's lunch!"

You should set aside at least a half hour for people to eat. If you're behind in your schedule, it may seem inefficient to take that much time away from shooting (after all, can't they eat pizza and set up lights at the same time?). But it's important to give people a mental break as well as a chance to eat. You'll find they work faster and smarter after lunch if you've given them time to sit down and relax.

TECHIE'S TIP

Between meals, there should be plenty of snacks and drinks available. Be sure to include water and some fresh fruit in addition to sodas and candy. In the professional world, the snack table is called *craft services* and having a well-stocked craft services table is a sure way of boosting the morale of your cast and crew.

Permits and releases

Depending on where you shoot and the plans you have for the film when it's finished, you may need to deal with *permits* and *releases* in your planning. A *permit* is an agreement that allows you to shoot in a specific location.

Sometimes cities or parks require permits to shoot in certain areas. Your instructor should have specific information on permits required in your area.

A *release* is permission to shoot pictures, video, or film of specific locations or people. Having a signed release gives you the right to use the image or likeness of a person or a recognizable place in your movie. Some festivals and distributors require signed releases before they will watch or show your movie. We'll discuss releases in greater detail in Chapter 10 (see Figure 7.7).

Final details

Alright. You've done your breakdown and found your locations. You've gathered your equipment and put together a shot plan. You've assembled a cast and crew and had some rehearsals. And you've bought some snacks for craft services. You're in the home stretch. The last stage of preproduction is making sure everyone knows when and where to show up for the first day of shooting. That means you'll need to figure out your *call time*.

KEY TERM:

CALL TIME The actual time of day you want everyone to show up at the location. This is usually early in the morning (unless you're shooting at night). On productions in which the location needs significant preparation before shooting, sometimes there are separate call times for the cast and crew.

Of course, you've selected a location with enough parking for your cast and crew, and you've made sure everyone knows the address (or maybe given them maps and directions if needed). You've checked and double-checked your props and equipment (and made sure your camera batteries are fully charged), and the last thing you've done is set aside enough time for a good night's sleep. You're going to need it.

FIGURE 7.7 Depending on the plans you have for your movie, you might need to get a signed release from everyone who appears onscreen, including the extras. Releases let festivals and distributors know you have permission to use the images (called the *likeness*) of everyone who appears in the film.

For your first few projects, you might try to do everything yourself (writing the script, setting up the lights and microphones, operating the camera, and directing), but this will be quite a challenge. Although you probably won't have a trained, experienced crew, get some friends to help. Having someone to help move and set up equipment makes a huge difference when you're shooting.

TECHIE'S TIP

Production: Where Everything Comes Together

It's the day of the shoot! Everyone has shown up on time and they've brought all the equipment, props, costumes, and snacks. You're anxious to get started. But before you roll camera for your first shot, there are a number of tasks you must complete:

- **Set up the craft services table.** It's good for the crew to have something to snack on as they're unloading and setting up the equipment. If it's early in the morning, it's traditional to have donuts, bagels, juice, and coffee.

- **Set up the camera and microphone.** Make sure the camera is ready to record (battery charged, memory card or tape in place, etc.). Mount the camera on your tripod (unless you're shooting handheld), and make sure the microphone has a fresh battery and is generating a good, clean signal.

- **Do a blocking rehearsal of the scene.** Bring in your actors and rehearse the scene. Concentrate on finetuning the blocking and the use of any props. Don't worry about performance. Discuss the shot plan so everyone knows how much coverage you'll need and where the camera will be for each shot (see Figure 7.8).

- **Complete the lighting setup.** Once you know where the camera and actors will be, set up your lights (or reflectors) to get a modeled shot with good separation.

- **Do a final rehearsal of the scene with all the elements in place.** Generally, you'll watch the rehearsal through the camera (or on its monitor). Again, don't worry too much about performance. You're looking to make sure all the technical aspects of the shot are good. Is the framing and lighting right? Do the actors know their lines and blocking? Do the performances look natural? Is the microphone getting good, clean dialogue? (see Figure 7.9).

Standard shooting procedures

After the last rehearsal, you're finally ready to shoot your scene! Many first-time directors are tempted to do everything alone—directing, operating the camera, and monitoring the sound through headphones. But you'll find life much easier if you have at least two other people on the crew: someone to operate the camera and someone to be in charge of recording sound (and

FIGURE 7.8 When you're blocking a scene, you're finetuning how all the physical actions will appear on camera. Even something as simple as flipping on a light switch will sometimes need to be carefully rehearsed.

FIGURE 7.9 For the final rehearsal (sometimes called the *technical rehearsal*), it's important to rehearse all aspects of the shot, from the actors' blocking, to the camera moves, to the placement of the boom. Only by practicing all the elements of a shot can you know if everything is going to work as planned.

operating the boom if you're using an external shotgun mic). Having those other crewmembers will allow you to focus on your actors and ensure you're getting the performances you want.

Anytime you're working with a crew, there are standard procedures you should follow during shooting. Using these standardized procedures reduces confusion and helps ensure everyone's efforts are smoothly coordinated. Each procedure is announced by a specific phrase or command, and those commands tell the cast and crew what's coming next. Here are the commands in order, and their associated actions:

1. *First positions*: This tells everyone to get where they need to be at the start of the shot. The actors will move to their beginning places and the camera operator will frame the opening shot.

2. *Quiet on the set*: This lets the cast and crew know you're about to roll the camera. While the camera is rolling, no one should talk or move unless they're in the scene or performing their crew duties.

3. *Roll camera*: This tells the camera operator to start recording. After pushing the record button and seeing the indication that the camera is actually recording, the camera operator will say *speed*. This lets the director know he can start the scene.

4. *Action*: As director, you'll call action when you're ready for the scene to begin. It's important for actors to wait for your command, otherwise, the camera or boom operator may not be ready. The single call for *action* ensures everyone on the cast and crew begins the scene at the same time.

5. *Cut*: When the scene is over (or the shot has reached its logical conclusion), the director will call *cut*. This command tells the camera operator to stop recording and lets the actors know the take is over.

6. *Moving on*: After you've gotten a take you like, the announcement of *moving on* lets the cast and crew know you'll be getting ready for a different shot. This could involve moving the camera, changing the lighting, or even beginning a new scene.

7. *That's a wrap*: This is the last command of the day. You'll call *wrap* after you've said *cut* on your final shot for any given shooting day. It lets the cast and crew know to shut down the equipment and begin putting it away. After a long day of shooting, this is a very welcome command.

NOTE

These are the most common phrases and commands used onset, but they aren't the only ones. For example, if you're recording sound separately, you'll need to tell the sound recordist to start recording with the command **roll sound.** *Then it's common practice to wait for the reply,* **speed,** *from the sound recordist before rolling the camera.*

On a professional movie set, many of these commands are given by the *assistant director*, but on student and low-budget films the director often gives all the commands. When you give these commands, be sure to speak in a loud, clear voice. You may feel self-conscious at first, but using these commands consistently reduces confusion and helps ensure a smooth-running set.

KEY TERM:

ASSISTANT DIRECTOR A specific crew position responsible for running the set and coordinating the efforts of all the other crewmembers. The assistant director usually gives all the commands on set except for *action* and *cut* (which are reserved specifically for the director).

Shooting considerations

Once you start shooting, you'll usually begin with the master shot, then move the camera closer to get the singles and inserts outlined in your shot plan.

The general rule of thumb is to shoot the widest shots first, then progress to tighter and tighter shots as you capture your coverage. This makes sense for a couple of reasons. It gives your actors a chance to warm up in the widest shots and usually improves their performance in the medium and closeup shots in which you want more intense and compelling performances.

Going from wider to tighter shots also makes lighting easier. The widest shots are usually the most difficult to light, since they show the largest area. By shooting the wide shots first, you get the most difficult lighting out of the way early. Then as you move closer, you only have to change the lighting slightly for your coverage (since the basic lighting setup should remain constant for the entire scene).

When you're shooting different takes of your coverage, there's one important concept to keep in mind: *Get what you need*. No more and no less. Don't waste time shooting more than you'll ever use, but don't move on from a setup until you have enough for the scene. Just what does that mean? It means you don't necessarily need to get a perfect take from beginning to end of every shot in your shot plan.

Suppose you're shooting a master. You know you'll probably only use the master at the beginning and end of the scene (and maybe for a couple of moments in the middle). You probably don't need a perfect take all the way through. Keep in mind that a master shot is wide. Making small changes to an actor's performance may not be noticed. Save the nuances for your closeups. Get what you need.

TECHIE'S TIP

Although it's common practice to shoot the wider shots before the closeups, there may be times you want to shoot the closeups first. Suppose you're doing a very emotional scene that requires someone to cry. Some actors give their best performances the first few times they perform a scene. You may have a situation in which you know your actor will be able to cry for the first couple of takes, but after that, they'll be cried out. In that case, shoot the closeups first. As always—do whatever it takes to get what you need.

How to Direct Actors

It's time to talk a little about working with actors. Knowing how to shape a performance is a skill every director must learn. But to successfully direct an actor, you need to understand how their craft differs from yours.

As a director, your primary concern is *results*. You begin the project with very specific ideas about what a performance should look like and how it should sound. Before you even begin casting you've already decided that halfway through the second page, a single tear should roll down the face of your stoic leading man. That's a good thing to know, but the worst thing you can do is tell an actor exactly what their performance should look like. That's called *result-oriented direction*. A good example of this is anytime you tell an actor what to *be*, as in "be angry," "be happier," or "be sad." This has the effect of making an actor worry about what their performance looks like, and because they're thinking about how it looks, they're not truly immersed in the scene.

When an actor is acting, they're living through the scene moment by moment. Their primary concern is what they're doing. They're focused on specific actions. So when you're directing an actor it's far better to give them a task to accomplish. That way, instead of telling them what to *be*, you're telling them what to *do*. An example of this would be to tell an actor, "use this line to soothe your sister" or "flatter your boss with that line." This is called *process-oriented direction*, and it has the effect of focusing an actor's attention on the other person in the scene.

Notice that when you use process-oriented direction, you're using verbs to communicate with your actor. Verbs like "seduce, "attack," "praise," or "apologize." Also notice that you can change the tone of the performance simply by changing the verb, and sometimes the differences can be subtle, but significant. For instance, if you want an actor to be a little more insincere when giving someone a compliment, instead of telling them to "be insincere" (which is result-oriented direction), you can say, "instead of praising your brother, flatter him." Changing the verb in process-oriented direction will change the performance without making your actor self-conscious.

Learning to think of a performance in terms of verbs isn't easy, but it more closely matches how an actor approaches a scene, and it can help steer an actor towards a more compelling performance. Just remember this: If you're telling an actor what the performance should look like, you're not speaking his or her language. Don't tell them what to *be*. Think up a verb. Give them a task. Tell them what to *do*. More often than not, you'll get a much better performance.

When you're actually shooting, don't worry if your actors' performance varies a little from take to take. That's a good thing. Encourage it. It's a sign they're still exploring the scene, trying to keep their performance fresh. More importantly, it will give you many more choices when you're editing, which means you could just end up with a scene that's far better than you originally imagined.

Preparing for Postproduction

The time you spend on set will be exhilarating, frustrating, inspirational, maddening, and magical all at the same time, and until you experience it, there's no way to completely understand it. There's often so much going on it's difficult to keep track of all the details. That's one reason you do so much planning. The more preparation you do, the less likely you'll be to let something slip through the cracks.

The careful organization you do during planning should be continued when you're shooting. The more organized you are as you shoot, the easier your editing and postproduction will be. Two techniques that will help keep you organized during shooting are *slating* and keeping *script notes*.

Slating

Everyone knows what a movie slate looks like (refer back to Figure 6.18 if you need a reminder). On professional sets, the camera operator shoots a few seconds of the slate and then *clacks* the clapper at the beginning of every take. This serves two purposes. It visually identifies each shot by recording the scene and take number within the first few frames, and the *clack* provides a visual and aural reference to synchronize the production track if you're recording separate sound.

Being able to specifically identify each take just by looking at the initial frames makes editing much easier, but you don't have to have an actual movie slate to accomplish the same results. You can shoot a piece of notebook paper with the scene and take number written on it, or you can announce in a loud, clear voice "Scene 4, Take 2" at the beginning of your take. If you're not shooting separate sound, that's all you have to do.

But what if you're shooting separate sound and you don't have a slate? All you have to do is clap your hands. As we'll see in the chapter on editing, the sharp noise of the clap can be used to synchronize your sound just as easily as the clack of a slate.

Script notes

In addition to uniquely identifying each take by slating it, you should keep a written record of how many takes and angles you use to cover each scene. These written records are called *script notes*, and on a Hollywood set, there's a person called the *script supervisor* whose sole job is to make those notes.

A script supervisor takes notes directly on a copy of the script using a kind of shorthand (see Figure 7.10).

These notes are then given to the editor to let her know exactly how many takes and angles were filmed (and which takes the director preferred).

You may not need this level of detail on your project, but you should take some form of notes to have a record of exactly what you shot and which takes you liked.

Many student filmmakers don't bother with script notes. They're certain they'll remember what they shot and which takes they liked. But no matter how good your memory, script notes will save you hours of searching through your footage in the editing room trying to find a specific moment.

NOTE

FIGURE 7.10 On a professional set, a script supervisor takes notes directly on a copy of the script. The upper part of the figure shows how long each shot lasts, and the lower part of the figure (usually written on the back of the previous script page) gives an exact description of each shot, including the actors' blocking and the length of each take.

 ## Other On Set Considerations

The more time you spend shooting, the more you'll develop your own list of tips, techniques, and considerations. Every director has different priorities, and every director interacts differently with their cast and crew as they run a set. The more you direct, the more you'll discover what works best for you.

The following suggestions will help you find your own style of directing.

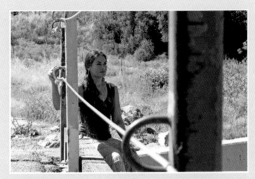

COLOR PLATE FIGURE 1 Here's an outdoor picture with the white balance set properly. Notice how the skin tone of the subject appears healthy and natural. Compare this with Color Plate Figure 2.

COLOR PLATE FIGURE 2 Here's the same picture as Color Plate Figure 1, but the white balance has been improperly set. Notice how everything has a bluish tint. This is the result of using an indoor white balance preset to shoot a scene outdoors.

COLOR PLATE FIGURE 3 This figure and Color Plate Figure 4 demonstrate the effect of using light sources with different color temperatures. Natural sunlight is coming in through the window, however the goat is being lit with an indoor movie light. In this example, the white balance is set for indoors. Notice how the goat's fur is white, but the overall picture has a bluish tint because of the sunlight coming in through the window. Compare this with Color Plate Figure 4.

COLOR PLATE FIGURE 4 In this example, the white balance has been changed to an outdoor setting. Notice how the goat's fur now has an orange tint, but everything outside the window looks normal. When you mix light sources as in this example, something is always going to end up with either a bluish or an orangish tint regardless of which setting you choose.

COLOR PLATE FIGURE 5 This figure and Color Plate Figure 6 demonstrate how you can use white balance to create images with specific color casts. In this example, the camera was white balanced using a red sheet of paper. The result is an image in which everything has a cool green hue. Compare this with Color Plate Figure 6.

COLOR PLATE FIGURE 6 In this example, the camera was white balanced using a blue sheet of paper. The result is an image with warm golden tones. Using color balance this way can produce some striking images, but you can achieve the same effect in post production using your editing software.

COLOR PLATE FIGURE 7 This image was shot with the intention to create a *day for night* effect. Notice how the subject's face is mostly in shadow. Look at Color Plate Figure 8 to see the same image after some processing to make it look like night.

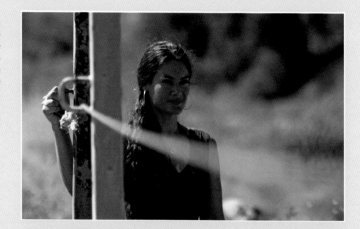

COLOR PLATE FIGURE 8 This is the *day for night* effect created with Color Plate Figure 7. In order to create this effect, we lowered the contrast of the image and added a blue filter with our editing software. Notice the resulting image is highly stylized. It wouldn't be appropriate for every night scene, but it can be very effective when properly used.

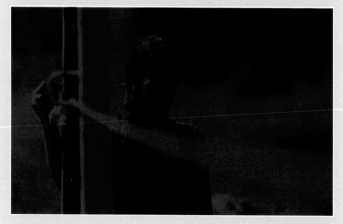

COLOR PLATE FIGURE 9 This is an example of a typical color corrector supplied with most editing software. Notice it has controls that allow you to adjust hue, saturation, and white balance. Color Plate Figures 10-13 show the results you can achieve by changing hue and saturation.

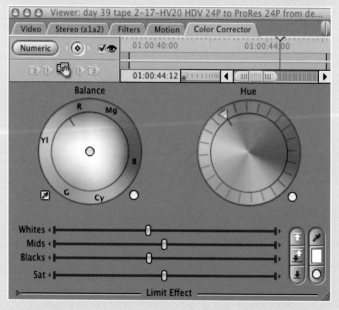

COLOR PLATE FIGURE 10 This figure and Color Plate Figure 11 demonstrate the effects of altering the hue of an image. In this example, the hue has been shifted towards the red end of the spectrum. Notice how the skin tones of the actors have a rosy glow. Compare this with Color Plate Figure 11.

COLOR PLATE FIGURE 11 In this figure, the hue has been moved toward more blue tones. Notice how the entire image has a cool feeling. What subliminal message could you send to an audience about the relationship of your characters by slightly altering the hue of a scene depicting a wedding?

COLOR PLATE FIGURE 12 This figure and Color Plate Figure 13 demonstrate the effects of altering the saturation of an image. In this example, the saturation has been increased. Notice how the colors pop and have almost a comic book feeling. Compare this with Color Plate Figure 13.

COLOR PLATE FIGURE 13 In this figure the saturation has been reduced and the colors are more muted. How could you use saturation to change the impact a scene might have on an audience?

COLOR PLATE FIGURE 14 This still from *As You Like It* hasn't been corrected or altered in any way. This is how the camera captured the image. In Color Plate Figures 15 and 16, you will see two different *preset color corrected looks* applied to this scene.

COLOR PLATE FIGURE 15 This is the still from Color Plate Figure 14 after using the preset look called *Basic Sepia*. It creates a desaturated image with a brownish tint. This look is often used to make footage look old-fashioned.

COLOR PLATE FIGURE 16 This is the still from Color Plate Figure 14 after using the preset look called *Cool Diffusion*. How would you describe the difference between this image and Color Plate Figure 14?

Collaborate and delegate

As the director, you're responsible for the vast majority of creative decisions on the set. People will ask you for decisions about costumes, about lighting, about performances, about framing, about sound, and about anything and everything you can imagine. Many beginning directors feel that if they don't have answers to each of these questions they'll somehow lose creative control of their projects, but the truth is you're not making the movie alone. You've got a cast and crew of creative artists working beside you. They each have talent, opinions, and ideas. The best thing you can do for yourself and the movie is tap into that resource. It's easy to do. When someone asks you for a creative decision, look them in the eye and ask, "What do you recommend?" You're not obligated to agree with them or use their suggestion, but they just might have a really good idea, or their suggestion could trigger an ever better idea in you. You'll never know if you don't ask.

While asking for input is generally a good idea, it isn't appropriate in every situation. Sometimes a quick decision is needed and there isn't time for a discussion. In those instances, make the best choice you can and move on.

NOTE

The happy accident

If you've been careful during pre-production, you've predicted and prepared for many of the things that could happen on set. You've got a list of shots and a timetable to ensure you get all the shots you need during the time you have. The more preparation you do, the more you'll be inclined to stick to the plan you created.

If you manage to shoot everything you had planned, in Hollywood lingo, they would say you *made your day*. On the other hand, if you have to stop shooting and leave before getting all the shots needed for the scene, you *didn't make your day*.

TECHIE'S TIP

Generally, sticking to the plan is a good idea, but sometimes, focusing on your plan can keep you from seeing spontaneous opportunities when they arise.

Suppose you were planning to shoot an intimate scene in a park, but when you show up at the location, you discover a local school has set up a fundraising fair complete with balloons, carnival rides, and exhibits. It's a very visual (albeit somewhat noisy) environment. You could drive across town to another

park and shoot the scene as planned, or you might decide to re-imagine the scene to take advantage of the incredible backdrop offered by the fair.

In this instance, either choice might work. The point is to look at each possible setback as a potential for something better. When viewed properly, an unexpected situation can often be turned into a positive opportunity—a happy accident.

Respect your locations

Shooting at an actual location (such as a friend's house or a coworker's office) is a very intrusive act. You're bringing a small army of people and equipment into a place in which people live and/or work. To set up certain shots, you may be moving furniture to make room for lights or the camera, and the cast and crew will be eating snacks, sitting on chairs and sofas, and using the restroom at the location. The possibility of breaking something, improperly rearranging personal belongings, or just making a mess is very high.

When you're shooting, never forget that you're a guest. Respect the location you use (even if it's your own home). Make every attempt to leave the location exactly as you found it (or even cleaner, if possible), and if you do accidentally break something, tell the owner and offer to repair or pay for the damage. It's the responsible thing to do (and it may ensure that you get to use the location again in the future).

Safety

Making movies is a lot of fun. People in movies do things mere mortals cannot. They get into fights, car chases, and shootouts and always seem to emerge with only a small scratch on their forehead or a bruise on their cheek. But everything in movies is choreographed and rehearsed to an incredible degree, and anything more dangerous than walking down stairs is performed by a stunt man or woman (despite the claims of many leading men).

Additionally, movie sets are notoriously dangerous places. Hot lights, heavy equipment, long hours, and the desire to capture unique and compelling imagery often combine to create the perfect storm for an accident.

Here's the point: No single shot, effect, or stunt is worth endangering any member of your cast or crew. You're only making a movie. If you (or anyone on your set) ever get the uneasy feeling that you're pushing the envelope a little too far, stop and re-evaluate. Nothing you could ever shoot is worth the possibility of injuring someone.

SUMMARY

In this chapter, we concentrated on two main topics: Getting ready to shoot and then actually shooting. We also spent a fair amount of time talking about what it means to be a director and how to interact with both actors and crewmembers. But you should never forget that everything you do (either in preparation or on the set) is aimed at only one objective: To tell a story with pictures and sound.

When everything else is said and done, that's all that matters. Your skill and effectiveness as a director is measured in results. If a shot doesn't look right, or a moment doesn't ring true, you have to fix it. But unless you're personally going to relight the set or act in the scene, you have to rely on the help of your cast and crew. Communicate with them. Ask their opinions. Treat them with respect. You'll end up with a better movie.

There's an old saying that writing is rewriting, and there's another old saying that every movie is written three times. The first time is on the page by the writer. The second time is on the set by the director, cinematographer, and the actors. And the third time is in the editing room. So what you're actually doing on the set is rewriting the story. You're converting it from words on a page to actions and images, and as you rewrite, you may have to make a few changes. Be on the lookout for good ideas. Be open to inspiration. And use any means at your disposal to tell the best story possible.

REVIEW QUESTIONS: CHAPTER 7

1. What is the most important skill a director must possess?

2. There are two things you're looking for when you audition an actor. What are they?

3. What does the command *first positions* mean?

4. What is *slating*, and why is it important?

5. Why should you constantly be on the lookout for *happy accidents*?

DISCUSSION / ESSAY QUESTIONS

1. Why are leadership skills important for a director?

2. What is *breaking down a script*, and why is it important?

3. Why is having food on the set important?

4. What is the difference between *result-oriented direction* and *process-oriented direction*? Give examples.

5. Why is collaboration important on a set?

Research/Lab/Fieldwork Projects

1. Watch the *Making Neo's Ring* video included on the companion DVD and listen to the director's commentary. Even if you've already seen it once, watch it again. It will mean more now.

2. In Chapter 2, you had to flesh out the story for the dialogue scene given. Then in Chapter 4, you designed coverage for that story. Now you're finally going to shoot the scene. Here's the plan:

- Get together with at least two other filmmakers. One of you will be the director, one of you will be the camera operator, and one of you will be the boom operator.

If you're using lavalieres or plant mics instead of a boom, then the third person on the crew will be in charge of lighting the scene.

NOTE

- Each of you should have your own version of the scene. Between the three of you, choose one of the scripts to use for this exercise.

- Break the scene up into thirds.

- You will switch directors for each third of the script. Set up a rotation in which you each direct, operate the camera, and boom (or lights) for a third of the script.

- As a team, complete all the necessary casting, rehearsing, and preproduction.

- Shoot the scene!

- Compile your dailies.

THE CUTTING ROOM

OVERVIEW AND LEARNING OBJECTIVES

In this chapter, you will:

- Learn the purpose of editing
- Become familiar with the basic characteristics of all editing software
- Explore key editing concepts
- Learn how to shape a story
- Understand the incredible importance of pacing
- Start to think like an editor

Where it All Comes Together

Until now, we've concentrated on the tools and techniques used in production. Our focus has been on collecting the images and sounds we need to tell our story. But that's only the beginning of the process. After production comes *postproduction* (or *post*, for short), and that's where the real magic takes place. Post is where all the story pieces you collected during production are carefully assembled into a final product.

Post is often the most labor-intensive and time-consuming part of making a movie. For example, in Hollywood, they may spend three or four months shooting a film, but over six months to a year completing postproduction. At the beginner level, it could easily take two to four weeks to edit a short you shot in only two days.

Why does post take so long? Think of it this way. You're putting together a very complicated jigsaw puzzle, and the pieces of that puzzle fit together in many different ways. There's no single, absolute right way to solve the puzzle, and even though you *thought* you knew how the pieces were going to fit when you began, things don't always work out that way. Many times you end up rewriting and reinventing parts of the story along the way. That's how movies are made.

NOTE

Before the days of computers, all editing was done with razor blades, tape, and glue. The film was cut into individual shots, and those shots were spliced together to create scenes, and because the editing room was where the film was sliced and spliced, it was called the cutting room.

The magic of editing

Postproduction has many parts. You're manipulating the images you captured during production. You're creating a world of sounds and music. You may even be changing the laws of nature with special effects. But at the root of postproduction is editing. That's where you first assemble the images and moments of performance you captured on the set.

Editing is truly magic. In the editing room you'll bend time and space. You'll create moments and performances that never actually happened. You'll create drama or comedy or tragedy, and you'll manipulate the expectations and experience of an audience merely by rearranging sounds and images. The editing room is where the story is rewritten for the third and final time as it becomes a movie.

Beyond the magic, editing is one of the best ways to become a better director. Why? Because after you've spent some time trying to piece together a story with incomplete coverage, you develop a keen sense of exactly which shots are needed to complete a scene.

NOTE

Editing Software Basics

In this chapter, we'll explore the theory and practice of turning shots and takes into scenes and sequences. But before we talk about the hows and whys of editing, we need to spend a few moments learning about the tools you'll be using. We need to explore some basic characteristics shared by all editing software.

Computers and editing

Editing images and sound on a computer is a relatively new concept. Up until the mid-1990s, film was edited by hand and videotape was edited using videotape players and recorders. This type of editing was very similar to writing a letter by hand. You started at the beginning and put one shot after another until you got to the end (much like putting one word after another on a piece of paper).

When computers entered the equation, everything changed. You no longer had to assemble shots in a linear fashion from start to finish. You could move easily and instantly anywhere within a project as you were editing, and you could make as many changes as often as you liked. This type of editing was *nonlinear*, and it was more like using a word processor than writing something out by hand.

SIDE NOTE

NONLINEAR EDITING: A NEW CONCEPT

All computer-based editing systems are called *Non-linear Editors* (or NLEs, for short), and the best way to understand the concept of something non-linear is to realize what it isn't—it isn't linear.

Something that's linear proceeds in a straight line from start to finish. You can't get to the middle or end of a linear object without going through the beginning. A standard videotape is an excellent example of something linear. You can't get to the middle of a videotape without running the tape past the beginning. You can fast

forward the tape, but you still have to physically wind through the beginning of the tape to access the middle or end.

With something nonlinear, you can instantly access any part of the object just by selecting it. A DVD is nonlinear. You can jump instantly to any spot on a DVD without having to wade through the beginning or middle of the material.

With nonlinear editing, you have instant access to any of the shots or sounds you captured during production. You no longer have to find the reel of dailies that contains a desired image and wind through the film to find where the shot begins. You just have to select the shot and it pops up on the monitor.

Of course, being able to find any given shot quickly depends on being organized and having good notes, but that's a requirement in any type of editing, linear or nonlinear.

As a matter of fact, there are many similarities between digital editing and word processing. When you're writing on a computer, you're arranging words to form sentences and paragraphs. When you're editing, you're arranging images and sound to form scenes. In each case, you're trying to communicate a thought or tell a story.

It's Nondestructive Too!

Another key difference between editing by hand and using a computer is the idea of *nondestructive editing*. In the old days when you wanted to make an edit, you had to physically cut the film. That's a destructive process because you can't *uncut* a piece of film (you could splice the film back together or print a new copy, but you were still dealing with actual, physical film stock).

 All figures and shorts are included on the companion DVD with this book.

With computer editing, all you're doing is moving electrons around. It's all virtual. Your original footage is never altered. If you don't like an edit you've made, all you have to do is hit *undo* and it's as if the edit never happened. That's nondestructive editing.

This capability has greatly changed the process of editing, and made it possible to try many different versions of a scene quickly and easily.

Of course, having the ability to instantly try and undo endless variations sometimes makes it harder to make a final decision. Endless flexibility and unlimited options don't always make a better product.

NOTE

Getting your footage into the computer

Before you can do any editing, the first thing you've got to do is transfer your footage from the camera to your computer's hard drive. There are many ways to do this, depending on your computer and your camera, but the basics are fairly simple:

- If you're using a tape-based camera, connect your camera to the computer with a Firewire. Make sure the tape you're transferring is in the camera and has been rewound. Your editing software will have an interface that allows you to control the camera and transfer your shots from the camera to the computer (see Figure 8.1). This process is called *capturing*.

This text will use examples from the Final Cut Express editing software, but the concepts are the same no matter which program you actually use. The only thing that changes are how the controls are laid out.

NOTE

- If you're using a camera with a memory card, you'll connect the camera to the computer with a USB cable (you could also use a dedicated card reader instead of the camera). Each separate shot will be a file on the card, and the process of capturing is as simple as transferring each file to your hard drive. Consult the instructions for your camera and your editing software to determine where and how to copy the files.

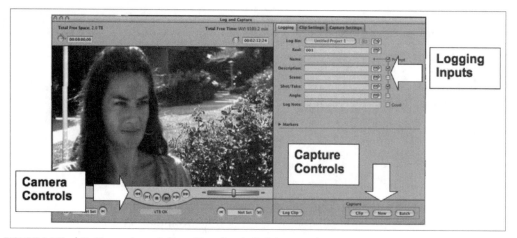

FIGURE 8.1 Final Cut Express has a dedicated interface (called the *Log and Capture Window*) for controlling the process of capturing video to the computer. Using this window, you can label (or *log*) each clip and cue up the camera. You can also capture an entire tape at once.

> **NOTE**
>
> *Because tape is linear, transferring the shots from the camera to the computer proceeds in real-time. If a scene runs for five minutes, the tape will play for five minutes as the scene is captured by the computer.*

As your individual shots and audio recordings are captured by the editing software, they're turned into computer files. These computer files are called *clips*. A clip will usually have both a *video track* and an *audio track*. We'll talk more about tracks and clips in the next section.

> **NOTE**
>
> *The discussion of computer-based editing is intentionally generic and nonspecific to any individual piece of software. Read the documentation (or help files) for your particular software to discover which keys and mouse clicks you should use.*

Editing software components

Regardless of which software you're using, there are three components every editing program will have. Those components are:

- The Bin
- The Viewer
- The Timeline

Some editing programs also have a fourth component that allows you to see the timeline as it plays. Final Cut Express calls this window the Canvas *(see Figure 8.2).*

NOTE

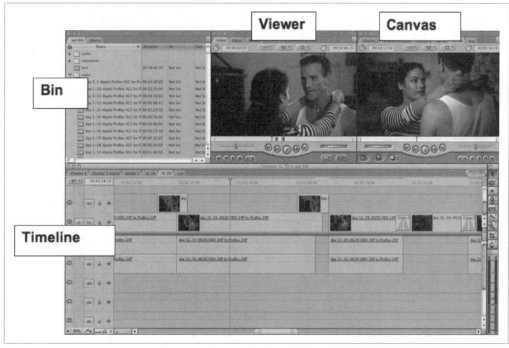

FIGURE 8.2 The editing interface for Final Cut Express consists of four basic windows: the *Browser (or Bin)*, the *Viewer*, the *Canvas*, and the *Timeline*. These windows are described in the next few sections.

Transferring scenes from a memory card to your computer is usually much faster than real-time. A scene that runs for five minutes will usually be captured in far less time. Exactly how long the transfer will take is determined by the speed of your computer and the data transfer rate of your hard drive.

NOTE

The Bin

The bin is a window that shows you all the audio and video files (or clips) in your project. Some programs allow you to create separate folders within the bin to help organize your shots (see Figure 8.3).

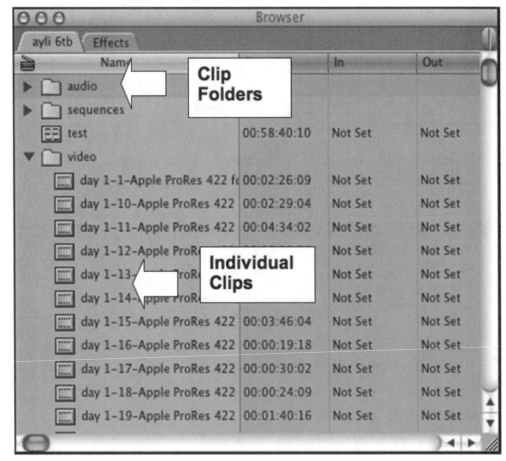

FIGURE 8.3 The *bin* in Final Cut Express is called the *Browser*. This is where all the *clips* (image and sound files) in your project are stored.

NOTE

In the days of cutting film by hand, editing rooms contained large steel barrels that resembled trash cans. These barrels were lined with canvas bags, and there were hooks above the barrels on which the editors would hang the individual strips of film that comprised separate shots. These barrels were called bins.

The Viewer

The viewer is a window in which you can watch the video clips of your project. Some programs have a single viewer that's used both to preview individual clips and to watch the collection of clips as they appear on the *timeline* (see the next section). Other programs have two separate viewers: one for watching clips from the bin and a second viewer dedicated to showing the

timeline (see Figure 8.4). A viewer will typically have control buttons along the bottom to allow you to move through the clip or timeline.

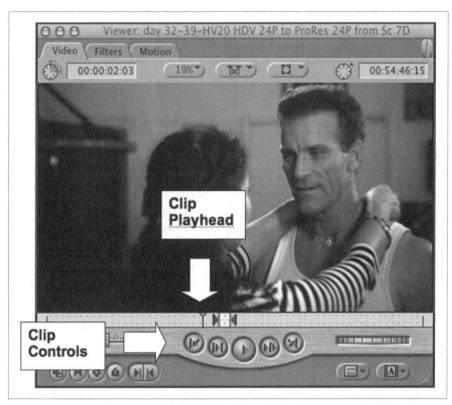

FIGURE 8.4 The *viewer* allows you to watch clips so you can make decisions about which parts of each take to use. The *control buttons* along the bottom work like the controls on a camcorder or tape deck. You can also control the clip using *keyboard shortcuts*. In most editing programs, hitting the *space bar* will cause the clip to play and using the *arrow keys* will allow you to move through the clip one frame at a time.

In Chapter 1, we talked about the idea of using a separate hard drive to store your video files. Keeping all the files for a certain project on a small, portable hard drive has many benefits. It helps you keep organized. It allows you to edit your project on more than one computer by simply plugging your hard drive into different computers (as long as each computer has the same editing software), and it keeps the hard drive on your computer from filling up with video files (which can significantly decrease your computer's performance).

TECHIE'S TIP

The Timeline

The timeline is the heart of all editing programs. It's a graphical representation of the editing choices you make as you create your project. Think of it like this—if you took a finished film and rolled it out onto a table, you'd have a timeline. You'd be able to see each shot individually in their proper order. You'd be able to see where each shot started and stopped, and you'd be able to see how long each shot was. The timeline shows the clips of your project in a similar manner (see Figure 8.5).

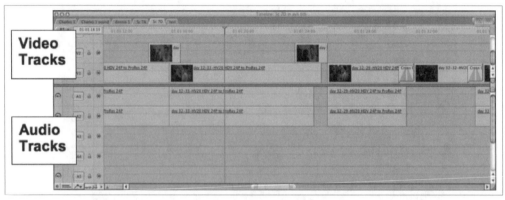

FIGURE 8.5 The *timeline* is a graphic representation of the *clips* you've selected for your project, laid out in the order in which they will appear. The timeline shown here has clips on two video tracks and two audio tracks. There are more tracks available, but they're currently empty.

The timeline is where you'll assemble the video and audio clips as you edit. Depending on which software you're using, the timeline can have several, separate *tracks* for both audio and video.

KEY TERM:

TRACKS Each track on a timeline represents a separate collection of clips. Tracks are stacked on top of (or underneath) each other (see Figure 8.6). There are both audio tracks and video tracks. When multiple audio tracks are played simultaneously, you can hear them all at the same time (unless you choose to hear only certain tracks by muting the others). When multiple video tracks are played together, you will see only the uppermost track (the highest track in the stack).

The ability to layer several different audio and video tracks gives you enormous creative flexibility.

FIGURE 8.6 The timeline shown here has two video tracks and four audio tracks. Video track one (V1) is linked to audio tracks one and two (A1 and A2). V2 is linked to A3 and A4. In this example, V2 is muted (not visible) as are tracks A1 and A2. When this timeline plays, you'll see V1 and hear the audio from tracks A3 and A4.

Timeline Basics

Before you start editing, there are a few features and concepts of the timeline you must know. While there may be slight variations from program to program, every editing timeline will have the following characteristics and capabilities:

- **The playhead.** A symbol that moves along the timeline (or through a clip) as the project is played. The location of the playhead corresponds to the image shown in the viewer and can be used to locate a particular location within a clip (see Figure 8.7).

- **Markers.** As the name implies, markers are used to mark certain spots in an audio or video clip. Using markers can make it easy to identify and return to specific sounds or images within your clips (see Figure 8.8).

- **In- and out-points.** An *in-point* is where a clip starts. An *out-point* is where a clip ends. You can change the in- and out-points of your clips, which will change where they start and/or where they end. The process of making a clip shorter by changing its in- or out-points is called *trimming* (see Figure 8.9).

FIGURE 8.7 The *playhead* on the timeline corresponds to the location in the clip where the image displayed in the *viewer* (or *canvas*) is located. As a clip plays, the playhead moves from left to right. In most programs, you can click on the playhead and manually move it left or right with your mouse to rapidly move through a clip.

TECHIE'S TIP

In addition to changing the in- and out-points of your clips, you can also cut (or split) your clips into separate pieces (much like cutting a physical piece of film). But unlike cutting film, you can restore your clips (or undo the cut) with a single keystroke or click (see Figure 8.10).

- **Transition.** When two clips are placed next to each other on the timeline, you have a *transition*. The simplest (and by far the most common) transition is called a *straight cut*. A straight cut is very simple. It occurs when one clip ends and the other starts (see Figure 8.11).

The next most common transition is called a *dissolve*, which occurs when an outgoing image is gradually replaced by an incoming image (see Figure 8.12).

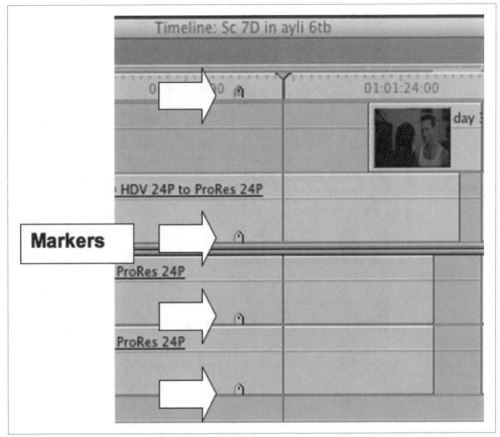

FIGURE 8.8 You can place *markers* on the timeline or in individual clips. Markers will correspond to an exact frame within a clip. Markers are very useful for identifying and aligning specific moments and sounds along the timeline.

Basic Editing

Now that you know what your editing software looks like, it's time to explore the basic mechanics of editing. In its simplest form, editing is nothing more than placing one clip after the other on the timeline. To edit a project, you would perform the following steps:

1. Review your coverage and decide which shots and takes you want to use.

2. Mark your selected clips and set appropriate in- and out-points.

3. Place the clips on the timeline in the proper order.

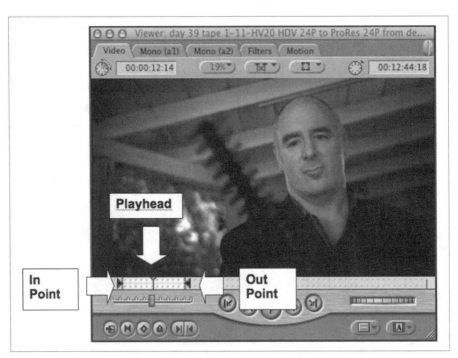

FIGURE 8.9 In this clip from *As You Like It*, we've marked an *in-point* and an *out-point* to identify where we want the clip to begin and end. Setting in- and out-points is *nondestructive*, which means they don't alter the actual clip stored on your hard drive. You can reset (or move) in- and out-points at any time.

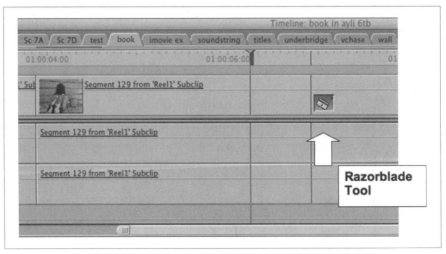

FIGURE 8.10 The *razorblade* tool allows you to *split* a clip as if you were physically cutting a piece of film. In the example shown here, the tool will cut both the *video* and *audio* tracks at exactly the same place. You can also use the razorblade to cut only the video or only the audio, and you can also undo the split and *restore* the clip at any time.

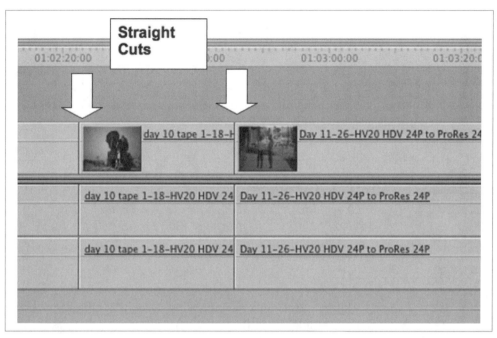

FIGURE 8.11 Two *straight cuts* from the *As You Like It* timeline are shown here. Notice the video and sound tracks for each clip start and end at the exact same place. That's what makes this a *straight* cut. If the audio and video tracks start and end in different places, you have a *split edit*, which we'll discuss later.

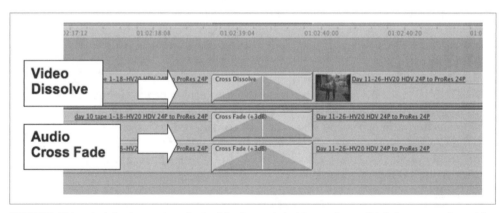

FIGURE 8.12 A typical dissolve consists of a *visual dissolve* coupled with an *audio cross fade* (where one audio track is gradually replaced by another). This dissolve is one second long, but you can make them any length. You can also do dissolves and cross fades separately.

If you don't use any dissolves or special effects, the transition between each clip will be a straight cut.

That's it! Easy, right? In theory, yes. But it rarely goes that smoothly. Deciding which takes to use and figuring out the most effective way to piece them together often takes a significant amount of time, and *matching action* can be particularly frustrating.

In the sections that follow, we're going to discuss some basic editing concepts. But we're not going to give you a click-by-click description of how to achieve these tasks with any specific editing software. For specific instructions on how to use Final Cut Express to perform these functions, see the book Film Editing Theory and Practice by C. Reed in this series.

Matching action

When you're editing, you're usually trying to create the illusion that the scene on screen is unfolding before the viewer as a single, continuous event in real-time. This is called *seamless editing* (or *invisible editing*), the process of creating the illusion of continuous action.

Of course, this isn't the way the scene was shot. During production, the scene was performed many times with the camera in different locations creating shots of different sizes from different *angles*.

KEY TERM:

ANGLE In movie lingo, every time the camera is repositioned between shots, you create a new *angle*. The wide shot, the medium shot, the various singles (and any other coverage) are all considered to be different angles. When reviewing footage, it's common for the editor to ask, "Have you got any other angles on this?" (*Translation*: Is there more coverage of this scene shot from a different angle?)

The only problem with shooting a scene many times from many angles is that each time it's performed, the scene will be probably be slightly different. These slight differences are called *continuity errors*.

> **KEY TERM:**
>
> **CONTINUITY ERRORS** This term refers to any differences that exist between takes and angles of a scene. If an actor scratches his nose on a different line in different takes, that's a continuity error. If a clock on the wall shows a different time in different takes, that's a continuity error as well. On a Hollywood set, the *script supervisor* is in charge of ensuring continuity errors are avoided.

The fact that each performance is slightly different is both a blessing and a curse. It's a blessing because differences in performance give you more flexibility to *build a better performance*. It's a curse because differences between shots that are supposed to match make it harder to create a seamless edit.

> **KEY TERM:**
>
> **BUILDING A PERFORMANCE** One of the most satisfying challenges in editing is *building a performance* from different takes. By carefully choosing and assembling performance moments from a variety of takes, you can create dramatic (or comedic) moments with more nuances (or more impact) than ever existed in any single performance.

Fortunately, there's a technique all editors use to help make their cuts invisible. That technique is *cutting on action*.

Cutting on action

The best way to make an edit look seamless (and to hide continuity errors) is to cut on action. Here's how it's done (see Figure 8.13):

1. Pick a physical action performed by an actor in the scene. This action can be as small as a leading lady turning her head, or as large as a bad guy kicking in a door.

2. Pick the two shots you want to cut between. Usually, you'll be changing image size on the cut (i.e., cutting from a medium shot to a closeup).

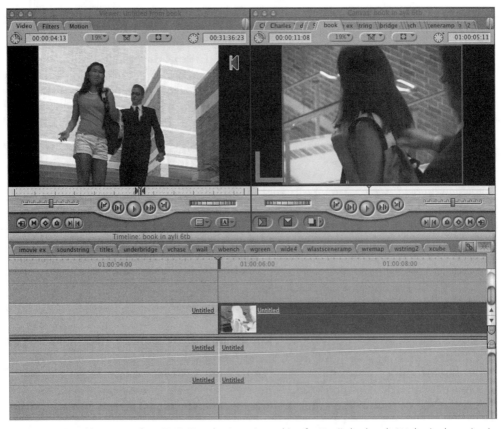

FIGURE 8.13 In this moment from *Neo's Ring*, the Agent is reaching for Traci's backpack. We begin the action in the shot on the left, where the agent steps forward. We find the same moment in the shot on the right to continue the action. This is called *matching action*, and when the edit is played, the action will flow smoothly across the cut.

NOTE *The greater the change in image size, the easier it is to hide continuity errors.*

3. Pick a spot halfway through the action in each shot. The goal is to begin the action in the *outgoing shot* and complete the action in the *incoming shot*. Mark the out-point of the outgoing shot and the in-point of the incoming shot.

KEY TERM:

OUTGOING AND INCOMING SHOTS The shot you are cutting *from* is called the *outgoing shot*. The shot you are cutting *to* is called the *incoming shot*.

4. Put the outgoing and incoming shots on the timeline. Play the edit and see how it looks. If the cut *bumps*, make a change to either the out-point or the in-point and watch the edit again.

> When a cut isn't seamless, it *bumps* or doesn't flow smoothly. When it's seamless, you don't notice the edit at all. You start in one shot and finish in another, but the transition feels natural and doesn't call attention to itself. Sometimes changing the in- or out-point by a single frame will make the difference between an edit that *bumps* and one that doesn't.
>
> **TECHIE'S TIP**

Jump Cuts: The Deliberate Mismatch

Being able to create invisible, seamless edits is a prized editing skill. When used in a movie, these cuts ensure the action flows smoothly and the audience is swept effortlessly through the story, blissfully unaware of any continuity errors.

But suppose you don't want the story to flow smoothly. Suppose you want to create a disjointed, alienated feeling that fragments time and experience. Then you might deliberately choose to make edits that didn't match. Cuts that ignore matching action and call attention to themselves are called *jump cuts*.

Because action isn't smoothly depicted in a jump cut, it creates the feeling of jumping past a moment of time. These cuts are useful if you want to show a character feeling disoriented and out of sync with the world around her.

Dissolves and other transitions

We've already talked about *straight cuts*. You'll use these more than any other type of transition. We've also introduced *dissolves* in which the outgoing image is gradually replaced by the incoming image. This is the second most-used transition. Generally, a dissolve implies a passage of time, especially when used within the same scene or location. Contrast this with the straight cut where you're trying to create the illusion of continuous, uninterrupted action. Unlike straight cuts, dissolves call attention to themselves, but in a gentle way (not like the jump cut, which is intentionally jarring). They can also be used to ease an audience into or out of a scene. This would be useful if you've had an intense, emotionally-charged scene and you wanted to give the audience a chance to reflect on their own thoughts and feelings before moving on with the story.

Dissolves are measured by their duration. A quick dissolve could be as short as four frames in duration and a long dissolve could last for several seconds (see Figure 8.14).

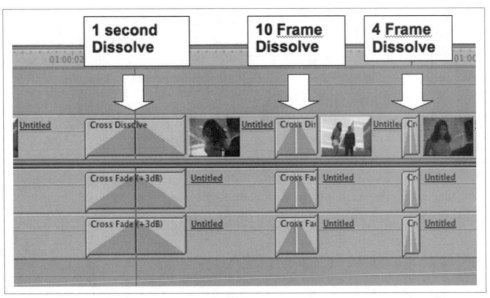

FIGURE 8.14 Dissolves of different lengths will affect the audience in different ways. Long dissolves have a graceful, elegant quality and are often used to signal a significant transition from one place to another. Short dissolves are more commonly used within a scene and signal slight disruptions in the normal flow of time.

Most other transitions fall into the category of *wipes*. In a classic wipe, one image pushes the other off the screen (see Figures 8.15, 8.16, and 8.17).

TECHIE'S TIP

There's another use for dissolves that isn't discussed much outside the editing room. Dissolves are an easy (and some say lazy) way to avoid continuity errors. Since the dissolve implies a passage of time, audiences don't expect exact matching between shots connected by dissolves. Sometimes this can be useful in situations where there seems to be no other way to deal with impossible continuity challenges. That's when experienced editors say, *"If you can't solve it, dissolve it."*

In most editing programs, there are an almost infinite variety of shapes and styles of wipes. Wipes are fun to play with, but they all call attention

to themselves. They're useful when you're mocking certain filmmaking conventions, but unless you're intentionally trying to be cheesy, you should avoid them in narrative filmmaking.

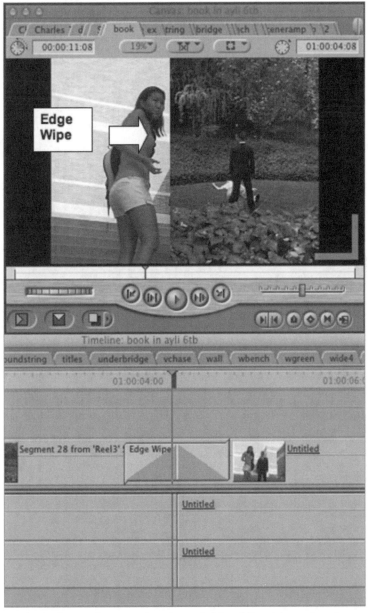

FIGURE 8.15 In a classic *edge wipe*, the *incoming image* is revealed from left to right as a bar *wipes* across the *outgoing image*. The wipe can also occur from right to left or top to bottom.

The following figure shows a *clock wipe*.

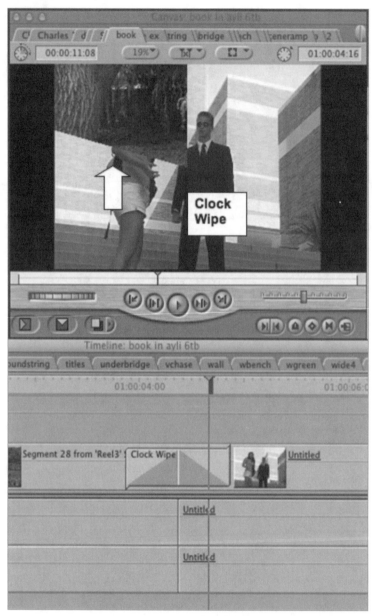

FIGURE 8.16 The *clock wipe* is more stylized. It occurs as a circular sweep moves across the outgoing image in a clockwise direction. This is not a subtle wipe and should only be used when the nature of the transition is part of the tone of the total project.

The next figure shows an *iris wipe*.

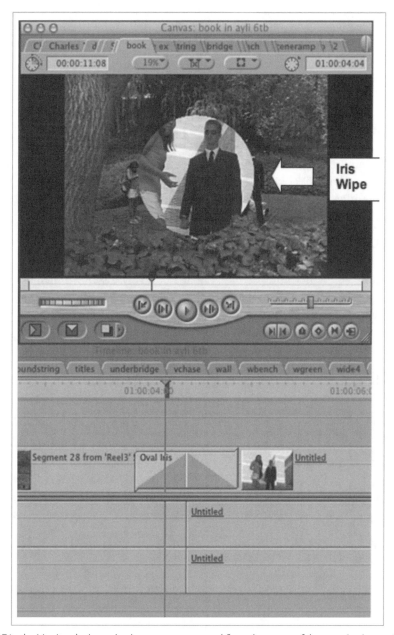

FIGURE 8.17 In the *iris wipe*, the incoming image grows outward from the center of the outgoing image. The wipes pictured in the last three figures are only a small fraction of the wipes available in any editing program. Experiment to see what your software can do.

One of the simplest wipes goes back to the earliest days of filmmaking. It's the iris-in *and the* iris-out. *You'll see these at the beginning and end of silent films (and old cartoons) in which a black circle opens up to reveal the image at the beginning, or closes down to obscure the image at the end.*

Cutting sound and picture separately

So far, we've treated picture and sound as if they were a single track. Every time we've cut the picture, we've cut the sound. That's the definition of a straight cut. But in reality, picture and sound are separate tracks on the timeline and can be cut and moved separately. Anytime you cut or move the sound of a shot separately from the associated image, you create a *split edit*. This gives you a great deal of flexibility when cutting a dialogue scene (which we'll discuss a little later).

The most basic type of split edit is to have the sound of a shot extend beyond the visual boundaries of the image. The first example of this is when the sound of an incoming scene is heard before we see the images that go with that sound. This is called *prelapping* (because the sound *precedes* the image). This type of cut is also called a *J-cut* because it resembles the letter *J* on the timeline (see Figure 8.18).

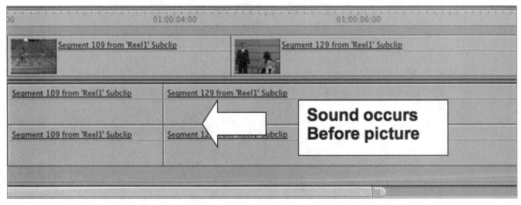

FIGURE 8.18 The video and audio tracks of *a J-cut* resemble the letter J on the timeline. In this configuration, the sound is heard before the associated image is seen. This is also called *pre-lapping* the sound.

The other way to use this technique is to have the sound of the outgoing shot continue *under* the first images of the incoming shot (*post-lapping*). This is called an *L-cut* because the edit resembles an *L* in the timeline (see Figure 8.19).

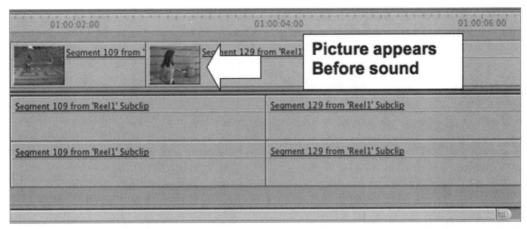

FIGURE 8.19 In an *L-cut*, the picture is seen before the associated sound is heard, as in the timeline shown here. This is called *post-lapping* because the sound occurs later than the image.

Pre- and post-lapping sound is a way to imply a deeper connection between the incoming and outgoing scenes. For instance, pre-lapped sound can be used to indicate a character is thinking about the images or activities about to appear in the incoming scene.

In most video-editing programs, the video and audio tracks of a shot are linked, *which means when you cut or trim one, you cut or trim the other. To edit sound and picture separately, you'll need to* unlink *the audio and video tracks for certain shots. Consult your documentation about how to link and unlink tracks if necessary (see Figures 8.20 and 8.21).*

NOTE

Some editing software, including Final Cut Pro, has a Linking tool you can use to link and unlink video and audio tracks.

Mid-chapter status check

FIGURE 8.20 One way to *link* and *unlink* video and audio tracks on the timeline is by selecting or deselecting the *Link* option in the *Modify* menu.

By now, you should feel comfortable performing basic editing functions. You should know how to capture footage. You should know how to select clips and trim them. You should know how to place clips on the timeline and create seamless edits with matching action. You should also be able to manipulate the audio and video tracks of a shot separately.

NOTE *For the rest of the chapter, we'll assume you know how to perform basic edits with your software. If you're still unsure of how to perform these functions, consult your software's documentation.*

Storytelling Conventions

Before we say any more about editing techniques, we need to spend a moment talking about storytelling. We introduced the basic elements of story in Chapter 2, and we said every story needs a beginning, middle, and end. We also discussed creating characters and situations that would spark the curiosity of an audience and make them care about what happens next. These are the elements you should consider as you figure out what will happen in your story.

But after you've figured out *what happens* in your story, you need to decide *how* you're going to *tell* the story. Think of it this way—the *what happens* aspect of a story determines all the events and information the story contains. The *how you tell it* aspect is the order in which you present this information to your audience. From this perspective, storytelling is the art of controlling the flow of information an audience receives.

Linking Tool

FIGURE 8.21 Final Cut Express also lets you *link* or *unlink* tracks using the *Link Button* in the toolbar above the timeline. Whichever method you choose, you must unlink audio and video tracks before you can create a split edit.

Once you know what happens in the world of your story, you have three opportunities to decide how you'll reveal that information to an audience (i.e., how you'll control the information flow):

1. **In the script.** When you write the script, you make conscious choices about when and how the audience will learn different elements of your story.

2. **On the set.** When you design coverage and shoot the script, you choose how you're going to present information to an audience visually.

3. **In the cutting room.** When you edit, you assemble all the story elements (both pictures and sounds) in the order that best tells your final story. Many times you'll rearrange scenes in ways different from the script and different from the ideas you had while you were shooting.

We said earlier that the first step in editing is to review your footage. That's when you'll look over everything you've shot and think about how best to assemble the images and sounds you've collected. Your ultimate goal is to tell your story in the most compelling and impactful way possible, and that goal should guide every choice you make.

But there are some general guidelines to help you as you start assembling your footage. We'll talk about these guidelines next, but never forget they're not hard and fast rules, they're only suggestions. You're always free to make any choice you feel is best for your story.

Convention one: Big to small

In classic Hollywood filmmaking, the convention is to start a scene with the widest shot available, and then use shots that are progressively tighter as the scene plays out. When using this convention, the first shot is often a long shot of the building or location in which the scene takes place and is called the *establishing shot* since it *establishes* the location of the scene.

> Often, the dialogue of the master shot will pre-lap under the establishing shot to let the audience know who's in the scene even before the viewers see their images.
>
> **TECHIE'S TIP**

After the opening shot, you'll generally see a master shot of the action in which you learn who's in the scene and establish the *geography* of the location.

Following the master shot, they'll cut to a medium two-shot (assuming it's a two-person scene), then they'll use matching over-the-shoulders, and finally clean single closeups by the end of the scene (see Figure 8.22).

FIGURE 8.22 This is a typical editing progression based on shot size. Image 1 *establishes* the *geography* of the scene. Image 2 serves as both a *master* and a *two-shot*. The progression from image 3 through 6 then occurs as the scene develops.

Notice that you're getting progressively closer to the actors each time you change image size, which matches the concept that you're learning more about the characters as the scene progresses and you're becoming increasingly familiar with those characters and their situation.

During the days of the studio system in Hollywood, movies were churned out with factory-like precision. Directors would sometimes shoot a film, turn the footage over to the editors, and move on to another project. Editors would then assemble the footage using standard conventions like the ones we're discussing. If you watch movies from the 1930s to the 1950s, you'll notice many of them share similar visual styles and editing conventions.

NOTE

Convention two: Shot size relates to emotional intensity

This convention is related to convention one. According to this convention, changes in shot size are directly related to changes in the emotional intensity of the scene. This convention assumes you have a scene that's getting more and more intense as the scene progresses.

For example, a scene may start with two characters having a mild disagreement. As the scene unfolds, the discussion gets more and more heated until one of them insults the other. The insulted character steps back, and there's a moment of awkward silence. Then the disagreement begins again as both characters begin to shout. Finally, the character that was insulted slaps the other character and storms out.

If you were to graph the emotional intensity of this sample scene from beginning to end, you would get something that looked like Figure 8.23.

Standard Hollywood convention would start this scene in a wide shot and move toward closeups as the disagreement intensified. Following the insult, the scene would cut back to the master for the moment of silence. Then the progression toward closeups would begin again, culminating in a tight closeup right before the slap. After the slap (or during the slap, if you were cutting on action), you'd cut back to the master as the insulted character storms out (see Figures 8.24, 8.25, and 8.26).

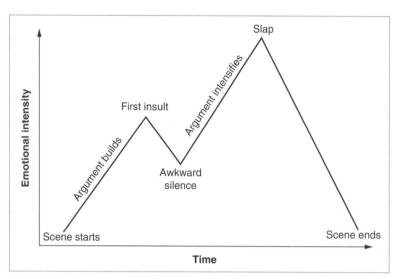

FIGURE 8.23 When editing, it's important to know how the emotional intensity of a scene changes as the scene progresses. The graph above is one interpretation of the scene discussed in this section (and visually represented in Figures 8.24, 8.25, and 8.26).

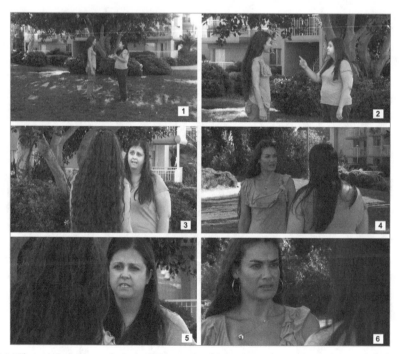

FIGURE 8.24 These six images match the build in emotional intensity as the argument approaches the first insult. In image 5, the insult is spoken by Vanessa. After the insult, you might hold on image 6 for a moment to let us see Victoria's reaction. Then you could cut to the first wide shot in Figure 8.25 to briefly release the tension.

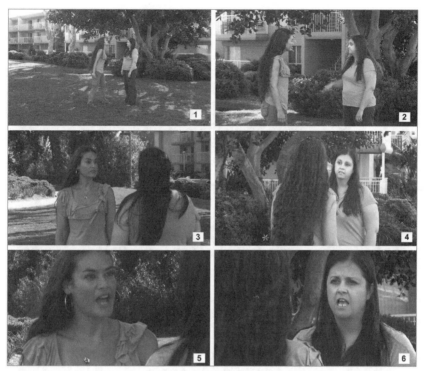

FIGURE 8.25 After an awkward silence, the tension begins to build again as the argument intensifies. As the emotions get higher, the images once again move closer. Emotions peak in images 5 and 6. Note: You may not need all the coverage in shots 2 through 4, depending on the script and the dynamics of the scene.

Convention Two and a Half: Shot Size Holds and Releases Tension

As we saw in the last example, scenes with escalating tension usually build to a breaking point after which the tension is released. These builds and releases are what keep a story moving forward emotionally, and the moments of release are just as important as the tension created in dramatic moments. That's because there's a limit to how long you can keep an audience engaged in highly-charged moments.

You can see from our discussion of emotional intensity that closeups hold tension. The larger an actor's face onscreen, the more we relate to her emotional state. By contrast, the smaller an actor is in frame, the more removed we are from her feelings. Editors use this fact when assembling a scene.

And finally, we now see the end of the scene in Figure 8.26.

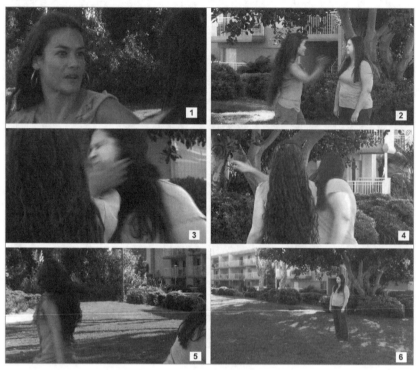

FIGURE 8.26 When the argument reaches its emotional peak after the final insult, Victoria slaps Vanessa and storms off. This is shown in a series of quick cuts (carefully observing matching action). The scene ends with a long shot of Vanessa as the tension of the scene bleeds off. Note: No actors were harmed (emotionally or physically) in this exercise.

NOTE *The limit of a story to sustain tension is directly related to the skill of the storyteller. Talented directors can create more tension and keep it going longer than those with less skill.*

To build tension, use more closeups. To release tension, cut to a wide shot.

TECHIE'S TIP You've probably heard the term *comic relief*. A classic storytelling convention is to follow a scene of high drama with a lighthearted moment to give the audience a chance to relax. The *relief* of a comic moment releases the tension of the drama that came before. Skillful editing also creates moments of tension and release for an audience.

Convention Two and Three Quarters: Changes in Shot Size Signal Changes in Direction

So far, we've said that changes in shot size are related to changes in dramatic intensity. As the drama builds, the shots get closer. But what if your scene doesn't have a dramatic build?

> *Some folks would say if your scene doesn't have a dramatic build, then it doesn't belong in your movie. But that's a discussion for a screenwriting class.*

NOTE

Changes in shot size can also signal that a scene is changing direction. For example, if two characters were talking about a test at school and the conversation changes to a discussion of the upcoming spring formal, you could change shot sizes to indicate which subject mattered more to those characters.

If the dance were more important, then you might cut to closeups as they began talking about the dance. But if the test were more important, then you'd be in closeups when they were talking about the test and cut out to a wider shot as they began to discuss the dance.

Convention three: Reactions are king

We've talked before about the idea that storytelling is controlling the flow of information you give a viewer. This becomes especially important when you're cutting a dialogue scene. A common mistake made by beginning filmmakers is thinking they have to show the person who's actually talking on screen during a conversation.

While someone is talking, we're receiving information from his dialogue, and unless he's having an emotional revelation while he's speaking, it's usually more interesting to see the reaction of the person he's talking to while the dialogue is occurring. That way, we're giving the audience two streams of information at the same time: The information contained in the words of the dialogue and how that information is affecting the person hearing it.

The added bonus of using reaction shots is that you don't have to use the actual reaction that took place when the performance occurred. You can *steal* any reaction shot from anywhere in any take, as long as the reaction is appropriate to the dialogue being delivered (see Figure 8.27).

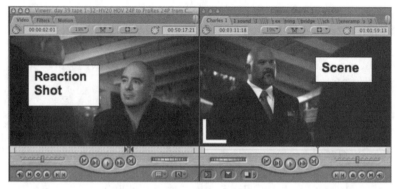

FIGURE 8.27 In this scene from *As You Like It,* Charles the Wrestler discusses his upcoming match with Orlando. Charles' performance plays out as seen in the Canvas on the right. The reaction shot on the left actually occurred at a different part of the scene, but was used here to cover an edit where we switched between two different takes of Charles' coverage.

While we're looking at a reaction shot, we can cut between different *line readings* from different takes of the dialogue since we don't have to worry about the visual continuity of the speaker (refer back to Figure 8.27).

KEY TERM:

STEALING A SHOT When you're editing, any shot you've captured at any point during shooting is fair game (as long as it matches). When you find and use a shot from a different take or a different part of the scene and use it in a way it wasn't intended, that's called *stealing a shot* (not to be confused with shooting at a location without a permit, which is also *stealing*).

This ability to pick and choose among reaction shots and line readings is one way to build a performance, and it's one of the most powerful techniques an editor can use. In a scene that isn't just a conversation, you can cut away from the speaker to show objects in his environment or things he's working on while the dialogue is playing.

KEY TERM:

LINE READINGS Different interpretations (or different performances) of the same lines in different takes are called *line readings*. By carefully choosing different line readings from different takes, you can sculpt very powerful performances.

By showing the audience things other than the speaker in a dialogue scene, you're giving them additional streams of information without taking any additional screen time. This will improve the pace of your story.

The Incredible Importance of Pacing

The pace of your story is the speed at which new information is revealed to the audience. This new information can be visual (as in many shots cut together quickly), it can be informational (as in many lines of dialogue delivered rapidly), or it can be emotional (as in significant evocative events occurring during a short time frame).

It's commonly acknowledged that most beginner films move way too slowly. If you've written the script or composed the shots or directed the performances, you probably have a certain affection for the footage you're assembling. There's a common tendency among beginning editors to think that every moment is significant and should be given enough screen time to create a powerful impact on the viewer.

But the reality is audiences are very sophisticated. They *get* what a scene is about very quickly, and when a scene keeps dragging on after an audience has grasped what's happening, they either tune out or feel insulted (think about how *you* feel when a movie insists on moving very slowly).

Remember that pacing is measured by how often you're presenting new information to the audience. No matter what's happening in a scene, the audience should be getting new information from the screen or your soundtrack during every second that passes.

One way to get a feel for your pacing is to show the project to someone who hasn't seen it. As the story plays, pay attention to your own reactions. If you find yourself wanting to jump in and say "Something really cool's about to happen," or "Wait for it...wait for it..." then your pacing is too slow. Or if someone turns away from the screen to ask you questions while the story is playing, that's an indication you haven't fully captured their attention. You may need to tighten up the story.

TECHIE'S TIP

Improving your pacing

It's been said that a well-cut scene is like a Hollywood party. Your goal is to arrive late and leave early. What does that mean? It means whenever possible, you should cut to a scene already in progress, and you should cut away from the scene as soon as you've shown the most significant moment. Everything else is *shoe leather*.

KEY TERM:

SHOE LEATHER In movie lingo, scenes of characters walking from place to place are called *shoe leather*. Sometimes shoe leather scenes are justified, for example, if they serve as a release of tension or show a significant transition. But if shoe leather is only showing a character getting from one place to another, it's probably extraneous. For this reason, shoe leather is also used to describe unnecessary transitional material between scenes that should probably be cut.

Consider a scene in which your main character arrives home to find a note from his girlfriend informing him that she's breaking up with him. When you edit this scene, you could show him walking up the steps, coming through the front door, checking the mail, going to the kitchen for a snack, dropping off his backpack, and then finding the note on the counter. That would be a chronological way to tell the story (which contains some shoe leather).

NOTE *However the scene begins, from this point forward, you'd spend the rest of the scene exploring his reaction to the news.*

An alternate way to present this information could be to start with a closeup of the note and hear the front door opening. After a *beat*, you'd then see a backpack landing on the counter next to the note as your leading man finds the bad news.

KEY TERM:

BEAT When you're discussing editing or acting, a *beat* refers to a short pause. But there's no exact definition of how long a beat is. It's as long as it needs to be.

Which version is better? That depends on your movie and what happens before and after this scene. But the second version is definitely faster and gets right to the point.

The key to improving your pacing is to look at your movie with a ruthless eye. Any moment in which the audience isn't receiving new, significant information has to go. Sometimes this means cutting out one of your favorite shots (which was really cool, but which slowed the story down). Sometimes it means taking out lines of dialogue (good actors can say more with a single look than you can reveal with a whole page of dialogue). Sometimes it even means losing entire scenes (audiences are good at *connecting the dots*, and you rarely have to show them as much as you think).

Almost every DVD has deleted scenes (and sometimes even alternate endings). Why do you think that is? It's because even the best directors often cut entire scenes to improve their pacing. But even scenes removed to improve pacing can have cool performances and effects. So the director keeps them for the DVD.

NOTE

No single shot, or line, or scene is more important than keeping the story moving. When you're working on pacing, nothing should be sacred except keeping the audience engaged. Only by being ruthless will your story reach its full potential.

SUMMARY

We covered a lot of ground in this chapter. We started with an introduction to nonlinear editing and learned how clips are transferred to your computer. We looked at software and the basic concepts of the bin, the viewer, and the timeline. Then we introduced the fundamental building

block of all editing—the straight cut. From there we looked at other transitions, continuity, cutting on action, and working with picture and sound separately.

And that's just the beginning, an introduction to the tools you need to put a story together and build performances. Learning how to do these things is like learning how to write. You have to be able to write to tell a story. But there's a big difference between putting words on paper and storytelling, and there's a difference between assembling clips on a time-line and real editing. To really edit, you have to know how to tell a story.

We also discussed storytelling and editing conventions because it's important to remember that when you're editing, you're rewriting the story. You're using the shots and sounds you captured during production to re-imagine the story originally conceived in the script.

It's important to keep an open mind during editing because once you're dealing with actual shots and sounds, they take on a life of their own, and as you assemble them, the story may change. Moments you thought were critical may turn out to be extraneous, and random shots you captured on a whim could turn out to be profound when used in the context of your emerging story.

Finally, we looked at pacing, which is critical to the success of any visual story. We discussed the need to be ruthless during editing. You have to be willing to cut anything that doesn't propel the story forward, even if it's your favorite scene.

We covered a lot of ground, but we really just scratched the surface. Editing is something you have to experience to understand; you have to wade into the footage and let it wash over you. Only by wrestling with shots and sounds and learning their logic will the process make sense. As you edit your own footage, you'll be frustrated and exhilarated and disappointed and awestruck all at the same time. This is normal. This is editing. This is filmmaking.

1. What is *nondestructive editing*?
2. What does the playhead do?
3. Why is matching action important?
4. What does a *J-cut* do?
5. What does it mean when an audio and video track are *linked*?

DISCUSSION / ESSAY QUESTIONS

1. Does nonlinear editing make an editor's job easier or harder? Why?
2. When would you use a jump cut?
3. What's the difference between watching a scene in a wide master and watching the same scene in tight closeups?
4. How can you use reaction shots to build a performance?
5. What makes pacing so important?

Research/Lab/Fieldwork Projects

1. On the DVD there is a folder called "Harried Clips." In that folder, you'll find video clips of the coverage for Scene 3 from the romantic comedy short *When Harried Met Sally*. You'll also find a copy of the shooting script and the shot plan in the course documents folder. Your job is to cut together a version of the scene using the footage provided. The following guidance applies:

- You don't have to use all the shots provided. Use the ones you think tell the story best.

- You don't have to strictly follow the script. If you think a line is redundant or that a series of lines would work better if they were slightly rearranged, you can make changes as you see fit. The only restriction is that you may not alter the overall meaning of the scene. Your final cut must work within the context of the story as a whole.

- Concentrate on using the dialogue, but don't forget that your primary focus is to tell the story visually—use reaction shots and cutaways as needed.

- Remember, this scene doesn't stand on its own. It has a responsibility to the scenes before and after it, and it must meet that responsibility.

- Don't obsess over sound or any effects beyond putting the scene together (we'll cover those topics in the next chapter).

The best way to get the footage into your editing program is to copy the entire folder (the one called "Harried Clips") to the hard drive on which you usually capture video footage. Then open your editing program and import the clips one by one. Once they show up in your editing bin, you can cut them as usual. To save space, we've only provided one take from each angle.

NOTE

2. In the last chapter, you shot the story you wrote in Chapter 2. Now it's time to edit that story. But there's going to be a twist: You divided the scene into thirds when you shot it, and you're going to edit the scene in thirds as well.

- Every member of the team gets one of the thirds to edit. No one should be editing the portion of the scene they directed.

- Cut your third of the scene. Feel free to ask the director of your third what their intent was, but you have final say in any creative disputes.

- Don't obsess over sound or any effects beyond putting the scene together (we'll cover those topics in the next chapter).

- Compile the rough assemblies of your thirds.

POSTPRODUCTION SOUND AND VISUAL EFFECTS

OVERVIEW AND LEARNING OBJECTIVES

In this chapter, you will:

- Learn postproduction techniques for dialogue
- Learn postproduction techniques for music and effects
- Get prepared for (and complete) the final mix
- Understand color correction
- Experiment with other cool visual effects
- Put the final finishing touches on your project
- Get ready to screen your masterpiece

You're Not Done Yet

So you've spent a few weeks going through all your footage and building the most compelling performances possible. You've cleverly restructured your story to cover the unusable handheld shots you thought would be edgy but just looked bad. You're sure the pacing and structure can't possibly get any better. So you decide to *lock the picture*.

KEY TERM:

PICTURE LOCK When the director and editor are happy with the edit, they *lock the picture*. Once a picture is locked, you're not allowed to make any further picture edits. Picture lock is important because it lets the sound editors and the composer know there won't be any further changes to the length of the film (which is important if you want the soundtrack and score to stay in sync).

But locking the picture doesn't mean the movie's finished. Not by a long shot. If sound is more than 50% of the movie-watching experience, you're only halfway through.

We talked about the inescapable importance of sound in Chapter 6. We're going to continue that theme in this chapter as we explore how all the sound elements you captured during production are assembled (along with a whole collection of sounds created or found after production is over).

Beyond sound, we're going to look at all the other effects that make a well-produced movie different from a home video. Proper image adjustment and *color correction* are vital to giving your movie that blockbuster feel (or making it look like your favorite indie film). Final touches like titles and letterboxing will also give your finished project a polished and professional finish.

KEY TERM:

COLOR CORRECTION The process of changing the color characteristics of your visuals is called *color correction*. But even though the process is called *correction*, the goal isn't to obtain the most technically correct and lifelike colors. The goal is to alter the colors to achieve maximum dramatic impact for your particular story.

Sound Postproduction

Before we get into the specific techniques and considerations of sound postproduction, let's get philosophical for a minute. Everyone understands the importance of creating stunning (or sometimes disturbing) visuals for a movie. When shooting a film, you're often trying to create and depict a unique visual world in which your story is taking place. And that unique world, in addition to having a specific look, should also have a specific sound. Think of your favorite sci-fi or fantasy film. The universes in those stories sound as magical as they look.

The techniques used to create those soundscapes are what we'll discuss in this section. But to create it, you've got to imagine it, and when you're trying to imagine the world in which your story takes place, it helps to think of sounds as being in one of three concentric circles (see Figure 9.1).

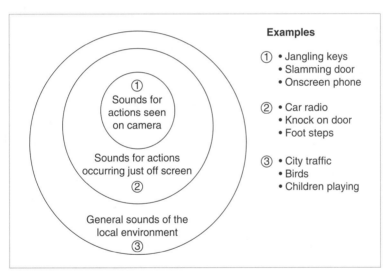

FIGURE 9.1 A well-designed soundtrack will incorporate more than just the sounds for the actions and dialogue appearing onscreen. Finding unique sounds for the environment in which your story takes place will make it easier for the audience to fully immerse themselves in the world of your characters.

The largest circle holds the general sounds of the local environment. If your story takes place in a city, this is where traffic sounds, or the wail of a distant siren would be heard. If your story is in the suburbs, you might hear the chirping of birds, an occasional dog bark, or the sounds of children playing.

ON DVD All figures and shorts are included on the companion DVD with this book.

The second circle contains sounds of things that are happening just off camera. If you're in an office, this could be the sound of someone typing in the next cubicle or a subdued conversation just offscreen. Or in a home you might hear the radio or TV show your character is watching.

The sounds in the third circle are for things we see onscreen. Someone sets down a glass, or slams a car door, or picks up a jangling set of keys. If we can see it onscreen, there should be a sound associated with it. The more sounds you add to each of these circles, the more rich and multilayered the world of your story becomes.

So as you collect the sounds for your movie and start to build each of your individual tracks, keep the world of your story in mind. What unique sonic elements surround the people who live there? Is it a tranquil place to live, or is there an oppressive quality to the sounds bombarding them? Or maybe everything is spooky and a little unsettling. Be as specific as possible when imagining what that world sounds like. It'll only make your final movie (and your story) better.

A quick review

To begin our discussion of sound postproduction, let's review some key concepts that we covered in the chapter on production sound. All these concepts will be important as we begin cutting and assembling our soundtrack:

- The many elements of a soundtrack can be grouped into three broad categories. Those categories are *Dialogue*, *Music*, and *Effects* (abbreviated D, M, E).

- The primary goal when recording dialogue on set is to get strong, *clean* vocals with presence. A line of dialogue is considered clean if no other sounds occur when the words are being spoken.

- Having clean dialogue and production sound effects will allow you to build tracks with *separation* (i.e., the level of each line and sound effect can be adjusted separately).

- Your ultimate goal is to create a well-balanced soundtrack in which the *levels* (relative volumes) of each element complement each other and you can hear each word and effect clearly. The completed combination of relative volume levels is called the *final mix*.

With these concepts in mind, let's take a look at how you prepare your production sound for maximum separation and control in your final mix.

Dialogue

Let's assume you have perfect production dialogue in a scene between your leading man and leading lady. Your leading man has a deep bass voice and your leading lady speaks in silky-soft tones. If you followed classic technique, you got a single mono production dialogue track that contains both their voices (or you might have two identical mono tracks in a stereo pair, depending on how you mic'd the scene).

If your levels were good, and each character spoke with the same volume you might not need to do anything to prepare the dialogue track. But suppose the male voice is consistently louder than the female voice (a common occurrence on production tracks). You'll probably want the option of raising the volume for each of your leading lady's lines....

But wait! Aren't both voices on the same track? How can you raise the level of one without raising the level of the other? The answer lies in a technique called *checkerboarding*.

Checkerboarding

Checkerboarding is a way of creating two or more separate tracks from a single mono production track. The goal is to get the separation you need for a professional sounding final mix. Here's how you do it:

- Go through your production track and create a separate audio clip for each line of dialogue by splitting the tracks during the pauses. In the example that follows, the dialogue alternates between Vanessa and Victoria.

NOTE

If you have more than two characters in a scene, create more than two tracks. Each character should have a track of his or her own. The reason it's called checkerboarding is because the resulting tracks create a checkerboard pattern on the timeline.

- Move all the dialogue for each character to a separate track. Be careful not to let the dialogue slip out of sync during the move.

- You should now have two separate tracks—in this case, one for Vanessa and one for Victoria (see Figure 9.2).

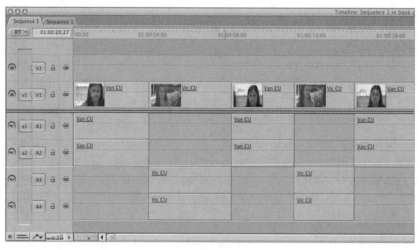

FIGURE 9.2 In this scene between Vanessa and Victoria, we've placed all Vanessa's dialogue on audio tracks *one* and *two*. Victoria's dialogue has been moved to audio tracks *three* and *four* (each character has two tracks because the audio was recorded as a stereo pair). This gives us complete separation of their dialogue and will make mixing their individual levels much easier.

That's it. You can now manipulate the levels and *equalization* separately for each track.

KEY TERM:

EQUALIZATION The process of changing the *frequency characteristics* of sound is called equalization. The two most commonly used frequency characteristics are *bass* and *treble*. Using an equalizer (or the equalization feature of your editing software), you can add or remove bass or treble from any sound. You can think of equalization as color correction for sound (see Figure 9.3).

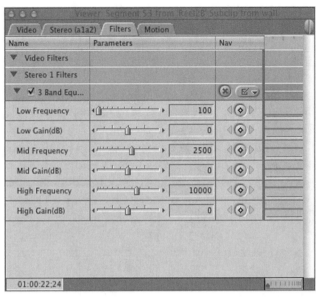

FIGURE 9.3 The *Three Band Equalizer* in Final Cut Express allows you to isolate and adjust three separate frequency bands. The *low* frequency corresponds to *bass* and the *high* frequency corresponds to *treble*. The *mid* frequency is where most human voices are usually found.

As shown in the following figure, Final Cut Express allows you to isolate and adjust three separate frequency bands.

Creating Even More Separation

Checkerboarding is such a powerful technique it's used for more than dialogue. Suppose that during your dialogue scene the female character opens and closes the front door.

> *Of course your characters were very careful not to actually deliver a line while the door was opening and closing, so their lines are clean. Since their lines are clean, the sound of the door is also clean.*

NOTE

So when you're splitting (or separating) your tracks, you should also create a track for *production sound effects* (sounds other than dialogue that occur on the production track). This will allow you to control the level of each effect separately from the dialogue.

While you're splitting out the dialogue and production sound effects tracks, you'll also be *cleaning* your tracks—which means you'll be removing any

unwanted sounds that occur between the lines of dialogue. For example, suppose a dog barks between two lines. Unless there's supposed to be a dog in the scene, you'd want to remove the sound of the bark.

TECHIE'S TIP

But suppose the dog barks during a line of dialogue? Then you're stuck with it. Hopefully, you noticed the dog barking while you were shooting and did another take (that's one reason you need to wear headphones and monitor the dialogue while shooting). Or maybe you did a wild line instead. Or maybe you decide to keep this take but replace the dog-spoiled lines with audio stolen from another take. Whatever your solution, you're going to need a clean version of the line to get rid of the dog. Even with the latest digital technology, there's no dog bark neutralization filter.

Room Tone

So now you've gone through your production track and removed all the barking dogs, sirens, and squealing children. Unfortunately, this leaves holes in your soundtrack, and holes sound different than silent moments in your scene. If you don't know the difference, play back part of your soundtrack in which you've removed a sound. Notice how the sound completely drops away? That's a hole. If you have any holes in your final soundtrack, the audience will notice and briefly disengage from your movie.

NOTE

Anytime there's a technical glitch on screen (either in the soundtrack or the visuals), an audience will momentarily disengage from the story and realize they're watching a movie (and a flawed one at that). In movie lingo, you'd say the audience was taken out of the movie at that moment.

How do you plug the holes left behind when you remove a sound? Remember the 60 seconds of room tone you recorded at each location? You fill the holes with room tone. Room tone keeps the sound from dropping away and keeps the audience engaged in your story (see Figure 9.4).

Replacing Dialogue

We've already talked briefly about replacing individual lines of dialogue. This is something to consider when parts of the production dialogue for a specific take are unusable. You'll usually have two primary sources of replacement dialogue: Stealing (also called *lifting*) dialogue from other takes or using wild

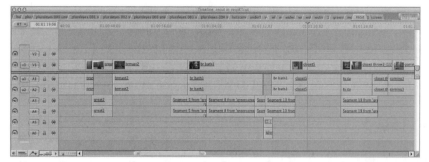

FIGURE 9.4 This section of the timeline from *Neo's Ring* shows how *dialogue, sound effects*, and *ambience* are all combined to create a more complete soundtrack. *Dialogue* is on audio tracks *one* and *two*, *sound effects* are on audio tracks *three* and *four*, and replacement *ambience* (room tone for an exterior location) is placed on audio tracks *five* and *six*.

lines you recorded on the set. Your goal is to find an alternate version of the flawed line that matches the original in volume, performance, and *lip sync*. This should be easy if your actor's performances have been fairly consistent from take to take.

SIDE NOTE

ROOM-TONE TRIAGE

If you're doing a lot of first aid on your dialogue tracks (i.e., removing numerous sounds and replacing many lines of dialogue), you might consider creating an entire track with nothing on it but room tone. You would then raise or lower the level of this track to smooth out variations and fill holes in your dialogue track. This is an easy way to smooth over numerous rough spots at once.

But what if you forgot to record room tone? It's possible to create a room-tone track from the "quiet space" between words or lines of dialogue in a scene. Simply find a moment in the scene where no one is speaking. Also make sure no other identifiable sound is occurring (such as clothing rustle or movement of props). Create a short clip from this section of "quiet space." Ideally, this clip would be several seconds long, but sometimes it's possible to do this with a clip only one or two seconds long.

Put this short clip on a track of its own, then paste several copies of this clip in succession on the same track. If you've chosen a clip that's long enough and has no other sounds on it, you'll have a usable track of room tone. But if there's any noticeable sound (even an unidentified *tic* or *pop*) that sound will repeat over and over in a cycle and ruin the track. If that happens, find a different clip and try again.

Depending on the dynamics of a particular scene, you may or may not be able to construct a usable track of room tone. But the way to avoid this problem altogether is to ensure you record room tone during production.

But suppose none of the alternate line readings matches the visual of the performance? In that case you have a couple of options. If the timing of the line is slightly off, it's possible to cut up the line into individual words and synchronize each word with the picture individually. Depending on how many lines you're replacing, this can be very time consuming.

KEY TERM:

LIP SYNC In the music video and concert world, lip sync usually means a performer who's pretending to sing while a recording of her performance is playing. In movies, the meaning is slightly different. When an editor talks about lip sync, he's referring to how well the audio of a replacement line matches the visual lip movements of the actor on screen.

Your other option is to recut the scene. Use a different take. Or possibly cut to a reaction shot of the person listening while the replaced line is playing. Then cut back to the original visual of the person speaking when you cut back to the original audio. If you have enough coverage (i.e., you shot enough different takes from enough different angles), you can find a solution to almost any audio problem.

TECHIE'S TIP

There's one other way to solve the problem of unusable production dialogue–discussed briefly in Chapter 6–*Automated Dialogue Replacement (ADR)*. When recording ADR, actors recreate the unusable lines in a sound studio while watching video playback of their performance.

Effects

Once you've got your dialogue tracks clean, cut, and separated (and you've replaced any unusable production dialogue), you're ready to start adding sound effects. Generally, these sound effects will come from one of four places:

- **Production sound effects.** These are the sound effects you cut out of the production tracks when you were cleaning your dialogue. They will usually consist of things like doors opening and closing, or sounds made by the actors during performance.

- **Captured sound effects.** These are *hard effects* (i.e., they correspond to actions seen onscreen) you record separately. These can be anything from the ticking of a clock on the wall to the screeching of tires as a car goes around a corner. You might have recorded them as wild sound during production, or you might go out during post and specifically create these sounds.

Online sound effects libraries are a great resource, but be sure to read the small print of their licensing agreement. Since the libraries technically own the sound, the licensing agreement outlines the rules and restrictions regarding the use of these sounds in individual projects.

NOTE

- **Foley.** These are effects specifically related to human movement that are created and recorded in a sound studio called a *Foley stage*. Foley usually consists of things like footsteps, clothing rustles, and sounds made when actors handle props such as dishes. The people who create these sounds are called *Foley artists*, and they watch video playback of the scenes while recording to ensure the sounds are in sync. You can think of Foley as ADR for movement-related sounds.

While you probably won't have access to a Foley stage, you can still record Foley effects by using props in a quiet environment.

NOTE

- **Cut effects.** These are pre-recorded sound effects that come from a sound effects library. Most editing software comes with a built-in library of sound effects. There are also many individual sound effects available for download from libraries online (see Figure 9.5).

Effects Tracks

Once you've collected all your sounds, the next step would be to build separate tracks for each category of effect. For example, you'd have separate tracks for production effects (both naturally occurring and created) for Foley and for cut effects. Depending on the sophistication and complexity of the soundtrack, there might be several tracks within each category (i.e., separate Foley tracks for footsteps and props, or a separate track just for sounds associated with cars).

FIGURE 9.5 *Sounddogs.com* is one of many online sites with sound effects (often abbreviated as *sfx*) you can download and license for use. But be sure to read and understand their *licensing agreement* before using their sounds in your project (see the sidebar, "Licensing, Rights, and Royalties"). Screenshot courtesy of Sounddogs.com.

NOTE

Online sound effects libraries are a great resource. But be sure to read the small print of their licensing agreement. Since the libraries technically own the sound, the licensing agreement outlines the rules and restrictions regarding the use of these sounds in individual projects.

associated with the license. These payments can be in the form of a *license fee* (usually a one-time fee) or *royalties* (usually recurring fees based on use). These fees are one way an artist earns income with his art.

Any online site at which you can download music or sound effects will have an area where they discuss their licensing and rights. These rights will often vary from site to site and will even vary depending on how you plan to use the sounds.

For example, many sites will let you use music or sound effects for free if the project is a student film that will only be shown in film festivals. But if you were to make a deal to show your short on a cable channel for a fee, then you'd probably have to pay royalties.

Sometimes you'll see the phrase *royalty-free*. This can be a little misleading because it doesn't always mean it's free to use the material. Royalty-free might mean you pay a one-time fee to purchase an *unlimited license* (sometimes called a *buy-out*) that allows you to use the material as often as you like.

Another area to watch out for is using popular songs or theme music from television shows or movies. The rights to use this type of music will usually be very expensive and will require extensive negotiating with corporate lawyers.

But here's one bit of good news. You don't need to worry about any of this if you're making projects for your own use. A movie you only show in a class or to your friends can use just about any music or sound effects you want. However, if you want to upload your project to a video-sharing site, that's a different story. Videos posted to a website could be considered *public exhibition* and you could conceivably get in trouble for using copyrighted material.

So how can you keep yourself legal? Read and comply with the licensing agreements for any material you want to use (and stay away from known songs and theme music).

The goal is to create maximum separation (allowing for maximum control), while grouping similar sounds together (because similar sounds will usually need similar equalization and processing).

Ambience

There's one other type of effect that will also be placed on a separate track. This effect is *ambience*. In Chapter 6, we defined ambience as *the unique collection of sounds that exist at any given location.* We also talked about taking time to record the unique ambient sound present at each of your locations.

NOTE	*In addition to the sounds you record yourself, sound effects libraries also have many pre-recorded ambience tracks.*

Regardless of whether you record your own or use pre-recorded sounds, there are certain ambience effects used so often they've become standard convention. For example, most day exteriors will have an ambience track of chirping birds. If it's a night exterior, an ambience of crickets is often used.

Other common ambience tracks include city traffic for urban settings and office noises such as ringing phones and clicking keyboards for workplace environments. Laying in an appropriate ambience track and mixing it at a low level will further smooth out any imperfections in your dialogue track, adding yet another level of realism to your final mix.

Music

The remaining element of D, M, E is music. It's common knowledge that music often determines the emotional impact of a movie. It lets people know whether a scene is funny or serious, ironic or heartfelt. Many times a scene that seemed lackluster on its own will acquire great weight and significance with the right music. Obviously, proper selection and use of music will contribute enormously to the ultimate success of a film.

In general, you'll find two different types of music on a soundtrack—*source* and *score*. Source music is music that belongs within the location you're showing onscreen. For example, a song playing on a car radio or the dance music at a nightclub are examples of source music (the *source* of the music is part of the scene).

TECHIE'S TIP	One way to create original music even if you can't play an instrument is to use *loop-based music creation software*. This software allows you to create original compositions by assembling and layering pre-recorded loops of music. These compositions can often sound very professional. The added benefit of this technique is that you own the rights to the music you create. One example of this type of software is Apple's *Garageband* (see Figure 9.6).

Score is what most people think of as movie music. On many films, it's the music specifically composed for each particular moment and scene of the

story. But popular songs can also be used as score. As a matter of fact, any music that isn't source will generally be considered score, whether it was composed for the film or not.

As with the dialogue and effects tracks, you'll create separate tracks for the music in your movie, and source music will usually be placed on different tracks from score since it will need different processing.

FIGURE 9.6 Apple's *Garageband* allows you to create unique customized music for your project even if you can't play an instrument. You do this by layering and arranging pre-recorded *loops* of music on a timeline as shown here. Since you're creating the compositions yourself, you don't have to worry about rights and royalties.

Where to Find Music

There are many places to find music for your projects. If you've got any musical ability (or know anyone who does), you can create original music for

your film. In many ways this is ideal because you can custom tailor the music to your individual project. You also won't have any problems with licensing or rights when using music you've created.

Another source of music is a *stock music library*. These are collections of music created specifically for use in movies, television, and radio. You can find just about any kind of music from classical to pop to dance in these libraries, and just like sound effects libraries, there are many stock music libraries available online where you can sample, purchase, and download individual tracks and entire collections. Just be sure to read and comply with the licensing agreements for any music you use (see Figure 9.7).

FIGURE 9.7 *Freeplaymusic.com* is one of the online sites where you'll find pre-recorded *stock music* (a quick Web search will uncover many more). They each have a wide variety of styles suitable for almost any type of project and can give you a very professional score. Screenshot courtesy of Freeplaymusic.com.

Processing and mixing

Okay. You've done your preparation. You've got separate tracks for dialogue, music, and effects. You've also got tracks for each character and tracks for different categories of music and effects. At this point you're ready to apply any special processing to individual sounds or tracks and get ready for your final mix.

NOTE

Depending on how complex (or simple) your project, you may not have all the tracks we've covered. You may only have a single dialogue track, a track with a few sound effects, and a music track. That's okay. As long as you understand the importance of separation on your final mix, you're doing fine. Your soundtracks will get more complex with experience.

Processing, Filters, and Audio Effects

Depending on which editing software you're using, you probably have a variety of different audio filters and effects you can use to modify the characteristics of individual sounds (or entire tracks). Here are some of the most common effects:

- **Equalization.** As we've already discussed, this is a way to alter the frequency characteristics of sound. This is often used to add more treble (sometimes called the *high end*) or bass (the *low end*) to a track (refer back to Figure 9.3).

- **Reverb.** This is a form of echo. It changes the perceived location of a sound (i.e., reverb can make a small room sound like a concert hall). Sound without any reverb is called *dry* (and sound with reverb is called *wet*). Reverb is best used sparingly (see Figure 9.8).

FIGURE 9.8 Like all filters in Final Cut Express, the *Reverb Filter* is highly configurable. It can add anything from just a touch of reverb to great resonating echoes. The trick is to experiment with the sliders until you get just the sound you want.

- **Filters and distortion.** There are many types of filters used to create specific types of distortion. For example, you may want a line of dialogue to sound as if it's coming through a telephone (or maybe a loudspeaker). Or you might have a song you want to use as source music that should be playing from an old static-filled AM radio. A *high-pass filter* would help to create these effects (or a *low-pass filter* or a *band-pass filter* depending on the desired result) (see Figure 9.9).

- **Noise reducer.** Sometimes it's possible to reduce (or even remove) certain imperfections from production sound with a *noise-reduction filter*. Depending on the software, you can reduce hums, hisses, static, wind noise, and other background noises from production dialogue.

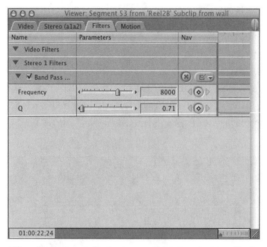

FIGURE 9.9 The *Band Pass Filter* allows you to eliminate everything except a specific frequency band from individual sound elements. Just select a frequency (using the slider), then use the *Q* slider to determine how wide the band of allowable surrounding frequencies should be (i.e., how large the *band* you want to *pass* through the filter unaffected is).

TECHIE'S TIP

Noise-reduction software usually requires you to find a section of the track with nothing but the offending sound to create a *noise print*. Then you can apply the filter in degrees to *dial out* the noise (see Figure 9.10). But the process isn't perfect. If used too aggressively, you'll get dialogue with a processed, robotic sound. Only trial and error will let you find an acceptable balance between noise and unnatural sounding dialogue.

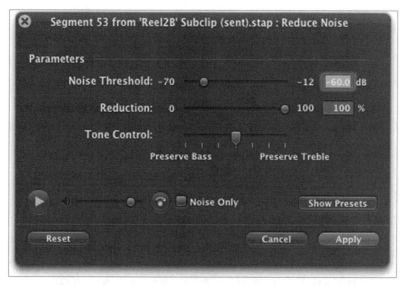

FIGURE 9.10 Noise-reduction filters are usually found in more sophisticated sound-processing software such as Apple's *Soundtrack Pro*. As with all types of digital-audio processing, noise reduction should be used sparingly to avoid creating unnatural-sounding artifacts.

The Final Mix

After you've applied all the needed filters and processing to your tracks, you're ready to begin mixing. If you were doing a full-fledged feature, now is when you'd take all your tracks (along with your picture-locked video) to a sound postproduction facility for the final mix. During the final mix, a *rerecording mixer* would adjust the levels of each line, sound, and piece of music to create the finished soundtrack for your movie.

> Most editing software allows you to set the levels of an audio clip in many different ways. One of the most common methods is by dragging a line that represents the volume of the clip up or down (this process is called *rubberbanding*, since the volume line can be moved and stretched like a rubberband). You can usually change the volume many times within a single clip by using markers called *keyframes* (see Figures 9.11, 9.12, and 9.13).
>
> **TECHIE'S TIP**

But most likely, you won't be enlisting the services of a rerecording mixer. You'll probably be doing the mixing yourself with your editing software. That means you'll be listening to each line, sound, and piece of music yourself and setting appropriate levels for each one.

FIGURE 9.11 Final Cut Express allows you to adjust the volume of an audio clip from within the timeline by raising or lowering the *volume rubberband*. This is a quick way to change the volume of an entire clip, but it's difficult to make small, precise adjustments with this technique.

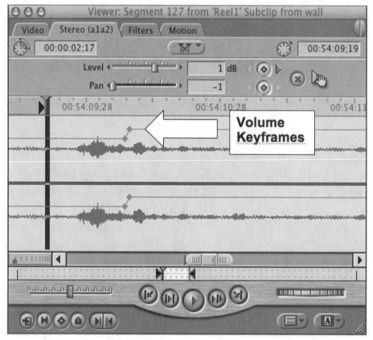

FIGURE 9.12 Another way to adjust the volume within a clip is to view the audio clip in the *viewer*. This method is similar to using the timeline, except your adjustments can be more precise because the graphic representation is larger. In order to raise or lower the volume of a specific portion of an individual clip, you need to use *keyframes*.

Some software will let you set levels for an entire track at once, and other software will require you to set the level for each clip individually. Regardless of the interface your program uses, the concept behind mixing is simple. You want to set the appropriate signal strength (level) for each individual sound (whether it's dialogue, music or a sound effect) in your project. Once you're satisfied with how each element in your soundtrack sounds relative to all the other elements, your mix is done!

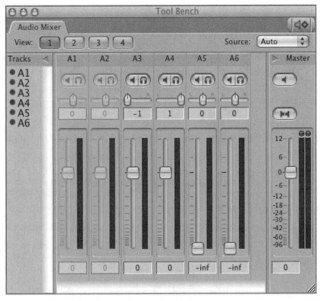

FIGURE 9.13 If you want to adjust the volume of an entire track at once, you can use the *Audio Mixer* tool in Final Cut Express. This interface is designed to mimic the controls you'd find on a professional mixing board. By using the master slider on the right, you can also raise or lower the level of the entire soundtrack at once.

But as with everything in filmmaking, the devil is in the details. It can take quite a bit of work to get everything sounding the way you want it. Here are a few pointers:

- **Get a good set of speakers.** Don't try to mix using your computer's built-in speakers. You need to be able to hear everything clearly. You should also mix in a quiet location. If you have to work someplace noisy, consider using headphones, but use a good pair of closed-back headphones (refer back to Figure 1.13). Don't try to mix using earbuds. The bottom line is this: The quality of your final mix depends on how well you can hear the material while you're setting levels.

- **Don't mix too hot (i.e., too loud).** Try to keep the average level of your mix around –12db. Remember, you can't go above 0db at any time with digital audio, and if the overall level of your mix is too high, you won't have the ability to make a particular noise or sound stand out by raising it above the level of the rest of your mix. By keeping your average level around –12db, you'll have enough *headroom* to make loud sounds be loud.

> **KEY TERM:**
>
> **HEADROOM** The difference between the average signal strength and the maximum allowed signal strength is *headroom*. It tells you how much loudness you have left before the signal distorts.

- **Get a second opinion.** By the time you're setting the final levels, you've heard each line and sound in your project many, many times. You'd be able to understand the lines regardless of how loud the other elements were. But someone who doesn't know the lines might have trouble understanding them (beginning filmmakers have a tendency to mix their music too hot). So let someone who doesn't know your film listen to the mix. You might be surprised at their feedback.

Perfecting your final mix is a time-consuming process, but it's worth the effort. Having a top-notch soundtrack will set your movie apart from the vast majority of beginner films and make it something worth listening to.

Video Finishing

Creating the perfect soundtrack is only part of the home stretch in postproduction. You probably want your movie to look as good as it sounds. We'll assume you paid careful attention to lighting and framing during production and captured well-exposed images that tell your story in a visual way. Now it's time to add some professional polish and *finish* your visuals.

> **KEY TERM:**
>
> **FINISHING** The process of adding the final touches to the images in your project is called *finishing*. With most video-editing software, it's possible to do some fairly sophisticated image manipulation with just a few mouse clicks.

In this section, we're going to cover the following common finishing tasks:

- Color correction
- Deinterlacing
- Filters and Effects
- Titles
- Letterboxing

Color correction

Earlier in the chapter, we defined color correction as *the process of changing the color characteristics of your visuals*. There are two main reasons for doing this:

- To correct white balance
- To make an artistic statement

Correcting White Balance

You already know your camera should be white balanced for the type of light hitting your subject. Improper white balance will cause your footage to have either an orange tint or a blue tint depending on the lighting. Even if you white balance before every shot, it's still possible for there to be slight color variations from shot to shot.

Ideally, you want your white balance to be consistent for the entire film (unless you're purposely skewing the color for artistic reasons, which we'll discuss next). Your editing software should have a built-in color corrector that will allow you to change the color balance of individual shots. Use this feature to correct differences in white balance so that colors and skin tones look the same for each shot in your film.

Most color correctors have a *sampling* or *selecting tool* (often shaped like an eyedropper) that allows you to sample (or copy) the color anywhere in your image. When you're correcting white balance, use this tool to select a portion of your shot that should be white. By clicking on a white reference point, the rest of the colors will automatically adjust (see Figure 9.14).

TECHIE'S TIP

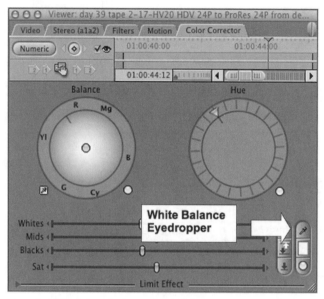

FIGURE 9.14 You can use the *White Balance Eyedropper* in the *Color Corrector* to reset the white balance of any shot. You can also use this tool to skew the white balance of a shot by picking an object in the frame that isn't white and telling the Color Corrector to use that color as the white-balance reference.

Artistic Color Correction

But color correction is more than ensuring that you have a consistent white balance. You can use color (or the lack thereof) to emphasize parts of your story. Suppose your movie is about a depressed character contemplating the meaninglessness of life. You may want every shot in your movie to have a cool, *low contrast* feel to represent your actor's state of mind. Or you may be telling an urban story set during a summer heat wave. What colors and characteristics could you use to emphasize the oppressive heat?

SIDE NOTE

A BRIEF INTRODUCTION TO COLOR, BRIGHTNESS, AND CONTRAST

To completely understand color correction, you need to know a little about how color imagery is described and manipulated. Most color correctors allow you to adjust both *hue* and *saturation*. Here's what those controls do (see Color Plate Figure 9):

Hue refers to color cast or tint. For example, if an image has a bluish tint, by adjusting the hue, you can change the color cast to any other color. If you shift the hue in the right direction, you can make the colors appear normal. White balancing is a specific type of hue adjustment(see Color Plate Figures 10 and 11).

Saturation refers to the intensity of the color. A very saturated image will have vibrant almost cartoonish colors. At the other end of the scale, an image that's completely *desaturated* will be black and white. An image with most of the color *washed out* has low saturation (see Color Plate Figures 12 and 13).

Hue and Saturation apply specifically to color imagery. There are two other descriptions that apply to all images, whether they're color or black and white. Those characteristics are *brightness* and *contrast* (and they can also be controlled by color-correction tools).

Brightness is self-explanatory. It refers to how light (or bright) the image is. When you change brightness, the entire image is either darkened or lightened. Reducing the brightness of an image is the first step to adjusting a shot to create the effect of *day for night*.

Contrast refers to the difference between the brightest and darkest elements of an image. For example, an image of a gray, cloudy sky has low contrast. An image of a dark pine tree against a white wall has high contrast. By increasing the contrast in an image, you're pushing the darker tones toward complete blackness and the brighter tones toward complete whiteness. Images with high contrast are often described as *punchy* because they seem to *pop*.

Learning how these characteristics interact is the first step in controlling the appearance of your images. All color correctors allow you to adjust hue, saturation, brightness, and contrast. There are even more sophisticated tools that allow you to adjust only one specific color or one particular part of your image.

FIGURE 9.15 In the image on the left, we've reduced the brightness to make the shot look like it was captured near twilight. Compare this with the same image on the right, where we've boosted the brightness to make it look like midday.

The following two images show how increasing the contrast in an image adds definition and makes it *pop*.

FIGURE 9.16 In this image from *As You Like It*, we've reduced the contrast on the left and boosted it on the right. As a result, the image on the left is dull and lacks definition. By comparison, the image on the right *pops* and holds your attention.

Deinterlacing

Deinterlacing is a technique you can use to make your video images look more filmic. It's an easy effect to apply (usually just a single mouse click), but to understand how it works, you need to understand *interlaced* video.

In Chapter 1, we said that typical video shoots 30 frames per second, but those images are further broken up into two fields as the image is recorded. Then when the image is recreated for playback, those two fields are *interlaced* (woven back together) to create a single image (see Figure 9.17). The visual characteristic of these interlaced images is what gives video its crisp, window-on-reality appearance.

NOTE

Interlacing is a dinosaur left over from the earliest days of television. It was created to overcome a technical limitation of old picture tubes that made TVs flicker. Modern TVs don't have that limitation and are capable of displaying progressive *images (a progressive display shows the entire image at once, instead of breaking it up into fields).*

When you *deinterlace* an image, you blend the two fields together and record them as a single image (instead of two separate fields). This process softens the harsh, edgy look of video and makes it appear more film-like.

Filters and effects

One advantage of digital video is visual effects that used to be expensive and difficult to create on film can now be achieved with a few keystrokes and mouse clicks. The number of available filters for creating effects is almost infinite and will depend entirely on which editing software you're using

FIGURE 9.17 The enlarged image on the left shows the *interlacing artifacts* that can occur when an interlaced image is shown on a *progressive* screen (such as a computer monitor). To eliminate these artifacts (as seen on the right), *deinterlace* the image using one of the video filters in your editing software.

(in addition to any standalone software you may have such as *Adobe After Effects*). Some of the common filters included with most editing software are discussed as follows:

- **Old movie/damaged film.** These filters will make your footage look like it was shot a long time ago with an old camera. Some filters will desaturate the video and make it look like faded Super 8 film, while others will make it look like a silent movie shot in the 1920s. Most of these filters will also let you add scratches, damage, and dirt to the footage to make it look even older (see Figure 9.18).

FIGURE 9.18 In this example from *As You Like It*, we've taken the original image on the left and added an *old movie filter* to the footage. In addition to changing the brightness and contrast, this filter also added dirt and film scratches to the image. Using *slider controls* in the filter, you can control exactly how much dirt and damage to add to the final image.

- **Preset color-corrected looks.** These filters apply a preset recipe of color-correction adjustments to your footage to give it a specific *look*. These *looks* have names like *Warm Diffusion* and *Basic Sepia*. Using these filters is a quick way to apply a very sophisticated collection of color-correction changes to your movie (see Color Plate Figures 14, 15, and 16).

- **Motion smoothing.** This filter can remove some of the shakiness caused by handholding a camera. In certain instances, it can make a handheld shot look like you were using a steadicam. However, motion smoothing will slightly also alter your framing and usually causes some loss in resolution.

- **Single-effect filters.** There are many filters that add a single specific attribute to your shots. Some of these effects are *Blur, Glow, Sharpen, Solarize, Mirror,* and *Flop*. You may not use these filters often, but they can be very evocative at the right moment (see Figure 9.19).

FIGURE 9.19 In this example, we've added a slight *blur filter* to the image on the right. But before adding the blur, we placed an *oval mask* over Phoebe's face (which means everything except her face blurred). Notice how this makes her face stand out and gives her clean separation from the background.

TECHIE'S TIP

These are just a few of the many filters available. Trial and error is really the only way to become familiar with how these filters work and the effects they create. Don't be afraid to experiment. But don't use an effect just because it's cool either. A splashy effect that calls attention to itself can sometimes distract the audience. You should only use an effect if it makes your story more compelling and effective.

Titles

You know you're almost done when you're thinking about titles! Although you might think titles are pretty straightforward, there are a few important considerations to discuss. But before we can talk in much detail, let's define a few terms.

KEY TERM:

OPENING CREDITS These are the titles shown at the very beginning of a film. They usually list only the most important crew members (Producer, DP, Director), the cast members in major roles, and the title of the film. Sometimes a brief scene may appear before the opening credits. This scene is called a *cold open*.

KEY TERM:

SERIF AND SANS SERIF These terms refer to font types. A *serif* font has small decorative strokes or "tails" at the beginnings and ends of some letters (see Figure 9.20). A *sans serif* font doesn't have these decorative elements. Generally, *sans serif* fonts work better for movie credits.

This is a *serif* font This is a *sans serif* font

FIGURE 9.20 The *serif* font on the left has small decorative details on the tops and bottoms of the letters. These details often don't look right in computer-generated video titles (especially if the letters are moving—such as rolling end credits). A *sans serif* font like the one on the right looks much better when rendered and shown on video.

But that doesn't mean you should never use a splashy animated font in your credits. Just be aware of how you're affecting the audience. Don't forget that opening credits generate the first impression an audience receives of your movie. Make sure that first impression is a good one.

When choosing your font sizes, be sure to consider the different ways your movie will be seen. If most people are going to see your project on a big screen TV, then you can use relatively small fonts. But those same fonts might be unreadable by someone watching your movie on their mobile phone or over a video streaming website.

KEY TERM:

CLOSING CREDITS These are the titles shown at the end of a film. They typically include the entire cast and crew as well as any thank-yous.

A general rule regarding credits is *the simpler the better*. This seems to run contrary to the many title styles available in your editing software, where you'll see choices like *Bouncing, Tumbling, Unscramble, Spinning, Flying,* and *Gravity*. While these styles can be used to set a certain lighthearted, comic tone, they're not a good choice for most projects.

KEY TERM:

TITLE CARDS These are individual titles (or groups of titles) that appear one after the other as single pages (or cards). Opening credits typically use title cards.

Hollywood convention is to use a combination of title cards at the beginning of a movie and a title crawl at the end. The title cards will usually be either superimposed over pictures or simple white type on a black background. While these choices may seem boring and uncreative, they work because audiences are used to seeing them and they let you get on with telling your story while still giving cast and crew appropriate recognition for their work.

TITLE CRAWL (OR ROLLING CREDITS) These are the credits that scroll up the screen from bottom to top. They're typically used for closing credits.

Letterboxing

Just about everybody knows that *letterboxing* is a way to show widescreen movies on a regular television by adding black bars to the top and bottom of the image (see Figures 9.21 and 9.22). The reason this is necessary is because movies have a different *aspect ratio* than regular television.

ASPECT RATIO This describes the ratio between the length and width of a rectangular object. It's a way to describe how square or elongated a rectangle is. For example, a perfect square has an aspect ratio of one to one (which means that the sides are the same length as the tops and bottoms). You'd write that ratio as 1:1. A nonwidescreen television (which is almost square) has an aspect ratio of 4:3 (which means it's slightly longer than it is tall), and a widescreen television has an aspect ratio of 16:9 (see Figure 9.23).

Why do you care about aspect ratio? Because different video formats and different televisions have different aspect ratios. Standard-definition digital video has a 4:3 aspect ratio (like standard-definition television), while high-definition formats have a 16:9 aspect ratio. If you shoot in high definition, but plan to make a standard-definition copy of your project, the resulting image will be letterboxed, and when standard-definition material is shown in a widescreen format, vertical black bars called *columns* or *pillars* are added to the sides of the image.

FIGURE 9.21 The *letterboxed* aspect ratio of *Neo's Ring* was created in postproduction by adding a *wide-screen matte filter* to the original image. The original image captured by the camera was the 4:3 aspect ratio shown on the left.

As You Like It was shot in HDV, which gives the image a 16:9 aspect ratio, as shown in the following figure.

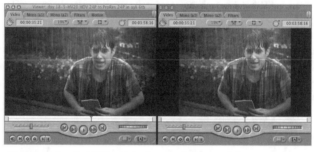

FIGURE 9.22 *As You Like It* was shot in HDV, which gives the image a *16:9 aspect ratio* as seen on the left. If this image were shown on a *4:3 aspect ratio* screen (such as an old standard definition TV), the image would be cropped as seen on the right.

NOTE

Movies weren't always shown in the widescreen format. Until the mid-1950s most movies were shot in 4:3, but when television came along, movie studios were worried that audiences would stay home and stop going to movie theaters so they started adding technological innovations to their films to make the movie-going experience unique (and more spectacular than television). These innovations included stereo sound, color photography, and widescreen images.

A common technique used by new filmmakers is to add a letterbox *matte* to a standard-definition image. This changes the image to a widescreen aspect ratio, which can give a more cinematic feel to a standard-definition image.

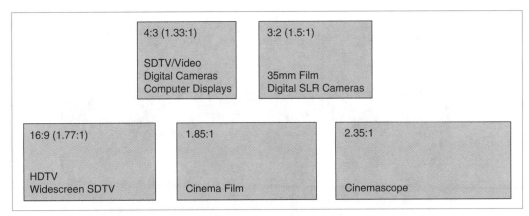

FIGURE 9.23 Different aspect ratios create rectangles with different dimensions. It's not always easy to artistically and creatively fill the image space of different aspect ratios using well-composed visual elements. Take a look at Figure 9.24 to see what a 2.35:1 matte placed on a 4:3 image might look like.

KEY TERM:

MATTE An overlay that obscures part of an image is called a matte. Mattes come in many shapes such as outlines of binoculars or keyholes. A letterbox matte places black bars over the top and bottom of an image thereby changing its aspect ratio.

Most video-editing software will allow you to apply a letterbox matte to your image through the use of a video-effect filter, and you aren't just limited to a 16:9 image. You can usually specify any aspect ratio you want, enabling you to create some very widescreen images (see Figure 9.24).

If you know when you're shooting that you'll be letterboxing the final product, be sure to frame your shots so there's nothing important along the top and bottom of your image. Also consider the fact you're losing screen real estate by using a letterbox matte. This will make your resulting image smaller (and more difficult to see on mobile devices with tiny screens).

NOTE

FIGURE 9.24 In this image from *Neo's Ring*, we've placed a *2.35:1 matte* over the original 4:3 image to give the shot a *Cinemascope* feeling. The long horizontal aspect ratio of 2.35:1 highlights the strong horizontal graphic elements created by the stairway behind Traci.

SUMMARY

In this chapter, we covered elements of postproduction beyond the editing process. Primarily, these consist of creating your soundtrack and adding finishing touches to your project such as color correction and titles.

But most of the chapter was devoted to preparing for and completing your final mix. This is an area in which many beginning filmmakers

make mistakes. They don't realize that sound is more than 50% of how you experience a film. An audience is far more willing to put up with a substandard picture than with substandard sound. The vast majority of what you hear in a movie isn't recorded during production; it's created after the fact. This is where a thorough understanding of postproduction sound is important.

We covered the preparation of various tracks and sound elements in pretty significant detail. You won't use all these techniques in your first few projects, but if you've got some troublesome moments on your dialogue track, remember you can always steal dialogue from unused takes and smooth everything out with room tone and ambience. Selective use of these and other techniques can create a very professional-sounding project without too much extra effort.

We also looked at a few finishing touches including color correction, deinterlacing, filters and effects, titles, and letterboxing. These types of enhancements are crucial to how an audience experiences a film, but the good news is improvements in digital-video and postproduction software have made very sophisticated techniques and effects available to everyone.

People unfamiliar with how films are really made tend to think that production (the actual shooting of your footage) is the magical part of making a movie. While it's true that production is the glamorous (and sometimes nerve-wracking) part of filmmaking, the real magic happens during postproduction. That's when all the separate bits and pieces you collected during production are pieced together to make a finished film.

It's often said that the last 10% of any project takes 90% of your time. This is especially true in filmmaking. As you've seen in the last two chapters, there's an incredible amount of work between calling *cut* on the last day of production and screening your finished movie. Be sure to take the time during postproduction to get things right. It can make or break the success of your finished project.

1. What is picture lock and why is it important?

2. Describe the process of checkerboarding.

3. What is source music and when would you use it?

4. What is deinterlacing?

5. Why would you want to letterbox your video?

DISCUSSION / ESSAY QUESTIONS

1. What are some things to consider when you're trying to decide what the world of your movie should sound like?

2. Suppose you had to replace a line in your movie with a wild line you recorded on set. What are some techniques you could use to make the wild line blend in with the production track?

3. Find a website that offers stock music. Which one did you find? What would you have to do to use their music if your short got accepted to a film festival?

4. How would you prepare for mixing your soundtrack?

5. Name a movie that has some unique color correction. Was it effective? Why?

Research/Lab/Fieldwork Projects

1. There is a folder on the DVD called "Neo Scene." In that folder, you'll find the final cut of a scene from the movie Neo's Ring. You'll also find a copy of the shooting script. The scene has not had any color correction or effects applied to it, and the sound has only the production dialogue. Your job is to finish the soundtrack and apply appropriate color correction and visual effects to the scene. The following guidance applies:

ON DVD

- The scene takes place in an alternate universe. Create a soundscape that creates a feeling of otherworldliness. Don't forget music.

- Play with color correction and add some visual effects. Try to create a universe that matches your soundscape.

- The finished movie is also included on the DVD. Try to make your interpretation of the scene different than the final movie. Be creative and take chances.

The best way to get the footage into your editing program is to copy the entire folder (the one called "Neo Scene") to the hard drive in which you usually capture video footage. Then open your editing program and import the scene.

NOTE

2. In the last chapter, you edited the story you wrote in Chapter 2. Now it's time to finish the movie. But you're not going to do it yourself. You're still going to work in a team of three:

- Edit the three thirds together so they make one complete scene.

- Divide up the responsibilities:
 - One person will be responsible for preparing the soundtrack for a final mix. Don't forget to add sound effects (including ambience).
 - One person will be the mixer and set all the final levels. This person will also select and mix the music for the scene.
 - One person will color correct the scene and add any finishing touches.

GETTING SEEN

OVERVIEW AND LEARNING OBJECTIVES

In this chapter, you will:

- Discover the importance of feedback
- Explore ways to improve your movie
- Learn about different compression and exhibition formats
- Discuss different ways to showcase your movie
- Learn about submitting to film festivals
- Look ahead to other projects and goals

Now the Work Begins

Here we are. You've finished the final mix and added some awesome (but very tasteful) effects to your movie. It's a modern masterpiece capable of redefining pop culture as we know it. Excellent! Now you're finally ready to get to work....

(Sound effect of tires *screeching* to a halt) What?!! "Wait a minute," you may be thinking, "I just spent weeks crafting the perfect script, casting, rehearsing, and doing meticulous planning. Then I designed and shot eye-popping footage and captured compelling performances, which I carefully cut into a story both edgy and touching with just a dash of irony. I composed original music and designed a detailed sonic landscape and everything works together to create a groundbreaking filmic experience. What do you mean I'm ready to *start* work?"

Fair question. Completing a movie takes a considerable amount of effort and is an accomplishment to be proud of. But a movie without an audience is like the sound of one hand clapping—it's a paradox. Movies exist to be seen. They're defined by the effect they have on the people who watch them.

That means completing a movie is only the beginning of a filmmaker's work. It's the price of admission to the circus. But you're not really a filmmaker until your work has been seen. So now you have to find an audience for your movie.

The good news is there are now more ways to reach an audience than ever before in the history of filmmaking. The bad news is there are also more people clogging up video websites and film festivals. But we're getting ahead of ourselves. Before you start uploading your masterpiece (or sending it out to festivals), there are still a few things left to do.

Get Some Feedback!

Regardless of how much work you've done on your movie, it's not really done until you've gotten some feedback. And by feedback, we mean more than the comments you got from friends and classmates when you showed them your *rough cut*.

That means showing your finished movie to people who have no reason to be nice to you. Friends, family, cast, and crew are all going to love the movie, no matter how good or bad it actually is (and if they don't love the movie, they won't tell you so, no matter how often you say, "Don't hold back, tell me what you *really* think").

As directors, your goal is to create something that has an impact on an audience. Whether you want them to laugh, or cry, or be roused into action, or just entertained, your success as a director depends on your ability to connect with your viewers. But after writing, directing, and editing your project, you're so close to the material that you've probably lost perspective on what works and what doesn't work. That's why feedback is so vitally important. It's a measure of whether your work is having the effect you intended.

SIDE NOTE

NEVER SCREEN A ROUGH CUT

When you're editing a movie, you never see your rough cut the way it *really* is. You see what it's *going to be*. You know where every sound effect goes. You know what type of music you want (or at least the impact you want the music to have). You can hear every line of dialogue clearly even when it hasn't been mixed. And every time you watch your evolving work-in-progress, you see a finished film because your brain fills in all the missing parts.

But anyone else you show the movie to doesn't know your postproduction plans. They can't hear the music, or see the missing visual effects. They only see what's on the screen. And no matter how much you tell them about the touching piano solo you're adding, or the cool desaturated color palette you'll use, they still only see what's on the screen.

They may say, "Oh, I know how to watch a rough cut. I can fill in the missing pieces," but unless they've watched (and edited) a significant number of projects, they will still only see what's on the screen.

Why does that matter? Because without knowing it, they'll be affected by what's missing. They'll feel like your scenes don't work. Like they don't have any sparkle. Like your movie somehow just misses the boat.

And the feedback they give you will mostly be about what's missing. About things you already know you're going to do, but haven't gotten around to yet. They won't be able to give you an accurate assessment of what might still need work after all the pieces are in place.

If you want to test this theory, pay attention to your own reaction when you watch someone else's work. How do their rough cuts make you feel? If they seem a little slow and unfocused, then that's how your own rough cut probably looks to anyone who sees it.

Now this doesn't mean you shouldn't show your work-in-progress to fellow filmmakers. If anyone could possibly fill in the gaps, they'd be able to. But it does mean you shouldn't show your rough cut to anyone you want to impress. And *never* post it online or show it to festival programmers (even if they say they accept *works in progress*). An unfinished work looks unprofessional, and no matter how much you add to the movie later, it rarely undoes that first impression of a flawed, unfinished film.

So where do you get good, honest feedback? It isn't easy. Your fellow filmmakers can only help so much because after they've seen the project a few times they lose their objectivity. And your friends and family are going to be worried about hurting your feelings.

What you really need are people with *virgin eyes*, people who've never seen your project. Sometimes friends of friends are a good choice. Or maybe people you know from school or work but don't really hang out with. But whoever you choose, there are a few things you can do to improve your chances of getting good feedback.

Getting the most useful feedback

The first thing to do is set up a screening. It doesn't have to be big. Sometimes smaller is better. A group of anywhere from two to twenty would be ideal.

NOTE *If your movie is a comedy, you probably want a slightly larger group—at least ten or more. Sometimes people feel self-conscious laughing in small groups.*

After you've got your audience together, follow these guidelines before, during, and after your screening:

- Do not show a rough cut. Showing the finished film would be ideal. But if you can't show the completed project, make sure you've got music (even if it's *temp music*), along with sound effects. Mix the dialogue so it's clean and clear and correct any mistakes in white balance (and if possible, apply a film look close to your final, desired look).

> **KEY TERM:**
>
> **TEMP MUSIC** It's common practice to use music from other movies (or even classical music, if appropriate) as a temporary score when you're editing. This music is usually replaced with a custom score or stock music before the final mix.

- Even if the audience is watching what you consider the final version of your film, tell them it's a work-in-progress. Let them know you're looking for honest, constructive feedback to make the movie better. If they feel like their input will make a difference, you'll get better feedback.

- Once the screening begins, stand or sit somewhere near the back of the room and watch the movie yourself. You'll find a curious thing happens. When you're in the presence of people who've never seen the movie, it'll look different to you. It's almost as if you're seeing it for the first time, too. Pay close attention to your own reactions as the film plays. They will give you new insights.

- When the screening is over, start a discussion about the movie. Ask people what they liked and what they didn't like. Ask them if there was anything that surprised them, or impressed them. Ask them if anything was predictable or cliché. But no matter what they say, don't get defensive. Don't try to explain what you were trying to do. The movie should speak for itself. If someone criticizes an element of the film, the best response you can give is, "That's very interesting. Tell me more…".

Not defending or explaining your creative choices will be difficult. You like your choices and will naturally want people to understand them (and hopefully be impressed). But not everyone will get your movie, and if people have a lot of questions, maybe something needs more work.

- Take notes on the feedback you get. Even if you don't agree with someone's comments, write them down. You might refer to them later.

- In addition to the discussion, you could also hand out questionnaires. But a discussion is best, because people will always say more than they would bother to write down.

After the screening, thank everyone for coming, then go home and get a good night's sleep. You'll need it. Try not to think too much about any negative comments you may have gotten. We'll talk about those in the next section.

Making sense of your feedback

After you've screened the movie and gotten feedback, you'll have some choices to make. Even if the feedback audience liked your movie, the odds are good you got a list of suggested changes, and you probably have mixed feelings about those suggestions.

One part of you was hoping your movie was finished and ready to show the world. But another part of you thought some of the suggestions were pretty good. And yet another part of you is sure the audience was just a bunch of dolts who didn't get your movie. This part of you is certain if you showed the movie to the right people they'd see the brilliance the feedback audience missed.

But regardless of your feelings about the screening, you have to decide what parts of the feedback are valid. Some of the suggestions will be completely impractical and would require you to rewrite and reshoot the entire film. That's not usually an option. Some of the suggestions are small, easy adjustments—but you may not agree with them. And a few of the suggestions will point out story or character flaws you missed, but feel are valid. These are the ones you need to deal with.

It's very common for your feelings about different suggestions to change over time. An idea you thought was bone-headed at first may sound better after a few days. So don't make snap decisions about feedback. Give your sub-conscious a chance to sort through all your options.

Making changes

Once you've decided which issues you want to address, then you have to figure out how to change your movie to correct those issues. There's no right or wrong way to make those changes, but most issues fall into a few general categories. Here are some common issues along with techniques used to address them:

- **Pacing.** As mentioned before, beginner films tend to be slow so there's a good chance parts of your film may feel sluggish. There are many ways to improve pacing. You can often cut words and lines (and sometimes entire scenes) without confusing the audience. Reactions shots and pauses are often far too long and should be tightened. Improving the pacing will give your movie new life and energy.

- **Scene order.** Sometimes rearranging scenes will make a significant difference in how the story unfolds. You can also experiment with *cross cutting* or *parallel action* to tie elements of your story together.

> **KEY TERM:**
>
> **CROSS CUTTING/PARALLEL ACTION** When two (or more) events are happening simultaneously in the world of your story, you can often create tension by cutting back and forth between the different scenes. This technique can also be used to link two people (or events) that may be separated by time or space.

- **Adding Information.** If parts of your movie confused the audience, you may need to add an additional line or two to clarify things. This doesn't mean you have to go back and reshoot the scene. Often you can add a line to a scene by putting new audio over a reaction shot, and sometimes you can put two or three additional lines at the beginning or end of a scene while showing an establishing or long shot.

- **Shooting pick-ups.** Sometimes the only way to fix things is to shoot some new material. Any scene or shot you capture after principal photography has wrapped is called a *pick-up*. A pick-up can be as simple as a new closeup shot of a prop (like the title of a book), or it can be as complex as shooting a whole new scene (or group of scenes). The trick is to plan carefully and only shoot what you need.

These are a few of the most common ways to rethink a scene or sequence that isn't working. You'll discover others as you work to improve your movie. Needing to make changes doesn't mean you've failed. It's all part of the process of telling an effective story with pictures and sound (see Figure 10.1).

FIGURE 10.1 Compare the final moments of *Minneapolis* (included on the companion DVD) with the ending in the script (also on the DVD). During production, we shot the entire movie as written. But after getting feedback, we decided the scene with the necklace wasn't needed. So we changed the ending. Do you think we made a good choice?

Of course, after you've made your changes, you want to know if they're effective. You'll need more feedback. In the ideal world, after each round of changes, you'd have another screening with a whole new group of people. But this isn't really practical. Usually, you'll show the changes to a few selected friends and filmmakers you respect. Their feedback may result in a few more tweaks, but at a certain point you'll decide your movie is as good as it can be. At that point, you'll turn your attention to other details.

All figures and shorts are included on the companion DVD with this book.

Formats, formats, formats

Once your movie is ready to show, you have to decide on a presentation format. In the days of film, it was simple. You'd make a screening print of your film (either 16mm or 35mm) and that was it. But with digital media, things are a little more complicated. Let's start at the beginning.

Shooting formats

You shot your movie in a specific format, determined by the capabilities of your camera. Most likely your footage was captured in one of the following formats (listed from lowest to highest resolution):

- Standard-Definition Video (DV)—resolution 640 × 480 lines

- High-Definition Video 720 (HD or HDV)—resolution 1280 × 720 lines

- High-Definition Video 1080 (HD or HDV)—resolution 1920 × 1080 lines

These aren't the only possible formats, only the most common. We're also making the assumption that you're shooting in North America where the video standard is NTSC as opposed to the European PAL standard.

NOTE

KEY TERM:

NTSC/PAL NTSC stands for *National Television System Committee* and refers to a set of broadcast television standards used in North America. One of the primary features of NTSC is a frame rate of 29.97 fps. PAL stands for *Phase Alternate Line* and is the European broadcast standard, which has a frame rate of 25 fps and slightly higher resolution than NTSC.

Each of these formats could also be either 24 or 30 frames per second (fps), and the images could either be interlaced or progressive (as described in Chapter 1). The two most common formats are 24P (24 fps progressive) and

30i (30 fps interlaced—sometimes referred to as 60i to reflect the fact that each interlaced frame is made up of two fields).

You probably did all your post in the same format captured by your camera, and you should have a *master copy* of your finished project in its original resolution.

KEY TERM:

MASTER COPY In the pre-digital analog days of videotape, every successive copy made from the original was called a *generation*, and with each generation came *generational loss*. This meant each generation was slightly worse (in terms of image quality) than the previous generation. The first original tape made during the editing process was called the *master copy*, and it represented the highest quality available. In the digital world, each copy is an exact clone of the original, and there is no loss of quality. In this case, the phrase *master copy* refers to a director- (or producer-) approved copy of the finished project in its original resolution.

Changing Formats

But just because you shot in one format doesn't mean you have to stay in that format. Most editing software will allow you to convert from a high resolution to a lower resolution. For example, if you shot in 1080 HD, you could create a copy of your project in either 720 HD or standard DV. This process is called *down-converting* (or sometimes *downrezzing*), and it will decrease the sharpness of your footage.

TECHIE'S TIP Some programs will also allow you to *up-convert* (or *uprezz*) your footage from a lower-resolution format to a higher-resolution format (i.e., converting standard DV footage to 720 or 1080 HD). But while up-converting video changes the technical specifications of the footage to a higher resolution, it doesn't actually improve the quality of the up-converted images. In general, uprezzing any digital image (whether video or still) is not a good idea.

Beyond resolution, it's also possible to change interlaced footage to progressive footage through a process called *deinterlacing*. There's even software that can change 30 fps footage to 24 fps footage. Deinterlacing and changing

to a 24 fps frame rate will make your project look less like video and give it a filmic quality, but these changes will also result in a slight loss of sharpness and reduce the quality of your images. So before you decide to change the format of your project, experiment with different settings to get familiar with how different choices affect the quality of your footage.

Screening and distribution formats

Changing formats between HD and SD, or deciding to deinterlace your footage, are actually creative decisions, since those changes affect how an audience will experience your movie. But some format changes will be determined by where and how you want to screen your project. For example, if you want to put your movie on a standard DVD, it will have to be in standard-definition format.

> You would use a Blu-ray Disc if you wanted to put HD material on a disc. You would also need to know if your intended audience has access to a Blu-ray player. If you were planning to use a video projector to screen your HD project, you'd need to know if the projector were HD capable.
>
> **TECHIE'S TIP**

You'll also have to change formats if you want to post your movie online, load it onto your phone, or send it to someone as an attachment. Standard DV and HDV each use over 200MB per minute, which means a 5-minute movie would take over a gigabyte of space. Since these files are too large to easily send or store, you'll need to compress your project before posting or sending it. And like everything digital, when it comes to compression formats, you have quite a few choices.

> *If you use a camera that records to a hard drive or memory card, your footage was most likely stored using the AVCHD format. AVCHD stands for Advanced Video Coding, High Definition, and it's a compression format capable of storing almost any shooting format.*
>
> **NOTE**

Compression Formats

There are many different compression formats in use. These compression formats (also called codecs) all do basically the same thing. They reduce the amount of data needed to record a stream of video images.

NOTE *See Chapter 1 for information on codecs.*

For example, the compression scheme used for standard DVDs is called MPEG-2, and it allows an entire feature film (along with DVD extras) to be recorded on a single DVD without any apparent loss in visual quality. This is no small feat, and MPEG-2 can easily reduce the amount of data in a video file by a factor between 10 and 20.

TECHIE'S TIP

Codecs are very sophisticated pieces of software that can be extensively customized. Some of the compression choices you can make will change the frame rate (fps), screen size, and data rate of your project. These choices in turn affect the amount of compression applied to your footage, which affects the final size and visual quality of the compressed file (see Figure 10.2).

FIGURE 10.2 This frame from *Neo's Ring* has been highly compressed to allow the video to be sent as an e-mail attachment. While the compression results in a much smaller file, it also significantly reduces the image quality. This level of compression may be acceptable for viewing on a mobile phone, but it would look pretty bad on a computer screen or TV.

But in the rapidly-changing world of codecs, MPEG-2 is relatively old. A more recent (and common) codec is MPEG-4—also called H.264 or AVC (Advanced Video Coding). This codec is used on Blu-ray discs and on many video websites.

A complete discussion of codecs would be exceedingly technical and is far beyond the scope of this text. Here's what you really need to know:

- In most video-editing programs, you can compress your projects using either the *Export* command or the *Share* command (see Figure 10.3).

- You will usually be presented with choices about the intended audience for the compressed file (i.e., Web, e-mail, phone, etc.).

FIGURE 10.3 These are two of the menus you'll encounter in Final Cut Express as you compress your project to create a file you can share with your audience. If you're not certain which type of compression to use, experiment with different options until you get an image that looks good.

- Each choice will apply a different amount of compression, which will result in a particular file size (i.e., a file for sending by e-mail will be smaller than a file intended for a website).

- The smaller the resulting file (and the more compressed your footage), the more degraded your video image will be. This means choosing the proper compression for a given use is a trade-off between file size and image quality.

If you're using DVD-burning software to make a DVD, most of these choices are made automatically. Just drag-and-drop (or import) your final master copy into the program, and it will figure out the right amount of compression to give you the best-looking DVD.

Figuring out which compression formats to use and how to apply them can be tricky and is best learned through trial and error. But with enough experimentation (and some help from your fellow filmmakers), you'll find it isn't really that complicated at all.

TECHIE'S TIP As you get more comfortable with compression, you may want to get down into the weeds and customize specific settings to maximize the video quality of your final file (see Figure 10.4).

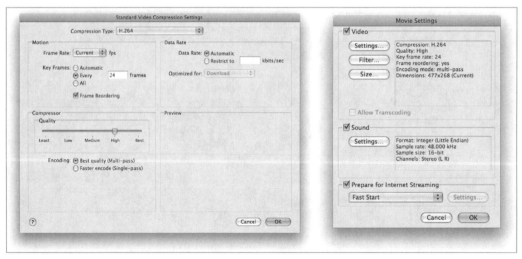

FIGURE 10.4 By using some of the advanced sub-menus, you can control many aspects of compression from frame rate and image size to the sampling rate of the audio on your soundtrack. Each of these choices will affect the file size and image quality of the resulting video.

Where to be Seen

So now you've finished your movie, tweaked it with feedback, and know how to compress and format it for any possible screening opportunity. It's time to be seen! The good news is you're in luck. These days it's easier to find an audience than ever before, and not just an audience of your friends and relatives--the global audience that surfs the Web every day.

> In the next few sections, we're going to talk about different ways to showcase your movie and find an audience. But we're not going to talk about marketing your film, securing a distribution contract, or being signed to a three-picture deal in Hollywood. Those are topics covered in the book *Short Film Distribution* by J. Moore in this series.
>
> **TECHIE'S TIP**

Going online

Everybody watches videos online. That's both a good thing and a bad thing. It's good because you have instant access to a global audience. Never before in the history of filmmaking has this level of exposure been possible for each and every filmmaker. That's the problem. Anybody and everybody can do it. Hundreds of thousands of new videos are posted online every day. Granted, the vast majority of those videos are not carefully-produced works of narrative fiction. But how do you make your movie stand out in a sea of piano-playing cats and dancing babies?

> *We're going to assume you know how to post your video online. But if you've never uploaded video before, you'll find detailed instructions accessible from the homepage of all major video-hosting websites.*
>
> **NOTE**

Standing Out

If you just post your video online and sit back waiting to be discovered, you'll be sorely disappointed. Regardless of how good your movie is, no one is going to find and watch it without some work on your part. You need to take an active role in getting people excited about your movie. Here are a few ideas to get you started:

- **Choose the right Web site.** Everybody knows about YouTube. It's huge. YouTube is like a giant warehouse store, but sometimes a small

specialty store is better than a warehouse. There are specialty-video websites that only host specific types of content. Some specialize in comedy. Some specialize in narrative work. Do a little research. Odds are you can find a website that might be a really good match for your particular movie and give you a better chance of being seen.

- **Create a mailing list.** Once your movie is posted, send the link to everyone you know. Encourage everyone on the cast and crew to send the link to everyone they know. Tell your friends and relatives (and everyone who watches the movie) to send the link to everyone they know.

NOTE

If everyone who watches the movie sends the link to two people, and each of them in turn sends the link to two additional people, you'll create an ever-expanding audience.

- **Engage the audience.** As people watch the movie, they'll make comments about it. Respond to the comments (just be careful not to get into a flame war if someone makes a negative comment). Your goal is to create a meaningful (and interesting) dialogue about your movie. The more people talk about the movie, the greater the odds of even more people watching it.

- **Use all possible Web-based resources.** Don't rely on just having the video posted. Talk about the movie on social networking sites like Facebook and Twitter. If you write a blog, talk about the movie and your experiences making it. If you don't write a blog, consider starting one (or convince your blog-writing friends to talk about the movie in their blog). If you're website savvy, think about building a website or a fan page for the movie where you could post outtakes and *behind the scenes* pictures. All these things make the movie more interesting and increase the chance people will tell their friends about it.

TECHIE'S TIP

The whole goal is to build as much awareness of your movie as possible. A secondary goal is to build a fan base of people who like your work. These are people who will tell others about your movie and who will anxiously await any new movies you make.

Finding a real audience

Getting thousands of hits on a video Web site is cool, but nothing beats hearing and feeling the reaction of a real live audience as your project flickers across the big screen, and the only way to get that thrill is at a screening. If you are part of a film program at school, there's a good chance they'll have a screening of student films at the end of the term. If you aren't enrolled in school, here are some other ways to get your project on the big screen:

A key element to ensure the success of your screening will be publicity. Use any and all means to make people aware of the screening (school newspaper, Web site, calendar, announcements, flyers, etc.). The more excitement and curiosity you can create, the bigger your audience will be.

NOTE

- **Join an independent filmmaking group.** Many cities have organizations that support independent filmmakers. Independent Filmmaker Project (IFP) and Film Independent (FIND) are two such organizations with chapters in various cities across the country. Many of these organizations routinely have screenings of short films created by members. Not only is this an excellent way to get a public screening of your movie, but it also offers a chance to network with other filmmakers, actors, and crewmembers that could work with you on future projects.

- **Organize your own screening.** If there's no local filmmaking group and you aren't enrolled in school, you can set up a screening on your own. Get together with a group of other filmmakers and assemble a program of short films. Then find a community center (or a local community theater, library, or any public space that will host a screening). Ideally, you'd find a space with a video projector and a sound system, but those items can be rented or borrowed if necessary. Pick a date for the screening and get as much publicity as you can. Think about getting local TV and radio stations to mention the event. With a little planning, you can create a memorable event and attract a sizable audience.

If your screening occurs during warm weather, you could even host a screening outdoors by projecting your movies on any large white wall.

NOTE

These are just a couple of suggestions to get you thinking about how to showcase and present your movie. If you apply creativity and determination, you'll come up with even more ways to get your movie in front of an audience.

Let's get festive!

There's nothing quite like screening your movie in your hometown. But regardless of where you live, at a certain point you'll want to reach an even larger audience. That's where film festivals come in. Here are a few good reasons to apply to festivals:

- Film festivals are a way to get your movie out in the world. At most festivals, your movie will screen at least twice, and you may even get reviewed.

- Festivals are an excellent way to network with other filmmakers and learn more about the business side of filmmaking. Almost all film festivals have discussion groups and panels covering many different aspects of financing, making, and distributing movies.

- They give you a chance to see the work of other filmmakers (and compare their work with yours). The more movies you see, and the more filmmakers you talk to, the better your work will become.

- You might win an award. The vast majority of film festivals give out many awards for different aspects of filmmaking. It's like a homegrown version of the Oscars. Becoming an *award-winning filmmaker* is the first step toward beginning a career.

- Finally, film festivals are a great deal of fun. They're organized and attended by people who truly love movies. You'll never find a better and more receptive audience for your work. Festival people often treat each filmmaker that attends as an artist and a celebrity.

Which Ones Should I Try For?

Everyone knows about the big festivals (i.e., Sundance, SXSW, Toronto, Berlin, Cannes, etc.). These festivals are like the major leagues. It's a big deal to get accepted. And applying to them is a rite of passage for any filmmaker.

But the big festivals aren't the only ones you should consider. There have
never been more festivals to choose from than there are right now. In fact,
there's a film festival going on somewhere in the country almost every week
of the year. Some of them may be in places you've never heard of, but all of
them offer a chance to meet other filmmakers and show your movie to a live,
receptive audience.

There are several sites online that list film festivals. Visit a few of them and
get a feel for when there are festivals in your area. Or if you've always wanted
to take a trip to Hawaii or New York (or anywhere else), check out festivals
anyplace you'd like to visit.

*Some festivals even offer to pay airfare or hotel fees if they select
your film. That can make it possible to attend festivals you might
not initially consider. Thorough research (and reading filmmaking
blogs) will uncover festivals with the best benefits for filmmakers.*

NOTE

How to Apply

While the application process will vary slightly from festival to festival, there
are certain basic steps you'll need to accomplish every time you apply:

- **Develop a target list of festivals.** There are many sites online that
 catalog film festivals and list their application deadlines. Explore
 these sites and develop a list of festivals you want to target. As you do

research on different festivals, pay attention to the *application fees*. If you target too many festivals, these fees can add up pretty quickly.

> **KEY TERM:**
>
> **APPLICATION FEES** Many festivals charge a fee just to apply. These fees are often based on the length of your project (but sometimes they can be waived for student filmmakers), and some festivals will offer a discount if you submit your film early. But keep in mind, festivals keep the application fee, regardless of whether you get accepted or not.

- **Build application packages.** Different festivals will want different supporting materials with their applications. Some will want behind-the-scenes pictures. Some will want bios of the director and the principal cast. Some will want releases for the actors and music you used. And almost all will want a short, catchy synopsis of your film.

NOTE *Many times, the festival will wait until you're accepted to ask for these items. But you need to have them ready, just in case.*

- **Send in your application and wait.** Bundle up your screening DVD with your application form and fee, drop them in the mail (FedEx them if you're close to the deadline or submit them online if the festival allows), then sit back and wait. While some festivals are very filmmaker-friendly and will cheerfully answer questions (and even grant deadline extensions), others are very terse and matter-of-fact. Don't take it personally. They're probably under a lot of stress. Just be aware that phone calls, e-mails, poking, and prodding won't make them decide any faster.

TECHIE'S TIP We've said it before, and we'll say it again. Don't ever submit a rough cut of your film to a festival. Even if the application form says they'll consider *works in progress*, and even if there's no way you can finish your film before the deadline, don't submit a rough cut. It's better to miss a festival than to submit an unfinished version that makes you look inexperienced.

What if I Don't Get Accepted?

You're not going to get accepted to every festival. That's just a fact. But not being accepted doesn't mean your movie isn't any good. Sometimes you don't get accepted because the festivals are huge and your odds of being picked are extremely small regardless of the quality of your movie (that's often the case with the major festivals). Sometimes the festivals are looking for specific movies exploring a common theme or subject matter (and that theme might not be mentioned in the application). And sometimes the tastes of the festival programmers are just different from your own.

> *But suppose you don't get accepted at any of your targeted festivals? Choose a couple of festivals to attend and go anyway. You'll learn about the festival atmosphere (which will increase your odds of being accepted the next time). You'll also see some cool movies, meet some filmmakers, and still have a great time.*

NOTE

Beyond film festivals

There's real joy in making movies and presenting them to an audience. For most filmmakers, that joy is the reason they were drawn to filmmaking in the first place. But filmmaking is expensive, even at the no-budget beginner level. And if you're going to progress beyond making short films, you need to find a way to make money while making movies.

Film festivals are the beginning. They can allow your work to be seen by agents and *distribution companies* that might offer to *license your film* for broadcast on cable outlets like the Independent Film Channel (IFC). There are numerous stories of unknown directors who've been discovered at film festivals and gone on to have successful careers.

KEY TERM:

DISTRIBUTION COMPANIES *(also called Distributors)* **These are companies that specialize in finding unknown films and bringing them to market. Some specialize in feature films, some in documentaries, and some in short films. If they like your film, they will offer you a contract to *license the rights* for your film, which will allow them to negotiate on your behalf with studios, theaters, and cable channels.**

The different ways a film can be distributed are covered in more detail in the book *Short Film Distribution by Jason Moore*. Becoming familiar with how a movie can earn money (thereby paying for itself and for future projects) is the responsibility of any filmmaker who wants to begin and sustain a career in filmmaking.

SUMMARY

In this chapter, we concentrated on getting your project off the computer screen and in front of an audience. This is the final leg of your filmmaking journey, but in many ways it's both the most difficult and the most important part, because until someone sees your film, your work as a filmmaker isn't finished.

But before you unveil your masterpiece to the world, you want to make absolutely sure it's ready for prime time. So the very first audience to see your movie should be a feedback audience. And if you've never gotten feedback before, listening to other people debate your creative choices can be both uplifting and disheartening. You will almost surely hear some ideas and questions you never even considered while making the film. Some of the comments will be dead on, and others will be way off the mark. But the more you can keep an open mind (regardless of how crazy and impractical some of the suggestions sound), the more likely you'll hear some constructive, useful feedback.

And of course before you can screen your film, you need to understand the effect that different compression schemes and formats will have on your project, which we also discussed in this chapter. It's important to remember that compression technology is constantly changing, usually for the better, so the more familiar you are with current technology and formats, the better the screening quality of your movie will be.

It's only after your movie's been finely focused and you've decided on the best screening format that you're finally ready to seek out an audience. We discussed several ways to get your movie seen, from websites, to local screenings, to film festivals. Each of these audiences is different, and it takes different skills to successfully engage each one. But one skill

you must have regardless of which route (or routes) you choose is the ability to generate public awareness and excitement about your movie. Because it doesn't matter how good your movie is if nobody knows it exists.

As we discussed in the first few pages of this chapter, finding an audience requires a change in mindset from the process of making your movie. You were an artist and craftsman while you were making the film, applying skill and inspiration to turn hard work into an entertaining and compelling movie, but to get your movie seen you have to become a salesman. You have to take your finished project and make people want to see it. For many filmmakers, this task is far harder than the work they did to create the movie in the first place.

REVIEW QUESTIONS: CHAPTER 10

1. Why is temp music important for a feedback screening?

2. What are some possible ways you can change your movie if feedback indicates parts of the film aren't working?

3. Which compression format is used on standard DVDs? Which compression format is used for Blu-ray? Which compression format do you plan to use? Why?

4. What are some good reasons to attend a film festival?

5. What does a distribution company do?

1. Why do some people think the real work of filmmaking doesn't begin until the film is finished?

2. What is feedback so important?

3. Why should you never screen a rough cut?

4. What are some ways to generate public awareness of and excitement about your project?

5. Do a Web search and compile a list of local film festivals you could apply to.

APPLYING WHAT YOU HAVE LEARNED

Research/Lab/Fieldwork Projects

1. By now, you've completed several projects and exercises. Pick the one you like best and set up a feedback screening. Follow the guidelines discussed in this chapter and collect feedback on the project. Based on the feedback, make any changes you feel are necessary.

2. Once you're satisfied your project is as good as you can make it, choose a video-hosting website and upload your project. There's only one restriction. You cannot choose YouTube. You must research and select an alternate video-hosting site. After the video is posted, generate as much awareness of the project as you can. Send the link to friends and post it where it will be noticed. You have two major goals for this exercise:

 - Generate as much discussion as you can about the project in the form of comments and blogs.

 - Accumulate as many views (or hits) for the project as you can.

EXERCISE 1: SHOOTING A REAL EVENT

OVERVIEW AND LEARNING OBJECTIVES

In this chapter, you will:

- Learn how the exercise chapters work
- Master specific techniques for shooting and editing real events

Ready, Set, SHOOT!

Congratulations! You've made it through the basics. You know about cameras and shots and lenses and lights. You know about story and shooting and sound. You know about post and polishing and finding an audience. That means you're ready to start making original projects of your own.

That's what the next four chapters are all about. We're going to take the Hollywood skills you've learned in the previous chapters and show you how to apply them in specific production situations. But those production situations won't be limited to shooting actors on a set. It's a common mistake to think the techniques we've covered so far only apply to fictional, narrative scripts.

There are many types of stories you can tell with a camera and sound. Just think of all the different types of programming you see on television (from narratives to concerts to interviews to sporting events). Each of those programs tells a story, and they use standard production techniques and equipment to do it, so we're not going to limit ourselves to narrative, script-based stories in the chapters ahead. Don't worry, we'll definitely discuss traditional narratives, but we'll also look at a few other popular formats. In particular, we're going to look at the four following types of projects:

- **Real events.** How to shoot and edit an event happening in real-time like a birthday party, sporting event, or wedding.

- **Multi-camera shoots.** Techniques for using multiple cameras to get more complete coverage of live events like plays or concerts.

- **Interviews.** The best techniques for lighting, shooting, and shaping talking heads in different environments.

- **Narrative projects.** Proven tips and techniques for planning, shooting, and editing a fictional short or a music video.

NOTE
Obviously, these aren't the only types of projects you can shoot. We haven't mentioned reality shows, documentaries, reenactments, etc. But most other projects are combinations of the skill sets we're going to cover. To create a documentary, for example, you could combine interview techniques with footage obtained by shooting real events.

How the exercise chapters work

The first three of the next four chapters will all be organized the same way. We'll examine the aspects of *philosophy*, *planning*, *execution*, and *editing* for each of the projects, and under these general headings, we'll explore the following topics:

Philosophy (Definition)

We'll begin with a basic definition and examine what story you might want to tell. What typical characteristics does this project have? What makes it unique? What are its strengths and weaknesses? What considerations would make you choose this particular format?

Planning (Preproduction)

Next, we'll talk about the type of planning you should do to ensure success. Should you have a script? How much equipment will you need? How big should the crew be (or can you do it all yourself)? How long will it take to shoot?

Execution (Production)

After planning, we'll move into production and look at how to manage the equipment, the crew (if you have one), and the location. What type of coverage will you need? What are the most efficient and effective ways to shoot your footage? What common mistakes (or *gotchas*) should you watch out for?

Editing (Postproduction)

The last thing we'll explore is postproduction. What are the unique editing challenges and requirements of your project? What techniques can you use to organize and assemble your footage? How can you correct (or cut around) any missing shots or problem footage?

> *The fourth exercise chapter (Chapter 14) will cover tips and techniques for shooting narratives and music videos. Since the majority of the book so far has concentrated on narrative filmmaking, that chapter will take a somewhat different approach.*

NOTE

One more thing

So that's where we're headed. But there's one thing you need to remember, regardless of which project we're discussing, or what equipment you have, or

how many cool shots you captured. Every time you set up the camera, you've got one, single purpose:

Your goal is to tell an engaging story with pictures and sound.

That's it. It doesn't matter if you're shooting a wedding, an interview, or a scripted short. The reason you turn on the camera is to tell a story. We've spent ten chapters teaching you the skills you need. Now we'll show you some ways to use them.

Real Events: Philosophy and Definition

The dictionary defines an event as "a noteworthy happening." A secondary definition gets even more specific, calling it "a social occasion or activity." Think about the events we mentioned in the introduction: Birthday parties, sporting events, and weddings. They each fit the definition.

NOTE
One important distinction we're going to make is we don't include plays, concerts, or any staged performance under the category of a real event. We're going to discuss shooting these kinds of performances under multi-camera events.

Usually with real events, we're talking about a group of people who've come together for a specific purpose (e.g., to celebrate or to play a game). Your goal as the storyteller is to pick an aspect of the event and capture it. Maybe you want to emphasize the competition of a specific sport, or the joy of two people uniting at a wedding.

The important thing to realize about shooting a real event is you can't capture it all. There's simply too much happening all at once for you to document every single moment. The most you can realistically accomplish is to capture and distill certain features of the event, so you'll need to pick what you feel are defining moments and focus on getting footage to depict those moments.

NOTE
The process of selecting and presenting key moments is how you turn an event into a story. Realize that no two people would shoot the same event the same way. Your personal point of view about what's important is what will make your project a unique creation.

Typical characteristics of real events

Regardless of whether we're talking about a birthday party or a soccer game, all real events share certain typical characteristics. Some of those characteristics are:

- **Real-time.** The event starts at a certain time and unfolds in a straight line from beginning to end. You are usually there as an observer, not as the person who sets events in motion and keeps them going.

- **Nonrepeatable.** The event is only going to happen once. If you miss a moment or a shot, you generally can't ask for a second take.

- **Nonscripted.** The event follows its own timeline and logic, and while there are predictable elements (i.e., four quarters in a football game, halftime, etc.), you never quite know how things are going to play out.

What makes shooting a real event unique

When you're shooting a real event, you generally assume the audience for your video knows the participants involved. If the event is a wedding, the viewers will usually be friends and family of the bride and groom. If the event is a sporting event (even at the national level), the viewers are usually fans of one of the teams. So you can assume a certain amount of familiarity on the part of the audience. The exact degree of familiarity will determine how much screen time you'll need to set up or explain the event.

The obvious exception to this assumption is if you're capturing an event precisely because it's an unknown and unique occurrence. If you're shooting a native ritual in a foreign country, you'll spend more time setting the stage for the event.

NOTE

Strengths and weaknesses

Even though events aren't strictly scripted, they usually include certain well-known and predictable moments. These moments will make it easier to tell the story. At a birthday party, for example, there will usually be a moment in which someone brings in the birthday cake (along with singing and blowing out the candles). The more ritualized the event (and the more familiar you are with those rituals), the easier it will be to decide what to shoot (and the better chance you'll have of capturing the moments you need).

But suppose you're shooting an unfamiliar event for the first time. Unless you do some research and know what to expect, you'll be shooting blind. And while it's not impossible to work under these conditions, it becomes harder to shape the story as you're shooting. In these situations, you often won't discover the specific story you want to tell until you review and organize the footage in the editing room.

Why choose this format

You don't really choose this format, it chooses you. If you're trying to capture the story of a moment or an emotion at a real event (assuming you're not staging the event for a fictional narrative), you have to use this format by default. Keep in mind that your goal in shooting a real event is to focus on the essence of a few key moments and present them in a compelling, entertaining manner. You're not documenting the event, you're telling a story about it.

Planning to Shoot a Real Event

Shooting a real event presents a number of challenges. Usually, you're just an observer at the event. You don't want to get in the way or have any effect on the event itself. That'll place limits on how much equipment you can use, the size of your crew, and the shots you can capture.

Should you have a script?

When you shoot a real event, you won't be able to control the events, so you can't have a script in the traditional sense. But you should ensure you're familiar with the basic structure of the event. You should know when and where key moments are going to happen, and you should have a list of shots you intend to capture.

Whenever possible, visit the location ahead of time to preplan certain shots and angles. Know where you need to be at important moments to get the best footage.

What equipment do you need?

Generally, the equipment for any kind of video shoot breaks down into three categories:

- Camera equipment
- Lighting equipment
- Sound equipment

We're going to look at the different types of equipment in each category best suited to shoot real events.

All figures and shorts are included on the companion DVD with this book. **ON DVD**

Camera Equipment

The most important piece of camera equipment is obviously the camera. And two important considerations when you're shooting a real event are the *size* and *sophistication* of the camera.

Size is important for a couple of reasons. Generally, a small camera would be preferred, since it would be less noticeable and less likely to draw attention to the fact the event is being recorded. Additionally, a smaller camera would be easier to handhold for extended periods of time without tiring you out.

> *One exception to the preference for small cameras would be if someone hired you to videotape an event (such as being hired to shoot a wedding). In that case, you want your customers to feel comfortable with your ability to deliver a professional product, and your camera should be more sophisticated (and probably a little larger and more professional looking) than a standard consumer point-and-shoot camcorder.*

NOTE

In terms of sophistication, certain features will make it easier to get good results at a real event. Having an extended zoom range (greater than a 10x zoom) will make it easier to get closeup shots without intruding on the action. If the event is indoors in dim light (or outdoors at night), having a camera with good low-light capability will make it easier to get clean, usable footage without lights.

The other key piece of camera equipment is some type of camera support. While it's possible to shoot an entire event handheld, getting usable (stable and steady) shots when you're zoomed all the way in will be a serious challenge. And although a full-sized tripod might be cumbersome to move during the course of an event, using a small travel tripod or a monopod could be an ideal solution (see Figure 11.1).

FIGURE 11.1 This unique pocket-sized camera support doubles as both a table-top tripod and a clamp for securing your camera to a railing or ledge. Having a lightweight camera support makes shooting impromptu events much easier (and results in more professional footage).

TECHIE'S TIP

Depending on the nature of the event, it might be possible to use a full-sized tripod that you leave pre-positioned at a good vantage point. Then you could use the tripod's *quick-release mounting plate* to easily transition from tripod shots to handheld shots as the event unfolds (see Figure 11.2).

Lighting Equipment and Setups

At a real event, you probably won't have very much control over the lighting. It's not very likely you'll be able to bring in and set up movie lights. For that reason, it's important to visit the location before the event if possible, and see what ambient light is available. If the lighting is too dim, you may want

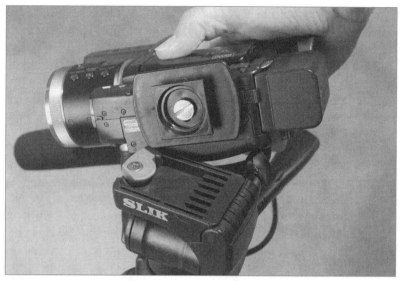

FIGURE 11.2 Most tripods have a quick-release plate like the one shown here. Using the quick-release allows you to switch quickly between handheld shooting and stable tripod-mounted shots.

to talk with someone in charge of the event to see if it's possible to turn on a few more practical lights.

Two possible ways you might provide additional light are by bouncing light off the ceiling (or a nearby wall) and by using a camera-mounted light. But these strategies have limited use and should be considered a last resort. If you decide to bounce light, be careful to position the light someplace it can't be knocked over and be sure to use sandbags to keep the light stable. Also be sure to aim the light carefully so it doesn't create a bright spot that's uncomfortable for people at the event. Camera-mounted lighting is generally only good for closeup talking heads (which we'll discuss in Chapter 13). It's not a good idea to use camera-mounted lighting as a form of additional ambient light at a location. It'll be too distracting.

TECHIE'S TIP

Sound Equipment

Getting good sound can be one of the most challenging aspects of shooting a real event, and the exact nature of the sound you'll need to capture will

depend on the event itself. A sporting event would generally be the easiest. You may not need anything more than ambient sound (i.e., general sounds of the game, cheering fans, etc.). The on-board mic should be more than sufficient for this situation. But if you've got an event in which the spoken word plays a significant role (such as the vows at a wedding ceremony), you're going to need a definite strategy for recording usable sound. Here are a couple of techniques to consider:

- **Lavalieres for main characters.** At a wedding, there are only a few key players: the bride, groom, and the person administering the oath (and at a birthday party, there's usually only one birthday boy or girl). It might be possible to put lavalieres on each of the principal characters, but these can't be wired lavalieres, and the transmitter of a wireless lav might be too awkward or bulky. There are certain small MP3 players that have the ability to record several hours of sound, and some of these players can also use external mics, which makes them ideal as body mics for participants in a real-time event (see Figure 11.3).

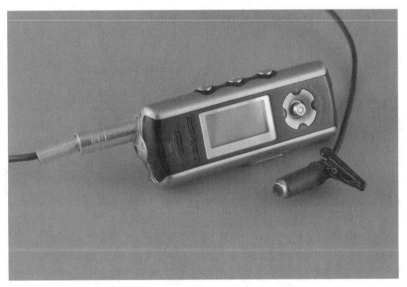

FIGURE 11.3 This MP3 player allows you to record audio using an external mic. It also allows you to manually set both the data rate and recording level. The long recording time and small size of recorders like this make them ideal for getting excellent sound at real events.

- **Plant mics.** Often, it's not practical to put mics on people at an event. In this case, you should consider placing a few plant mics. Carefully scouting the location before the event begins (and having good knowledge of how the event will unfold) will be key to determining where you should place a mic. The self-contained MP3 recorders mentioned previously also make ideal (and inconspicuous) plant mics.

- **Shotgun mics.** A last resort for getting good sound (which won't be as good as a lavaliere, but will still be much better than your camera's onboard mic) is a handheld shotgun mic (see Figure 11.4).

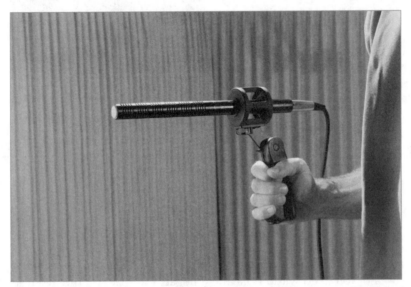

FIGURE 11.4 Using a shotgun mic in a handheld shockmount makes it possible to get good sound in places where using a boom would be impractical. For even more flexibility, it's possible to connect the mic to a wireless transmitter, allowing the mic operator to roam freely and get the best possible sound.

- Ideally, you'd have a partner whose sole responsibility is to concentrate on recording good sound. But if you have to work solo, it's also possible to mount a shotgun mic on the camera itself (see Figure 11.5).

None of these solutions is ideal. In reality, you'll probably need to use a combination of different techniques to get bits and pieces of sound you can assemble in the final mix. Having the ability to mix sound from a lavaliere

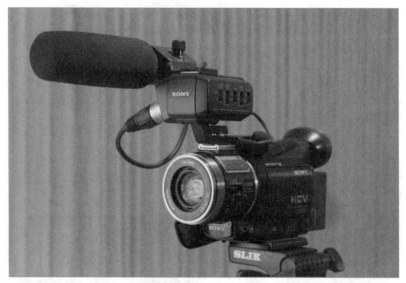

FIGURE 11.5 Mounting a shotgun mic to your camera will give you better sound than using the camera's built-in microphone. But its best use is for capturing the general sounds of an event. You'll still have problems getting strong dialogue with presence because the mic is probably too far away from the action.

with ambience from the on-board mic (and some carefully selected music and sound effects) will enable you to create a professional soundtrack even in a difficult shooting environment.

What size crew should you use?

As stated earlier, the challenge when shooting a real event is to get the footage you need without having a negative impact on the event itself. This will generally mean having the smallest crew possible (often, you'll end up shooting as a crew of one).

Any task is easier when you've got help, so bringing along one or two other people is usually a good idea. They can carry and set up equipment and help alleviate the common feeling that you've got to be in several places at the same time. Additionally, they can operate a handheld shotgun mic if you've got one.

NOTE *In some instances, you could have an extra crew member shoot additional footage with a second camera. We'll talk more about this in the next chapter, when we discuss shooting multi-camera events.*

How long will it take to shoot?

This one's easy. It will take as long as the event lasts. But that doesn't mean you should show up just before it starts and plan to leave as soon as it's over. We've already discussed the importance of getting to the location early so you can scout out the best shooting angles, check the lighting, and possibly put a few plant mics in place. Another good reason to arrive early (which is also a good reason to hang around after the event is over) is to shoot some *B-roll footage*.

> **KEY TERM:**
>
> **B-ROLL** A concept borrowed from shooting news footage (which has many similarities to real event shooting). B-roll footage consists of any shots of people, objects, or places that can be used to further illustrate the story or event you're capturing. Often, B-roll shots serve the same purpose as cutaways and inserts in narrative filmmaking. From a practical, editing point of view, B-roll footage is commonly used to transition from one piece of coverage to another.

Execution: Getting the Shots You Need

Shooting a real event can be both exhilarating and frustrating. It's exhilarating because you're shooting real people in a live, unscripted situation. Anything can happen. You'll often capture amazing shots and moments you hadn't foreseen.

But it can also be frustrating when you can't get the shots you need. Or when you miss an important piece of the action. Or when there doesn't seem to be anything happening and you don't know what to shoot next.

The best way to avoid that frustration is to have a game plan—a list of shots and moments you want to capture. Understanding the event is the first part of creating your game plan. Understanding shooting conventions is the second part of the plan. That's what we'll discuss next.

What type of coverage will you need?

The key to getting good coverage at a real event is to treat it as a fictional narrative. If you were designing coverage for a scene in a movie, you'd plan for an establishing shot, a master shot, two-shots, singles, and inserts. And when you framed your shots, you'd pay careful attention to the rule of thirds, positive and negative space, headroom, and overall composition. Having all these well-conceived shots would give you maximum flexibility in the editing room.

Shooting a real event is exactly the same. You still need a collection of well-framed shots of various sizes for the final edit. You need closeups and medium shots and wide shots. You need shots of movement and action, and you need quiet shots of listening and reaction. But how do you get all these shots if each portion of the event only happens once? The answer is you have to cheat.

If there are key actions that only happen once (such as blowing out the candles on a birthday cake, or the first kiss of a bride and groom), you need to ensure you get those important actions in a nice, stable shot that captures all the action. A medium shot or wider is usually best. And as long as you've captured key parts of the main action, everything else can be shot out of sequence.

Other pieces of coverage (such as closeup reaction shots of someone smiling or inserts of a hand clutching a tissue) can be shot at any point during the event. These inserts and reaction shots can then be put anywhere you need them, regardless of when they actually happened. In the editing room, you'll stitch all the pieces together and create the illusion you had multiple cameras all covering the event at once.

Efficient and effective ways to shoot a real event

You now know you're going to have to cheat. However, the ability to cheat and still get all the action footage you need is an acquired skill. The more events you shoot, and the more time you spend editing (both narrative stories and real events), the better you'll get at capturing the right mix of footage. But while you're gathering your own personal list of real-event dos and don'ts, here are a few tips to get you started:

- **Always be shooting.** There will be moments when not much is happening. That's a good thing. It's during these quiet moments that you can steal many of your inserts and reaction shots. Look for small details, such as a particular decoration on the wall. Look for people

who are smiling or nodding (or having any specific reaction). Shoot wide-angle shots of the crowd or the location or part of the event. Never waste a moment you could be shooting.

NOTE

Just be careful not to get so focused on shooting B-roll shots that you miss a key piece of action or an important moment of the event.

- **Each shot should be at least five seconds long.** A common mistake by first-time event shooters is to go *hunting* with the camera. They're trying to find interesting shots, but they have very short attention spans. They frame a shot, hold it for a moment, and then panic because nothing seems to be happening. So they abandon that shot and look for something more interesting. But in the end they wind up with a bunch of snippets of shots, none of which is long enough to use. To avoid this syndrome, each time you roll on a shot, count slowly to at least five before you cut. Most people will do something interesting if you watch them long enough, and you'll end up with cutaways that are long enough to use.

- **Incorporate movement into your shots.** Whether you're shooting handheld or on a tripod, get a mix of static shots and shots in which you slowly pan the camera across the crowd. And don't be afraid of using the zoom. A slow zoom in or zoom out can be every evocative when used at the right moment with the right music. Just be sure to practice so you can do even zooms that begin and end smoothly.

You might also want to do some quick pans and zooms, depending on the nature of the event and how you plan on editing the final project.

NOTE

- **Don't try to get everything.** As we stated earlier, you're not going to be able to capture the entire event with a single camera (although it is possible to be more thorough when shooting multi-camera, which we'll cover in the next chapter). You're going to miss a few things. You'll get better with practice, but don't get disheartened if you don't get the exact footage or shots you planned. A little creative editing can work wonders and help fill in any gaps in your coverage.

Common mistakes when shooting real events

Probably the single biggest mistake you can make when shooting a real event is not getting enough footage. As long as you have enough usable shots of different sizes showing different parts of the event, you'll be able to edit together a project that captures the flavor of the event. But if you don't have enough shots (or enough variety in the shots you've gotten), you'll have difficulty in the editing room.

The second common mistake is related to the first. Make sure the shots you're getting are long enough. If you're not counting for at least five seconds on each shot, you'll find much of your footage will be unusable.

NOTE

Even though it might feel silly, it's important to actually count to yourself during the shot. In the heat of shooting an event, your adrenaline will be pumping, and it will seem like your shots are a lot longer than they actually are. Counting will ensure your shots really are long enough.

Besides getting enough footage, other common mistakes include not having spare, charged batteries for the camera (and other spare batteries for your microphone or MP3 player/recorder) and not having enough blank tapes (if you're using a tape-based camera) or spare memory cards along with a plan to download and reuse the memory cards as you swap them out (another good reason for having at least one other person along to help). None of these potential problems are hard to solve, but they do require careful planning before the event begins.

The last mistake people make is not keeping the final project in mind. You're shooting the event for a reason. You're usually shooting the project for a specific audience, and there's a certain story you're trying to tell. Remember, you're not documenting the event, you're telling a story about it. The more focused you are about the type of story you're telling, the easier it will be to get the shots you need.

Editing Real-Event Footage

The amount of time it will take to edit your project will be influenced by two factors: how much planning you did before shooting and the amount of footage you actually shot. First and foremost, if you didn't shoot very much footage, it won't take very long to edit—you simply won't have much to work

with. Next, if you had a good plan (and you managed to get the majority of the shots you wanted), the editing should go fairly smoothly—just put the shots together according to your plan.

But the most likely problems will occur if you didn't get the footage you needed, or if you shot a great deal of footage, but don't really have a plan for how to put it together. In that case, editing a real event becomes a treasure hunt. You know there's a story in there—you're just not quite sure where it's at.

Unique challenges of cutting real events

The biggest challenge of cutting a real event is finding and defining the story you're trying to tell. Despite your best planning, there will be times when it seems like all you've got is a disconnected mass of footage.

In that case, your first task will be to become completely familiar with your footage. You've got to watch it all, and you've got to take notes. Break down your shots into categories. You should have wide shots, medium shots, and closeups. You should have beauty shots and action shots. You should have shots with clearly-defined moments and shots that convey certain moods and feelings.

> *Even if you know exactly what story you want to tell, it's still a good idea to completely immerse yourself in the footage. You will always find things you didn't know were there, and it will only make the final project that much better.*

NOTE

You'll have to watch the footage more than once. Each time you do, you'll see something new. It's going to take time, and there will be moments when you feel frustrated and lost. That's part of the process. But if you spend enough time with your footage (assuming you shot enough), you'll gradually discover common threads and themes in the material. That's when you're ready to start putting the pieces together.

How to organize and assemble your footage

Once you're completely familiar with your material, it's time to start putting together segments and sequences. Most event footage can be broken down into a few categories. Here are some common organizational groups:

- **Chronological.** Many events follow a certain script and that script can't really be altered. When you edit this type of project, it needs to be assembled in the proper order to make sense. Weddings fit this category.

- **Key moments.** Sometimes the order of an event isn't as important as specific moments or pieces of the event. In a project about a birthday party, it might not matter if they ate cake before or after opening presents, and you may decide the emotional response to a particular present should be the conclusion of your story, no matter when they actually opened the present.

NOTE

Remember, unless you're specifically trying to create an accurate documentary of an event, it's okay to change the order of moments for dramatic effect. Your goal should be to tell the best possible story.

- **Key people.** A company picnic is an example of an event in which you might want to structure your story around who was there, or how they behaved. Comparing the actions and reactions of certain key individuals (or following those individuals through a series of activities) can often be an effective organizational scheme.

- **Key themes.** At events with less structure (such as a class reunion or a casual get-together), you can often find common themes, such as nostalgia for the past or passion for political change.

NOTE

At events that are more about people than activities, you'll probably need to shoot some talking-head footage in which people express their feelings and opinions. We'll talk more about shooting interviews in Chapter 13.

Build Sequences or Chapters

Once you've decided on an organizational model, you can build the separate sequences or chapters of the project. Chapters can be built around specific moments (such as the vows at a wedding), people (such as the class president at a reunion), or themes (such as a particular emotion or memory).

Your basic goal when building chapters is to build a cohesive story block with a beginning, middle, and end. Introduce the moment, person, or theme, then explore the topic (or let us see it play out), then bring the sequence to a conclusion. But keep in mind, the sequence doesn't need to follow a strict, narrative logic. You can connect shots or moments in a sequence based on motion in a shot, or graphic elements like shape or color, or even the musical beat of a song chosen for the soundtrack.

A handful of chapters (three to five would be a good number) are all you need in a typical project. If the chapters are complete and well-structured,

you can link them together with simple transitions, such as music, static establishing shots, and/or title cards.

Don't Forget Sound

A key element for making effective event projects is sound. Ambient sound (such as the cheering at a sporting event or the music at a wedding) can be used to provide structure to a sequence or bring back a specific memory of the event. As you're watching and cataloging your footage, you should pay special attention to the sound captured during each shot. Individual sounds are as important to the creation of the final project as specific shots.

If you recorded people talking (possibly with MP3 recorder/players), listen to everything said for random comments or observations you can use in the project. It's very common to create a multi-layered sound environment that combines music and several ambience tracks along with carefully chosen and arranged sound bites. The sophistication of your final soundtrack is as important for a real event as it is for a narrative film.

Techniques for correcting common problems

As you assemble your chapters (or as you connect individual chapters to each other) at some point you're going to find holes in your footage. A particular shot isn't long enough, or you missed footage of a key moment. There are many ways to work around these problems.

Slow Down (or otherwise alter) a Shot

All editing software will allow you to slow down shots. This can be an effective way of making limited footage go farther. Additionally, you can usually make *freeze frames* (still images) from specific moments in any shot. Some software will allow you to manipulate shots by resizing them or flipping them vertically or horizontally. These effects should be used in moderation, but they can often allow you to complete a sequence for which you have little footage.

Use Still Photographs

If you can't find the images you need in your own footage, sometimes you can find still photographs taken by someone else that attended the event (and if you have an additional crewmember, it's often wise to have them take pictures on their own if at all possible). Any digital photos can be imported into a video project (and most software allows you to create moving clips that pan or zoom within a still image). Documentary filmmaker Ken Burns often uses this technique and it's remarkably effective.

Shoot Some Talking Heads

Depending on the importance of the project and how much additional effort you can put in, you may want to go back and shoot some interview footage of people who attended the event. Having a library of their thoughts and feelings regarding key moments can add an entirely new layer to the project (and allow you to bypass any missing shots). If you don't want to shoot talking-head footage, it's also possible to get much of the same effect by taping audio-only interviews and using their observations as sound bites.

And When All Else Fails: Use a Montage

You all know what a *montage* is (even if you're not familiar with the actual word). A *montage* is an edited collection of shots and images. It's usually accompanied by music (and usually the images flow in time with the music: rapid cutting for quick-paced music and slower cuts for graceful, elegant music).

NOTE

Montages have a reputation for being cheesy. They're often used in movies to compress time and get past some standard, cliché moments. The "falling in love" montage in a romantic comedy is a classic example.

People often get lazy when assembling montages. They put together some images and find a song or evocative piece of music and leave it at that. But if you incorporate still images (which have been animated with some zooms or pans) and build an ambience track that plays at a barely perceptible level under the music, a montage can be a creative solution for structural challenges in your project.

Final Thoughts

Because this isn't a traditional chapter, we don't have a traditional summary. We also don't have typical review questions or fieldwork. Your assignment for this chapter is to complete the exercise we've been discussing: go out and shoot a real event using the techniques we've discussed. That's why we wrote this chapter—to give you the knowledge needed to shoot a real event. But we're not going to turn you loose without a few final thoughts.

We've talked a lot about the necessity to be prepared. But you should also be ready for the unexpected. Since you're dealing with real people, anything can happen at any moment. If a moment of unplanned drama (or

comedy) occurs, be ready to ditch your original plans and follow the new story as it unfolds.

Don't ever forget that you're not going to get it all (if you absolutely, positively need to capture every moment of an event, you'll need to plan for a multi-camera shoot, discussed in the next chapter). So don't beat yourself up if you miss a shot or a moment. There's almost always a way to recover. The more events you shoot, the better you'll get at knowing what shots you need and where you need to be.

And just in case you're thinking that you're strictly a narrative filmmaker who has no interest in shooting real events, think about these points:

- Nothing will sharpen your shooting skills faster than having to quickly and efficiently find and frame shots in a fast-moving environment.

- You don't have to write a script, find locations, cast, or rehearse a real event. You have to do some research and planning before you shoot, but there's far less preproduction for a real event than for a narrative. It's an excellent way to gain experience in between narrative projects.

- You'll learn an incredible amount about editing, story structure, and effective shot design by immersing yourself in real-life footage and learning to find and craft a story.

And one final point to consider—footage from real events is a key element in many documentaries. So if you have any interest in documentary filmmaking, learning how to shoot real events is an excellent way to get started.

There are real events happening all around you all the time. Get out there and shoot one!

EXERCISE 2: MULTI-CAMERA SHOOTS

OVERVIEW AND LEARNING OBJECTIVES

In this chapter, you will:

- Master specific techniques for organizing, shooting, and editing multi-camera shoots

Give Me More Cameras!

So far, everything we've covered in this book has been geared towards shooting single camera. That's because most movies are shot single camera. But single-camera shoots take place under very structured and controlled conditions.

TECHIE'S TIP

One reason for the structured, methodical approach to shooting a movie is the meticulous way cinematographers light each shot. Generally, once the lights are set, each shot only looks good from a certain angle. For maximum artistic control, every time you move the camera, you need to move the lights. A multi-camera approach assumes a scene can look good from two different camera angles simultaneously. In order for this to be true, multi-camera lighting is usually flatter and less nuanced than single-camera lighting. That's one reason sitcoms (which are usually shot multi-camera) look more like a stage play than a movie.

Live events are unpredictable. They can't be stopped, started, and repeated the way scenes on a movie set can. So if you want to shoot a live event and still be assured of getting multiple camera angles and shot sizes, you've got to use more than one camera.

NOTE

In the early days of television, all programming was live—from news and variety shows to dramas--so all TV shows were shot multi-camera. Even though very few TV shows outside of news are broadcast live today, that tradition continues. Many television shows are still shot multi-camera, such as sitcoms, soap operas, and sporting events.

Multi-camera shoots on television are large and complex affairs. They have many camera operators all communicating by headsets with a central control booth where the director watches the unfolding action and coordinates the efforts of the cameramen to ensure the best possible coverage.

But you probably don't have the manpower and resources for that kind of shooting. That's okay. You don't need it. In this chapter, we're going to look at ways to use multi-camera techniques with a minimum of additional

resources. It's even possible to shoot a multi-camera setup as a single operator with only one additional camera. We'll show you how.

Multi-Camera Shoots: Philosophy and Definition

The definition of a multi-camera shoot is very simple. Any time you have two or more cameras shooting an event simultaneously, you've got a multi-camera shoot. There are two primary reasons you'd want to shoot an event with more than one camera:

- To get more coverage (and more footage) of a real-time event than is possible with a single camera. Think of two or more people applying the shooting techniques we discussed in the last chapter to cover an event more thoroughly.

- To get multiple camera angles of a performance from beginning to end. This would commonly be done to shoot a staged event such as a play or concert.

In the first instance, there's very little difference between shooting an event with either single or multiple cameras. You're still shooting "a noteworthy happening," and your focus is still on getting footage of defining moments so you can tell a story. It's just easier to capture those defining moments if you've got more than one camera.

But the second type of shoot is very different from the real-event shooting we talked about in the last chapter. In this instance, you use multiple cameras to capture a live performance from beginning to end. The goal of shooting a live performance is different than the storytelling goals we've discussed before. When shooting a play or concert you're more concerned with creating a faithful reproduction of the performance than with telling an original story about the event.

Accurately documenting a performance has its own set of requirements from both a shooting perspective and an editing perspective. We'll cover the specific differences between capturing a performance and shooting an event in the sections ahead. Just because you're faithfully documenting a performance doesn't mean your shooting and editing choices are less creative. Knowing when to use a closeup or a wide shot and how to shoot a well-composed image can make the difference between a home video and a polished, professional product.

Just to keep the distinction between the two types of projects clear, we'll refer to a multi-camera shoot designed to document a performance as a "performance video" or a "performance project." And we'll refer to shooting a real event with a storytelling focus as an "event video," or an "event project."

Typical characteristics of multi-camera shoots

Regardless of the type of project you're shooting, the biggest difference between single and multiple camera shoots is the need for increased coordination and communication. Even though you're not going to have a high-tech control room to communicate with your crew, you've still got to ensure the action's being covered and you're getting the proper mix of shots.

Beyond the need for greater coordination, the characteristics for a multi-camera *event project* remain the same as those for an event shot with a single camera (the event happens in *real-time*, it's *nonrepeatable*, and it's probably *not scripted*).

But if you're shooting a *performance video*, there might be a few differences. Although the event happens in real-time, it's probably scripted, and it may be repeatable. That gives you several options when planning. You may be able to shoot the performance over two or three evenings, which would enable you to get more coverage. At the very least, you might be able to attend the performance once or twice before you have to shoot. Knowing what happens in the performance (and when certain dramatic or comedic moments occur) will enable you to get far better coverage.

TECHIE'S TIP

If you want to shoot a performance like the pros, get a copy of the script and design coverage for the event with pre-planned wide shots, medium shots, and closeups. Then assign specific moments of the performance (and specific shots) to each of your operators. Shooting a performance this way takes a great deal of work, but it will give you the best possible results.

Unique strengths and weaknesses of multi-camera shooting

The nice thing about shooting multi-camera is you've got built-in insurance. With at least two cameras pointed at an event or performance, you at least double your odds of getting usable footage, and if you've planned it right, you'll always have a shot you can cut to.

But there's also a greater chance for making mistakes. When you're shooting single camera, you know exactly when you're shooting and when you're not. If you have to change a battery or memory card, you know when it's happening and what part of the event you may be missing.

But when you've got multiple cameras, it's possible to have a false sense of confidence. You may think something is being captured when it isn't. Unless your communication is rock solid, you might assume the other camera operator is shooting a key moment when in fact he's changing the battery on his camera. All of which points back to the need for communication and coordination. The multi-camera format can give you very professional results, but you've got to get the planning right.

Why choose this format

This format is a step up in sophistication. Shooting with at least two cameras generally means you'll have a larger crew. You'll at least double the amount of footage you capture, so you'll also need more time for postproduction. But there's a reason you take on this increased burden. You do it to create a better, more professional project.

If you're shooting a *performance video*, multi-camera is really the only way to get enough coverage (unless the performance is of short duration, like a single song or a monologue).

> *It's certainly possible to shoot a performance from beginning to end with a single camera. But you're limited to a single perspective. Watching the resulting footage would get visually boring very quickly. Multi-camera shoots allow you to create footage with visual variety without missing a single moment of the performance.*

NOTE

Planning a Multi-Camera Shoot

When shooting multi-camera, planning is even more critical than single camera. There needs to be a clear division of responsibilities regarding who shoots which aspects of the event or performance, and with more than one camera, you've got to figure out where the cameras should be placed. If you're shooting a *performance project*, you need to be aware of how your presence affects the audience and getting good sound becomes an even greater concern.

Should you have a script?

We've talked before about needing to be familiar with the event and having a list of key moments and shots you intend to capture. You need this same list when shooting multi-camera, but you also need to assign who is going to shoot what. There are several ways to do this:

- **By size.** You can designate one person to hold the wide shot, one person to concentrate on medium shots, and one person to shoot only closeups.

- **By person.** You can assign different performers or key people for your operators to cover. For example, at a wedding one operator could concentrate on the bride and one could concentrate on the groom.

- **By location.** Have different operators concentrate on specific areas or locations. If you are shooting a stage play, you could have one operator only cover what happens on the left side of the stage and one operator cover action on the right.

TECHIE'S TIP

Breaking up shots by size or by location is very useful if you have a limited number of operators. For example, a camera set to shoot a wide shot of an event could be unmanned if it were safely out of the way. Regardless of how you divide up your cameras and shots, it's always good to have a designated *roving operator* who can respond to spontaneous moments without disrupting your other shots.

KEY TERM:

ROVING OPERATOR A camera operator without a specific assignment such as a person or a location. This operator is free to get whatever she feels is the best shot at any given time, regardless of subject matter. In other words, she's free to *rove*. Also called a *roving camera*.

Having a shot list and assigning shots works best if you're familiar with how the event will unfold. It can also work when you're shooting an unfamiliar event, although you may not know who to concentrate on or where to look.

The most important thing to remember when shooting an unfamiliar event is to never assume someone else is getting a needed shot unless you can positively communicate with each other.

NOTE

What equipment do you need?

As before, we're going to look at the *camera*, *lighting*, and *sound* equipment you'll need for a successful multi-camera shoot. One distinction that'll affect the level of equipment you use is how much of an impact you want your taping to have on the event. With more cameras (and possibly more operators), your presence has the possibility of annoying or distracting people attending the performance or event.

If someone is paying you and they want the best possible product, then you'll probably use better equipment, and the cameras, tripods, and operators may be placed in more visible locations. You'll also be more likely to bring in some additional lighting, if needed. But if you want to remain unobtrusive and have the least impact, then you'll probably use smaller cameras and stick to available lighting.

Camera Equipment

Most of the considerations we discussed in the last chapter about the *size* and *sophistication* of your cameras still apply. But there's one new consideration when you're shooting multi-camera, and that has to do with how well your cameras match.

Under ideal conditions, every camera you use would be the same make and model. This is because different cameras tend to create images with slightly different characteristics (we're not talking about the difference between standard definition and high definition, or even the difference between 720 HD and 1080 HD). Different cameras can have different color casts and different image qualities, even if they have the same specifications on paper. These differences aren't always easy to correct and will be noticeable when cutting between shots from different cameras.

But if you can't use the same make and model for each of your cameras, try to use cameras from the same manufacturer, regardless of the model (i.e., use all Canon cameras or all Sony cameras). Cameras from the same maker will have the best chance of matching, even if they aren't the same model. No matter which cameras you use, make sure each camera is recording the same specs (i.e., HD vs. SD, 720 vs. 1080, interlaced vs. progressive, and 24 fps vs. 30 fps).

When choosing a camera, it's also important to check how easy it is to change batteries and memory cards (or tapes). Some cameras are designed so you can't remove the battery (or open the door to change a tape) when the camera is mounted on a tripod. This type of camera would be a poor choice for shooting a performance, since you could miss taping parts of the show while removing the camera from the tripod to swap tapes, batteries, or memory cards.

With multiple cameras, you're also more likely to use tripods (or monopods) for at least some of the cameras. And when shooting a *performance video*, you'll probably use tripods for all the cameras.

Lighting Equipment and Setups

The lighting considerations when shooting an *event video* are the same for multi-camera shoots as for events shot with a single camera. But when you're planning to shoot a *performance project*, you could encounter some unique situations.

Under ideal conditions, you'd be shooting a play or concert that was a polished, rehearsed performance on a stage (or in an environment) that was properly lit. In that case, no additional lighting would be needed. But sometimes you might want to shoot a musical event or performance that doesn't take place on a stage. It might be in a gymnasium, a conference hall, or even in a living room. In this situation, there would probably be enough ambient light at the location to get an image, but you may want to add some light for more professional results.

When adding light for a multi-camera *performance event*, you generally want to accomplish the following:

- Raise the ambient light level on the performers

- Provide some back light for separation

- Ensure the added lights don't detract from the performance (and are completely safe)

The best way to raise the ambient light level in a location without creating harsh shadows or blinding the performers is to use soft light sources. Bouncing light off the ceiling or using soft light boxes are two easy ways to get nice even light (refer back to Figure 5.5).

 All figures and shorts are included on the companion DVD with this book.

Back light can be tricky. Unless the ceiling at the location is high enough, any lights you use for back light will be visible in your shots. The only way to keep back lights from being seen is to raise them high enough so they're out of the shot.

FIGURE 12.1 In this closeup from *As You Like It*, Amiens is performing with his band in the Duke's nightclub. Since the back light behind his head is part of the setting for the stage, it's perfectly acceptable to see the light in the shot.

Alternatively, you can move back lights off to either side of the performance space, but then they act more as side lights or kickers (which isn't necessarily bad, it's just a different look).

Whether you raise the lights above the performers or move them off to the sides, another concern is how the back lights affect the audience. Since the back lights are aimed at the backs of the performers, they're aimed toward the audience. It's important that you don't blind members of the audience by hitting them with the back light.

Careful placement of barn doors and flags can keep your back light on the performers and out of the eyes of your audience (see Figure 12.2).

FIGURE 12.2 The back light behind our goat is providing nice separation from the background, and the *top leaf* of the barn door is keeping the light from shining into the eyes of the audience (in this case, the lens of the camera).

NOTE *There will be times when using back light just isn't practical at your location. That's okay. Remember back light exists to provide visual separation. As long as the images of your performers don't get lost in the visual clutter of the background, you don't need to worry.*

The final consideration when using lights at a performance is *safety*. You need to make sure the lights are placed out of the way so there's no possibility of someone bumping into a light (or getting burned by the bulb). Additionally, you should use sandbags to keep the lights from tipping over and ensure all cables are routed away from foot traffic (or securely taped to the floor) so they don't become a tripping hazard (see Figure 12.3). Setting, adjusting, and ensuring the safety of your lights will take time, so be sure to arrive at your location early.

Sound Equipment

When shooting an *event video*, the sound equipment and recording techniques are the same regardless of how many cameras you use. But an additional issue on multi-camera shoots is synchronizing the footage from different cameras (along with any sound from separate recorders). We'll discuss some specific techniques for recording and synchronizing sound in the production and postproduction sections ahead.

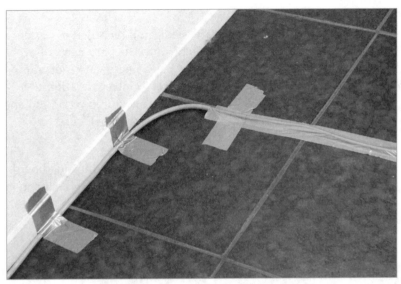

FIGURE 12.3 Ideally, electrical cords should be kept away from all foot traffic. But if you must cross a sidewalk or hallway, run the cord directly across the walkway and secure it with duct tape so no one will snag their foot and trip.

There's another difference between *performance videos* and *real-event videos* from a sound perspective. Since the goal of a *performance video* is to accurately capture and depict the performance, getting good sound is paramount. A play where you can't hear the actors or a concert where the music doesn't sound right isn't very useful (and probably won't be watched very often). When you're editing a *performance video*, you don't have the option of replacing your production sound with music and a multi-layered ambience track. You have to use sound of the performance, and it has to be good.

Fortunately, when you're shooting a performance, there's a pretty good chance the performers are mic'd. If it's a concert, the musicians (and singers) often use microphones, and many plays and musicals put lavaliere mics on the actors. At these productions, there's usually a sound technician responsible for mixing the different sound inputs and controlling the output sent to the theater speakers. If you're lucky enough to shoot at one of these events, it's often possible to plug a line into the sound mixing board and record professionally mic'd and mixed sound (usually on a separate recorder you leave in the sound booth). This is the best way to record sound at a performance.

And if for some reason you can't plug into the sound mixing board, the next best thing is to position a microphone directly in front of the theater speakers and record their sound. Just be careful to ensure you set a good level on the recorder and don't let the signal go above 0 db.

FIGURE 12.4 With an audio program like *GarageBand*, it's possible to use your laptop as a portable digital recorder. This is a convenient way to record sound directly from the mixing board at an event with professional-caliber sound.

But if the performers aren't using microphones and there's no sound mixing board, you'll have to mic the performance yourself. In the best case, you'll be able to set up a couple of microphones directly in front of the performers (just ensure the mics won't distract the audience). But sometimes the best you can do is hide a few plant mics where they won't be seen.

Regardless of which techniques you use, your goal is to get the fullest, cleanest sound possible. It will make all the difference in the quality of your final project.

If you're ever lucky enough to shoot in a concert hall with carefully designed acoustics, you'll get full, rich sound using nothing but the on-board microphone. This is a rare occurrence, but it highlights the importance of matching your recording technique to your location.

NOTE

What size crew should you use?

Ideally, you'd have a camera operator for every camera, along with a couple of extra crewmembers to help set up and move equipment. Sometimes there will be just you and two or three cameras on tripods. Keep in mind, the more crewmembers you have, the more coordination is required to ensure you're getting the best mix of coverage.

There's one advantage to doing it all yourself. The communication and coordination are much simpler. You know exactly what you're getting. You'll be incredibly busy, but you'll have total control of the shots.

NOTE

How long will it take to shoot?

The biggest change in shooting time for a multi-camera event is adding extra time for setting up your equipment. Having all your cameras ready to go well before the start of the event or performance is key, and setting up always seems to take longer than you expected (especially if you haven't been to the location before).

So be sure to arrive at the location early. It's best if you can scout the location a day or two in advance. Also allow some time for mistakes and some time to change your mind and reposition the cameras. It's better to be set up and waiting than to be scrambling at the last minute.

If you're shooting an *event video,* sometimes it's a good idea to stick around after the event is over to interview people who attended the event. As discussed in the last chapter, interview footage can be invaluable during editing (we'll cover techniques for shooting interviews in the next chapter).

TECHIE'S TIP

Execution: Getting the Shots You Need

Getting more shots with greater variety is the whole point of shooting with multiple cameras. You already know you need to get shots of different sizes from different angles. In the next few sections, we'll discuss strategies for getting good coverage for both event and performance projects with two or three cameras. We'll also look at scenarios in which you're shooting alone and situations in which you've got an operator for each of your cameras.

What type of coverage will you need?

Before we look at specific situations, let's discuss some basic philosophy. Remember to think of your project as if it were a movie and get as many shot types as possible (wide shots, medium shots, closeups, and inserts). This is where your shooting plan comes into play. Decide which wide shots you need and dedicate a camera or a specific operator to get those shots. Do the same for medium and closeup shots. Always make sure you have at least one roving camera (so if you're shooting by yourself, you'll be roving and the other cameras will be on *sticks*).

> **KEY TERM:**
>
> **STICKS** Movie slang for tripods. Anytime a camera is placed on a tripod, it's said to be *on sticks*.

Always be sure to get plenty of inserts (shooting inserts is the responsibility of the roving camera). If it's a musical performance, get closeups of hands on keyboards and fingers strumming guitars. If it's a play, get some inserts of important props and set pieces. In any performance, grab a few shots of audience members reacting to what's on stage. Just like with single-camera shoots, these inserts can be used out of sequence when you're editing to cover any awkward camera moves or gaps in coverage.

NOTE
Having inserts for insurance is even more important for multi-camera performance videos, since you have to provide continuous imagery for the entire length of the video.

And to the maximum extent possible, make sure you use tripods. If any of your cameras are unmanned (and on tripods by default), it's even more important

for the manned cameras to also be on tripods. Otherwise, you'll be cutting between tripod shots and handheld shots, which can make your editing more difficult (and potentially more awkward).

Efficient and effective multi-camera techniques

Now it's time to discuss specific shooting strategies. We'll talk first about strategies for operating solo as a crew of one, and then we'll consider situations in which you've got additional cameramen.

Shooting by Yourself

When you're shooting by yourself, you'll have one or two unmanned cameras (depending on whether you're shooting two or three total cameras). These cameras will be pre-positioned on tripods, and generally won't be moved during the shoot.

If you only have one additional camera, you should frame the unmanned camera for a wide master of the entire event or performance. This will be your *safety shot*. When you're editing, you'll be able to cut to the master at any time (which will give you the freedom to rove and change shots with any other cameras).

KEY TERM:

SAFETY SHOT In a multi-camera shoot, any shot you can cut to at anytime, regardless of what's happening, is called a *safety shot* (or an *insurance shot*). A safety shot is usually a wide master of the entire stage or event.

Now suppose you've got a second unmanned camera. This will give you some freedom. When you select a shot for this camera, be sure it's a very different angle (and different framing) from your wide-angle shot. The exact subject of this second shot will depend on the nature of the event. If your subject is relatively static such as a singer standing behind a microphone, you might frame a medium shot centered on the microphone. But if there's too much movement to concentrate on a specific person, pick an area in which much of the action takes place and compose a shot focused on that area.

Once your static cameras are placed, decide where you want to be with your manned camera. We've already discussed that this should be a roving camera. There are three primary ways you can rove:

- You can have the camera mounted on a static tripod and change shots by panning and zooming to reframe. This will give you the most stable shots (which will easily intercut with your static cameras), and if the tripod is small and light, you'll be able to move to different locations during the shoot.

- But if freedom to move is important (such as when you're covering a real event), you may want to use a monopod. This is generally the best compromise between mobility and stability (and stability is especially important when shooting telephoto shots).

- And as a last resort, you can go handheld. This will give you the greatest mobility, but your shots will be less stable (and getting usable telephoto shots will be difficult).

TECHIE'S TIP

If you're shooting three cameras, at certain moments during the performance (or event), you can reframe your second camera to give you additional variety when editing. Just be aware that while you're reframing the second shot, you can't be roving with the third camera—which generally means for the amount of time it takes you to reframe, the only usable coverage you have will be your master (unless you frame and lock off your roving camera before reframing the second camera).

Regardless of how you choose to shoot with your roving camera, remember the shots your static cameras are recording. Don't duplicate those shots when you're roving. Get as many different shots as you can, including panning and zooming shots, and if you find an especially beautiful or evocative shot, don't be afraid to hold it for several minutes (or to return to it several times while you're shooting). Always keep in mind that your goal is to get as much unique (and usable) footage as possible.

Shooting With a Crew

Beyond the need for coordination we've already discussed, there's not much difference between using manned and unmanned cameras for an event or performance. You still need a wide master shot. You still need medium and closeup shots. And you still need a roving camera.

The primary advantage of having manned cameras is the ability of the operator to continually reframe to follow the action. So if you've decided a certain camera should concentrate on getting medium shots, the operator can make sure he's getting the best possible medium shot at any given moment. But there needs to be a plan, and everyone needs to stick to that plan to ensure you get the proper coverage.

For example, you may decide the wide shot can remain unmanned (since it's capturing the entire environment, which probably won't change). Then you may assign one operator to get medium shots and one to rove and get closeups and inserts.

> It's important for each operator to understand their assignment and only shoot what they've been assigned. The rover will cover any unexpected or unforeseen moments. You'll run into problems if everyone starts roving because there'll be moments when none of the roving shots are usable.
>
> **TECHIE'S TIP**

Common mistakes when shooting multi-camera

The most common mistake when shooting multi-camera is to place the cameras too close together. This might not be a problem if the image size captured by the two cameras is significantly different (i.e., one camera is shooting a wide shot and the other is shooting a closeup), but if the image sizes are similar, the two shots will look too much alike. Remember, the goal is to get as many different shots as possible. So anytime you've got two cameras capturing virtually identical shots, you're wasting footage. Whenever possible, make sure your cameras are placed far apart and are seeing the action from different perspectives (see Figures 12.5, 12.6, 12.7, and 12.8).

FIGURE 12.5 If you're using two cameras, it's important to place them far enough apart so they create different-looking shots.

Figures 12.6 and 12.7 show what the shots from the setup in Figure 12.5 would look like.

Notice how having a significant difference in camera angle completely changes the background seen directly behind the character.

If the cameras were placed too close together, cutting between them would look awkward.

FIGURE 12.6 This is the shot from *camera one*. Compare it with the matching shot from *camera two* in Figure 12.7.

FIGURE 12.7 The difference in angle between *camera one* and *camera two* will allow you to give the audience a different perspective when you cut between the cameras.

FIGURE 12.8 If you're shooting HD, it's often possible to resize a shot (effectively zooming in) without losing too much resolution. The image shown here is a *medium shot* created by resizing the *wide shot* in Figure 12.7. This technique is especially effective if you're creating a standard-definition project using high-definition footage.

A Word About Coordination

When shooting a long performance (or event) with multiple cameras, it's likely that you'll need to change batteries, tapes, or memory cards at some point before the end of the event. This isn't a problem as long as you've always got at least one camera shooting usable footage (and if you're shooting with three or more cameras, only one camera should be taken out of circulation at a time).

Obviously, you'll run into problems if all your cameras run out of power at the same time (or if you have to swap tapes or memory cards at the same time). Planning and coordination is the way to avoid these problems. Set up a rotation so you're only servicing one camera at a time. This will mean changing some tapes or memory cards before they're entirely full. But this shouldn't be a problem if you've got enough spares.

> *If you're shooting cameras with memory cards, you'll need a way to download and erase the cards while you're shooting. One solution is a separate crewmember dedicated to downloading, erasing, and replacing memory cards.*

NOTE

Thinking About Sound

Another common mistake when shooting a *performance video* is not recording sound on a separate recorder. If you're shooting a long performance with multiple cameras, you'll be changing tapes or memory cards during

the course of the show. In this situation, no single tape or file from any one camera will contain the sound for the entire performance. This can cause problems during post where you need to have all the production sound for the project on a single track.

NOTE

While it's possible to construct a single, continuous production soundtrack using the sound from different cameras, each camera will have its own audio perspective (based on the camera's location and any external mics you have connected). Matching the sound created by these different perspectives may not be possible.

The only way to get a single production soundtrack is to record the sound on a separate recorder. That recorder would be connected to the sound-mixing board or any external mics (as discussed earlier) and should have enough capacity (and battery life) to record the entire event. You would then synchronize the footage from each of your cameras to this common soundtrack (as we'll discuss next).

Editing Multi-Camera Footage

The techniques for editing multi-camera footage will probably be different than you're used to. This is because multiple cameras shooting the same event give you different perspectives simultaneously. That means you can cut between any two cameras at any point and the action will match perfectly. Compare this with editing single-camera footage, where each take is a separate event. Although the takes may look alike, they're all different and you have to choose your edit points carefully to create the illusion of continuous action. With multiple cameras, there is no illusion. The action *is* continuous.

Of course, this only applies when multiple cameras are recording at the same time. This will obviously be the case if you're shooting a *performance video*. However, if you're shooting a multi-camera *event video*, there may be parts of the event that are only seen on one camera. For these parts of the event, you'll edit the footage as if it were a single-camera project. But for any moments where you have simultaneous footage, multi-camera editing techniques will apply.

The first challenge when editing multi-camera is making sure everything is in sync.

Unique challenges of multi-camera edits

The biggest challenge of preparing a multi-camera edit is getting all your footage in sync. This takes more work than preparing a single-camera project (even if you shot separate sound for the single camera). It also requires editing software that's more sophisticated than iMovie or Movie Maker.

> *Movie Maker and iMovie only allow you to use a single video track. For multi-camera projects, you'll need a separate video track for each camera.* **NOTE**

The key to synchronizing sound for a multi-camera project is planning for (and creating) discrete sync points. Here's the ideal setup:

- You're recording separate sound on an external recorder. You're also recording sound using the built-in mics on each of your cameras.

- Start the external recorder. Then start each of your cameras.

- While all the cameras and the recorder are recording, clap your hands together to create a single, sharp sound (if you want a visual sync point in addition to the audio sync point, make sure the cameras are pointed at your hands when you clap).

- Don't stop recording (with either the cameras or the recorder) until the event is over.

> *If you stop and restart any of the cameras (or the recorder) after creating the sync point, any footage after the point where the camera or recorder was restarted will not be in sync.* **NOTE**

By following these procedures, you'll end up with a sharp, audio spike on the soundtracks from the recorder and each of your cameras. To synchronize the soundtrack from the recorder with the footage from your cameras, all you have to do is line up each of the audio spikes on the soundtrack (see Figure 12.9).

> This is the ideal technique when you're recording separate sound. But if you're shooting a *real-event video* and using only the on-board mics (without an external recorder), you line up the sync points from each individual camera in the same way. **TECHIE'S TIP**

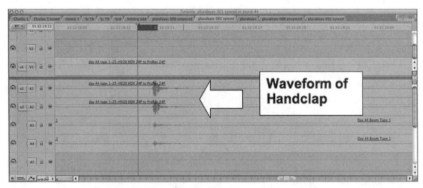

FIGURE 12.9 In the timeline shown here, the *stereo pair* on tracks *A1* and *A2* has been synchronized with the *stereo pair* on tracks *A3* and *A4*. The synchronizing spike in this example was created by a handclap. Notice how clear and distinct the *waveform* appears.

But what happens if you need to stop and restart your cameras (such as when shooting a real event or when changing batteries or memory cards)? In that case, you'll need to sync footage without a pre-planned sync point. Fortunately, the procedure is the same, except you need to find a distinctive word or sound that was recorded by all cameras (and the external recorder) to use as the sync point (see Figure 12.10).

TECHIE'S TIP

One way to tell if your footage is in sync is to listen to all the audio tracks simultaneously. If the tracks are perfectly in sync, the audio will sound completely normal. But if the tracks are out of sync by even a single frame, you'll hear a slight echo that sounds like reverb. The more frames the footage is out of sync, the more obvious the sound of the echo will be. Slip and slide the audio tracks until all trace of reverb and echo disappears.

How to organize and assemble your footage

The first step in organizing a multi-camera edit is to put all your footage on the timeline and synchronize each camera as described in the last section. Once this is done, each camera will have its own video track (along with two corresponding audio tracks), and the separate sound from your external recorder should have two audio tracks as well (assuming you recorded two tracks) (see Figures 12.11 and 12.12).

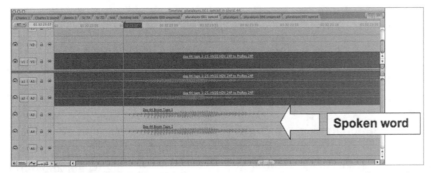

FIGURE 12.10 In this example, a spoken word was used to synchronize the *stereo pair* on tracks *A1* and *A2* with the *stereo pair* on tracks *A3* and *A4*. Although the shape of the waveforms is similar, there's no clear synch point as with a sharp sound like a handclap. Synchronizing in this manner takes much more time.

FIGURE 12.11 This timeline is from a simple, *two-camera shoot*. Video track one (*V1*) is paired with *A1* and *A2*. *V2* is paired with *A3* and *A4*. *A5* and *A6* is a stereo pair recorded by an external microphone.

FIGURE 12.12 This timeline is from a *ten-camera shoot*, with each camera synched to a single, stereo audio track. The top video track (*V11*) is a rough cut with the best shot from each track connected by dissolves.

Most editing software assigns two audio tracks to each video track. This is based on the assumption the camera is recording stereo sound. But in reality, you may have two separate mono tracks instead, depending on how you recorded sound and whether you used external mics. (To review how to record two separate mono tracks on the stereo channels of your camcorder, see Chapter 6).

After all the footage is arranged on your timeline, the fun begins. Assuming you've got two or three different camera angles for each moment of the performance (or event), editing is a process of deciding which angle to use for each specific moment.

The viewer window in most editing software usually only shows you whichever video is on top of your stack of tracks, but it's possible to *deselect* any of the upper tracks to view the footage lying underneath (see Figure 12.13).

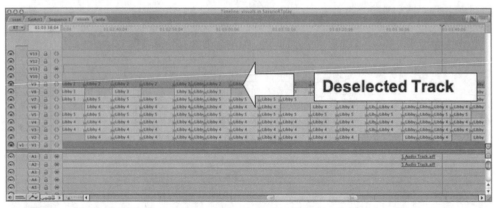

ON DVD

FIGURE 12.13 This is the project from Figure 12.12 halfway through the editing process. The top track (*V9*) has been *deselected* so the video on track *V8* can be seen. Also, certain shots from *V8* have been *deleted*, allowing the shots on track *V7* to be seen. *Deselecting* and *deleting* clips are two techniques for trying different combinations of shots when editing a multi-camera project.

By selecting and deselecting tracks, you can view each moment captured by each camera and decide which shots to use. This is what takes the longest. Just like editing a single-camera project, becoming familiar with your footage is the most important (and time-consuming) part of the process. But once you've selected your shots, editing is a simple process of cutting back any upper layers when you want to use footage on other tracks (see Figure 12.14).

FIGURE 12.14 This is the timeline for the project discussed earlier in Figure 12.5. The upper video track (*V2*) has been cut away at selected points to allow *V1* to show through, and parts of *V1* have been cut and resized to create medium shots for even more visual variety.

If you've got good production sound on a separate track, after you've selected and revealed your camera angles, you're done. But usually things don't go quite that smoothly. In the next section, we'll talk about finding solutions to common problems.

Techniques for correcting common problems

The most common problem with multi-camera projects is the same as for single-camera projects. There will be moments during the performance (or event) when you don't have any good shots. Generally, the techniques for dealing with this problem will be the same whether you're cutting an *event video* or a *performance video*. But with an *event video*, the odds are greater that there will be some moments when only one camera got a decent shot and other moments for which there's no good footage at all. In these cases, you have to revert to the single-camera strategies we discussed in the last chapter. So use multi-camera techniques for those segments of the event when you've got good coverage and use single-camera techniques (i.e., still photos, montages, talking heads, etc.) when that's all you've got. Remember, with an event project you're often trying to capture the flavor of a moment and tell the best story possible regardless of how many cameras you use.

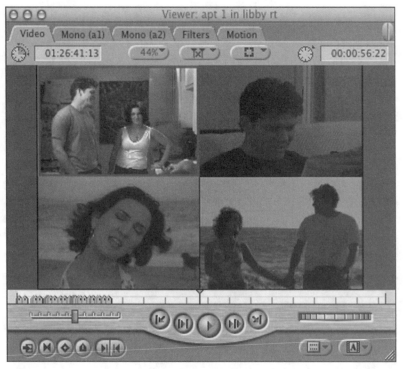

FIGURE 12.15 This display was created by a *multi-clip sequence*. This particular project was a music video, and the images were all in sync with a common soundtrack. When the track plays, all four images can be seen simultaneously. To cut between one shot and another, you can simply click on the shot you want in the viewer.

When cutting a *performance video*, you usually have far fewer options. That's because you can't arbitrarily skip over parts of the performance (assuming your goal was to capture the entire show). Here are some techniques to fill in holes in your performance footage.

Use the Master

Hopefully, you captured the entire performance in a wide master shot. That's why it's called your *insurance* or *safety* shot. You should be able to cut to it at any moment. But suppose there's a long section of the performance when none of the other cameras has a good shot. Watching the master for more than a few moments gets boring very quickly.

If you're shooting in HD, you can possibly resize (and reframe) the shot to get a medium shot or even a loose closeup (refer back to Figure 12.8). You'll lose some resolution using this technique, but if you make a standard-definition copy, it's not usually a problem.

Using this technique, you can cut from the wide master to a resized portion of the master. This can be used to break up long sections of the master and keep the project visually interesting.

> In extreme cases, you can shoot an entire event with just one camera, if it's high definition and your master has a clean view of all the action. By resizing and reframing within the shot, you can create enough different shots to create a multi-camera effect. Although this technique isn't ideal, it's better than sticking with a static wide shot.
>
> **TECHIE'S TIP**

But what if there are moments when your master isn't usable (i.e., somebody bumped the camera or you had to download the memory card)? In that case, you'll need to use one of the following techniques.

Use Your Inserts

Remember, one of the tasks assigned to the roving camera is to get inserts. The reason for these inserts is to cover problem areas in shots from other cameras (such as a bumpy camera move or quick reframing). You don't usually dwell on an insert very long.

Use inserts as band-aids to cover problem moments or transition from one shot to another. For example, in a musical performance, any closeup of an instrument can be used almost anytime. In a play, cut to a reaction shot of any character on stage who isn't speaking (even if you have to create a reaction shot by resizing or reframing). You can also cut to audience reaction shots at anytime.

Get Creative

But if you don't have enough inserts (and your master has a gap), it's time to get creative. Slowing down a shot might work if specific lip sync isn't involved. A freeze frame or still image could also help. You might even create a montage of still images if you're cutting a musical performance. If all else fails, think about omitting part of the performance. Cutting a few lines (or even an entire scene) from a play is a drastic measure, but it's better than giving up on a project.

Tricky Sound Techniques

So far, we've assumed you have a single, continuous recording of the performance that doesn't need any work. But that may not be the case. You might have used several separate plant mics. Or you might have shotgun

mics on either side of the stage. Or you may have nothing but sound from the camera's on-board mics. In these situations, you'll have to build your performance soundtrack the same way you choose the shots for your final edit. You'll have to listen to each mic and decide which ones sound best during which parts of the performance. For example, the microphone on the right side of the stage may sound best for certain scenes and the microphone on the left may work better other times.

But audio tracks have one major advantage over video tracks. You can play more than one track at a time. Sometimes playing the audio from two or three microphones simultaneously will give you the best sound.

TECHIE'S TIP If you've got one microphone very close to an actor or singer (such as a lavaliere) and one microphone at the back of the auditorium (such as your camera's on-board mic), put them both on the timeline and experiment with changing their levels relative to each other. Using this technique, you can make it sound like you're sitting anywhere from right next to the stage (when the lavaliere is louder) to the back of the auditorium (when the camera mic is louder).

Final Thoughts

Okay. Now you know everything there is to know about multi-camera prepping, shooting, and editing (well, almost everything). As you've hopefully discovered, in many ways it's quite a bit different than shooting and editing single camera. "So why," you're asking yourself, "would I ever want to do this?" There are a number of reasons:

- Once your friends and family know you're a filmmaker, you'll get a lot of requests to shoot events and performances. It doesn't matter that making a movie is completely different from taping your cousin's high-school play; they'll ask you to do it. Sometimes you'll actually want to....

- Being able to shoot weddings and special celebrations is a marketable skill. With some practice and a little publicity, it's possible to earn

good money as an event videographer. And it beats serving coffee to pay the bills while you're trying to find backing for your independent feature film.

- If you have aspirations of working in any of the multi-camera television formats (i.e., soap operas and sitcoms), shooting performances with multiple cameras is good practice. You'll learn which shots work best and how to visualize several camera angles simultaneously.

- And finally, it's fun! There's real satisfaction in shooting a celebration or capturing a performance and making it look like a professional, Hollywood production.

EXERCISE 3: SHOOTING INTERVIEWS

OVERVIEW AND LEARNING OBJECTIVES

In this chapter, you will:

- Master specific techniques to prepare for, shoot, and edit interviews

They're Not Just Talking Heads

When you think of interviews, what do you imagine? You might picture a reporter asking a political candidate about the election. Or maybe you see a talk show host and a celebrity talking about her latest movie. It could also be a historian answering questions about the Civil War. Once you start to look for them, interviews are everywhere. They're a key component in documentaries, reality television, and every kind of news (and Hollywood gossip) show.

Knowing how to shoot and edit interviews is a valuable skill for anyone who wants to tell stories with a camera. The event projects we've covered in the last two chapters could all be enhanced by interviews with key participants.

So how hard can it be? Like everything related to video production, there's more to shooting interviews than most people realize. There are many ways to structure and shoot an interview. There are single-camera, handheld interviews shot on the spur of the moment, and multi-camera studio-style interviews in which both interviewer and subject appear on camera. In the pages ahead, we'll look at ways to plan for and shoot several interview styles, and we'll also demonstrate that a good interview is far more than a few closeups of talking heads.

Interviews: Philosophy and Definition

The reasons for shooting an interview are fairly simple. You want a subject to *tell a story*, *provide some facts*, or *express an opinion* on camera. These stories, opinions, and/or facts can then be used in many different ways, such as:

- To provide narration (or a "you were there" quality) to event footage

- To provide a personal perspective for documentaries and reality shows

- To create standalone content for news shows or video podcasts

- As the foundation for an *oral history*

ORAL HISTORY The dictionary defines oral history as tape-recorded historical information obtained in interviews. This information usually concerns personal experiences and/or recollections.

The good news is interviews are relatively easy to shoot. Once you understand the basics, you can set up an interview with minimal preparation. Interviews are an excellent way to get additional footage (and provide structure) for event projects and documentaries.

Typical characteristics of an interview

Interviews have a very straightforward structure: An interviewer asks questions and a subject answers them. That's it. Really. Of course, there are many specifics related to shooting an interview, such as how many different angles you capture and what type of B-roll you need, but these are details. In its most basic form, an interview is nothing but questions and answers. That means only two things are really important.

- How good are the questions?
- How interesting are the answers (which brings up the related issue of how interesting is the person who's speaking)?

The quality of the questions and the content of the answers ultimately determine how compelling (and how potentially useful) an interview can be.

Why choose this format

You choose an interview when you want to relay information or relate experiences that come from a very specific point of view. Sometimes that point of view conveys information with the authority of an expert, such as having a geologist explain the causes of an earthquake. Other times, you want to present the first-hand account of a unique experience, such as the survivor of an earthquake describing how their house was shaken. When properly shot and edited, the experiences and/or authority conveyed by an interview can add credibility and authenticity to any project.

Of course, interviews can also be used to discredit or ridicule a speaker, depending on how they're edited. If you use too many talking heads, you risk boring the audience. Careful selection and use of interview footage is crucial to its effectiveness.

Planning an Interview

If you've tried some of the previous exercises, you should feel comfortable shooting real people in real situations. You should also know how to get good sound in various environments, and you should be comfortable shooting with either *available light* or adding a few well-chosen lights to a location.

KEY TERM:

AVAILABLE LIGHT Another term for the illumination existing naturally in an environment. Also called *natural light* or *ambient light*.

There really isn't anything new from a technical perspective. But there are some things to keep in mind as you prepare.

Should you have a script?

Unlike the other real events we've discussed, interviews require a well-researched and thought-out script, which consists of the questions you're going to ask. Writing good questions is by far the most important part of preparing for an interview.

Although you might think scripting your questions keeps the interview from being spontaneous, just the opposite is true. The more prepared you are, the more you can deviate from your questions and still get everything you need. Relying on inspiration to guide you through an interview is a sure way to fail.

A common technique used by lawyers during a trial is to never ask questions to which they don't already know the answers. This is excellent advice for

interviewers as well. Here are a couple of ways to guarantee you'll write good questions:

- **Research the topic.** Whether you're getting factual information from an expert, or collecting the memories of a unique experience, the more you know about the topic, the better. For example, if someone is describing how they lived through a historical event, the more you know about that event, the more specific your questions can be.

- **Pre-interview the subject.** Meet with the subject beforehand (or talk to them on the telephone) and discuss the questions you're considering. You'll quickly find out which questions lead to interesting answers and which questions are duds, and you'll also get ideas for even more questions.

In general, the best questions are *open-ended*, because they start a conversation and invite the speaker to talk about her feelings and impressions. The following are good examples of open-ended questions:

- *How did you feel at that moment?*

- *Why was this moment important?*

- *Tell me about the time you...*(fill in the blank).

Avoid asking questions with yes or no answers, or questions that can be answered with a simple statement of fact. For example, if you're asking about how someone survived a disaster, don't ask, *"Was it difficult?"* A better question would be *"What made the situation difficult?"*

> *Remember, the goal of an interview is to get footage with unique (and detailed) recollections or descriptions. You do this by asking questions that encourage your subject to delve deeper into his memories (or expert knowledge).*

NOTE

Learning how to write good interview questions is a skill that only gets better with practice. But it's a skill worth learning. Having well-written (and well-researched) questions is one way of insuring your interviews stand apart.

Camera equipment

Interviews can be shot both single and multi-camera. They can occur in staged setups with cameras on tripods and in event situations where you're shooting with a handheld camera.

Depending on which type of interview you're shooting, our previous discussions about *size, sophistication, matching, shooting formats,* and the *use of tripods* still apply (review Chapters 11 and 12 if necessary).

Lighting equipment and setups

The lighting equipment you need for an interview will depend on the type of interview you're shooting. We're going to look at two different scenarios:

- Interviews captured *in the moment* during an event
- *Staged interviews* conducted in a controlled environment

In-the-Moment Interviews

Interviews captured *in the moment* occur at an event when the opportunity arises. An example might be a chance meeting with the father of the bride during a wedding reception. In a situation like this, you might be shooting handheld as a rover, or you might have a tripod set up in the corner where you can interview people as they pass by.

KEY TERM:

SOURCEY When it's obvious where the light is coming from in a shot, that light is said to be *sourcey* (since you can tell where the light *source* is located). But this description only applies to light you add to a situation. The sun would never be called *sourcey* because it exists naturally in the environment.

A common way to light this type of interview is with a camera-mounted light (or a light built into the camera) (see Figure 13.1). When shooting something other than an interview, you'd normally avoid using an on-camera light because they tend to be *sourcey*.

FIGURE 13.1 The *LED light* on most smaller cameras is very *sourcey* and can be annoying to person you're interviewing. But it also allows you to get a usable image even in a dark environment (provided that your subject is close to the camera).

All figures and shorts are included on the companion DVD with this book. **ON DVD**

A sourcey light is bad because it calls attention to itself and highlights the artificial nature of filmmaking. But when shooting an interview, you're not trying to blend into the background. It's obvious you're there with a camera, so if you need the additional light to get a good image, a sourcey light is okay (provided it's not so bright it blinds the subject or disturbs other people at the event).

> *If you've found an out-of-the-way corner to interview people, it might be possible to set up a soft key and back light (refer back to Chapter 5 for some easy lighting setups). This setup will give you a more cinematic image (though technically, it's more like the staged interviews we'll discuss next).*

NOTE

Staged Interviews

Shooting a staged interview is similar to shooting a scene from a movie. Ideally, you're in a controlled environment and you can place the lights and camera (or cameras) anywhere you like. Obviously, this type of interview gives you the most freedom in setting up your shots.

If you're shooting a single-camera interview in which only the subject appears on camera, you'd typically use standard three-point lighting. Since interviews are generally shot in closeup, using soft light for the key will create the most flattering images of your interviewee.

If you're shooting an interview in which both the interviewer and subject appear on camera, you still want to create nicely modeled, separated images. The good news is it's possible to provide three-point lighting for both people using only three total lights (see Figure 13.2). The beauty of this setup lies in the fact it works for one, two, or even three cameras simultaneously.

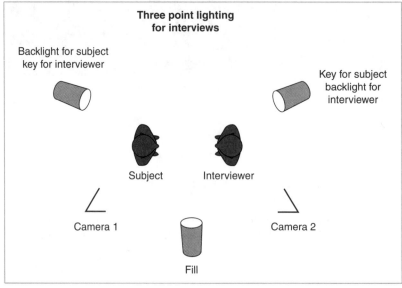

Three point lighting for interviews

Backlight for subject key for interviewer

Key for subject backlight for interviewer

Subject Interviewer

Camera 1 Camera 2

Fill

FIGURE 13.2 This lighting setup provides three-point lighting for both the interviewer and the subject using only three total lights. If the ambient light level is high enough, you could eliminate the fill and still have modeled lighting with only two lights. A similar setup was used for the interview shown later in Figures 13.7 and 13.8.

Sound equipment

The importance of getting good sound during an interview is obvious. You may choose not to use the talking-head images in your final edit, but you

can't choose not to use the sound (assuming you use the interview at all). But fortunately, getting good sound is relatively easy.

In a staged interview, both the interviewer and subject usually wear lavalieres (and wired lavalieres can be plugged directly into the camera or recorder if *the talent* remains stationary). And unlike narrative film, you don't need to hide the lavs. They can be worn out in public for the whole world to see.

KEY TERM:

THE TALENT In movie lingo, anyone who appears on camera can be referred to as *the talent*. This term can be used for either men or women, plural or singular. But since it's considered rather impersonal, it's usually only used by crewmembers when those it refers to are not around.

When shooting *in-the-moment* interviews, it's typical to use a handheld microphone shared between the interviewer and subject, since this allows for the most flexibility. But another common setup is to put a lavaliere on the interviewer and use the handheld mic solely for recording the subject.

It's also possible to use a shotgun mic and boom for both *staged* and *in-the-moment* interviews, but this requires a dedicated boom operator.

TECHIE'S TIP

If you're shooting as a crew of one with a handheld camera, it's even possible to use the camera's on-board microphone (although using an external mic mounted to the camera will usually give you better sound—see Figure 13.3). Using a mic on the camera should be your last resort, but if it's your only option, the key to getting good sound is standing right in front of the subject and getting the mic as close as possible to the person who's speaking.

What size crew should you use?

As discussed in the last two sections, it's possible to shoot interviews completely on your own using a camera-mounted light and the on-board (or an externally-mounted) microphone.

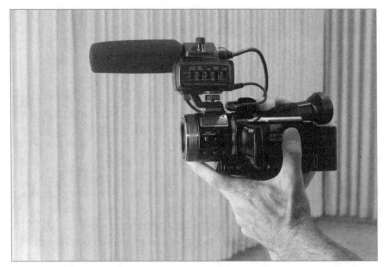

FIGURE 13.3 An external mic mounted on the camera will usually produce better sound than the camera's on-board mic. But anytime you're shooting handheld with either the on-board or an externally-mounted mic, you need to handle the camera very carefully to avoid recording the sounds of operating the camera.

TECHIE'S TIP

Most people assume shooting interviews as a single crewmember means you have to go handheld. But sometimes a better solution is to use a tripod. This arrangement allows you to stand beside the camera and make eye contact with your subject. It also allows you to use more creative lighting and mic'ing solutions.

But going solo when shooting interviews is not ideal. It's not easy to listen intently to your subject's answers while simultaneously operating the camera and framing your shots.

The best way to shoot an interview is to keep the interviewer and the camera operators separate, and if possible, you should have a separate camera operator for each camera (although you can also use an unmanned camera for wide shots in a staged interview). As an example, the crew for a three-camera staged interview using a boomed shotgun mic would be at least five people, counting the interviewer.

How long will it take to shoot?

Unlike events or performances that have specific start and stop times, interviews are often open ended. If you have a long list of questions, or a

subject who likes to talk, interviews can go on for a couple of hours. But if you're shooting *run-and-gun* style, an interview may be a single question posed to someone on the street.

> **KEY TERM:**
>
> **RUN-AND-GUN** A fast and loose style of shooting that usually involves a single handheld camera reacting to a dynamic, constantly changing environment. Also referred to as *running-and-gunning*.

Execution: Getting the Shots You Need

Getting all the shots you need is a challenge anytime you shoot an unpredictable event. But when you shoot an interview, you've got an additional challenge. Not only do you have to worry about getting the proper collection of shots, you also have to worry about the content in the answers your subject is giving. Are their answers interesting? Are they giving you enough detail? Do they appear relaxed or are they nervous? Is their manner of speaking clear and easy to understand, or are their answers convoluted and hard to follow?

It doesn't matter how much coverage you have or how beautiful your shots are if you're not getting usable answers to your questions. In the sections ahead, we'll not only discuss how to get good coverage, but also how to help shape the content of an interview.

What type of coverage will you need?

The type of coverage you need will depend on how you plan to use the material from the interview in your final project. Here are some questions to help you decide how to shoot an interview:

- Are you going to show much talking-head footage, or do you plan to use the interview primarily for an audio track to provide explanation and commentary for other footage?

- Do you want the subject to appear on camera alone, or do you want the interviewer to appear on camera as well?

- Is the interview footage a major component of the final project (as in the case of a documentary about a specific person), or is the interview only used to give additional perspective to other material?

The answers to these questions will shape your style of shooting (i.e., single-camera or multi-camera, carefully lit and staged, or captured as opportunity permits).

Regardless of which style you select, you're going to need some inserts or B-roll footage to use for cutaways during editing. Sometimes these inserts can be pulled from other footage you're using for the project, but many times you'll need to shoot additional B-roll during (or after) the interview.

Efficient and effective interview techniques

Now it's time to get down to specifics. We're going to look at different techniques for shooting interviews with a single camera and with two or three cameras. We're also going to discuss some ways to get the most usable responses from your subjects regardless of which style you're using or how many cameras you have.

Single-Camera Techniques

Let's assume you've only got one camera (and that you've decided one camera is all you need). You don't want the interviewer to appear on camera. As a matter of fact, you don't even want the interview to seem like an interview. You want it to feel like your subject is just telling a story or remembering an event.

One version of this scenario would be a staged interview with your subject comfortably seated in a well-lit environment. You'd have a separate interviewer and camera operator and the camera would be on a tripod. You'd sit next to the camera facing your subject and your operator would frame a shot somewhere between a medium shot and a closeup.

NOTE

One reason you sit next to the lens is so the eyeline of your subject leads off camera. This makes it appear as if they're having a conversation with someone just off screen (which they are). Generally, you don't want your subject looking directly into the lens because this gives the impression your subject is speaking directly to the audience. This may be appropriate in certain situations (such as news shows), but it can sometimes make viewers and subjects uncomfortable.

Over the course of the interview, your camera operator should vary the shot size and framing to get some medium shots, some closeups, and some shots with slow zoom-ins and zoom-outs. A general rule for framing is this: When you're discussing factual topics the shots should be a little wider, and when you're talking about something more emotional, the shots should be a little tighter. But don't spend too much time in closeups (and don't get too close), otherwise the shot could feel uncomfortably intimate.

Most of these same techniques can be used if you're operating as a crew of one. If you've got a tripod, frame your shot and then sit next to the camera as you conduct the interview. You can pause between questions and reframe to get shots of different sizes. If you're operating handheld, a good technique is to hold to camera off to one side while shooting so you can maintain eye contact during the interview (see Figures 13.4 and 13.5).

TECHIE'S TIP

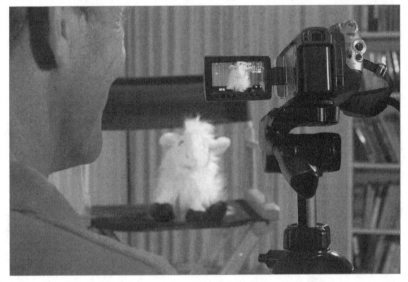

FIGURE 13.4 If you're shooting a single-camera interview and you're conducting the interview *and* operating the camera, position the monitor so you can maintain eye contact with your subject while still keeping an eye on the monitor.

If you are holding the camera, be sure it is off to one side, as shown in Figure 13.5.

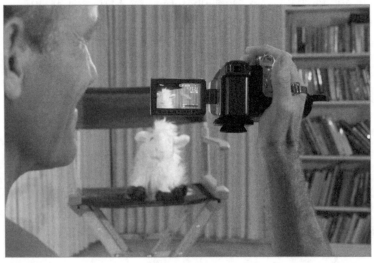

FIGURE 13.5 It's also possible to handhold the camera while conducting the interview, but remember to keep the camera slightly off to one side so you can maintain eye contact with your subject. The more you can concentrate on your subject (instead of the monitor), the more natural the interview will sound and the better your footage will be.

Multi-Camera Style with a Single Camera

One disadvantage to the style we've just discussed is the limited number of possible cutaways to use when editing the interview. If you've decided the interviewer shouldn't appear on camera, you'll have to use B-roll of the environment or shots from other footage if you need to cut away from the speaker. But if you have shots of the interviewer, you can use those reaction shots to cover camera moves or gaps caused by editing (a technique we'll cover in more detail later).

But how do you get reaction shots when you've only got a single camera? The same way you do when you're shooting a movie—you shoot the reaction shots separately. To use this technique, shoot the interview normally as described above. Then after the interview is over (and possibly even after the subject has left), move the camera and shoot reaction shots of the interviewer. Shoot a few minutes of the interviewer (or yourself) listening and nodding as if the subject were giving his answers. If the interview was humorous, you should get some shots of the interviewer smiling (and possible laughing), and if the interview was serious, make sure to get shots with appropriate reactions.

One final consideration when shooting separate reaction shots is whether you want to show the interviewer on camera when the questions are being asked. If so, then also shoot the interviewer asking each of the questions used in the interview. When you put this footage together in the editing room, you'll create the illusion that the interview was shot with multiple cameras. Even more important, you'll have total flexibility to reshape and tighten the interview.

Multi-Camera Shoots with a Single Operator

Now suppose you've got two cameras but only a single operator. If you've decided the interviewer shouldn't appear on camera, then both cameras should be pointed at the subject (and they should both be on tripods). Frame a medium to wide shot with the unmanned camera and lock it off. Your operator would then concentrate on getting closeups and medium closeups. Having the ability to cut between these two angles will give you almost as much flexibility as working with reaction shots.

> *When pointing two cameras at the same subject, make sure the eyeline is the same on both cameras (i.e., the interviewee is looking either camera left or camera right on both cameras). Having an eyeline to the left on one camera and to the right on the other will make the edited project seem disjointed.*

NOTE

It's also possible to use an unmanned camera to shoot a wide shot of both the subject and the interviewer (see Figures 13.6, 13.7, and 13.8). In this configuration, your camera operator (who mans the second camera) concentrates on getting shots of the subject as if he were shooting a single-camera interview.

The images in Figures 13.7 and 13.8 come from an interview shot with this technique.

Figure 13.8 shows the perspective of this same interview as seen from the manned camera.

True Multi-Camera Shoots

The number of variations possible when shooting with multiple cameras and multiple operators is limited only by your imagination. One of the most common setups is using two cameras to get matching singles of the subject and the interviewer (see Figure 13.9).

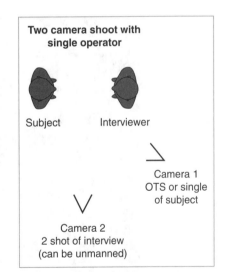

FIGURE 13.6 Even if you've only got one operator, you can still do a two-camera interview. Camera 1 is focused on the subject and is manned by your operator. Camera 2 is an unmanned wide shot.

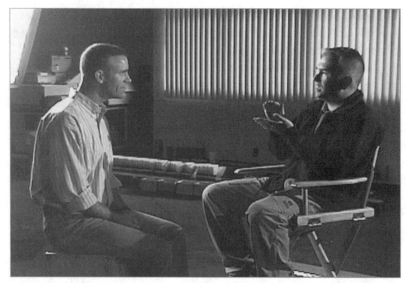

FIGURE 13.7 This is the wide shot (camera 2) of a two-camera interview. Notice the soft lightbox visible in the upper left hand corner. It provides both backlight for the interviewer (on the left) and keylight for the subject.

FIGURE 13.8 This is the subject of the interview as shot by the manned camera (it is a mirror image of the setup shown earlier in Figure 13.6, meaning the manned camera is on the left instead of the right). It's important that the operator of the camera pay attention to any movement by the subject so he can correct the framing as necessary.

From a technical perspective, shooting a multi-camera interview is exactly like shooting a multi-camera performance or event (except it's generally easier since the people you're shooting usually remain seated). When you get into the editing room, having a true multi-camera shoot will give you greatest possible flexibility in cutting and shaping the material for your project.

Tips For Getting Better Responses

We've already talked about how important it is to get good responses to your questions. But how do you do that? The easiest way is by giving the subject your full attention while they're answering. Listen to what they're saying. Does it make sense? Does their response truly answer your question? And most importantly, will their answer be useful in your project?

Two or three camera shoot with two operators

Subject Interviewer

Camera 1
OTS or single
of interviewer

Camera 2
OTS or single
of subject

Camera 3
2 shot of interview
(can be unmanned)

FIGURE 13.9 This setup will give you the most flexibility in the editing room. It also requires the most cameras and operators. Interviews done for broadcast television often use this technique. The lighting shown earlier in Figure 13.2 would be a good choice for this setup.

Ideally, your subject is giving you great answers and all you have to do is keep asking the questions in your script. But if they're nervous, their answers aren't complete, or you think they could do better, try some of the following tips:

- Being in front of the camera is stressful for many people. Don't dive right into the interview. Spend some time relaxing with them on the set. Let them know their answers don't have to be perfect. They can stop to think or restart at any time.

Remember, you don't have to be perfect either. Staying loose and being able to laugh at yourself will keep everyone relaxed.

NOTE

- Be ready to ask follow-on questions if you need more information. You don't have to stick strictly to your script. The most important thing is to get the information you need.

- Don't be afraid to start over. If a question didn't come out right (or maybe it was misunderstood, or the answer was disjointed), tell them you'd like to give that question another try and do it again.

Another widespread technique (used most often when the interviewer won't be heard or seen on camera) is to have the interviewee repeat the question within the context of their answer. For example, suppose the question was, "Can you describe how you were feeling as you saw the meteor hurtling toward your house?" If this question were part of a normal conversation, the answer might be, "I felt scared. I didn't know if the children were home." But this answer makes no sense unless you knew what question it was answering.

The answer you'd prefer would sound like this, "I was scared when I saw the meteor hurtling toward my house because I didn't know if the children were home." You could use this answer without any reference to the question, and it would cut easily into a project about rogue meteors without needing any additional explanation.

NOTE

Sometimes it takes a few tries before the interviewee gets the hang of incorporating the question into their answers, but most people pick it up pretty quickly. Don't be afraid to ask them to start again if the answer won't stand on its own.

Common mistakes when shooting interviews

By now you've probably noticed that most common mistakes fall into one of two categories:

- **Technical.** Not getting good sound, having the cameras too close together, not having enough batteries or memory.

- **Lack of coverage.** Not getting enough varied coverage or not capturing essential shots or moments.

We've covered these problems in great detail in the previous two chapters, but that still leaves the one common mistake unique to interviews: Not getting enough detail (or the right kinds of detail) in your answers.

The most obvious way to avoid this mistake is to do enough preparation. A thorough knowledge of the topic and a good list of questions will almost always keep you on track.

A second way to avoid this problem is to know how you want to use the interview material in your final project. That knowledge will enable you to listen to the interview with the ears of an editor. Analyze each answer as you're taping and consider where (and how) you'll use that information. Are the answers concise? Are they succinct (or could you make them concise and succinct with a little editing)? Is there enough information and detail? If you're paying careful attention during the interview, you can modify your questions to shape the answers for your particular project. It's far better to leave the interview knowing you have what you need than to discover holes in your footage while editing.

> *The need to pay close attention during the interview is one reason it's a good idea to have a dedicated camera operator instead of doing it all yourself. It's very difficult to effectively monitor the interview while simultaneously paying attention to lighting and framing your shots.*

NOTE

Editing Interviews

When you're editing an interview, you've got one basic goal in mind: You want to distill the answers in your footage into clean concise statements that are easy to understand and follow. It doesn't matter if the purpose of the interview is to provide factual information or if you're collecting oral histories for a documentary. It also doesn't matter if you shot single-camera, multi-camera, or simulated multi-camera. The most important task during editing is to create a smooth orderly flow of information, and most of that information will be contained in the audio track of the interview.

> *Sometimes interviews have an emotional side as well. An example might be someone describing the loss of a loved one. In these cases, the images of your subject can be more powerful than their words.*

NOTE

But creating this orderly information flow isn't always easy, and deciding just how much you can alter an answer to make it fit your project often presents a challenge.

The unique challenges of editing interviews

The first time you edit an interview, you'll discover a very interesting fact. You have almost infinite power to alter and reshape answers and make them seem to say just about anything (assuming you got enough footage). Taking phrases out of context, moving them around, and omitting or adding a word here or there can completely alter the original meaning of an answer. Some filmmakers use this power for comic effect and others use it to make political or social statements, but this type of manipulation isn't usually the point of editing an interview.

Usually, you want to use the words and phrases of your subject with as little alteration as possible. But you also want the material in the interview to be interesting and easily understood. If you're lucky, your subject will be a naturally-polished speaker, and her answers will require very little work. However, there will be times you'll have to do the equivalent of major surgery on your footage to get anything useful.

In the end, editing an interview is a balancing act. You want to keep the perspective of your subject intact while getting quickly to the point and making the interviewee look and sound as polished and intelligent as possible.

How to organize and assemble your footage

Editing an interview is actually a fairly simple, two-step process:

1. *Cut for audio*: Find the pieces you want to use and make any changes you need to make the information flow smoothly. Don't worry about jump cuts in your visuals at this point.

2. *Cover any jump cuts*: Use angles from other cameras or B-roll footage to mask any jumps in continuity.

Cut for Audio

Regardless of how many cameras you used, there's usually only one audio track to an interview. Put this audio (and the accompanying video) on the timeline, then play through the interview and cut out anything you don't want to use. Start with the easiest cuts first. There may be whole answers or chunks of discussion you don't need. Cut them out.

Sometimes you'll find that moving a few phrases around will make an answer clearer without changing its meaning. But you should generally avoid changing the intent of an answer unless you've discussed making those changes with the interviewee.

NOTE

After you're satisfied with the content of a response, go through it again and see if there are places in which you can tighten the material or remove any awkward pauses. Many times you'll find you can easily cut out "uhs" and "ums" and sounds like lip smacking or throat clearing. Sometimes you may want to delete repeated phrases or nervous comments. Depending on the speech patterns of the interviewee, this can be a time-consuming process, but it can make an answer flow much more smoothly and sound far more concise.

Don't worry about any jump cuts you create (we'll deal with them next). Your goal right now is to create the best-sounding answers.

NOTE

Cover Up Any Jump Cuts

Once you're satisfied with how your audio sounds, you're ready to work on the visuals. If you're using the audio primarily as narration for existing event footage, then your job is mostly done. All you have to do is drop the audio into your event project at the proper place. But most likely, you're going to need to hide some of your cuts in other ways. Here are some suggestions:

- **Use B-roll footage.** A cutaway to any visual related to the topic being discussed can be used to cover a whole string of edits (see Figure 13.10).

FIGURE 13.10 The B-roll shot in this timeline sits on top of (and hides from view) three edits underneath. By using B-roll footage this way, you can remove (or reshape) awkward sections of an answer in a way the audience will never notice.

- **Use interviewer reaction shots.** If you've decided the interviewer can appear on camera, cutting to a reaction shot can also cover a jump cut, and it doesn't matter if the reaction shot came from a second camera or was shot later. The only thing that matters is that the reaction of the interviewer is appropriate to the topic being discussed.

- **Cut to another camera.** If you have a wide shot of the interview (or a wider shot of the interviewee), you can cut to that shot on the edit. But you can't use too many of these cuts in succession or the interview will look choppy.

- **Use a transition.** If you shot single-camera (and you don't have any B-roll or related footage), sometimes you can do a quick dissolve (4 to 6 frames long), or use a *flash frame* to bridge the edit. If you're shooting HD, it's possible to create a closeup for the edit by enlarging a shot of your interview footage. These techniques are a last resort because they don't mask the edit. Instead, they call attention to the cut and make it look like a stylistic choice.

KEY TERM:

FLASH FRAME Inserting one or two frames of a solid color (usually white) between two shots during an edit will make the edit *pop* or *flash*. Some editing software will do this automatically with a transition called a *Dip to Color Dissolve*.

But what if, despite your best efforts, none of these techniques work? What if the unique combination of your project and the footage you have available severely limits your choices for masking the edits you've created? At that point, you can go out and shoot more footage (or find appropriate still photographs) or you can recut the interview.

Common problems in using interviews

Learning how to skillfully use interview footage takes time and practice. One of the most common mistakes made by beginners is using too much talking-head footage. We've said the goal of an interview is to collect detailed descriptions and recollections. We've also said most of your emphasis when editing an interview will be focused on getting the answers to flow just right. Both these facts are true, but remember, film is still a visual medium. Shots of people talking are only interesting for so long.

Although certain program types are more forgiving of talking-head footage (such as documentaries, oral histories, and dedicated interview shows), in general, you want to limit the amount of screen time in which you're showing nothing but people talking. The most obvious way to do this is by having plenty of visual material that supports the topics covered in the interviews. This visual material can take many forms. It can be event footage, it can be stock or archival footage, or it can be still pictures (or pictures with movement in the frame). Often, after conducting interviews, you'll find you need to go out and shoot (or find) new footage and stills to keep your project visually interesting.

Another common mistake is using interview segments that are too long. When possible, break an interview up into small, easily digestible chunks. Only use a single observation at a time and sprinkle them throughout the project. A good technique if you've interviewed several people about the same topic is to intercut between each of them as they each reveal a single thought or observation about an event. The combination of constantly changing points of view with the visual variety of seeing different faces can add real energy to a sequence that's essentially nothing but different talking heads.

The exact strategy you decide to use when interweaving interview footage with other visual material will vary from project to project depending on the subject matter and the desired style of the project. But no matter how many people you interview or how you edit your footage, never forget that you're working in a visual medium. Words are important, but they don't lessen your primary responsibility: To tell an engaging story with pictures and sound.

Final Thoughts

Along with the ability to create performance and event videos, knowing how to shoot and edit interviews is an important skill for any aspiring video professional to master. Even if your primary goal is to make narrative feature films, perfecting the ability to shoot real people telling real stories and then shape that footage to create compelling visual projects will only make you a better filmmaker.

There's one interview project everyone with a video camera should consider shooting, regardless of your career goals. Shoot an oral history of your parents and/or grandparents. And do it right. Set up some lights. Use lavaliere mics (the affordable, wired kind are just fine). Make up a list of questions about things you've always wanted to know (i.e., how did they meet each other,

what are their favorite childhood memories, what's the coolest thing they did in high school, etc.). Your dad probably has a story he's told so many times you already know it by heart. Get it on tape.

Take your time. Spend a few hours with each person on your list. Maybe do it as a summer project. Or shoot it during a family reunion or over a holiday weekend. Don't worry about how the pieces are going to fit together, or when you'll be able to edit a finished project. Just shoot the footage. It's never too early (or too late) to get some of your family history on tape.

Regardless of what you do with the material (even if it's never more than raw, unedited footage), shooting the interviews is a valuable (and irreplaceable) experience. It may feel a little awkward, but do it anyway. There'll come a day when you'll be glad you did.

EXERCISE 4: NARRATIVE PROJECTS: TIPS FOR SUCCESS

OVERVIEW AND LEARNING OBJECTIVES

In this chapter, you will:

- Learn specific planning and shooting tactics that will improve your chances of success when making music videos and narrative shorts

Been There, Done That

Here we are. This is the exercise chapter specifically about planning, shooting, and editing narrative projects and music videos. For those of you with no interest in shooting event videos, performances, or interviews, this is the chapter you've been waiting for.

Learning how to shoot events, performances, and interviews will only increase your skill as a director, regardless of your goals.

But here's the good news. If you've been through the first ten chapters of this book (and done some of the fieldwork projects), you already have the required knowledge. You know about the importance of story (and what an audience expects to see). You know how to select and operate cameras, lights, and sound equipment. You know how to design and shoot coverage and how to get the best performances on the set. And you know the different ways to assemble pictures and sound to achieve maximum dramatic effect. You've got all the technical knowledge you need (and even if you don't remember it all, you can go back and review the material). The only thing you're lacking is experience.

Sadly, there's no substitute for experience. You don't get to say "been there, done that" until you've made a handful of silly (or stupid) mistakes of your very own. And you *will* make mistakes. But the cool thing is they'll be your own mistakes. They'll be mistakes as unique as your fingerprints.

So if you already have enough technical knowledge, and nothing can keep you from making mistakes, what's this chapter about? Good question. The path for creating a successful narrative video is different for each project. But regardless of your specific project, there are some techniques that generally work better than others.

In the next few pages, we'll give you *10 helpful tips for shooting a music video* and *10 tips for making a better short film*. Depending on the goals for your particular project, some of these tips will be more useful than others. That's normal. Use what works. As you collect experience on the shoot, add some tips of your own to the list.

Why Shoot a Music Video

Before we get into specifics about shooting music videos, let's take a moment to discuss why you might want to shoot one. In many ways, music videos are an ideal way to hone your skills as a director and gain confidence working with equipment and crews. Indeed, many of the top directors working in Hollywood began their careers shooting music videos. Here are a few of the unique advantages that music videos offer to aspiring directors:

- **They're short.** A music video is generally only three to five minutes long. With proper planning, you can shoot the entire project in a single day.

- **They're a complete story.** A good song tells a story with solid narrative structure. It has a defined beginning, middle, and end. Although you'll still need a script (as we'll discuss), you're not starting from scratch.

- **You've got lots to choose from.** Many people think they need to have an original song by an unknown band for their video, but that's not necessarily true. You can shoot a music video of any song, whether it's a current hit or an oldie. That means you can tell a story of any genre set in any time period.

Keep in mind that your video doesn't need to be a performance piece in which you see a singer and a band. Many videos tell a visual story while the song plays. But if you feel the need to see someone singing, it's perfectly acceptable to have an actor lip sync the vocals of another singer.

NOTE

- **You don't have to worry about sound.** The song is your soundtrack. You don't need to write or record any dialogue (although you can, as we'll discuss later). That gives you incredible freedom in picking locations, since you don't have to worry about how noisy they are.

There's one other way music videos differ from any of the projects we've discussed so far. Since the song exists before you shoot the project, you may need to have your performer lip sync to your chosen song (and any musicians in the band will need to synchronize their performances as well). The technique for synchronizing a performance to a prerecorded soundtrack is called *shooting to playback*, and it's discussed in the following sidebar.

SHOOTING TO PLAYBACK

Playback is the term for playing the audio of a song over a boombox or portable sound system while the camera is actually rolling. As the music plays, the performers lip sync and the musicians play their instruments to match the music on the recording. Since the pre-recorded song will replace any sound recorded on the set, it doesn't matter what the actual performance sounds like (or how much noise the crew makes while shooting). The only thing that matters is what the performance *looks* like.

The typical procedure for using playback is to have the recording cued up and ready to play before the camera starts rolling. It's common practice to put *three beeps* spaced one second apart before the song actually starts on the recording. This is similar to the procedure used in ADR, and it lets the performers know when to expect the music to begin. Without these beeps, the performers (especially those playing instruments) may have trouble beginning exactly at the start of the music.

When you're ready to shoot, the assistant director (or the director if there's no AD) will call for the camera to start rolling. When the camera's up to speed and recording, the AD (or director) will call for *playback* and the performers begin when the music starts playing. It's important to record sound when shooting to playback, since having the production sound of the playback music will make it easy to synchronize the footage with the song during postproduction.

Although we're talking about music videos, playback has been around as long as musical performance and dance have been a part of movies. That's because in most Hollywood musicals, the songs were recorded in a recording studio before the directors shot any of the singing scenes. Then the stars would lip sync to their own voices (or sometimes to the voices of singers with better voices who sounded like the stars) while dancing through city streets and singing in the rain.

NOTE
As you read through the following tips, keep in mind that they can be used on any type of project.

Once you're comfortable with playback, everything else is the same as shooting a standard narrative or event video. Now let's look at tips for shooting music videos.

10 Tips for better music videos

1. Have a Script and/or a Shot Plan
Music videos can take many forms. Probably the simplest is a *performance* video, which consists of nothing more than visuals of the singer and the band performing a song. At the other end of the scale are the *story* videos, which

tell a visual story while the song plays (usually related to the lyrics, but not always). Then there are the *hybrid videos* that intercut a performance of the song with a story (usually featuring the singer and members of the band as characters in the story).

Regardless of the type of video you choose, you need a script and/or a shot plan. If you're shooting a story video, the need for a script is obvious. But even if you're shooting a performance video, you need to answer certain creative questions:

- *Where is the band performing?* Are they in a club? On the beach? Or maybe on the roof of a skyscraper? Do the lyrics of the song make some locations more appropriate than others?

- *What is the mood of the song?* Is it happy? Sad? Angry? How do you plan to reflect that mood in your visuals?

The best way to be prepared (for either a story or performance video) is to create a shot plan. Know which shots you need to tell your story (or to capture a compelling performance). Thorough planning will make your finished video better.

2. Shoot Everything Vanilla

Often the visuals in a music video are highly stylized. Sometimes they're in black and white, sometimes the colors are richly saturated, and sometimes digital processing is used to achieve certain effects (for example to soften or recolor the image—see Figures 14.1 and 14.2). And although most of these effects can be created by the camera while you're shooting, it's usually a good idea to capture your footage with as little processing as possible. This is called shooting *vanilla* footage, and it gives you much more flexibility during post-production. That's because any effect created in the camera is usually difficult to undo if you change your mind after shooting. But since any *look* you could want can be created by your editing software, having vanilla footage gives you far more flexibility. Vanilla footage lets you change your mind.

All figures and shorts are included on the companion DVD with this book. **ON DVD**

3. Get Lots of Coverage

Although having lots of coverage is a good idea no matter what you're shooting, it's even more important for music videos, especially if you're shooting a performance video. That's because the editing pace in music videos is usually much faster than standard narrative projects (i.e., the shots are shorter and there are many more cuts in any given timeframe). That means the audience

FIGURE 14.1 In this scene from *As You Like It*, Rosalind gets back at Touchstone for taunting her. This image is from the original, unaltered footage. Figure 14.2 shows the same image with a heavy *diffusion filter* added.

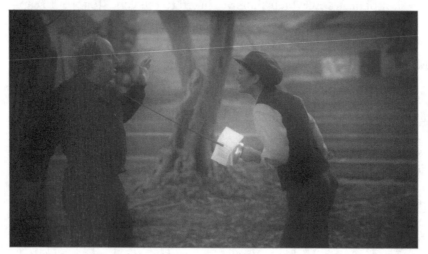

FIGURE 14.2 *Diffusion filters* (like the one applied here) are often used to give a fantasy, dreamlike quality to an image. Like all digital filters, you can easily vary the intensity of the final result. This gives you enormous creative flexibility when deciding what *look* you want for the finished project.

is being exposed to a great deal of visual information in a relatively short time, and unless you have a good supply of different shots and angles, you'll end up using certain angles over and over. Relying too much on key shots (such as close-ups of your lead singer) will make your video visually repetitive (and potentially boring). Avoid this by getting a wide variety of shots.

The standard technique for shooting coverage of a performance music video is to shoot the song in its entirety many different times from many different angles. Once you've got the set lit, this can happen fairly quickly (assuming the song is only three to five minutes long). But it's important to have a shotplan. Know which instruments you want close-ups for and know how many different ways you plan to shoot the lead singer.

4. Consider Multiple Cameras

One way to get more coverage quickly is to use multiple cameras. This is covered extensively in Chapter 12, and all the planning considerations covered in that chapter apply to music videos as well (such as assigning specific shots to specific camera operators). But only use multiple cameras when shooting the performance sections of your video. Any narrative (or story) parts of your video should be shot using standard single-camera techniques (we'll discuss the reasons for using a single camera in the section on shooting better short films).

5. Move the Camera

Another way to impart energy and visual variety to your shots is to keep the camera in motion (at least for some of your shots, because there will also be moments in which a *locked-off* still shot is effective and appropriate). But avoid using too many handheld shots. A little handheld is acceptable, but too much can make a project seem amateurish. There are many other ways to move a camera. Homemade dollies, wheelchairs, shopping carts, skateboards, and an endless variety of DIY Steadicams will let you create affordable moving shots.

There are also many types of motion you can create with the camera on a tripod. Pans, tilts, and zooms can give you stable, professional shots that still have the energy of motion. A varied collection of moving shots is a good way to keep your project from becoming visually repetitive.

6. Match the Shots to the Mood

As you design your coverage (and shoot your footage), try to capture the mood of the song (or of your story) with the visuals you create. If the song is bright and cheery, use bright colors and well-lit locations. If the song is dark and somber, use low-key lighting with oppressive shadows. Likewise, if the song is fast-paced and energetic, motion in the shots (as well as the pace of your editing) should be quick and decisive. For a slow, reflective song, longer

shots with more deliberate movement might be appropriate. Just remember that your visual choices should match the overall artistic intent for the finished piece.

7. Consider Editing the Song

When your music video is finished, it will stand alone as a creative project with its own artistic integrity. Everything from the visuals to the editing to the performances should work together with the music to create a certain effect. Depending on the song you've chosen, it's possible there are parts of the song that don't match the other elements you have in mind for the video. Maybe there's an instrumental section that's too long, or maybe one verse of the lyrics runs against the mood you're trying to create. The good news is most songs can be edited fairly easily on your timeline. As long as you pay attention to the beat and the instrumentation, you'll find you can make fairly extensive changes to a song, and those changes will be undetectable to anyone except people who know the song extremely well.

NOTE

Some will say editing a song is an insult to the vision of the musician who created it. They're right. It is. If you're shooting a music video to showcase a particular musician's work, or if your video is going to be viewed by a wide audience, you might want to reconsider (or contact the musician and get permission for the changes). But if you're shooting the video for your own enjoyment (and for practice as a director), altering the song is just one of many ways to make all the pieces of your video fit together.

8. Don't Always Cut on the Beat

As you start to edit your video, you'll discover that cutting visuals in time to the beat is oddly satisfying. Something about seeing the image change in time to the music makes the visuals seem more like an extension of the song. But just like any technique used too often, if all your cuts happen on a musical beat, your video becomes visually repetitive and predictable (and predictable is *never* good in art).

So find other motivations to make an edit. Usually, these cuts will be action or motion based (as discussed in Chapter 8). You can also use specific lyrics to motivate cuts (and those lyrics may or may not be linked to beats in the music). The key is to find a specific reason for each cut and not just cut on the beat because it's easy. This doesn't mean you should never cut in time to the music, just be selective about when you do so. Many times a single cut timed to the music can be very powerful, especially if it follows a series of edits based on motion or lyrics.

The usual procedure for editing a performance music video is very similar to cutting a multi-camera event. You have many different angles all in perfect sync with a single soundtrack (the song). Put the song on an audio track all its own. Then sync each of your shots with the song (which will stack the shots on top of each other in the timeline; refer back to Figure 12.12). Then you can cut your video like a multi-camera project (even if you shot all your coverage single camera). For more information on cutting a multi-camera project, see Chapter 12.

9. Think About Adding Sound

We've already said that one of the key advantages of music videos is the fact that your soundtrack is completed before you start. The song is your soundtrack. And for most music videos, that's true. You don't need anything except the song. But depending on your visuals (or the plot of your video's storyline), adding a single line of dialogue, or a subtle ambience (such as the sound of the surf for visuals occurring at the beach) can be very effective. You don't want to overdo it (and you don't want to detract from the song), but a few carefully-placed sounds can pull an audience deeper into the song and the story you've created.

10. Push Your Limits

Music videos are an incredibly flexible and expressive format. In some ways, music videos allow you to be more creative visually (with fewer restrictions) than any other video format. Use that freedom. Push yourself to try things beyond your comfort level. Anyone can point three cameras at a band playing on a stage, shoot lots of footage, and edit together a performance music video. Don't settle for that. What creative choices can you make in the staging, the setting, or the concept that will make your video stand out and will push you as an artist?

For example, if you're not comfortable with abstract or nonlinear storytelling, devise an unconventional story for a popular song and shoot it. If designing moving camera shots is difficult for you, shoot a music video with nothing but moving camera shots. Use the built-in soundtrack of the song and the reduced technical challenges of music videos (such as short, fixed length, and not having to worry about production sound or sound editing) as opportunities to focus on visual filmmaking. Challenge yourself. It will only make you a better filmmaker.

Why Shoot a Short Film

Think of short, narrative films as another step on your filmmaker's journey. You've probably already done other video work (such as music videos, event projects, and fieldwork exercises). There's also a good chance you have hopes of shooting a feature film someday. Shorts are a good way to continue gaining skills and experience. They can help bridge the gap between where you are now and where you want to be. Here are some of the advantages of shooting short films:

- **They're short.** An ideal length for a short film is between three and eight minutes. That's long enough to tackle some serious filmmaking challenges but short enough to shoot in a single weekend.

- **They're good practice.** Making short films is like a quick trip to the gym. It strengthens your filmmaking muscles. Even if you've got a feature film in the planning stages (which can easily last for several years), making shorts is a way to stay connected to the passion of filmmaking while you're preparing those larger projects.

- **They're a visual calling card.** You're probably aware of the *first-time filmmaker's dilemma*. How can you prove to someone you can shoot a feature if you've never shot a feature? Shorts are a way to show off your visual style and storytelling ability without needing the resources to make a full-length feature.

- **They can get you on the festival circuit.** As we discussed in Chapter 10, festivals are a good way to get your work seen by a wider audience (and they're also a great deal of fun). Having a good short is the easiest way to enter the festival circuit, and winning an award for your work is another way to gain credibility as a filmmaker.

- **Use them to illustrate a feature concept.** Suppose you have an idea for a feature, but you can't get anyone else excited about your concept. Make a short that contains elements from the feature (i.e., similar characters, a similar situation, similar effects, etc.). Being able to show people a polished visual demonstration of your abilities and ideas can sometimes make a difference in their level of interest.

These are only a few of the reasons you might want to shoot a short. There are many others. But perhaps the most important reason is because it's fun. You don't have to ever enter a festival or make a feature to enjoy the experience

of telling a story with pictures and sound. All you have to do is make a short. And that's reason enough.

10 Tips for better short films

1. Use All Available Resources

When you're writing the script for your short, think about all the resources and assets you have available. Maybe you live by the beach or a national park of incredible beauty. Maybe you work in an office with an endless maze of cubicles. Maybe you drive a cool old car (or known someone who does). Or maybe you know a local theater group with some really good actors. Make a list of all the people, places, and things you can get or use for free. Then write a story that uses those people, places, and things. You'll end up with a movie with great *production value* without spending much money (see Figure 14.3).

> **KEY TERM:**
>
> **PRODUCTION VALUE** This term refers to how expansive and detailed the visual world of a movie appears. For example, a movie set entirely in someone's dorm room has very limited production value. On the other hand, a movie set on a university campus with scenes on the central quad and at crowded sporting events has much more production value. The trick to production value is making it look like you spent a great deal of money to create the beauty and variety of your visuals.

2. Keep Dialogue to a Minimum

We've said it before, and we'll say it again. Film is a visual medium. Endless shots of talking heads engaged in conversation are not going to show off your skill as a visual filmmaker. Anyone can shoot close-ups of a dialogue scene. Create visual conflict and obstacles for your actors (and resolve their dilemmas in visual ways).

> *Movies full of clever, scintillating dialogue are a great deal of fun, but they show off the skills of the screenwriter more than the director. You're probably both the writer AND director on your short film. Which skill do you want to showcase? Try for both, but NEVER forget the visual.*

NOTE

FIGURE 14.3 For *As You Like It*, we made extensive use of existing resources to maximize *production value*. We set many scenes on the beach because of its beauty, and we used props owned by members of the cast and crew whenever possible (such as the wetsuit and the bicycle).

3. Make Them Laugh

This tip's a little controversial. Not everything has to be funny. But a short film isn't the ideal format for heavy drama or for controversial political commentary. On the other hand, it's very easy to structure a short film as a joke or amusing anecdote. If you can surprise an audience and make them laugh, then you've proven your ability to entertain. It doesn't matter what your goals are as a filmmaker—your first responsibility is to capture the attention of an audience and entertain them.

4. Get the Casting Right

It's been said that casting is 80% of directing. The visual images and performances of the people onscreen have to be believable, or all the other work you've done is wasted. Don't cast someone in their 20s as a character in their 40s or 50s. It may work onstage in a school production, but it won't work on film. And don't cast someone with limited acting ability in a role with significant emotional demands (see Figure 14.4).

NOTE *Sometimes you need to tailor your script to the ability of the actors you have available. If you're going to use your parents and your best friends as actors in your movie, make sure you write roles for them within their capabilities. If they play characters similar to themselves, you'll get performances that are much more believable.*

FIGURE 14.4 Shakespeare actually named this character *Old Adam*, and he's a servant who's been in Orlando's household since before Orlando was born. It was important to cast someone the right age for this to be believable. Trying to use an actor in their 20s or 30s for this vital part would not have worked.

5. Don't Shoot Multi-Camera

You're trying to make every moment of shooting count, so you might be tempted to shoot a fictional narrative scene using multi-camera techniques. After all, you've got two cameras and it's a two-person scene, so why not shoot both close-up singles at the same time? That way, you'd be sure the performances would match when you were editing. But although it might sound reasonable, shooting a narrative scene with multiple cameras is a bad idea. Here's why:

- An artistically-lit scene only looks really good from one angle. To light a scene so you can shoot it from two opposing angles simultaneously, you have to use flat lighting. Although this may be acceptable for television, you should aim for a higher standard.

- As a director, it's very difficult to monitor the framing of two different shots and the performances of two different actors simultaneously. While your attention is on one camera, you might miss something on the other camera that needs correcting.

There is *one* acceptable configuration for shooting parts of a scene simultaneously with two cameras. If the two cameras are placed side by side and the shots are framed so that one camera shoots a medium shot while the other shoots a close-up of the same actor, you'll get well-lit shots and still be able to adequately monitor the framing and performance on both cameras.

TECHIE'S TIP

6. Make Every Shot Count

When designing coverage for your movie, you should strive to make each shot efficient and evocative. Resist the temptation to settle for "standard" coverage. For example, if you've got two people sitting at a table talking, you might be tempted to shoot a two-shot followed by two matching singles. But that coverage would be boring and predictable (and wouldn't demonstrate any particular visual genius on your part). Can you think of another way to shoot the scene? What else could you do with the camera?

But there's only so much you can do with two actors seated at a table. Do they have to be seated? Does it have to be a table? If you can't design a creative (but appropriate) way to shoot a scene, try changing the setting and/or the blocking. Remember, your goal is to create visuals that move the story forward in a distinctive way.

NOTE

Of course, there will be times you have to shoot standard coverage. Maybe it's the end of your shooting day and you're running out of time. Standard coverage is better than no coverage. Sometimes you'll want to focus on an actor's performance or the dialogue in a given scene, and standard coverage might be appropriate. Just be aware of your options when designing coverage and make appropriate, artistic choices.

7. Record (or create) Good Sound

We've spoken numerous times about the importance of a well-recorded and well-mixed soundtrack. Even if your project has no dialogue (or only limited dialogue), it's still important to create a fully-realized sonic reality for your film because nothing says *amateur project* more loudly than bad sound. If you're trying to demonstrate your ability as a filmmaker, your sound has to be as impressive as your visuals. Never think someone will be able to overlook a substandard soundtrack and still be impressed by the visual brilliance of your work. Everything works together. Make sure it's working in your favor by having great sound (see Figure 14.5).

8. Shoot Still Photos

Get in the habit of shooting *behind-the-scenes* photos on each of your sets. These pictures serve several purposes:

- Most film festivals want *behind-the-scenes* photos of the films they accept for screening.

- Having a good collection of *making of* pictures is a great way to create interest in the project on a social networking site or dedicated website.

FIGURE 14.5 Many beginning filmmakers don't pay enough attention to recording good production sound. Although it may seem extravagant, having a dedicated boom operator and using a shotgun mic will dramatically increase the quality of both your soundtrack and your overall film.

- Press kits, newspaper articles, and almost any kind of publicity you generate will want pictures showing you and the crew at work.

- You probably aren't paying anyone to work on your film. Being able to give your cast and crew pictures of the experience is a great way to show thanks for all their work.

Although you (and other crewmembers with cameras) can take these pictures yourself, it's generally a good idea to have someone on set whose sole purpose is taking pictures. That way you'll be sure to get action shots of everyone on the cast and crew, regardless of how busy everyone is (see Figure 14.6).

9. Look For Happy Accidents

You're making a short film. Your goal is to make the most impressive and effective project you can. You don't have much money and you don't have much time. But you do have ingenuity, and because you have less equipment

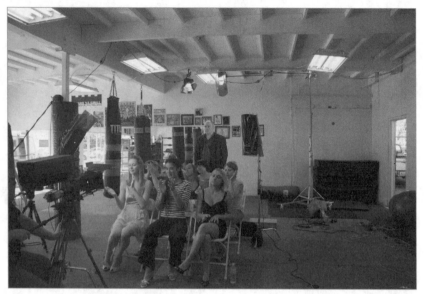

FIGURE 14.6 *Behind-the-scenes* photos are an excellent way to document the making of your project. This shot shows the set we used to capture crowd reaction shots during the wresting match between Charles and Orlando.

and a smaller crew, you have the ability to react and adapt quickly. Always be looking for opportunities to improve your story or get more production value.

Suppose one of your actors breaks his arm before you shoot. Can you weave the broken arm into your story? Suppose it rains the day you planned to shoot on the beach. Could the scene take place in a museum or other indoor public place? Or could the scene actually take place on a damp and deserted beach?

With the proper perspective, there are no such things as setbacks. There are only challenges to your creativity and opportunities to make your film even better. There are only happy accidents. Make sure not to miss them.

10. Have a Zen Moment

There will be moments during your shoot when you're overwhelmed. When everything seems to be going wrong. When you're sure you'll never get all the shots you want or be able to finish on time. But regardless of how crazy it gets, remember this: Anytime you've got actors, equipment, and crew-members gathered together for the purpose of making a movie, it's a special occasion. You need to recognize and celebrate it.

So when things are at their most hectic and your head's about to explode, take a deep breath and look at the panorama spread out before you. Look at the actors and the lighting equipment and the camera and the crew, and say to yourself, "I'm making a movie. How cool is that?" And in that moment, savor the fact you're doing something many people dream about, but few ever achieve....

Then get back to work! The sun's going down and you're *burning daylight*!

KEY TERM:

BURNING DAYLIGHT Movie terminology for wasting time. When you're shooting day exteriors, your day is over when the sun goes down, and since the sun keeps moving even when you're not shooting, you're always burning daylight (whether you're shooting or not).

One Last Short Exercise

We've talked a great deal about writing, planning, shooting, and editing a short film. At this point you have all the skills and knowledge you need to make a film of your own. But you may not have a script yet. And for many folks, coming up with a script is the hardest part. This exercise is for you. Use the following guidelines (and the tips in this chapter), and you'll avoid the pitfalls that plague many beginner films.

Basic requirements

Your goal is to create a video short between three and eight minutes long that you'd feel comfortable showing as a sample of your work. Ideally, you could enter the finished work in a film festival or two. But first you've got to write (and rewrite) the script. Consider the following requirements:

- The script should be between three and eight pages long (using standard script format that equates to about one minute per page).

- It should be a complete, standalone story with a beginning, middle and end. For this project, don't shoot a music video or a trailer for a feature project you're developing.

- The story can be set in any time and place and have any number of characters, but it has to be achievable. Remember to maximize your assets.

- You can use dialogue, but remember that film is a visual medium. Concentrate on telling a story using action and pictures with only as much dialogue as is absolutely necessary. Avoid, at all costs, having two people sitting in a room talking.

- As you write the script, consider places in which you will use sound effects and music. The finished project must have a completely realized soundtrack.

- Make sure to get feedback from friends and fellow filmmakers after you finish the first draft. Remember that writing is rewriting, and it may take several drafts to get the best possible script for your project. Don't rush into production with a script that isn't ready.

Additional Script Considerations

Here's some additional guidance to keep in mind as your write your script. It's within your capabilities to make a short good enough to submit to a festival, but the success of the final product will be completely dependent on the choices you make when writing the script.

First and foremost, you want to make sure your story is visual. Anyone can direct a scene of two people sitting in a bar talking. That's called the "conversation grotto," and unless your dialogue is world class, your story won't be very interesting.

Second, you want to keep your story short and simple. Don't get bogged down with too much plot. Give your characters a single objective and have them pursue a single goal. You've only got eight minutes, and the more complicated your story, the more *exposition* you will need, which will only eat up screen time. You can't make *Lord* of the *Rings* in eight minutes.

KEY TERM:

EXPOSITION In the context of narrative screenwriting, exposition is background information you need to understand the plot. In *Lord of the Rings*, for example, the history of the ring and why it must be destroyed is exposition the viewer must have to understand the story.

Something else to consider when writing your script is how long it will take to shoot. Based on the work you've already done, you should each have a pretty good idea of how much you can shoot in a day. A professional can shoot about four pages of material in a day; so an eight page script would take about two days. This, of course, can vary depending on the complexity of shot design or the number of locations.

The important thing is to write a script you can realistically shoot with the time and resources at your disposal. For some people this will only be three minutes. Others will use the full eight minutes. Just know the quality of a project has nothing to do with its length or the complexity of its plot. The quality of your short is solely dependent on how well you tell a story.

And finally, don't forget to have fun and create a project you'll enjoy watching. Many directors, when asked why they wrote or chose a particular story will say they wanted to make a movie they themselves would like to see. That's always good advice.

Final Thoughts

We started this chapter with a discussion about experience and the fact that each of you will make mistakes as you learn to make movies. We've tried to give you some tips that will steer you away from common errors made by many beginning filmmakers, but you're still going to make mistakes. That's a good thing. It's normal. It shows you're trying new things and pushing beyond the limits of your comfort and current experience. While some of your mistakes might feel embarrassing (or even humorous), never be ashamed of them. Embrace them. Learn from them. And resolve to make even grander mistakes in the future.

THE ONE TRUE RULE

OVERVIEW AND LEARNING OBJECTIVES

In this chapter, you will:

- Plot out the next leg of your filmmaker's journey
- Learn the one TRUE rule of filmmaking (insert impressive music sting here)

KEY TERM:

STING A very short piece of music that builds quickly to a crescendo. Used in a soundtrack to accentuate an important moment or realization. A sting can sometimes be as simple as a cymbal crash. Also called a *stinger* when used as a music transition to link one scene to another (not to be confused with movie jargon for an extension cord).

Now What?

You made it. We're at the end of the book. We've covered an incredible amount of material in the preceding 14 chapters. You can be justifiably proud of the work you've done. But along with that sense of accomplishment usually comes a single, nagging question: Now what? No matter how brilliant your projects are, it's not very likely that studios are lining up to offer you directing contracts. So we're going to spend part of this chapter discussing options to consider as you look ahead.

Then we're going to reveal the one TRUE rule of filmmaking (obligatory music sting again). Believe it or not, everything we've studied in this book can be distilled down to one simple rule, and once you learn it, you'll never look at filmmaking the same way again.

But let's slow down, we're getting ahead of ourselves here. One step at a time. Before we talk about the one TRUE rule (low cymbal roll), we need to take a look at what's next.

The Next Step

One of the things you've learned by now is that telling a story with pictures and sound requires many different skills. There's a lot more going on behind the scenes than most people realize. And as a director, you need to know it all. Screenwriting, cinematography, acting, editing, sound design, and even production scheduling are all skills a director should have, especially at the independent level because even though you won't do every job yourself, you have to orchestrate the efforts of the cast and crew who bring your movie to life.

But how do you acquire and exercise the skills needed to be a good director? We're going to look at four different ways:

- Study
- Practice
- Connecting with fellow filmmakers
- *Greenlighting* yourself

Study

You know all about studying. You wouldn't be holding this book if you didn't. But this book is only the first in a series specializing in digital filmmaking topics. The other books in the *Digital Filmmaker Series* are designed to cover one specific subject in greater detail. So if you want to learn more about screenwriting, editing, distribution, or studio production, consider the following topics (all covered in the *Digital Filmmaker Series* from Mercury Learning and Information at *www.merclearning.com*):

Developing & Writing the Screen Story: This topic is designed as an introduction to feature-film screenwriting. It's the perfect practical guide to crafting scripts. Subject areas include the transmedia movement, writing style and genre, point of view, dramatic and comedic conflict, writing an action scene, developing a budget, improvisational writing, using social media, and more.

Film Editing Theory and Practice: Editing is the art of using the building blocks supplied by the writer and director to create a structurally sound, and hopefully brilliant, piece of cinematic dazzle. This topic teaches the aspiring editor how to speak the inspiring language of images. Written with the program *Final Cut Express* in mind, this topic emphasizes a more affordable editing process and is perfect for the beginner filmmaker on a budget.

Short Film Distribution: No area of independent digital filmmaking is evolving as rapidly as distribution. This topic introduces you to current distribution trends and practices. It covers marketing an independent film and making sure it gets into the right hands. All aspects of independent film distribution are handled, including publicity, distributor deals and contracts, physical product delivery, release windows, new distribution models, free and paid streaming video, social media, ownership issues, and finding your true audience.

Production Management: There are a lot of books on screenwriting, financing, directing, editing, and distribution but very few on the underlying "business" of filmmaking. Consequently, many film students complete their education

without an understanding of the *business* side of creating a film. This topic introduces contracts, budget constraints, personnel, scheduling, legal, insurance, and safety issues along with production-management strategies and business ethics. This knowledge will help prevent legal or insurance issues that often result in lawsuits, financial hardships, and/or the inability to distribute a finished film.

Other Skills

Many books cover the technical and artistic sides of filmmaking, but they don't cover everything you need to know as a director. That's because the ideal director would be a well-rounded *Renaissance man* (or woman).

KEY TERM:

RENAISSANCE MAN Wikipedia defines a *Renaissance man* as a person whose expertise spans a significant number of different subject areas. Basically, she's an individual who excels in a wide variety of subjects. The classic example of a Renaissance man is Leonardo da Vinci, who was a painter, sculptor, inventor, architect, musician, and scientist (among others things).

In addition to knowing about scripts, cameras, and editing, every aspiring director should know something about the following subjects:

- **Acting.** Many directors started as actors, and it's common for directors to appear in the movies they direct. But the reason to study acting isn't so you can appear in front of the camera. You study acting to be familiar with the actor's process. If you know how an actor creates a character and experiences a moment, you're much more likely to give *playable* direction.

KEY TERM:

PLAYABLE Direction is considered *playable* if it makes sense to the actor and they're able to incorporate your suggestions into their performance. The simplest example of playable direction is any change to blocking (such as "Stop at the table and pick up your keys."). Direction that isn't playable usually sounds like psychobabble (such as "You're conflicted about your father."). If you make a point of using verbs in your direction (as discussed in Chapter 7), you have a much better chance of giving playable direction.

- **Graphic Design.** How many times have we said it—*film is a visual medium*. Graphic design is the study of how visual elements such as line, shape, and color interact in an image to communicate ideas and messages. Understanding this interaction will make you a better visual artist (and a better filmic storyteller).

- **Music Theory.** Music plays a huge part in the effect a finished film has on an audience, and unless you're writing your own score (or using nothing but *canned music*), at some point you'll have to discuss musical ideas with a composer. A little knowledge of music will make those conversations easier (and probably give you more ideas to begin with).

KEY TERM:

CANNED MUSIC Pre-recorded stock music is sometimes referred to as *canned music*, since it's pre-cooked and ready to go.

- **Leadership.** Thomas Edison once said, "Genius is 1% inspiration and 99% perspiration." Directing is the same. Artistic inspiration is a very small part of directing. The rest is leadership. As the director, you're the leader of the cast and crew. The more you know about leading a group of individuals in pursuit of a common goal, the more effective you'll be as a director (and the more fun you'll have on set).

These suggestions are just the tip of the iceberg. The list of subjects useful to a director is almost endless (art, communication, creative writing, film history, critical studies, just to name a few), and learning doesn't only take place in a classroom. Join a photography group or get involved in community theater. You'll learn even more skills (and maybe meet some potential actors and crew members in the process).

Practice

Acquiring the knowledge of a Renaissance man is important, but it's only part of the equation. In the last chapter we talked about the importance of gaining experience (and making some mistakes along the way), but how do you gain experience? You practice. Musicians, athletes, actors, dancers all spend hours a day honing their craft. You should, too. But remember, your craft isn't just playing with actors and a camera. Your craft is telling stories. Every movie starts life as a script (or at least an idea). You may not

always have the time or resources to assemble a cast and crew, but you can always write.

Write More Stories

Write as many scripts as you can. It doesn't matter if it's a three-minute short or a three-hour feature. Every time you write a script, you have to wrestle with the basic elements of storytelling. You have to devise an intriguing beginning, a compelling middle, and a satisfying ending. And you have to create an impact with your story.

But how can you tell if your script (and the resulting film) will have an impact? By getting feedback. Show every script you write to trusted friends and family and listen to what they say. Then go back and rewrite the script. Going through the process of wrestling with feedback (which can be painful to hear) and striving to improve and sharpen each script you write will strengthen your skills as a storyteller.

After you've written (and shot) a few short films, try your hand at writing a feature-length script. It costs you nothing to write, and writing a *good* script (a script people believe in) is one of the quickest ways to be taken seriously as a filmmaker.

TECHIE'S TIP

If you ever make it to Los Angeles, you'll discover that EVERYONE is writing a script. The question they all ask is this: "How do I get someone interested in my script?" The truth is actually very simple. If your script is good (and I mean *truly, genuinely, no-doubt-about-it* good), you won't have any problem. Everyone you show it to will become your new best friend and will want to help. But if you show people your script, and they don't immediately offer to help, your script needs more work. They may say they like it, but if they don't take immediate action, they're just being nice.

Direct More Projects

Writing is only one aspect of the practice you need. You also need to keep directing. Set yourself a goal to make a short (or a music video, or an event project) every two or three months. Enter the shorts you make in festivals.

By going to festivals, you'll learn more about filmmaking and marketing than any class can teach, and you might even win some awards. As an award-winning director with two or three completed feature scripts (because

you've kept writing in your spare time), you become much more viable to people who are looking to finance films.

Always Be Working

There's no way to tell how long it will take before you direct your first feature. Some people are lucky enough to get work right away. Others spend years writing scripts and meeting with potential producers before anything happens. But no matter how long it takes before you're working on the set of a feature film, there's probably going to be a lot of downtime, and it's easy to get discouraged.

All figures and shorts are included on the companion DVD with this book. **ON DVD**

One way to keep focused is to always have a project you're working on. No matter what else is going on in your life, you should always have a short (or a music video, or an event project) in some stage of production. It doesn't matter if you're writing, planning, shooting, editing, or hitting the festival circuit, you should always be working. It sharpens your skills and keeps you in touch with your Muse (see Figure 15.1).

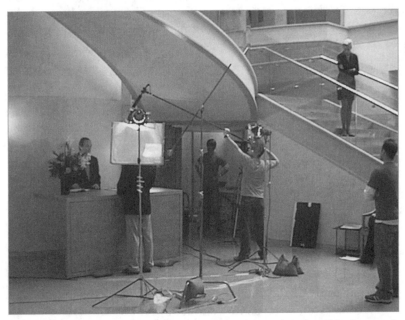

FIGURE 15.1 You don't need a lot of equipment or a big crew to shoot a short, and if the thought of writing your own script is daunting, you can even pick a favorite scene from an existing movie and shoot your own version of a Hollywood classic. The important thing is to keep practicing and developing your skills as a director.

Connect with fellow filmmakers

We said in Chapter 1 that making a movie takes a village. Whether you think of yourself primarily as a writer, director, cinematographer, or editor, you're part of that village now, and you need to know who else lives in your village because not only do they share your passion for filmmaking, they also have knowledge and experience to share. They can be a pool from which to draw crewmembers and equipment. Here are some common places to meet and network with other filmmakers:

- **On the Web.** There's an almost endless supply of blogs and forums for independent filmmaking. Whether you're looking for a review of the latest *DSLR*, or you need tips on easy ways to create soft light with homemade equipment, it's all out there. There's no better way to stay current with the latest digital equipment and techniques.

> **KEY TERM:**
>
> **DSLR** One of the latest trends in "high definition" is recording video on a Digital Single Lens Reflex (DSLR) camera. These cameras have traditionally been used for still photography, but now many of them have the capability to record HD video as well.

- **In filmmaking clubs and groups.** Most medium-sized cities (and many schools and colleges) have clubs and organizations for independent filmmakers. These organizations often hold seminars, host short film competitions, and organize screenings. Some of them rent equipment and editing facilities, and almost all of them maintain lists of local actors and crewmembers.

- **At film festivals.** We've already talked at length about how film festivals are a great place to meet fellow filmmakers and learn about current trends. Most film festivals also have seminars and panels on topics ranging from financing and distribution to finding agents and selling screenplays, and you don't need to have a film screening at the festival to attend these seminars. Going to festivals is a good idea even if you never submit a film of your own.

- **Offer to crew.** Working as a crewmember on someone else's film is an excellent way to gain experience when you're in-between projects. It's also nice to spend time on a set where somebody else is buying

the food and worrying about how many shots they can get before the sun goes down. Not only do you get to watch another director solve creative problems, you also meet other crewmembers that might work for you one day.

Greenlight yourself

Once you've written a script you're proud of and you have enough contacts to assemble a talented cast and crew (along with the required movie-making equipment), there's one sure way to get your movie made: Greenlight yourself. If you have the skills to make a short, you have the skills to make a feature.

From a production point of view, there's only one difference between a short and a feature-length film. The feature length film is longer. That's it. But that's a little like saying the only difference between running a mile and running a marathon is the amount of time it takes to run the race. While that's technically true, you can't run a marathon without significant training, and you can't make a feature without significant preparation. Here are some of the key planning challenges you have to solve to sustain production for the length of time necessary to shoot a feature:

Scheduling

An experienced independent crew can shoot a feature film in 18 days (typically over a 3-week period, shooting 6 days a week). But these are *very* long days—usually 12 to 15 hours each. So for that 3-week period, the cast and crew aren't doing anything else. Their sole focus is making the movie. If you can rally the support of a cast and crew for three solid weeks, this is a very efficient way to make a movie.

But if your cast and crew can't commit to a 3-week shoot, you'll have to get creative. It's possible to shoot a feature by breaking up the shooting schedule over a series of weekends (see the sidebar, "*As You Like It*: An Independent Case Study"). This approach takes more patience and dedication, but it's a good way to work with cast and crewmembers that have full lives and numerous other obligations.

Finances

While it's possible to shoot a short over a weekend and spend next to nothing, if you're going to shoot a feature, you're going to need some money. It doesn't have to be a lot of money (depending on your resourcefulness and

the goodwill of your friends, family, cast, and crew), but here are some things you'll probably have to buy:

- **Food.** You *have* to feed your cast and crew. Even if you don't spend a penny on anything else, you need to ensure you have a fully-stocked craft services table and a few good meals.

- **Expendables.** In movie lingo, expendables are supplies that are used up while making a movie (they're *expended*). *Duct tape* is a good example of an expendable. So are AA batteries. If you're shooting with a camcorder that uses mini DV tapes, you'll need a constant supply of fresh tapes.

KEY TERM:

DUCT TAPE Everyone knows what duct tape is (it's that gray cloth tape in the garage). What you may not know is how incredibly useful duct tape is on a movie set. Duct tape is used to hold down cables, to repair (or create) props, to modify costumes, and to perform countless other tasks limited only by imagination. It's no exaggeration to say that without duct tape, no movie could ever be finished.

- **Postproduction costs.** When you're editing your feature, you'll probably want to buy a separate (and very large) hard drive to hold your footage. If you use any stock music for your soundtrack, you'll also have to pay licensing fees.

These are just a few of the things you'll need money for. You might also need additional equipment (you can never have enough lights), and depending on where you shoot, you could have to pay for location fees or permits. Careful planning and creativity can keep costs low, but be prepared to pay for a few absolute necessities.

Motivation

We saved motivation for last because it's the most important (and can be the most difficult). Whether you've got a 3-week shoot (with back-to-back 15-hour days), or a schedule spread out over 6 months (or even longer), there are going to be moments when your cast and crew are tired and demoralized. There will be moments when the project seems doomed to failure, and there will be moments when people want to give up. Keep in mind, you're probably not paying anyone. The only thing that keeps them coming back is friendship and their belief in the project.

So you have to be a good friend. Thank people for their work. Show them how much you appreciate their time and commitment. Offer to return the favor and help them with their own projects (movies and otherwise). Socialize with them after shooting. Truly enjoy their company. Not only will you have a better time, you'll make a better movie.

You can *never* lose faith or passion for the project. Even if you're having a bad day, you can't let your enthusiasm fade. There will be days when your refusal to quit and enthusiasm are the only things holding the movie together. When those days come, don't get discouraged. They're normal. Just keep pressing forward. Enthusiasm is the fuel that gets independent movies made.

SIDE NOTE

AS YOU LIKE IT: AN INDEPENDENT CASE STUDY

Many of the still photographs in this book come from an independent feature that took over three years to plan, shoot, and edit. The movie is a modern adaptation of *As You Like It*, one of Shakespeare's most popular comedies. *As You Like It* was shot on weekends over the course of an entire year with a consumer-grade camcorder and second-hand movie equipment purchased on the Web.

The story follows Rosalind as she flees her evil uncle in the city and escapes to the island of Arden (which looks suspiciously like Southern California). Mistaken identity and misadventures follow until she eventually finds love and understanding with Orlando, a fellow city-dweller hiding out on the island.

As You Like It was conceived as a showcase for a no-budget independent production using the latest in affordable digital technology. The goal was to create a film with professional-grade production values using techniques and equipment available to everyone.

Here are some specifics about the production:

Camera: A tape-based HDV camcorder (Canon HV-20), with a 35mm adaptor (Redrock), used with Nikon lenses (see Figure 15.2).

Cast: The cast consisted of actors from a local community theater near San Diego, CA (see Figures 15.3 and 15.4).

Crew: A crew was assembled from friends and people who responded to announcements posted on the Web.

Schedule: 50 shooting days spread out over weekends from August to the following July. Shooting days were between 6 and 10 hours long.

Expenses: Shooting costs were held to a bare minimum. Equipment, expendables, food, a few costumes, and props were the primary expenses.

Be sure to watch the trailer for *As You Like It* included on the companion DVD. **ON DVD**

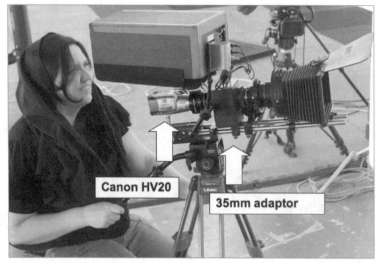

FIGURE 15.2 We used the Canon HV-20 and a 35mm adaptor for *As You Like It*. Although the assembled camera rig was fairly large, the camera itself was a small, consumer-grade camcorder (seen mounted upside down at the back of the adaptor). Refer to back to Figure 3.12 for a closer view of the camera setup.

As this book goes to press, *As You Like It* is just beginning its run on the festival circuit. For the most current information (and more behind the scenes pictures and stories) visit the Web site at www.indieshakespeare.com.

FIGURE 15.3 *As You Like It* was originally staged as a traditional Shakespeare production at a local community theater. In the scene shown here, Old Adam and Orlando decide to escape together for the forest of Arden.

Figure 15.4 shows the same scene as Figure 15.3 in an updated, realistic setting.

FIGURE 15.4 When we made the movie, we used Shakespeare's original script and the same actors as the original stage production, but we changed the setting to an alternate version of the 20th century. The image shown here is the same scene as Figure 15.3, but in a modern, realistic setting.

With *As You Like It*, we showed that digital video and postproduction is affordable enough for anyone to make a project with professional production values. There's truly never been a better or easier time to make an independent feature. So get to it. Greenlight yourself.

The One TRUE Rule *(inspirational strings tremble briefly)*

Okay. Now that we're at the end of the course, it's time to let you in on a secret. Most of what we've studied in this course can be boiled down to one single rule. Doesn't quite seem possible does it? Think about all the *musts* and *shoulds* and *rules* we've covered in the preceding 15 chapters. Here's a partial recap:

- A story *must* have three acts with a beginning, middle, and end.
- All shots *should* be framed according the *rule* of thirds.
- Your movie *must* be visual.
- You *should* never cross the stage line.

- You *must* avoid jump cuts.

- All movie soundtracks *should* create a rich sonic environment.

And the list goes on and on. Much of this book has been devoted to describing and explaining the rules that separate professional filmmaking from amateur home movies. But believe it or not, there's one rule that takes precedence over everything we've discussed—one TRUE rule (a lone timpani echoes).

This rule has been passed down from director to director. This author learned it from one of the true Hollywood greats, Edward Dmytryk, who directed over 50 films during the golden age of Hollywood, working with such stars as Humphrey Bogart, Clark Gable, Spencer Tracy, Elizabeth Taylor, and Bette Davis. Here it is. Are you ready? (music swells to an Aaron Copland crescendo) It's simple:

Have a reason for everything you do.

You're completely free to do anything you want with a camera, actors, and a soundtrack. Do you want to cross the stageline? Go ahead. Would you like to use a jump cut? Fair game. What about creating a hero with significant character flaws? That's okay, too. Every choice you make will have an effect on the audience. As long as you have a *reason* for wanting the effect your choice will create, you'll be fine. Because for every rule ever written in a textbook or taught in a class, there's been a successful film that blatantly violated that rule.

NOTE

Of course, just having a reason for each choice doesn't guarantee success. There have also been numerous films that broke rules and failed dismally. Breaking rules for the sake of breaking rules rarely works.

Whenever you write a script and make a movie, you have to make literally thousands of choices. It can be quite daunting. Rules and guidelines are the collected experiences of filmmakers who've worked with pictures and sound over the years. Some of their experiences will make sense for your project, and some of them won't.

Choosing to ignore a well-respected, long-standing *rule* is a risk. But making movies is a risky business. So make whatever choices you think are best. Just have a reason for everything you do.

Final Thoughts

Making a movie is an experience unlike any other. You have to master numerous difficult and seemingly incompatible skills. You have to think and feel with the artistic sense of a visionary, while at the same time organizing and managing the complexities of a film shoot. You have to be true to your instincts while allowing a diverse group of other artists (actors, cinematographers, etc.) the freedom to express their own individual truths.

In this book, we've tried to introduce you to the knowledge and skills needed by a successful director, and we've tried to make you comfortable with the collaborative process of telling effective stories with pictures and sound. But there's only so much a single book or class can do. The rest is up to you.

So what do you do now? Practice. Take some classes. Write. When you're ready, pull together a cast and crew of friends and make your feature. It really can be just that simple. Good luck to you.

INDEX

O

opening credits, definition, 333

optical zooms, 20

oral history, definition, 421

outdoor shooting

 bright sunny days

 add light to the scene, 183–185

 diffuse the sunlight, 183

 subtract light from the scene, 185–186

 cloudy day, 188–189

 day for night, 190–191

 magic hour, 191–192

 nighttime, 189–190

 in sunlight, 196

outgoing shot, definition, 280

out-point timeline, 273

over-the-shoulder shot, 124–125

P

pacing, incredible importance, 297–299

parallel action, definition, 349

peacekeeper. *See* director

phantom power, 200

phase alternate line (PAL), 351

picture lock, definition, 306

plant mic, definition, 208, 377

playable, definition, 466

playback, 446

point of view (POV), 87

positive space, 134

post-lapping, 286

postproduction

 definition, 23

 script notes, 255–256

 slating, 254–255

prelapping, 286

preproduction

 casting, 238–239

 feeding cast and crew, 245–246

 final details, 246–247

 getting right equipments, 243

 location, 241

 permits and releases, 245–246

 rehearsing, 244–245

script breakdown, 237–238

shot plan, 241–243

storyboards, 241–243

presence, definition, 197

process-oriented direction, 253

process shot, definition, 189

production dialogue

 clean dialogue

 avoiding noise movement, 214–216

 shooting in noisy location, 213–214

 offenders

 air conditioners, 217

 buzzing lights, 217

 computers, 217

 open windows, 217

 refrigerators, 216

 separation concept, 212

production sound, definition, 197

production value, definition, 453

purpose of lighting, 160–161

R

rack focus, definition, 62

reaction shot, 127

recording level

 automatic gain control, 218–219

 definition, 218

 setting manual audio levels, 219–220

recording media, 8

 DVD cameras, 10–11

 hard-drive cameras, 11

 memory-card cameras, 11–12

 tape cameras, 9–10

reflector, definition, 183

refrigerators, 216

rehearsing, 244–245

Renaissance man, definition, 466

result-oriented direction, 253

riding audio levels, definition, 220

rolling credits, definition, 334

room tone, 222, 312

rough cut, definition, 345

roving operator, definition, 394

royalties, 317